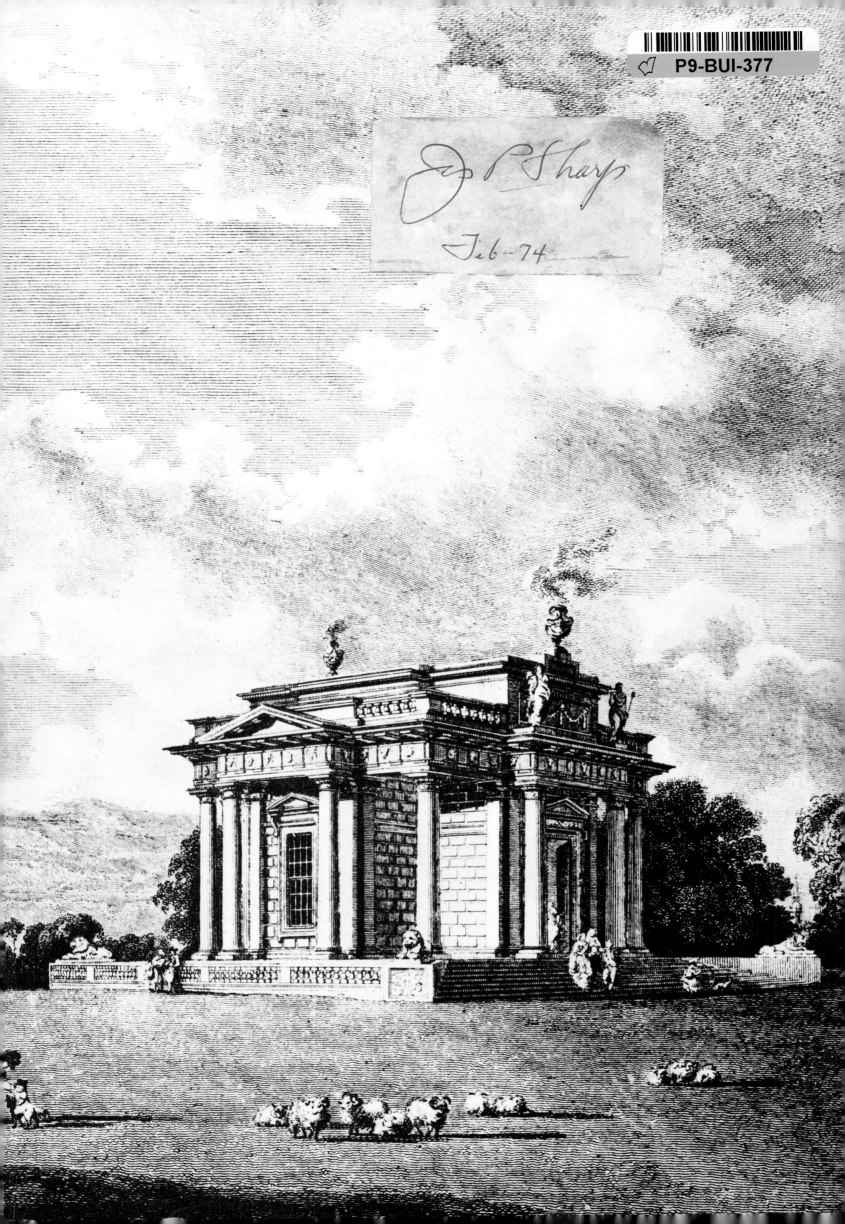

Irish houses & castles

Front endpaper. The Marino Casino (1762) at Clontarf designed by Sir
William Chambers for the Earl of Charlemont, and erected beside his marine villa
at Clontarf on the outskirts of Dublin. The Casino is the only non-functional
building of the Georgian period maintained by the state, and although the interior has
yet to be restored, visitors are admitted on application to the caretaker

Back endpaper. The Mussenden Temple, built for his kinswoman Mrs
Mussenden by the Earl of Bristol, Bishop of Derry, in 1783. The building was
inspired by the temples of Vesta at Tivoli and Rome, and was probably designed by
Michael Shanahan. The Earl-Bishop was, like Lord Charlemont, a great
collector but the two were rivals rather than friends. In the care of the National
Trust, Committee for Northern Ireland

Irish

DESMOND GUINNESS · WILLIAM RYAN

houses & castles

A STUDIO BOOK

THE VIKING PRESS · NEW YORK

For Mary Ryan
and
Patrick & Marina Guinness

Since the original publication of this book
in 1971 Lough Cutra Castle (pages
177–181) has been acquired by
Mr Timothy Gwyn-Jones, and
Mount Kennedy House (pages 315–322)
is now owned by Mr and Mrs Noel Griffin

Third printing May 1973

Published in 1971 by The Viking Press, Inc.
625 Madison Avenue, New York, N.Y. 10022

SBN 670-40121-8
Library of Congress catalog card number: 78-151883

Filmset in Great Britain by Keyspools Ltd Golborne

Colour plates printed in Switzerland by
Imprimerie Paul Attinger S.A., Neuchâtel

Monochrome plates and text printed in Switzerland by
Imprimeries Réunies S.A., Lausanne

Bound in Holland by
Van Rijmenam N.V., The Hague

CONTENTS

MAP OF IRELAND 6

INTRODUCTION 7

HOUSES AND CASTLES

Bellamont Forest *Co Cavan* 39

Bunratty Castle *Co Clare* 49

Mount Ievers Court *Co Clare* 55

Bantry House *Co Cork* 61

Fota Island *Co Cork* 71

Kilshannig *Co Cork* 77

Glenveagh Castle *Co Donegal* 85

Castleward *Co Down* 93

Dublin Castle *Dublin* 103

Aras an Uachtaráin *Dublin* 109

The Provost's House
Trinity College *Dublin* 117

Howth Castle *Co Dublin* 125

Lucan House *Co Dublin* 131

Luttrellstown Castle *Co Dublin* 139

Malahide Castle *Co Dublin* 145

Newbridge *Co Dublin* 151

Rathbeale Hall *Co Dublin* 159

Castlecoole *Co Fermanagh* 163

Florence Court *Co Fermanagh* 169

Lough Cutra *Co Galway* 177

Carton *Co Kildare* 183

Castletown *Co Kildare* 193

Leixlip Castle *Co Kildare* 211

Castletown *Co Kilkenny* 219

Abbey Leix *Co Leix* 225

Glin Castle *Co Limerick* 233

Beaulieu *Co Louth* 241

Westport House *Co Mayo* 249

Dunsany Castle *Co Meath* 257

Slane Castle *Co Meath* 261

Birr Castle *Co Offaly* 271

Lismore Castle *Co Waterford* 279

Ballinlough Castle *Co Westmeath* 289

Belvedere *Co Westmeath* 295

Tullynally Castle *Co Westmeath* 303

Charleville *Co Wicklow* 309

Mount Kennedy *Co Wicklow* 315

Powerscourt *Co Wicklow* 323

Russborough *Co Wicklow* 333

BIBLIOGRAPHY 349

ACKNOWLEDGMENTS 351

INDEX 352

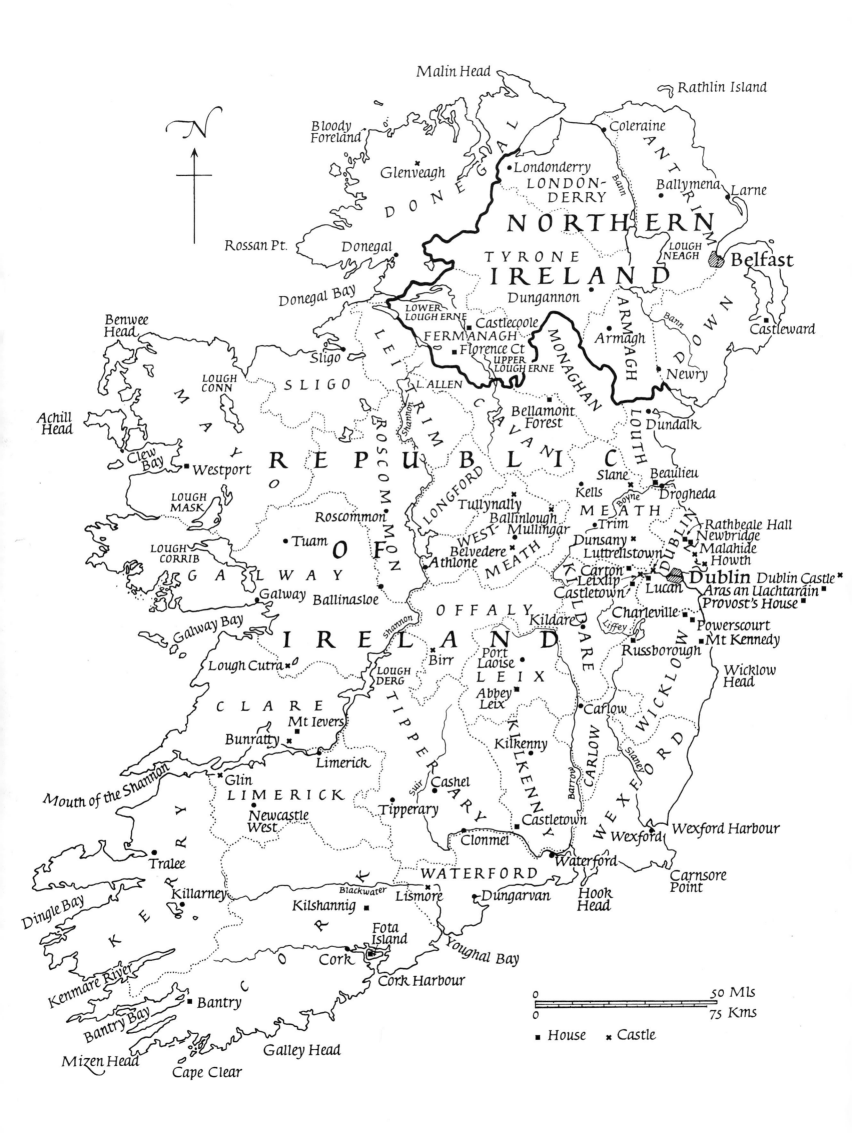

INTRODUCTION

The development of Irish domestic architecture

THE GREAT COUNTRY HOUSES AND CASTLES of Ireland are a living reminder of the richness of Anglo-Irish culture during the Georgian period. It was the architecture of the ruling class, the Anglo-Irish aristocracy, who have left the Ireland of today with a superb legacy of serene Palladian façades and embattled Gothic castles. These houses provide the fascinating background for the plays of Sheridan and Goldsmith, and were themselves star performers in the writings of Maria Edgeworth, Somerville and Ross, and Elizabeth Bowen. Although the Ireland of Tony Lumpkin and the half-mounted gentry is widely known through the eyes of these writers, few attempts have been made to set down the facts about the Irish country house.

The uneasy peace which followed the Battle of the Boyne in 1690 established the Protestant elite as rulers of Ireland, where the vast majority had clung to the old religion. The Penal Laws excluded Catholics from holding a commission in the army or sitting in Parliament. A blind eye was turned to priest-hunting and chapel-burning, and in County Galway where a landlord was particularly unpleasant Mass had to be celebrated from a makeshift hut that was taken down to the beach, where he had no jurisdiction. The Protestant landlords had loyalties to England that were not shared by their tenants, and they looked to England for protection in time of rebellion. The courthouse, the gaol, and the military barracks to be found in every Irish town bear witness to the unhappy state of the country. A friendly relationship existed between squire and villager in England that was the wonder of Europe. The lord of the manor and the blacksmith could even join in a game of cricket on the village green. In Ireland the two were separated by barriers of race, religion, and in some districts language. There was a need to be on the alert, a feeling of being in a foreign country – Irish in England and English in Ireland. This 'foreign' aspect has been beautifully summed up by Elizabeth Bowen in *Bowenscourt* when she describes her sadness at closing the great hall door in the evenings – at 'shutting Ireland out'.

For reasons of safety, the castle stronghold survived far longer than was necessary in England. The bloody rebellion of 1641 was followed by Cromwell's ruthless campaign

that laid waste to the countryside. It was not until the Battle of the Boyne that peace and prosperity returned to the land, and the building of country houses began in earnest. Sometimes the old castle would be modernized, large windows piercing the thick walls for the first time, but generally it was abandoned and left to fall, the new house springing up nearby like a newly hatched chicken beside its empty shell. At Blarney and Bunratty new rooms were added to the castle, while the great hall and kitchens continued in use.

The first country houses, built about 1700, were usually of brick; the fashion for building in this material (and for using sash windows) is said to have been introduced by William of Orange, the victor of the Boyne, from his native Holland. The roof was steeply pitched, and the tall chimneys were a definite part of the architectural design. In 1722 Castletown, the first great house in the Palladian manner, was built beside the River Liffey twelve miles from Dublin. It must have been seen and admired by a great many people, for it set the pattern which was followed in both large and small houses all over Ireland. The idea of putting utilitarian farm buildings in the wings of the house to lengthen the façade was born here, and it was an original contribution to country-house design. No streak of Puritan modesty restrained the Anglo-Irish for whom these houses were being built. Local rivalries, jealousy, and family pride had their effect on the architecture – people were ruined in the attempt to outbuild one another.

Generally Irish country houses of the eighteenth century were either built by men of taste and fashion, abreast of the latest architectural styles in England and on the Continent, or concoctions put up by a local builder or contractor, based on a rough sketch, or derived from an out-of-date architectural pattern-book. 'Went in evening', writes Dorothea Trant, an English visitor to an Irish household in London, 'noble house and everything in perfect style, but whether from prejudice or not, I fancied there was a *parvenu* air in all around; English stiffness grafted on Irish good nature!' And again: 'In most cases these houses maintain no culture worth speaking of—nothing but an insidious bonhomie, an obsolete bravado, and a way with horses.' In the course of a eulogy on Thomas Ivory in *Antologia Hibernica* for 1793, the following passage appears which sums up the bumpkin architecture of the lesser gentry and 'half-sirs': 'No sooner do these lads obtain a smattering of drawing, but they please to call themselves *architects,* and many gentlemen who have pretensions to taste in design and economy, give their scrawls to these tyros to make what they call drawings, which are afterwards produced, over the bottle, as their own. From these joint productions are the many medleys of country houses derived, that are scattered about to the disgrace of the taste of the country.' The writer may have been James Gandon, the architect of the Customs House and the Four Courts in Dublin, and a professional to the tips of his fingers. It is true that these amateurish creations have a somewhat confused architectural vocabulary, but that

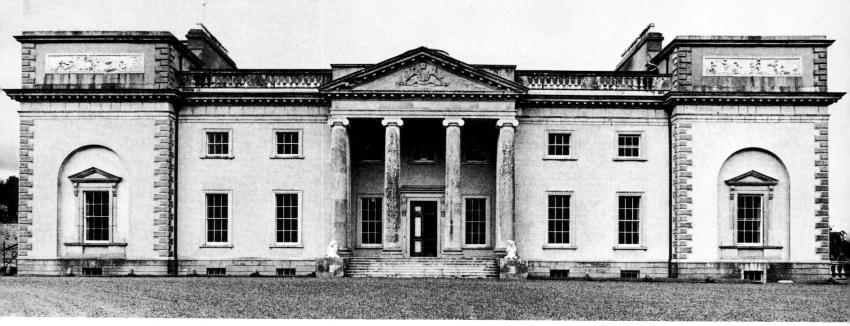

Emo Park, Co. Leix, was designed c. 1790 by James Gandon for the Earl of Portarlington, whose wife was one of those responsible for bringing Gandon to Ireland from England. The building was completed some years later by Gandon's pupil Sir Richard Morrison and a dome was added in 1852

is half their charm. They are generally twenty or thirty years behind England in design, joinery and so forth, and for all the splendour of the façade, the sides and back are too often a jumble of misplaced windows and ugly downpipes.

Professional architects were a rarity, and even when they were employed, they did not always oversee the work in person, and much responsibility devolved on the foreman. Sir William Chambers, to whose designs the Examination Hall and Chapel at Trinity College were built, relied on one Graham Myers for their execution. 'If there be any merit in the general intention I may claim some share in it; but the whole detail, on which the perfection of these works must greatly depend, is none of mine and whatever merit that has is Mr Myers' who I understand is the operator', he writes modestly. Chambers also designed the Marino Casino, an elaborate garden temple, one of the earliest (1762) examples of neo-classical architecture in the British Isles, for the Earl of Charlemont. He sent full instructions which might not have been committed to paper had he been in Ireland, and are of the greatest value today; he was afraid that the colour samples sent on wood might be affected by the sea air when crossing the channel!

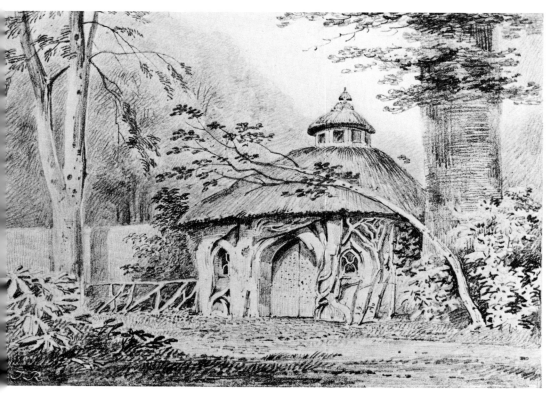

Sketch by T. Roberts of Lord Charlemont's rustic bower at Marino, of which there is now no trace. (Coll. the Earl of Ypres)

Robert Adam was another absentee architect, and his coloured designs for the interior of Headfort, Co. Meath, (1771) still exist. Thomas Cooley was the Irishman in charge. It is interesting to find that, on the upper floors, the detail becomes rather heavy appearing to be twenty years older than the delicate Adam work in the main rooms, an unusual example of the time-lag in operation under a single roof.

Although Castletown, Co. Kildare, had such an influence on country-house design in Ireland, its authorship has for long remained a mystery. It has lately been established that the architect was an Italian, Alessandro Galilei, who is best known for the great façade he designed for St John in Lateran, Rome. He had, however, left Ireland in 1719, not thinking there were opportunities for employment, and it is still not certain to whom his plans were entrusted when building started in 1722. By 1724 it seems clear that the building was under

Robert Adam's design for the front hall at Headfort, Co. Meath. (Coll. Paul Mellon)

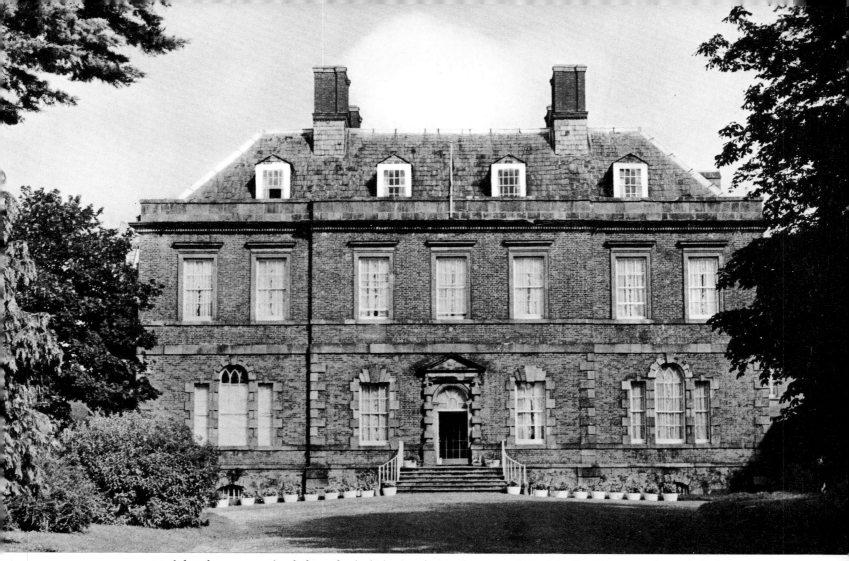

Cashel Palace, now an hotel, formerly the bishop's palace in the centre of Cashel, Co. Tipperary. It was built in 1731 to the designs of Sir Edward Lovett Pearce

the direction of a brilliant young architect, Edward Lovett Pearce, who had known Galilei and travelled in Italy. He was Ireland's first and greatest Palladian architect; his monument is the Parliament House in Dublin, now the Bank of Ireland, whose great portico faces Trinity College across College Green. His work at Castletown, Bellamont Forest, and Dublin Castle is illustrated here. He also designed Drumcondra House, near Dublin (All Hallows seminary); Cashel Palace, Co. Tipperary (an hotel); 9 and 10 Henrietta Street, Dublin (Society of St Vincent de Paul), and an obelisk together with an underground grotto of seven domed rooms at Stillorgan, Co. Dublin, now surrounded by modern housing. Pearce was knighted for his work on the Parliament House, and appointed Surveyor-General on the death of Thomas Burgh in 1730. He died in 1733 at the early age of thirty-four.

In 1728 Pearce wrote 'An Explanation of the Following Designs for a Parliament House in Dublin', when submitting his alternative plans, in which he recommends his friend Richard Castle: 'I know nobody in this Town whom I could employ capable of drawing from designs of this nature but one Person, and he, indeed, has done them infinite justice, his name is Castle, he is at present employed in building a House for Sir Gustavus Hume

near Enniskillen but I hope will find more and constant employment. I thought I could not do a better service than mentioning this to Gentlemen who may have occasion for such a person.' Pearce could not have known when he wrote these words that he was to die so soon, nor can he have guessed at the meteoric success of Castle who remained in Ireland until his death in 1751 and became her leading architect.

Richard Castle was born in Hesse-Kassel about 1690 and was brought over to Ireland from London by Sir Gustavus Hume in 1728 to construct Castle Hume, Co. Fermanagh, of which only the stables remain. As an architect he was less inspired than Pearce and his buildings are characterized by a certain massiveness, but he was a professional and his draughtsmanship was excellent. It may have been reassuring to those who were building at this time, some of whom could remember the Battle of the Boyne and the subsequent up-heavals, to make use of rather solid proportions in their houses. It gave them the illusion that their society was destined to endure – a feeling of permanence and stability, as well as splendour and magnificence.

In 1733 Castle married an Irish girl of Huguenot origins, June Truffet, and remained in Ireland for the rest of his life. So far as is known he never built elsewhere, but in spite of his

Port Hall, Lifford, Co. Donegal. This small house was built in 1746 by Michael Priestley who also designed the Lifford Courthouse

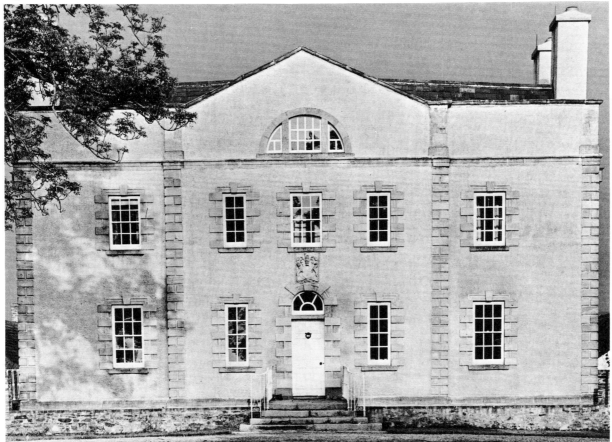

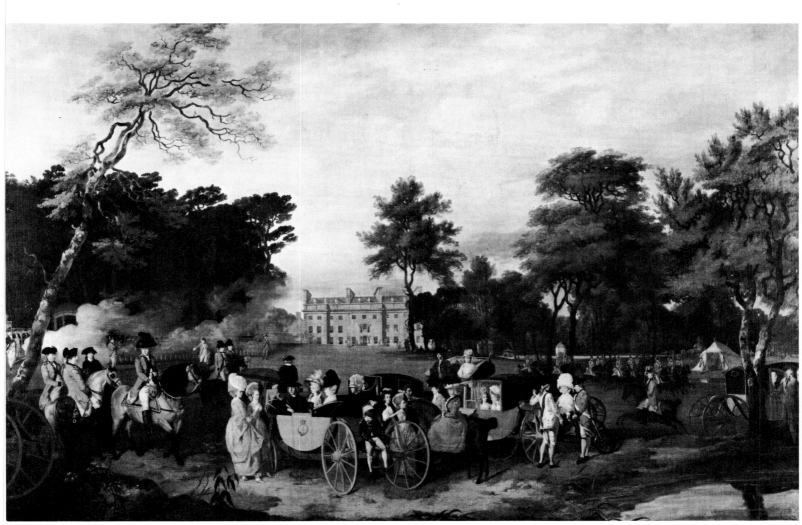

Lord Aldborough on Pomposo by Francis Wheatley. Belan (1743), Co. Kildare, formerly the seat of the Earls of Aldborough and now a ruin can be seen in the background; it was designed by Richard Castle and Francis Bindon. (National Trust, Waddesdon Manor)

enormous practice his name was almost forgotten by the end of the eighteenth century, when his buildings were considered gloomy and old-fashioned. He worked on the Newry Canal which was the earliest (1730) in these islands and built churches, bishops' palaces, and houses in both town and country. Much has been attributed to him on stylistic grounds – Adam and Grinling Gibbons have similarly been credited with many works. It is said that he had a weakness for the bottle, and that his drinking bouts would last for days on end. He died in 1751 at Carton, while writing a letter to a carpenter employed at Leinster House. 'He was an ornament to his time in Architecture on which his judgment was solid, his taste pure, and his inventions quick and free. To him this kingdom owes the true beauty and taste of architecture as well as the spirit of building well.' So ran his obituary in the *Dublin Gazette*.

He is thought to have collaborated with Francis Bindon, the painter, architect, and M.P., at Russborough and Belan, but the true successor to his practice was his clerk of works, John Ensor. It was he who completed the Lying-in Hospital in Dublin to Castle's design; building had just begun at the time of his death. George Ensor, the brother of John, was also an architect. The profession often ran in families, who formed alliances with families of stone-cutters like the Darleys and stuccodores like the Stapletons.

Owing to the dearth of factual records, tracing the work of architects in Ireland can only be done on stylistic grounds, except in the rare cases where documentation exists. Another amateur Palladian, more talented but no less shadowy than Bindon, was Nathaniel Clements, and the Knight of Glin has built up a convincing argument for his *œuvre*. It is most unfortunate that in 1753, when memory was fresh, a project mooted by George Faulkner, Swift's publisher, came to nothing. He issued proposals for a work to be entitled *Vitruvius Hibernicus,* 'containing the plans, elevations and sections of the most regular and elegant buildings, both public and private, in the kingdom of Ireland, with variety of new designs, in large folio plates, engraven on copper by the best hands, and drawn either from the buildings themselves, or the original designs of the architect.' It was to have been printed on Irish paper, with descriptions of the buildings in Latin, French, and English. The fact that it never appeared is a reflection on the general lack of interest in architecture which can be said to persist even today. Buildings are taken for granted; the architect's name is soon forgotten, and the closest approximation to a date will be 'hundreds of years old'.

It is difficult to feel as much affection for the neo-classical and Greek revival styles as for the Palladian, which was in fashion until about 1760. Fine as these later houses are, there is a more slavish imitation of English counterparts, probably the result of improved communications and the proliferation of pattern books. Davis Ducart, a Sardinian architect, kept the Palladian tradition alive in the provinces until the 70s and 80s, by which time the rococo plasterwork that enriches his houses would have seemed very out-of-date in Dublin. The dead hand of Adam had reached Ireland, and native exuberance was temporarily checked. It was to find its true expression once more in the embattled castles of the Gothic revival.

The Gothic revival reached Ireland in the 1760s with Castleward and by the end of the century architects had to be conversant with the Gothic as well as the classical style. Why the taste for Gothic took such a hold in Ireland is a matter for conjecture. It could hardly, at whatever stretch of the imagination, stem from nostalgia for the medieval period. Was it with half an eye to security? Was it that people had tired of the sameness of the classical house? Or did it quite simply suit the pretensions of the Anglo-Irish to live in a castle? It was probably a question of fashion. Many houses were pulled down and rebuilt, others had battlements and arrow-slits added (disastrous leaks appearing) sometimes leaving the classical house unaltered beneath. Perhaps an elaborate Gothic gateway, complete with mock portcullis and emblazoned with the inevitable coat of arms, would suffice to conjure up

Francis Johnston's design (1806) for the gothicization of Headfort, Co. Meath, a scheme which was never carried out. (National Library, Dublin)

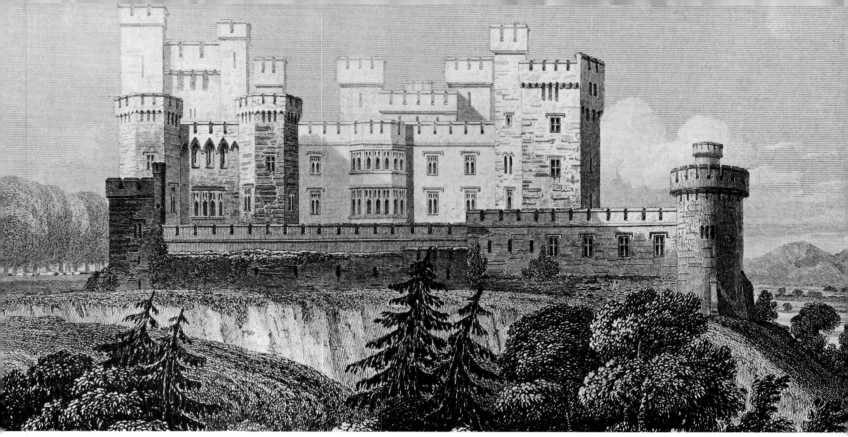

Mitchelstown Castle (1825), Co. Cork, formerly the seat of the Earls of Kingston, a Gothic castle designed by James and George Richard Pain, and burned down in 1922. Detail from Neale's Views of Seats

'visions of the true rust of the Barons' wars'. As in France, where the word 'château' so conveniently means both house and castle, so in Ireland 'castle' can have the double meaning – 'above at the castle' might turn out to refer to some sober, classical house.

Just as the Palladian house often concealed stables or cowsheds behind its splendid façade, so it was with the Gothic castle. At Cabra Castle, Kingscourt, the dairy is lit by arrow slits, and both at Knockdrin, Co. Westmeath, and Ballyseedy, Co. Kerry, impressive Gothic bastions are in fact curtain walls with nothing whatever inside them.

O'Neil-Feilding writes of Shelton Abbey in 1835 as follows: 'The architects who designed the mansion, proposed to themselves to represent a monastic structure of the fourteenth century, converted into a baronial residence of a date shortly subsequent to the reformation'— a challenge to any architect. In the same year Hughes was writing of Castle Howard close by in County Wicklow: 'The Architecture of it is designed on the principle of uniting the characters of a castellated place of defence, and a monastic structure – a combination difficult of attainment, but of striking effect when, as in the present instance, it has been well conceived and skillfully executed.' So lately abandoned, the castle was once more in fashion.

The nineteenth century, a period of tragic poverty due to the potato famine in 1847, saw little country-house building, and some landlords were ruined along with their tenantry. Paradoxically, the effect on Irish architecture was not all bad – the country house did not suffer from alterations and additions as did its English counterpart. Nor was the countryside darkened by slag heaps and the smoke of factory chimneys.

Characteristic features

The charm of the English country house often derives from the fact that it has been added to over the years by succeeding generations according to the fashion of the day. In Ireland, on the other hand, the houses tend to express one architectural style; Tudor and Jacobean scarcely exist, and Victorian 'improvements' are rare. The Irish country house, with its plaster coat of arms, its wooden family portraits and its air of arrogance and disrepair, might at first appear to be a second-hand imitation of its English counterpart. But Irish houses have a character of their own, shaped by the turbulent history of the country and the reckless character of its people.

NOMENCLATURE

Place names in Ireland sometimes have an Irish root, sometimes Latin, and sometimes English. The name of the house usually stands on its own (Carton, Castletown) without the descriptive adjunct that is common in England of 'House', 'Court', 'Hall', or 'Manor'. 'Castle' is frequently used, however, and on a manuscript map still preserved, a perplexed Irish cartographer has written 'Pakenham Hall Castle'. The names of rivers, such as Shannon and Glandore, were often chosen by those seeking a title. De Latocnaye, in his *Promenade d'un Francais dans l'Irlande,* wrote: 'Since great things flatter self-love, why has no one ever thought of calling himself Lord Atlantic—the sound of Lady Ocean coming into a drawing-room would appear to be very delightful.' Ordinary names like Morris, Smith, and Ford became 'de Montmorency', 'Smythe', and 'Fforde'. The family name often gives its name to the house; the Bland family still live at Blandsfort and the Congreves at Mount Congreve.

Sometimes the wife's Christian name was commemorated in the name of the house. Elizabeth Ponsonby gave her name to Bessborough, calling forth a howl of anguish from Dean Swift. In his essay 'On Barbarous Denominations in Ireland' he pours scorn on the landed proprietors; 'The utmost extent of their genius lies in naming their country habitation by a hill, a mount, a brook, a burrow, a castle, a bawn, a ford, and the like ingenious conceits. Yet these are exceeded by others, whereof some have contrived anagramatical appellations, from half their own and their wive's names joined together: others, only from the lady; as for instance, a person whose wife's name was Elizabeth, calls his seat by the name *Bess-borow.*' Perhaps his raillery took effect, for later in the century many people seemed to change to foreign appellations – Dollymount becomes Delamont, and Mount Tally-ho becomes Montalto.

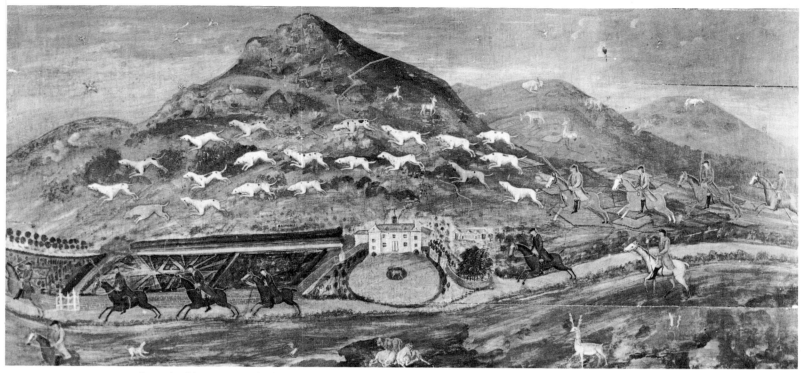

The Kilruddery Hunt: the horses and hounds are cut-outs adhered to the painting which is on wood. The garden shown in this illustration is a rare instance of a late seventeenth- and early eighteenth-century formal garden. It still survives. (Coll. The Earl of Meath)

DEFENCE AND LANDSCAPE

The economic Palladian layout, whereby farm buildings were sheltered in the wings of the house, was designed to make the façade appear impressive. It may equally have been re-assuring to have the animals close at hand, as in previous centuries they always had been; they could be driven in to the capacious bawn beneath the castle walls in time of emergency. The classical house had developed straight from the castle, and it too was built with half an eye for self-protection.

Elegant carved stone gun-ports are to be found high in the walls of country houses in County Wexford, that date from the eighteenth century. After the ponderous locks and chains on the front door, the next line of defence was the area that surrounds practically every Irish house, its barred and bolted windows giving light to the rooms in the basement where the kitchens are usually found. Beyond that was the ditch or ha-ha that separates house and lawn from the park beyond. Finally there was the demesne wall. These immensely long walls that herald the approach to a great house are generally crumbling now, held up by the ivy that is their ultimate destruction. Many of them were built or enlarged during the Famine to provide employment, and they were status symbols, like the towers of the nobles in Siena. They were built as much to keep people out as to keep animals in, and were a source of considerable resentment in the past.

If a house is in danger of being altered by succeeding generations, the landscape that surrounds it is even more vulnerable. Very few formal layouts survive in Ireland, but some have been recorded in paintings and engravings, and particularly on the map of County

Dublin by the French cartographer J. Rocque, 1760. In the early eighteenth century, the garden surrounded the house in the French or Dutch manner, and straight avenues stretched out towards the horizon like the spokes of a wheel. Under the influence of the taste for the informal, 'English' park, these were swept away later in the century and replaced with a man-made landscape 'where art and nature in just union reign'. Truly wild landscape, in which Ireland abounds, would have been considered 'rude' and 'horrid' at the time; it was not until the nineteenth century that it came to be appreciated.

When possible, the park was chosen for its landscape features. But the best land, bringing in the highest rents, was in districts that were scenically dull so that good houses were often built in flat districts where formal 'French' parterres might have suited the landscape to better advantage.

In the third quarter of the eighteenth century the garden was swept right away from the house and shut up in a high wall, where it was kept firmly under lock and key. Lakes and fishponds were dug, usually silted up now, and streams were diverted and widened to provide the Irish phenomenon, the 'sheet of water'. Ornamental bridges, Chinese and classical, were built, and perhaps an obelisk, a temple, or a Gothic ruin would spring up to vie with the natural beauty in embellishing the landscape.

At Lyons, Co. Kildare, the trees were planted according to the formation of the troops at the Battle of Waterloo. Miss Lawless, who lived there until her death in 1958, is said to have issued an order to 'cut down the Prussian armies' when she needed timber during the last war. There still is a deerpark with white deer that descend from some given by Queen

Downhill, Co. Derry, formerly the seat of the Earl of Bristol, Bishop of Derry. The aerial view shows the fortified yards behind the house, whose battlements make a strange contrast to the classical facade. (See also back endpaper)

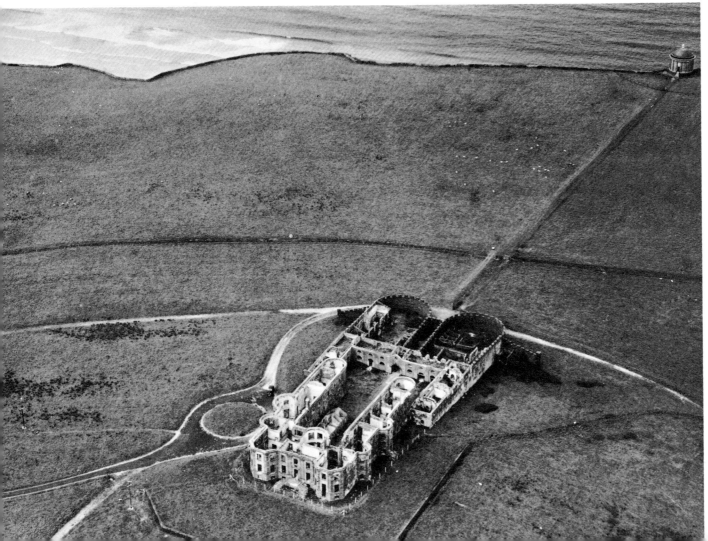

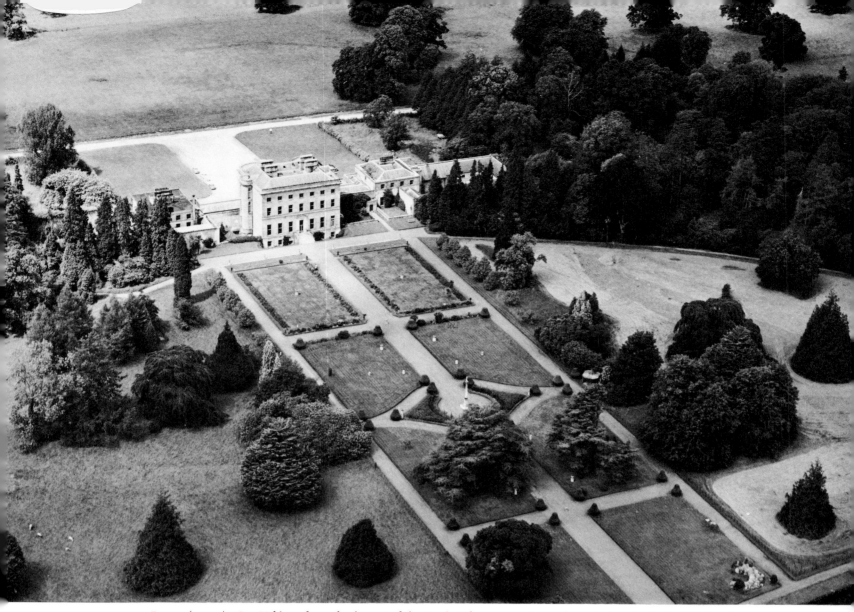

Lyons (1797), Co. Kildare, formerly the seat of the Lords Cloncurry and now the agricultural school of University College Dublin. The gardens between the house and the artificial lake were created in the last century

Elizabeth I at Mallow Castle, Co. Cork, and another at Grange Con, Co. Wicklow; there is also a herd of red deer at Doneraile Court, Co. Cork.

In the rational nineteenth century it seemed unreasonable to be employing fifteen or twenty gardeners without being able to see a single flower from the house, and in several cases (Lyons, Carton) a formal garden was made outside the windows.

The house and park were kept up by the income from tenant farms, generally in the immediate neighbourhood but sometimes scattered throughout Ireland. The Duke of Leinster, for example, owned forty thousand acres of rich land in County Kildare alone, but he had land in many other parts also. In 1903, the Wyndham act was put through, depriving Irish landlords of their tenant farms, in exchange for financial compensation. The head was severed from the body. The house and park were left, top-heavy and uneconomic. Families who might have hesitated before selling land had no such restraint when it came to spending money in the bank. Parkland was chosen for its beauty, not for its farming qualities.

Trees scattered across the land make it difficult to till. Farm buildings were as out-of-date as the old hands who were kept on because there was nowhere else for them to go. Spiralling wages and rates finally took their toll and one by one the great demesnes have gone. In too many cases the park is now cut up with concrete and wire, the house sold to a demolition contractor – nobody else would buy a country house without the field in front. Two hundred years of love and care, in purely financial terms a considerable national investment, have gone for nothing.

It is to be hoped that this downward trend has at last been checked. It is far easier to find a buyer for a large country house in Ireland today than it was fifteen years ago, and the government is at last taking an interest in the problem. They have recently asked for a survey of historic houses to be carried out by An Taisce, and the Tourist Board are at the same time encouraging owners to open their doors to the public. The future of the Irish house and park is indeed more hopeful now.

GATEWAYS AND FOLLIES

Taking into account their sometimes modest financial status, and their love of show, it is not surprising that the Irish gentry made the most of the entrances to their demesnes. What better place was there for impressing the passer-by? Few Irish houses can be seen from the road; the gate provides a foretaste of splendours to come – but not invariably. The most imposing gateways on occasion lead to the simplest of houses, as if the money had run out going up the drive. At Glananea, Co. Westmeath, an enormous set of gates ornamented with Coadestone statues and surmounted by a unicorn, led to the rather plain house owned by a Mr Smyth who had a great number of relatives of that not uncommon name living in the neighbourhood. To distinguish him from the rest of the clan he was nick-named 'Smyth with the gates'. This annoyed his son, who moved the gates at his own expense to Rosmead, a neighbouring property, where the remains of them stand to this day. After this he was simply known as 'Smyth without the gates'.

Grand gates with Coadestone dressings, designed by Samuel Woolley and erected at Glananea, Co. Westmeath, which were later removed to a neighbouring house, Rosmead. (Coll. Castletown Trust)

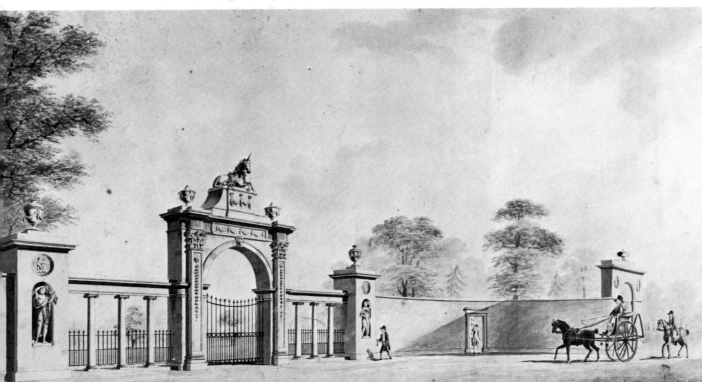

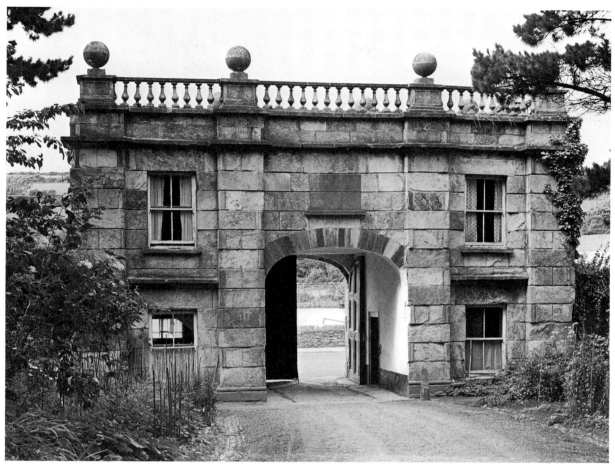

Bantry House, Co. Cork : the front lodge in the form of a triumphal arch

The oldest gates in Ireland are flanked by classical piers surmounted by urns, pineapples, or the balls said to denote a Justice of the Peace. The gate lodge, often built in the form of a temple, was usually just inside the gates, but occasionally across the road from them, to indicate that land on either side was owned. Sometimes there was a triumphal archway across the drive, and twin lodges making a pleasingly symmetrical effect. At Bantry, Co. Cork, and Rathfarnham near Dublin the triumphal arch was actually lived in, as was the Hindu-Gothic lodge at Dromana, Co. Waterford, which dominates a dangerous bridge over the tidal River Finisk near Cappoquin. The Dromana Gate was constructed in a temporary fashion to welcome home a honeymoon couple, who made it permanent. It is in a part of the Dromana demesne now owned by the Forestry Commission, from whom the Irish Georgian Society obtained leave to restore it, as they were letting it fall. The first official approached shook his head doubtfully, saying 'now you're getting into local politics'. It is the only example of 'Brighton Pavilion' architecture in Ireland, and is indeed a close copy of the free-standing gateway at Brighton itself. Its green onion dome and slender minarets reflected in the waters below, are a surprising reminder of the Orient to come upon in a quiet Irish valley.

One of the minarets had fallen into the river and has now been replaced in fibreglass; the roof is sound, the windows mended, and new floors have been put in. Unfortunately the Forestry Commission will not allow the Dromana Gateway to be lived in, which is the only way to be certain that it will not deteriorate once more. Gate lodges are often the only ornament left when a great house disappears, and the Irish countryside has too few objects of architectural interest to allow them to vanish likewise. They should be made habitable and put on the market, or offered to a pensioner in need of a house.

Gothic gateways follow much the same pattern as their predecessors. Some have gothicized clustered columns as at Clonin, Co. Westmeath, the more pretentious take the form of entire gatehouses like those at Tullynally Castle and Moore Abbey.

Early ironwork has rarely survived *in situ*. The superb gates from Hollymount, County Mayo have found a home in Kinsale; those from Belan are at Carton, those from French Park at Leixlip House, and so on. Father Browne, a Jesuit who made a study of Irish houses, was once kneeling in the road to photograph the French Park gates, when some people came by on their bicycles. Seeing a priest kneeling thus they thought he must have seen a vision, and when he had finished taking the photograph he found, to his amazement, that they were kneeling alongside him. Castlemartin in County Kildare has managed to retain its fine set of ironwork gates, although it is said that offers have been made for the house in order to obtain them.

The Hindu-Gothic gates (1830) at Dromana, Co. Waterford

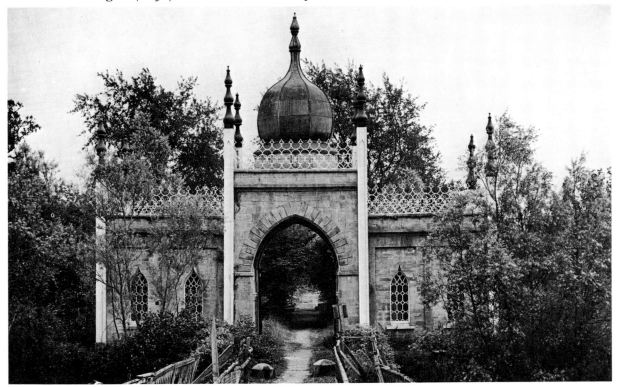

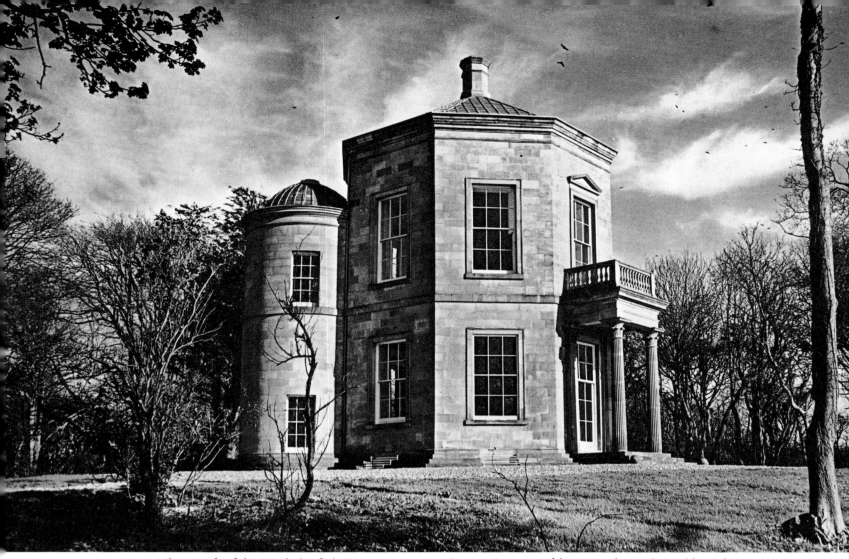

The Temple of the Winds (1780), Mountstewart, Co. Down. An octagonal banqueting house, designed by Athenian Stuart, recently restored by the National Trust, Committee for Northern Ireland

On the face of it eighteenth-century Ireland had much in common with eighteenth-century America. Both countries were ruled by England and copied the English in taste and manners, but there was a fundamental difference. The American settlers wished to escape from the pomposity of Europe and sought to lead the simple life. In keeping with the rational character of his country, 'King' Carter, whose estates in Virginia were measured in square miles rather than acres, built himself a house that would fit into one wing of Castletown. In Ireland, on the other hand, family pride was second nature. There was very often a streak of eccentricity also, of which the numerous follies that are scattered about the country are tangible evidence.

One Mr Watson, for instance, a sporting gentleman who lived at Larch Hill, Co. Meath, who had spent his entire life in pursuit of the fox, was convinced that in afterlife he would turn into one – he therefore built himself an elegant fox's earth, decorated with shells and Dutch tiles, with strict instructions that it was never on any account to be stopped up. The demesne of the Protestant archbishop's palace at Armagh is decorated with an obelisk erected to commemorate the Archbishop's friendship with a duke – it was in fact the Viceroy, the Duke of Bedford - and an obelisk at Killua, Co. Westmeath, commemorates

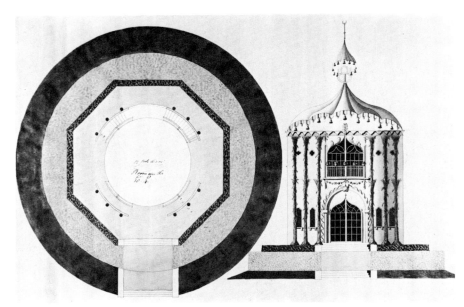

A Chinese Temple designed, but probably never built, by T. Eaton for Headfort, Co. Meath. (Coll. The Hon Desmond Guinness)

(Below) General Browne-Clayton's column, Co. Wexford. A spiral stone stairway, which can still be climbed, winds to the top

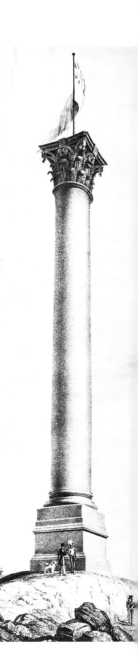

the arrival in Ireland of the first potato. A vast Corinthian column still stands on an eminence beside the Carlow-Wexford border, erected by a General Browne-Clayton. On the anniversary of the battle in which his regiment had turned the tide against the enemy, the French flag was flown from the top. At the very hour when the battle had turned in his favour, the Tricolour would be hauled down and the Union Jack hoisted in its stead, to the cheers of the assembled company.

Family graveyards and mausoleums are often found within the demesne walls, as at Clandeboye and Rossmore, and what appear to be follies were sometimes in fact memorials. At Bessborough, Co. Kilkenny, a tower was being erected to commemorate a Ponsonby who was thought to have lost his life in the Peninsular War – the building was abandoned however when he reappeared safe and sound. It is now used as a water tower. A less happy story belongs to the monument in memory of Sir Compton Domvile's Arab stallion at Santry Court, near Dublin. It appears that Sir Compton lost his temper with the fiery animal and ordered it to be shot, after which he climbed into his carriage and set out for the city. Half way there he relented, and ordering the carriage about he raced home to countermand the order. The stallion was still alive when he turned in the gates, but on hearing the sound of carriage wheels on the drive his servants hastened to fire the fatal shot, and the memorial bears testimony to Sir Compton's remorse.

The Irish Georgian Society has rescued the Conolly Folly at Castletown and the Temple at Belan, Co. Kildare, from decay, as well as the exquisite Ponsonby mausoleum at Fiddown, Co. Kilkenny. Monuments such as these that require practically no subsequent maintenance present little problem especially when someone can be found living nearby who is prepared to keep an eye on them. Together with the folly gate-houses, they are often the only reminder of a family that has gone.

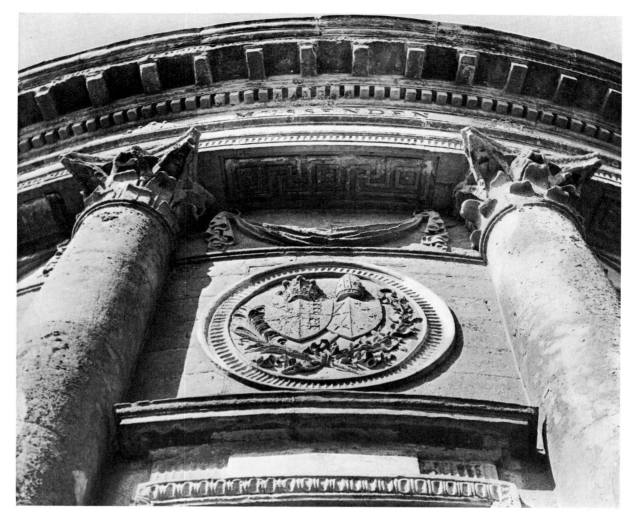

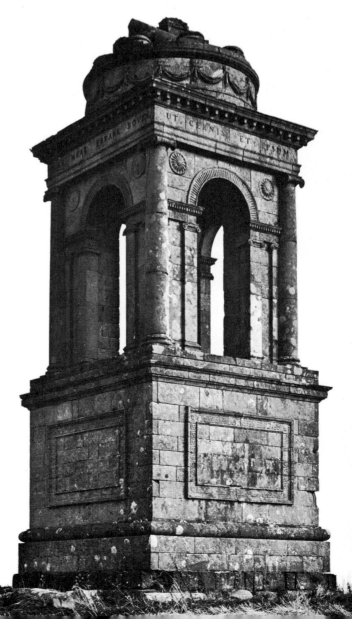

(Above) The Mussenden Temple
(1783), Downhill, Co. Derry,
detail of the carved stonework with
the arms of the Earl of Bristol,
Bishop of Derry. The Temple is in
the care of the National Trust,
Committee for Northern Ireland
(see back endpaper)

Downhill, Co. Derry, the Earl-
Bishop's memorial to his brother, who
was drowned at sea, modelled after
a Roman monument at Saint Rémy

The architecture of the Irish house is often superior to the contents. A few great collections were amassed on the Continent, however, notably for Russborough, Westport, and Bantry. The rival Earls of Charlemont and Bristol were great connoisseurs, and Lord Bristol, who was Bishop of Derry, actually died while travelling in Italy, buying statues and paintings for his enormous houses in Ulster, Downhill and Ballyscullion. He suddenly fell ill on the road, and was brought to a farm house, where they laid him out in the stable because the peasants thought that it would bring them misfortune if a heretic prelate died under their roof.

Today, works of art are more likely to leave Ireland than to be brought in, and there is unfortunately no law to prevent this. Antique dealers have for years now been scouring the country, buying Irish furniture to sell abroad. Some has been sold as 'American'; both American and Irish furniture are provincial expressions of English, and Irish cabinet-makers are known to have set up shop in Philadelphia in the eighteenth century. Of late, however, research at Winterthur and elsewhere into the secondary woods has put identification on a more scientific basis.

Irish furniture has a very definite character of its own. It is often black – even mahogany was sometimes blackened to resemble bog oak – and the carving on it is unlike anything made in England. The most interesting period, as with architecture, plasterwork, silver, and so on, is from 1725 to 1775. After that, the design was brought into line with English furniture of the Sheraton variety. The mask was widely used, both as a centrepiece and on the knees of side-tables. Whether lion, satyr, or human heads, the features are twisted into a spine-chilling grimace, very different from the expressionless heads on English furniture, apparently gazing out to sea and definitely tired of the view. The wide apron of the Irish side-table is a tumbling mass of exuberant carving; snakes eating their own tails, fruit, flowers, little distorted animal

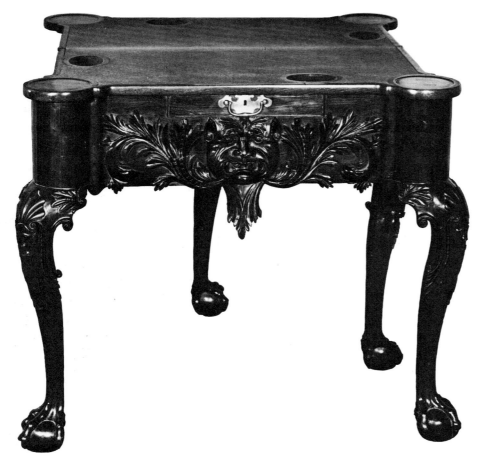

Card or gaming table at Castletown, Co. Kildare; Irish, mid-eighteenth century. (Castletown Trust)

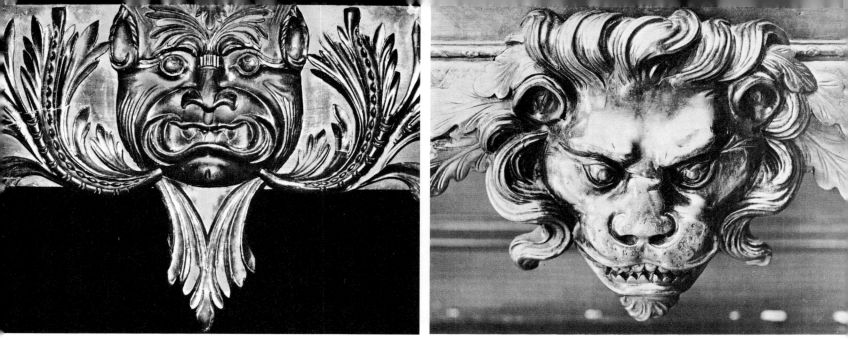

Detail of carved head (see facing page)
(Right) Sideboard at Powerscourt, Co. Wicklow; Irish, mid-eighteenth century. Detail of lion's mask

masks with haloes of shells. In its movement and madness this carving seems to conjure up the imaginary animal and human figures that decorate the pages of the Book of Kells.

Oval hunting-tables with absolutely plain legs were used for dining; the flaps could drop down when the table was taken outdoors for a lawn meet. They were also known as wake tables; at a wake, the coffin would be laid down the middle, surrounded by food and drink.

Irish silver follows basically the same lines. The great period from 1730 to 1760 shows the most lively chasing, the most uninhibited rococo scrollwork, soon to be combined with swans, pheasants, and Chinamen. The dish or potato ring provided the silversmiths of the period with the ideal vehicle for their animal fantasies, expressed with gaiety, freedom, and life. Later in the century, conventional 'bright-cut' designs supervened – as there were no pattern books, presumably actual pieces of silver that had been brought over from England were copied.

Sauceboat by Thomas Walker, Dublin c. 1738. (National Museum, Dublin)

(Right) Bog-oak bowl with silver cover and stand; Westport House, Co. Mayo

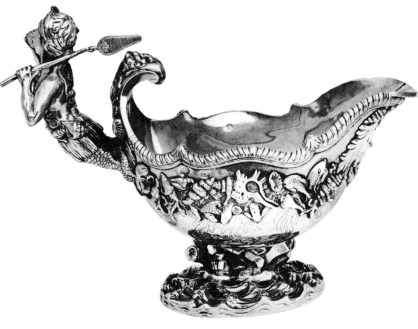

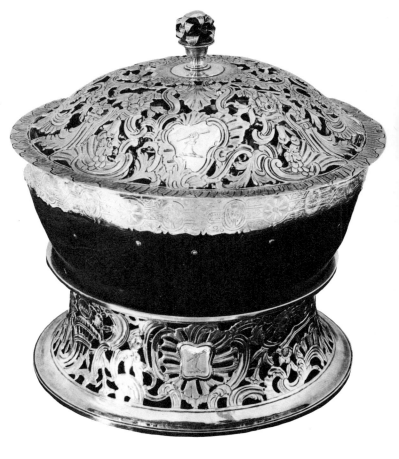

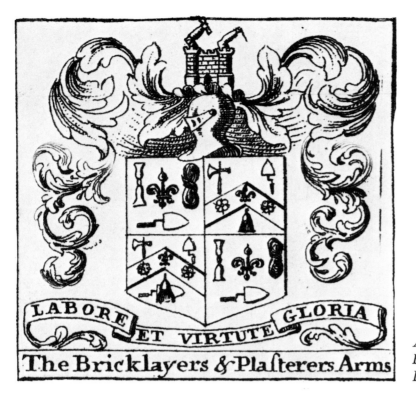

Arms of the Guild of Plasterers and Bricklayers, from Brooking's map of Dublin, 1728

PLASTERWORK AND PAINTING

Despite the oft repeated denials, the theory that Irish plasterwork was exclusively the work of Italians still persists. As far as is known, only three foreign stuccodores ever worked in Ireland; the two Francini brothers, Paul and Philip, and Bartholomew Cramillion. The names of those Irishmen who were members of the Guild of Plasterers and Bricklayers, on the other hand, are on record from as early as 1670. Long before the Palladian Invasion, the interiors of castles and town houses in Ireland were enlivened by plaster decoration.

In the 1720s plaster ceilings were compartmented in geometrical designs that probably derive from fretwork decoration along the beams of earlier dwellings. Strictly architectural as they were, these ceilings are competently modelled, and provide a sober accompaniment to the restrained wainscotting of the period. It was not until the advent of the Francini brothers, who are thought to have come to Ireland in 1734, that the true possibilities of the material came to be explored. It was they who introduced the human figure into plaster decoration. The dining-room at Riverstown House, Glanmire, Co. Cork, is probably their earliest work in Ireland; it was in use as a farm store in 1965 but has now been restored by the Irish Georgian Society and opened to the public. The classical figures that surround the walls are somewhat static and stylized – not likely to misbehave when left to themselves – although there is a certain freedom in the allegorical ceiling. This represents 'Time rescuing Truth from the assaults of Discord and Envy', and is a transcript into plaster of a painting by Poussin now in the Louvre.

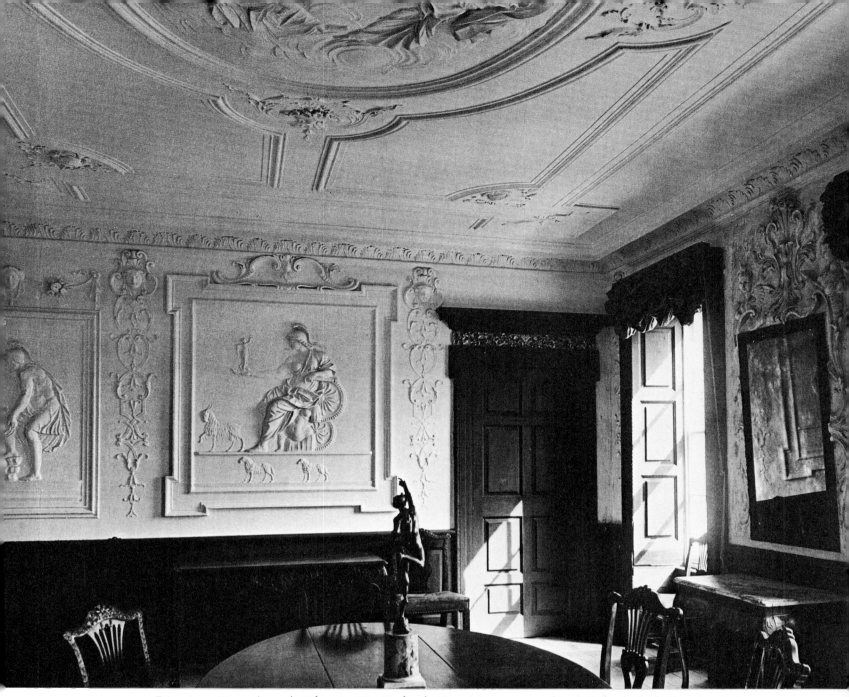

Riverstown House (1734), Glanmire Co. Cork: the Francini room, restored in 1965 by the Irish Georgian Society

In 1739 the Francini executed the great ceiling at Carton for the Earl of Kildare which, despite alteration, remains one of the finest rooms in these islands. It is probable that they decorated the walls with plaster figures as at Riverstown, as their very detailed account shows that they were paid almost as much for their work on the walls as for the ceiling itself. The wall decoration has gone, and Victorian plasterwork, with heads resembling the Queen herself, is now to be found below the frieze. Although conceived on the grand scale, the Francinis' work at Carton is not overpowering; the proportions are perfect, and there is a light touch in the cherubs sitting nonchalantly on the cornice, dangling their chubby legs over the edge. Being close to Dublin, Carton was frequented by many people, and the fashion for Italianate plasterwork swept the country.

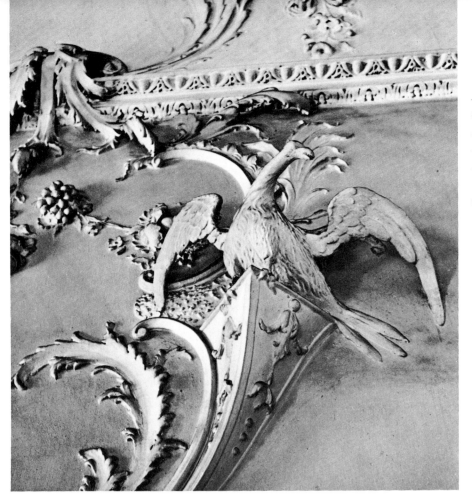

Detail of the staircase decoration at 20 Lower Dominick St (1755), Dublin, the work of an Irish plasterer, Robert West, who was also the architect of the house

(Right) Headfort, Co. Meath: the 'Eating Parlor' as executed

(Below) Robert Adam's design for 'finishing the chimney side of the Eating Parlor' at Headfort. Signed 'Adelphi, Dec. 2nd, 1773'. (Coll. Paul Mellon)

The Irish stuccodores were quick to learn the new designs and new techniques, and made them their own. Robert West stands out as the leading stuccodore cum architect of the mid-eighteenth century. He preferred the bird to the human figure and adopted it as his particular motif: birds in full flight, feeding their young, perched on branches, or swinging garlands of flowers from their beaks. His workshop was situated beside the Liffey, and he is thought to have been inspired by the flocks of seagulls circling the ships as they sailed in and out of Dublin Bay. The decoration on the staircase walls at No. 20 Lower Dominick Street, Dublin, (St Saviour's Orphanage) is his masterpiece; the birds are modelled in almost full relief here, standing out sixteen inches from the wall. He decorated country houses also, as will be seen at Malahide and Newbridge. At Colganstown, Co. Dublin, the temptation to shoot the heads off the birds in the dining-room cornice as an after-dinner sport was unfortunately too great to be resisted.

West had many followers, and there were equally brilliant exponents of the craft in the provincial towns. The plaster ebbs and flows with movement and life, imparting a Southern warmth and gaiety to the chilly Irish scene. The careless abandon of a cloak caught in the breeze, or the angry expression on the face of some imaginary bird, its neck twisted in anger – these were found no more when the neo-classical style associated with the name of Robert Adam came into fashion. The changeover did not come without a struggle: the rococo style persisted, especially in the provinces where taste was slow to change.

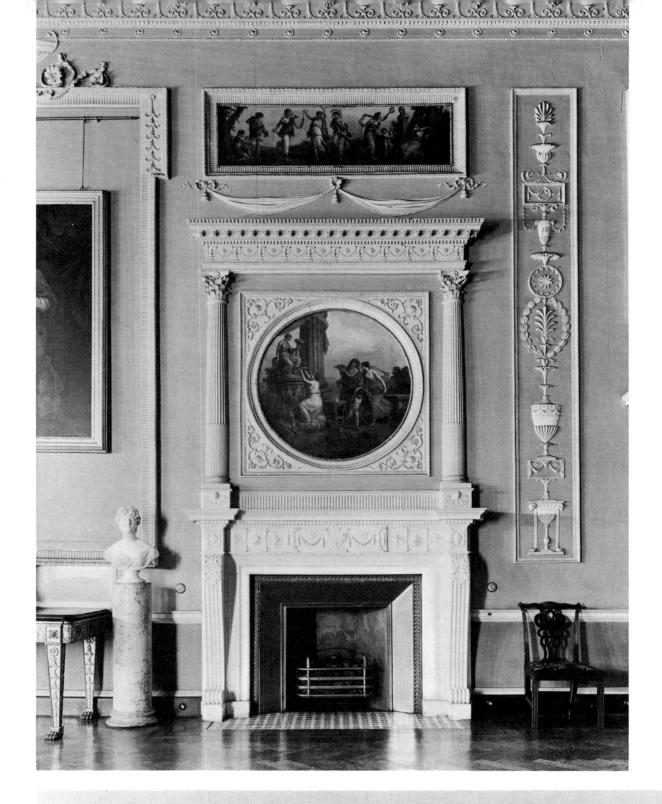

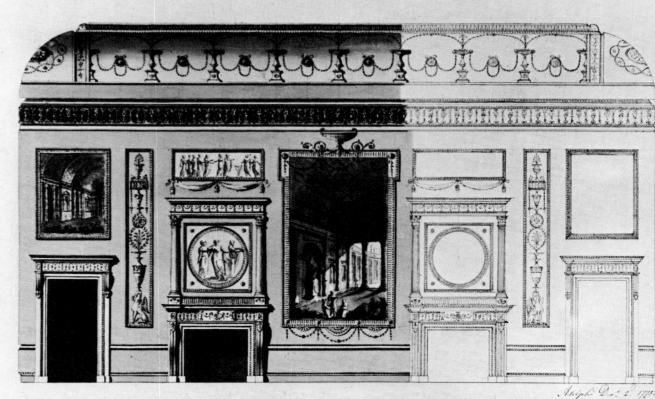

Michael Stapleton, the principal exponent of the Adam style in Ireland, was by no means a slavish imitator. His masterpiece is undoubtedly Belvedere House, Dublin, (James Joyce went to school there) where he was both architect and stuccodore. Adamesque decoration made extensive use of moulds, so that the art of free-hand plastering, which had reached such a high level in Ireland, soon came to be forgotten. The decoration tended to extend across the wall surfaces, and on occasion painted roundels by Kauffman or de Gree would replace the plaster plaques. This fashion was short-lived, however, since it left no space for paintings to be hung. Plasterwork coarsened after 1800 to suit the taste for Greek and Gothic revival houses, and a craft which had at times attained the level of fine art soon came to be forgotten.

It was in the landscape school of Barret, Ashford, Roberts, Wheatley, Fisher, and James Arthur O'Connor that Irish painting excelled. Itinerant artists such as Van der Hagen, Ricciardelli, and others whose pictures are unsigned, are sometimes of greater interest to the architectural historian, as they often show the house and landscape park in considerable detail. Apart from Barret, the landscape school tended to pay less attention to buildings, putting them far in the distance, if they were included at all. In 1783 Thomas Milton published a book of engravings of views of the seats and demesnes of the nobility and gentry of Ireland, taken from paintings by Barralet, Wheatley, Ashford and so on. Twelve of the twenty-four engravings, and the interesting Subscribers List, were reproduced by the Irish Georgian Society in 1963; buildings were of course given preference over romantic land-scapes. Milton promised 'further issues', including a treatise on Richard Castle, but unfortunately they never materialized.

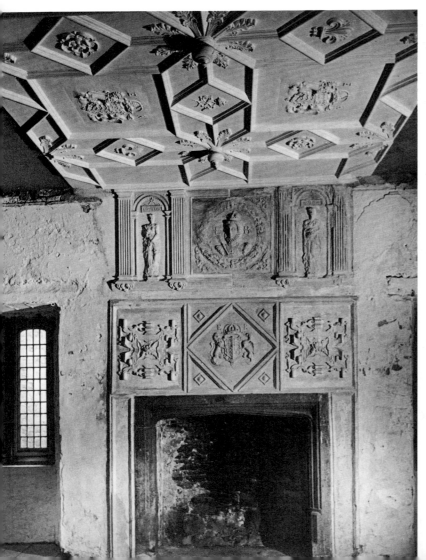

(Left) Portrait in plaster of Queen Elizabeth I, Carrick-on-Suir Castle, Co. Tipperary. This is one of the earliest examples of figured plasterwork in Ireland. Queen Elizabeth was a friend of Black Tom, the tenth Earl of Ormonde, who added an Elizabethan wing to the castle which is now being restored by the Office of Public Works

(Below) Detail from plaster ceiling at Red Hall, Co. Antrim, presumably representing the owner of the house and his wife. In view of the crudeness of the modelling it is surprising that they are dressed in the fashions of 1735

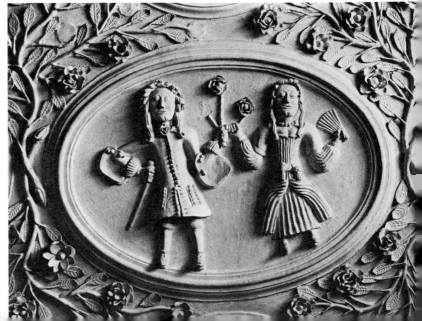

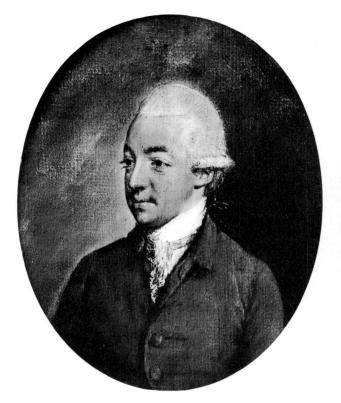

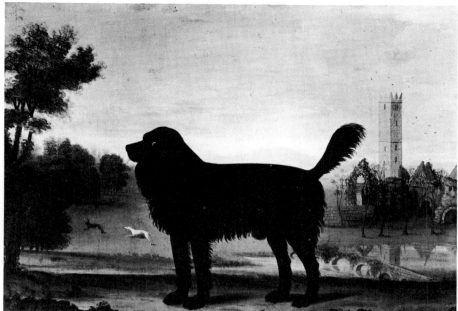

(Above) The Dog at Adare Manor, with Quin Abbey in the background. Unknown artist. (Coll: The Earl of Dunraven)

(Left) David La Touche, the Dublin banker. Pastel by the prolific Irish artist Hugh Douglas Hamilton (1739–1808). (National Gallery of Ireland)

There is a curious tendency in Ireland to revere the foreign at the expense of the native product, and it is only recently that there has been a serious appraisal of Irish portraiture, and an attempt to disentangle the work of the different artists. Although some of the family portraits are distinctly wooden, there does not seem to have been, consciously at any rate, a primitive school of painters. Those who could afford it had themselves painted by Reynolds or Batoni, and had small likenesses of themselves done to give away by the brilliant and prolific Irish pastellist, Hugh Hamilton. There was no Irish Hogarth or Devis to record interiors, except Herbert Pugh (fl. 1758–88) whose painting of Lord Granard having his wig powdered has been identified through the engraving by Golden. A thorough investigation of Irish portraits and portraiture was undertaken in 1969 at the time of the exhibition *Irish Portraits 1660–1860*, sponsored by the Paul Mellon Foundation.

Nathaniel Hone and Robert Hunter were fine portraitists who could hold their own when compared with English painters of the same period, and whose work is often confused with that of English contemporaries. Gilbert Stuart fled to Dublin from London to escape debts in 1787 and returned to his native America in 1793, leaving unfinished portraits and still more debts behind him. Robert Healy, who worked in *grisaille,* and painted people and horses in landscape, was one of Ireland's most original artists. If he had not caught a chill, while sketching the cattle in the Earl of Mornington's park, and died at the early age of twenty-eight, he might well have become an Irish Stubbs.

Preservation and Tourism

One of the consequences of Ireland's troubled past is that in this century there has been a continued hostility towards what is considered 'foreign'. When a Republican town council was elected in Wexford in the year 1919, the Mayor pointed to the mace and said: 'Take away that bauble!' Instead of seeing a beautiful piece of Irish silver, the work of Irish craftsmen, he saw only what it represented, centuries of British rule. During 'the troubles' many houses were deliberately burned by the I.R.A. when their owners were 'declared enemies of the Irish Republic'. Although neither the classical style of architecture nor the Gothic was native to Ireland, the great houses of the Georgian era were after all built with Irish money and Irish skills. They form a part of the Irish heritage to which the whole world looks with envy and admiration.

In Northern Ireland, the conservation of buildings of outstanding architectural merit or historic interest is undertaken either by the National Trust, or the Ministry of Finance. The National Trust has a regional Committee for the province with executive powers, and with voluntary and government help, it conserves thirteen buildings, three of which have an historic association with either American presidents or leading American families and are managed by the National Trust on behalf of the Scotch/Irish Trust. The National Trust divides the field of conservation with the Ancient Monuments Division of the Ministry of Finance, most of whose seventy-five monuments date from before 1700 and are largely uninhabited. Outstanding are Carrickfergus Castle, Hillsborough Fort and Dundrum Castle.

Although much work has been done, and many important buildings are conserved for posterity, the battle for retention of smaller buildings which give character to Ulster's towns and villages has yet to be waged, and it is in this field that the Ulster Architectural Heritage Society is playing an increasingly important role by drawing the attention of the public to the problem. If the buildings typical of the Ulster countryside are lost, regional character will be destroyed. Indeed, quite apart from aesthetic considerations, individuality will be a much-prized asset to later generations. Conservation legislation lags behind that in the rest of the United Kingdom, and financial resources are woefully inadequate.

However, with two established organizations active in this field since the end of the 30s, one government the other voluntary, and with two vigorous voluntary organizations, the Irish Georgian Society and the Ulster Architectural Heritage Society, creating the right climate of opinion the future holds promise, provided funds and legislation reach Ulster before too much has been lost.

In the Irish Republic there is also a National Trust (An Taisce), founded in 1948, which has a strong membership and branches throughout the country. It engages in planning battles, and is in the forefront of the campaign to save Georgian Dublin, as well as fighting for the retention of the canals, and helping to improve amenities generally. It has not yet undertaken specific restoration projects on buildings, nor does it have any in its care so far.

The Ancient Monuments branch of the Office of Public Works is in charge of antiquities, and its funds are so limited that, according to the published figures, more is spent on administration than on practical restoration work. It does maintain one non-functional eighteenth-century building, the Marino Casino at Clontarf; after thirty years it has yet to complete its restoration or furnish the interior. In most countries the Casino would be a shrine – in Ireland there is so little regard for it that a modern religious institution has recently been built on some of the few precious acres of green that separate it from a housing estate. It stands empty and neglected. Needless to say no funds are available from this quarter for the restoration of Irish country houses.

There is no Historic Buildings Council, as in England. The Department of Local Government will however give a grant for roof repairs, of up to £120, irrespective of the size of the house, when the work has been carried out to the satisfaction of their inspector.

There have been very few private attempts at preservation in Ireland, in spite of the indifference of officialdom. In the 1920s Oliver St John Gogarty bought one ruined castle, Dunguaire, and persuaded an American, Mrs William Thornton Watson, to buy another, Oranmore, both in County Galway – they would otherwise have been demolished and the stone used for making roads. His instinct was right; they are both now restored and lived in. An Englishman named C. J. Lytle offered £20,000 to the Irish government in 1965 for the restoration of a building or buildings of their choice. Trustees were appointed, and it was decided to roof the cathedral on the Rock of Cashel, which even as a ruin is the finest example of Gothic architecture in Ireland. On the pretext that in Ecumenical Year it would be unfortunate to stir up an argument between the Protestant and the Catholic church as to what they own there, the money was diverted for use at Kilkenny Castle – the right place was found for it, for entirely the wrong reasons.

Many houses of importance have been preserved by institutions and public bodies of one kind or another, and are fortunate to be cared for still and not reduced to dust. They have not been included here. It has often been necessary to add an unsightly wing or a modern chapel quite out of character with the house, and the whole effect of the exterior is frequently ruined by tarmac, cement curbs, and beds of pink roses. In any case, when a house loses its contents it seems to lose its soul as well.

* * *

The Irish Georgian Society was founded on 21 February, 1958, fifty years to the day after the original Georgian Society had been founded by the Rev. J. P. Mahaffy to make a record of Irish architecture, doomed, as he considered it was, to 'decay and disappearance'.

The Irish Georgian Society is a preservation group first and foremost, and has at present 6,000 members. A large part of its income is spent on bricks and mortar. Grants are given to buildings in need of repair, or else funds are raised for them. Appeals for dozens of buildings have gone to the long-suffering membership – Coolbanagher Church, the Kinsale Court-house, Riverstown, Wilson's Hospital, Mount Ievers, Gill Hall, Longfield, Doneraile, to mention a few. In 1966 the Society initiated the Tailors Hall Fund, and has raised most of the money through its members for the restoration of that historic building. The Society has taken over twenty-two houses in Mountjoy Square, an elegant piece of Georgian planning in a run-down part of Dublin, in an attempt to breathe new life into it.

The most ambitious task it has as yet undertaken has been the restoration of Castletown, where its headquarters have been established since 1967. This magnificent house had been bought by a speculator with a view to dividing up the land for modern housing, and some of the adjacent land is still in danger of being developed. Having stood empty for two years, lead had been stolen from the roof, light fittings smashed, door handles removed; in April 1967 the Irish Georgian Society decided to step in and save it. Parties of volunteers came out at weekends, funds were raised, furniture was given and loaned, and by 1 July the house was ready to open to the public, the first house near Dublin to open its doors to visitors. The Society hopes that one day the best of Irish furniture, silver, glass and so on will be displayed there. The Society's files of information on the art and architecture of the Irish renaissance will have room to expand and to prevent the house becoming a dead house-museum, concerts and other suitable activities are encouraged to take place there.

The Society for the Preservation of Historic Ireland is an American organization which has given a great deal of help and encouragement to the Irish Georgian Society. It is principally interested in early Irish art and architecture, but by no means to the exclusion of the Georgian period. Numerous American foundations have contributed to the work of the Irish Georgian Society, notably the Patrick and Aimée Butler Foundation, the American Irish Foundation, and so on.

Since 1958 the Irish Georgian Society has published a Quarterly Bulletin devoted to Irish art and architecture of the period, as well as describing its restoration projects and preservation battles. It has arranged outings, exhibitions, and lectures of all kinds in order to stimulate an interest in the period. It has always believed that in the end government aid for Irish houses, castles, and gardens, without which they must inevitably disappear, would eventually come from the Tourist Board. The tourist industry is vital to the Irish economy,

and by joining in the drive to attract visitors, there is at last an opportunity for the great house, regarded by some as an anachronism, to justify its existence in modern Ireland. It was essential to convince the Board that some sort of *quid pro quo* from the State would be necessary, either a relief of rates, or a direct grant based perhaps on the number of open days, if a house was to be open to the public. This principle is at last recognized, and grants have been given to lived-in houses on the condition that visits are allowed. It is obvious that the locality will stand to benefit from the opening of a country house – probably more in fact than the house itself, because the admission charge is nominal. The country house will add a new dimension to Irish tourism. It is likely to attract a more sophisticated visitor than the thatched cottage or the medieval banquet, it will spread the tourist load, and reveal another aspect of Irish life and culture to the world.

Most of the houses illustrated here are privately owned, and except where stated, they are not open to the public. Their inclusion in this book should not be taken to imply that visitors are admitted. An organization has recently been formed, under the auspices of the Irish Georgian Society, called HITHA, which stands for 'Historic Irish Tourist Houses and Gardens Association'. Since the saving of Castletown in 1967, several country houses in private hands have been opened to the public; up to then, Bantry and Westport were the only ones. Some of these are in remote parts, and advice on publicity, sign-posting, tours, and many other problems was essential, to help make the undertaking worthwhile and thus ensure that the property would survive the vicissitudes of modern life. HITHA was formed by the owners or administrators to help make a round of visits easier for the tourist. A complete and up-to-date list of all the houses, castles, and gardens that are open to the public in any part of Ireland may be obtained from HITHA, at Castletown, Celbridge, Co. Kildare.

The following castles and houses are, at the time of going to press, open to the public.

Abbey Leix*	Co. Leix
Bantry House	Co. Cork
Birr Castle*	Co. Offaly
Bunratty Castle	Co. Clare
Carton	Co. Kildare
Castlecoole	Co. Fermanagh
Castletown	Co. Kildare
Castleward	Co. Down
Dublin Castle	Dublin
Florence Court	Co. Fermanagh
Howth Castle*	Co. Dublin
Lismore Castle*	Co. Waterford
Powerscourt*	Co. Wicklow
Tullynally Castle	Co. Westmeath
Westport House	Co. Mayo

garden only

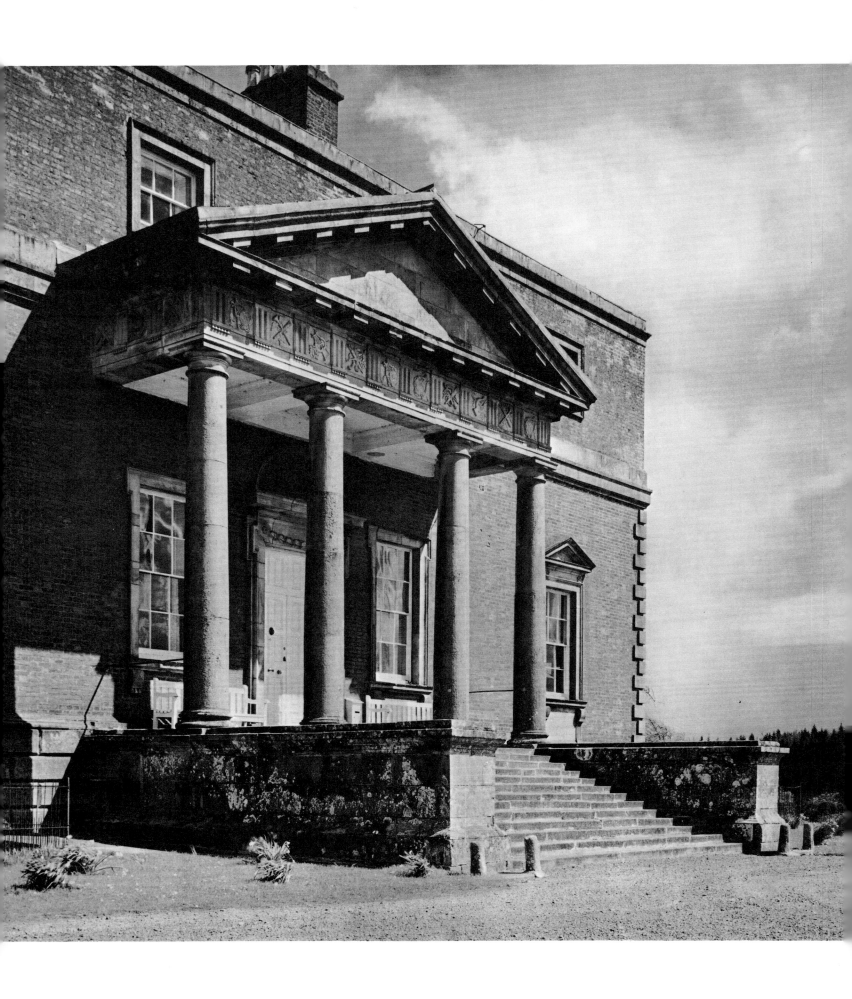

BELLAMONT FOREST

COOTEHILL, COUNTY CAVAN

Mr and Mrs Ronald Dorman White

THERE ALWAYS WAS a border dividing Ulster from the rest of Ireland, even in prehistoric times. It was known as the 'Black Pig's Dyke' because the double ditch and mound between were so dense that not even a pig could get through. It followed approximately the line of the modern border, making use of natural boundaries provided by the numerous lakes in this part of Ireland. Not far from the Dyke, at the end of a long, long drive, stands Bellamont Forest, which ranks with Mereworth and Chiswick as one of the purest examples of the Palladian villa in the British Isles. Rising clear out of the parkland, it surmounts an eminence, defying the dense regiments of fir trees which threaten to engulf it. Below the house an immense natural lake stretches out towards the neighbouring demesne of Dartrey.

Wide stone steps lead up beneath the handsome portico, decorated with a classical frieze of rams heads, to the hall with its black-and-white squared floor. Busts of the Coote family, disguised as Roman emperors, gaze at one another across this plain but noble room. The drawing-room and dining-room are elaborate by comparison, richly decorated with bold and ornate stucco-work. Like the hall, they take up a storey and a half in height, creating little mezzanine rooms halfway up the stairs.

The authorship of Bellamont Forest has recently come to light through the identification of a drawing by Sir Edward Lovett Pearce as an early study for the present building. The plan is in a collection of architectural drawings by Pearce and his cousin, Sir John Vanbrugh, belonging to Sir Richard Proby of Elton Hall, Peterborough. This sketch-plan shows that a recessed entrance portico, a favourite device of Palladio, was originally intended to be the chief architectural feature of the façade. Pearce is known to have travelled extensively in Italy, and to have studied Palladian buildings at first hand. His own copy of Palladio's *The Four Books of Architecture,* now in the library of the Royal Institute of British Architects, is annotated with his comments and criticisms.

Bellamont Forest was inspired by two designs of Palladio. The decoration of the façade, the treatment of the attic storey and its lighting through a cupola overhead derive from the

Bellamont Forest (c. 1730), Co. Cavan: the entrance front. The house was built for Thomas Coote by his nephew, Sir Edward Lovett Pearce

Villa Almerico, La Rotonda, at Vicenza. The basic proportions of the building, the floor plan, and the Doric portico are taken from the Villa Pisani at Montagnana. This villa has a tetrastyle recessed portico, and the side bays have the same disposition of rooms and stairs as in Pearce's plan. Since the depth of Bellamont is only three quarters of its width, whereas the Villa Pisani is nearly square, the two small rooms in the central bay of the original building are omitted in Pearce's adaptation. In this respect the Bellamont plan also closely resembles the arrangement of rooms surrounding the loggia of the Villa Cornaro at Piombino Dese. Finally, since the recessed portico of the Villa Pisani is on the garden side, Pearce has reversed the central bay end for end to place the portico at the entrance front of Bellamont. The proportions of the rooms and bays at Bellamont are quite close to those of the Villa Pisani.

The entrance hall. The Cootes, disguised as Roman emperors, gaze at one another across the shafts of sunlight

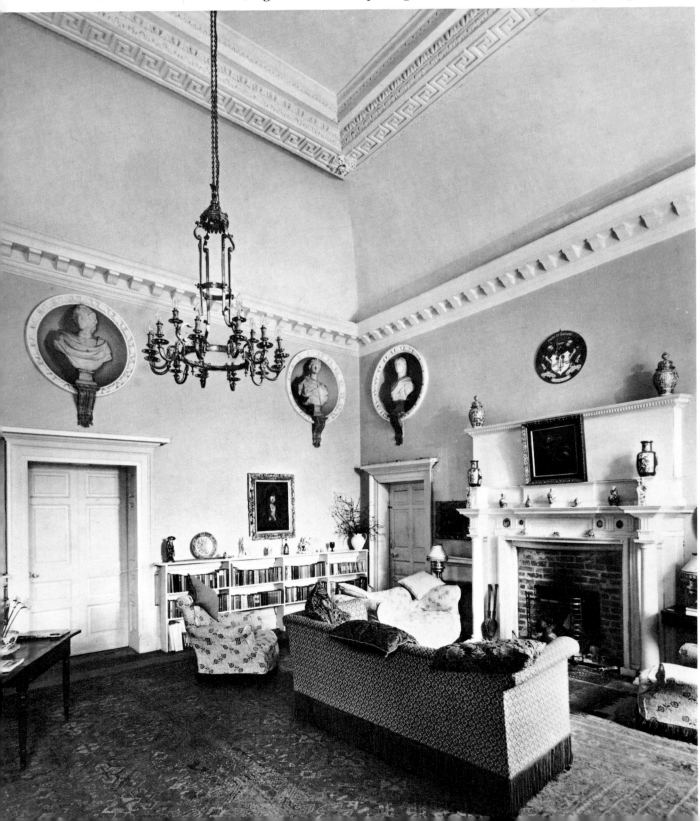

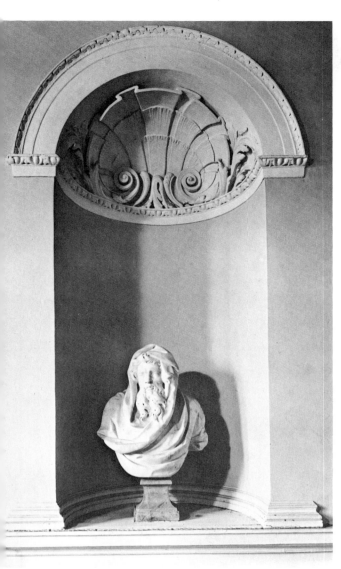

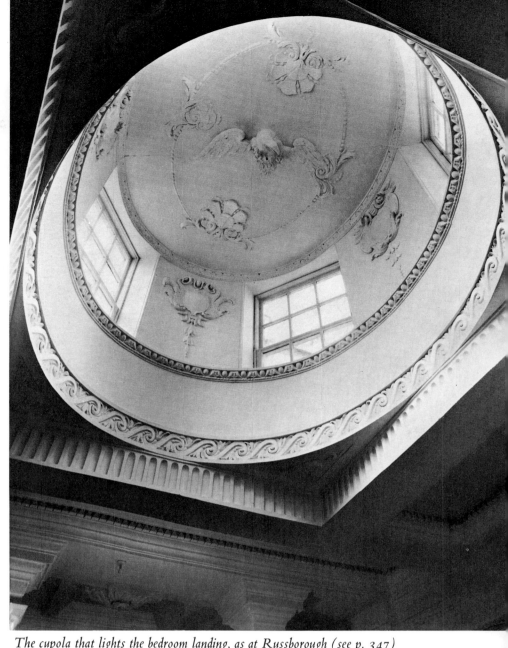

Niche in the hall *The cupola that lights the bedroom landing, as at Russborough (see p. 347)*

In fact, the numerical values of some dimensions are the same in both plans. Pearce, however, may have made the error attributed to Lord Burlington, of assuming that the Vicentine foot used in Palladio's drawings was the same length as the English foot. This may explain, for instance, why Burlington's villa at Chiswick is substantially smaller than La Rotonda.

There is good reason to believe that the exterior of the house as originally planned by Pearce looked much as it does today. On either side of the building there are triple windows, one of which has recessed columns; the central panels of both are blind. These are indicated on Pearce's sketch, as are triple windows to the rear. The Doric portico strikes many observers as a later addition, or an afterthought. It is perfectly consistent with Pearce's drawings, however, to assume that the portico was also inspired by that of the Villa Pisani, and was intended to be part of the design from the beginning. In the original recessed-portico scheme, the pediment might have been applied directly to the surface of the façade, as was

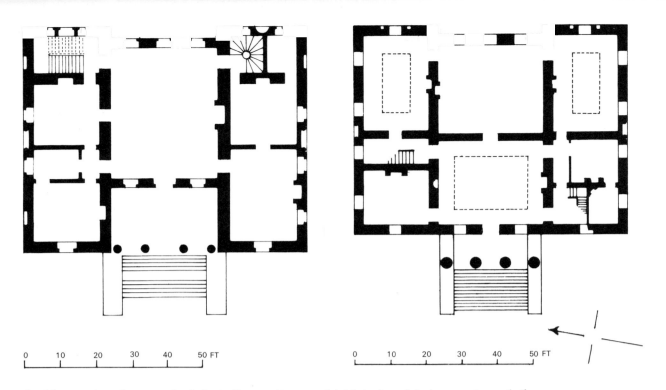

(Left) Pearce's preliminary sketch for Bellamont Forest and (right) plan of the house as it was built

later done by Castle at Russborough. To account for the differences between Pearce's sketch and the building as it was finally constructed, Dr Maurice Craig has offered the very reasonable explanation that after the shell of the house was substantially erected, it was decided to dispense with the recessed portico as wasteful, unsuited to the climate, and perhaps less defensible than a flush wall. This hypothesis may also account for the lack of respondent pilasters. In any case the window positions already determined did not leave space for pilasters.

It seems strange in a building of such open serenity and quiet dignity that defence should have been a consideration; this was due partly to its remoteness and partly to the political situation of the time. The front door is the only means of access on the ground floor. There still exists at Bellamont an iron hall-door with a spy-hole covered by a metal flap. At the basement level, a broad paved passage runs around the house like a dry moat, and a tunnel 600 feet long connects the house with the stables. Paving around the house has been removed; it has always been understood that this was done for defensive purposes, rather than for giving more light to the basement.

The demesne of Bellamont Forest was originally named Coote Hill by its founder, Colonel Thomas Coote, who married a Miss Hill and came to County Cavan in the 1660s. The Colonel died in 1671, and the property passed to his nephew, also Thomas. The younger Thomas Coote was called to the Bar in 1684. He was attainted by the Parliament of James II in 1689, but was restored to favour by William III, and became a Lord Justice of the King's Bench. In 1697 he took for his third wife Ann Lovett, daughter of the Lord Mayor of Dublin. Two years later their nephew Edward Lovett Pearce was born.

Bellamont stands at the end of a long drive that leads from the town of Cootehill, which was named after its founder, Colonel Thomas Coote, who married a Miss Hill and settled there in the 1660s. His nephew and namesake was the builder of the house

Just when Pearce designed the present house for Thomas Coote is not known. Pearce practised in Ireland only from 1724 until his untimely death in 1733. There is a date carved in the surface of the stone course just below a bedroom window which has been interpreted as either 1705 or 1765; neither has any obvious significance. Thomas Coote died in 1741, and was briefly succeeded by his son Charles who died in 1750. His son, also named Charles, then became owner of Coote Hill, as it was then still called.

There is a pompous account in Faulkner's *Dublin Journal,* of September, 1760, of his doings in the promotion of the linen trade, which give evidence of his strong Protestant opinions:

On 1st September, at Cootehill, Co. Cavan, about 500 of the linen weavers of that place, together with the linen drapers, led by Charles Coote, Esq., their landlord, and several other gentlemen of the county who accompanied him, walked in procession, with a machine carried, on which a boy was weaving and a girl spinning, dressed in linen, and white gloves, ornamented with orange and blue ribbons, after which Mr Coote gave a grand dinner in his own house to the gentlemen who accompanied him, and to the linen drapers, and had six houses opened in the town for the entertainment of the linen weavers,

which he had prepared for that purpose, when they drank many loyal, public, and private toasts, in particular the King, the Prince of Wales, the Royal Family, and success to the linen manufacturers. At night Mr Coote gave a grand ball and supper to the ladies at the new Assembly-Rooms in said town, and, in short, everything was conducted in the most decent and yet elegant manner, and vastly to the satisfaction of 3000 spectators.

By the death of his cousin, the last Earl of Bellamont, without issue, in 1764, he succeeded to the elder title of that nobleman, Lord Colooney. He was also made a Knight of the Bath 'in testimony of his good and laudable service in suppressing tumultuous and illegal insurrection in the northern parts of Ireland', with an order that the investiture should be made in as public and distinguished a manner as possible. He was painted by Sir Joshua Reynolds in the robes and insignia of the Order. He was further made Quartermaster-General of the Forces in Ireland, a Privy Councillor, and, in 1767, created Earl of Bellamont, of the second creation, choosing the title which had become extinct on the death of his cousin. The name of the house must have been changed at this time to Bellamont Forest.

He won the hand of the Duke of Leinster's sister, Lady Emily FitzGerald, to whom he became engaged in 1773. He caused a tremendous row a few days before the wedding by writing a letter to the young Duke stating that his mother, Emily, Duchess of Leinster, was secretly married to a Mr Ogilvie, tutor to the Duke's younger brothers. The Duke of Leinster

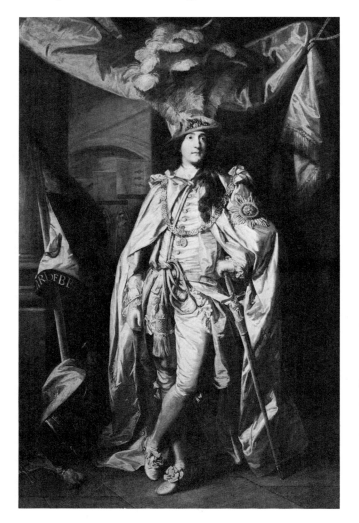

Charles Coote, first Earl of Bellamont of the second creation, in the robes of the Order of the Bath. By Sir Joshua Reynolds. (National Gallery of Ireland)

and his mother promptly denied this, and the wedding took place as scheduled, but with great coolness on both sides. Bellamont's suspicions were not unfounded, as Mr Ogilvie did marry the Duchess, in the following year. On his wedding day, Bellamont again caused a 'fracas', the details of which are not exactly known. His bride sided with him, and a permanent rift arose between the families. Lord and Lady Bellamont were henceforth ostracized by polite society; no member of the FitzGerald family and few others of the local aristocracy attended the funeral of their only son described below. Lady Bellamont eventually left him in 1794, and he died in 1800.

The son, the last Lord Coloony, died at Toulouse and was buried at Cootehill. The account of the ceremony appeared in Faulkner's *Dublin Journal* for 18 May 1786. An elaborate procession accompanied the remains from Bellamont Forest to the Earl's family vault in the parish church. It was led by twelve conductors followed by physicians, surgeons, apothecaries, the clerk of the parish, clergy of the Church of England, Dissenting clergy, Seceding clergy, Moravian clergy, and clergy of the Church of Rome. The hearse itself, drawn by six horses, with plumes, escutcheons and streamers, carried the remains in a black

Bellamont Forest: the drawing-room

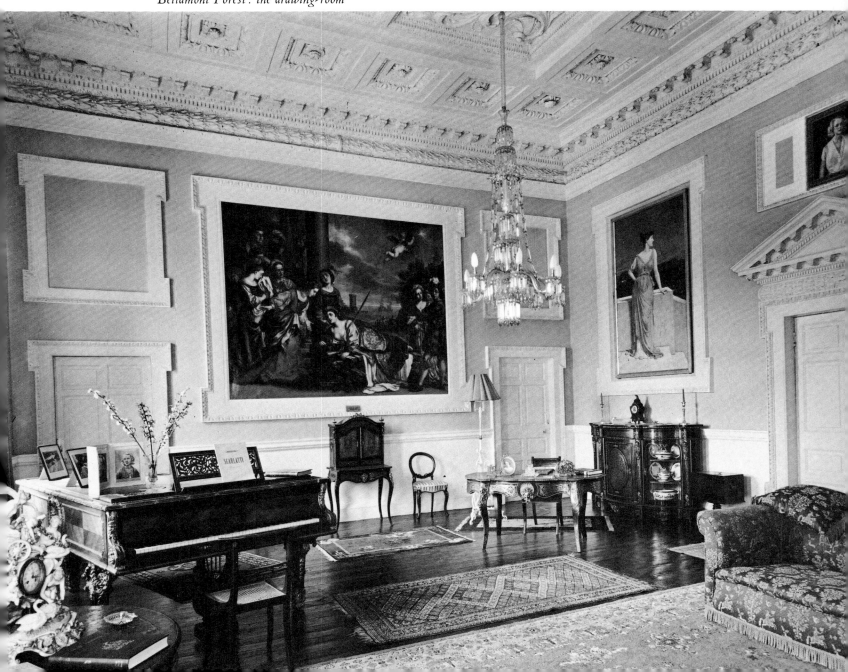

velvet coffin, and was accompanied by six servants in full liveries, scarfs and hat-bands. The bearers were gentlemen of the district: Charles Stuart Esq., Oliver Nugent Esq., Thomas Nesbitt Esq., The Rev. Joseph Pratt, Robert Saunderson Esq. and John Moutray James Esq. The hearse was followed by two mourning coaches and a great crowd, representing all ranks of society. The whole of the ceremony was conducted by a Mr Kirchoffer of Dublin, who failed in only one respect: 'the number of scarfs . . . fell far short of the number of qualified persons and attendants, although he made up for the deficiency at the moment as nearly as he could, about four hundred being distributed on the occasion.'

Lord Bellamont has been described not only as a man of 'gallantry and high spirits', of 'the highest refinement' and 'dazzling polish', but also as a 'tyrant', 'madman', 'a person of disgusting pomposity' whose actions were 'a singular mixture of diseased feeling and erroneous reasoning'. He was more popular in government circles than he was in society. A most licentious person – he acknowledged at least six illegitimate children by four different mothers in his will – he was the butt of much unkind humour when he was wounded in the groin during a duel with Lord Townshend in 1772.

The library mantel

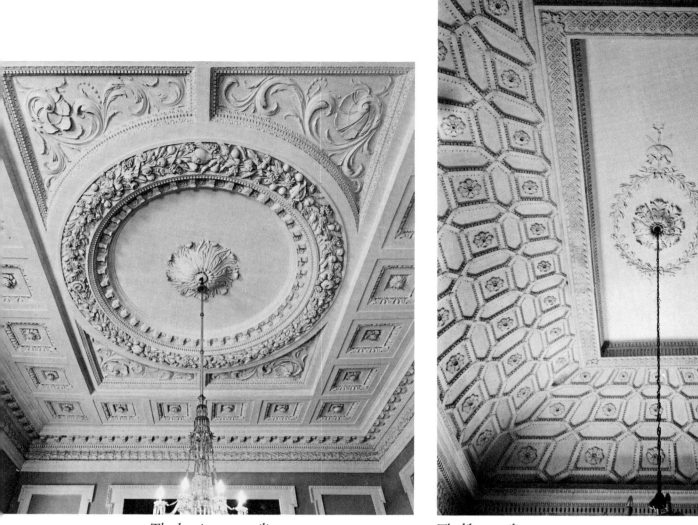

The drawing-room ceiling

The library ceiling

Lord Bellamont was responsible for replacing the flat ceiling of the library with a coved one in about 1775. This, and the Victorianization of one small room on the ground floor are the only alterations to have been made to the house since the time it was built. Bellamont Forest is now the home of Mrs Ronald Dorman White, whose second husband's grandfather bought the lands and house from the heirs of Lord Bellamont in 1874.

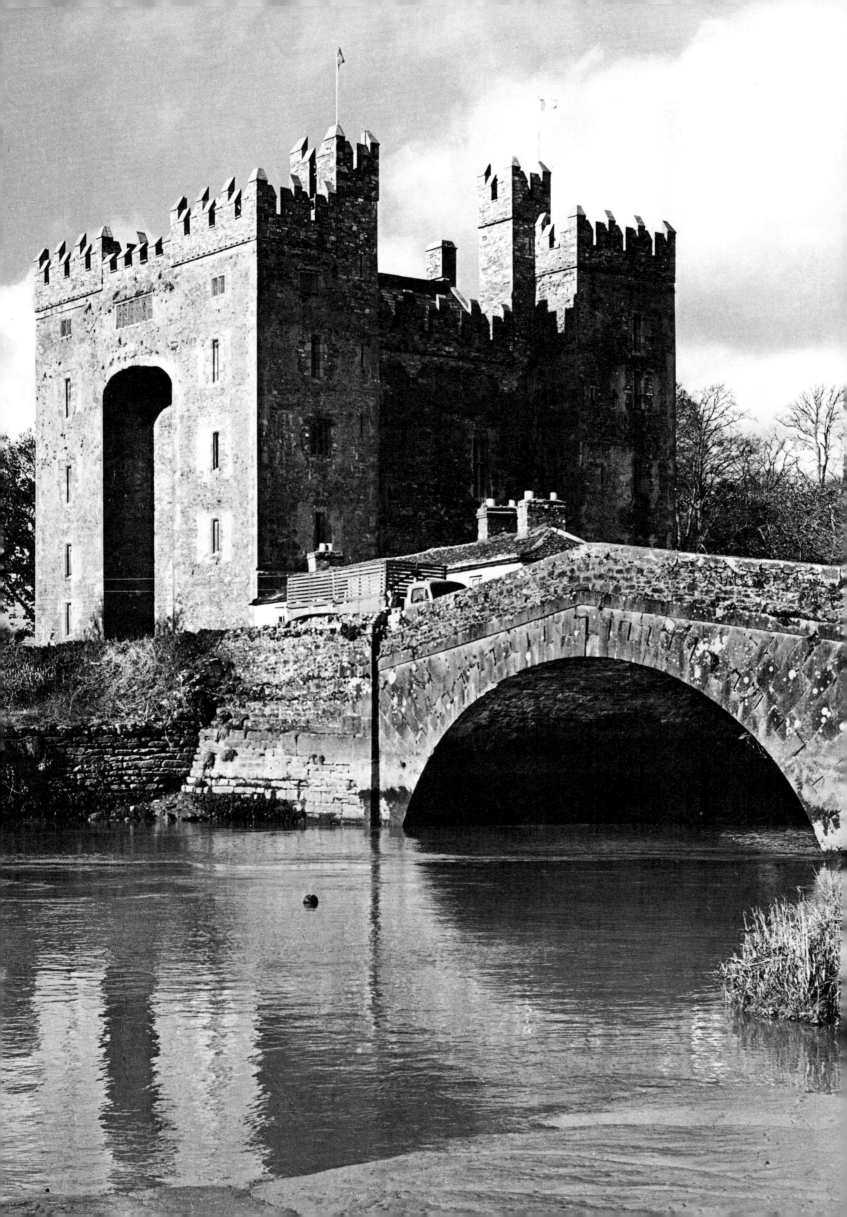

BUNRATTY CASTLE

BUNRATTY, COUNTY CLARE

Viscount and Viscountess Gort

THE NAME Bunratty means 'mouth of the river Raite'; the castle is built beside the river Ratty, at one time a position of strategic importance. The original castle, of which the motte-and-bailey can still be seen, probably stood on the site of the present Bunratty Castle Hotel. It was built in about 1250 by Robert de Muscegros, an Anglo-Norman, whose daughter and heiress married Sir William Mortimer. It was surrendered to King Edward I in the year 1275, and in the following year Geoffrey de Gyamul took for the King 'the castle of Bawred with the Cantred of Tradery'. It was then granted to Thomas de Clare, who settled in Thomond in 1277, from which time until the middle of the seventeenth century, Bunratty Castle was 'a storm centre around which surged a fierce tide of unrelenting war'. In 1318 Richard de Clare, the son of Sir Thomas, was slain in battle at Dysert O'Dea, and his widow fired the castle and town, and sailed for England, never setting foot on Irish soil again. Edward II then made a grant of Bunratty to James Bellafago, but in 1325 it was siezed by adherents of the Earl of Desmond, and in 1332 it was taken by King Muircheartach O'Brien of Thomond. In 1353 a new castle was built by the English Justiciar, Sir Thomas de Rokeby. Two years later this in turn was captured by Murchadh O'Brien, and from that date until the seventeenth century it remained in Irish hands. 'In Italy there is nothing like the palace and grounds of the Lord Thomond, nothing like its ponds and park with its three thousand head of deer', wrote Rinuccini, the Papal Nuncio, in 1646.

The existing structure was erected in about 1425, perhaps by one of the McNamaras, and in the early part of the sixteenth century it is found in the possession of the O'Brien's, later Earls of Thomond, who occupied it for a hundred years until in 1642 it was handed over to Cromwell's army by the sixth Earl. In 1645 the English commander was Admiral William Penn, the father of William Penn of Pennsylvania.

Bunratty Castle on the river Ratty. The battlements are modern

It appears that in 1709 Bunratty was leased to one Robert Amory, to include 'the castle, farm, and lands of Bunratty, of 472 acres, with free ingress, egress, and regress, for coach or cart through the Park of Bunratty to the town of Sixmilebridge'. Amory sold the castle in

49

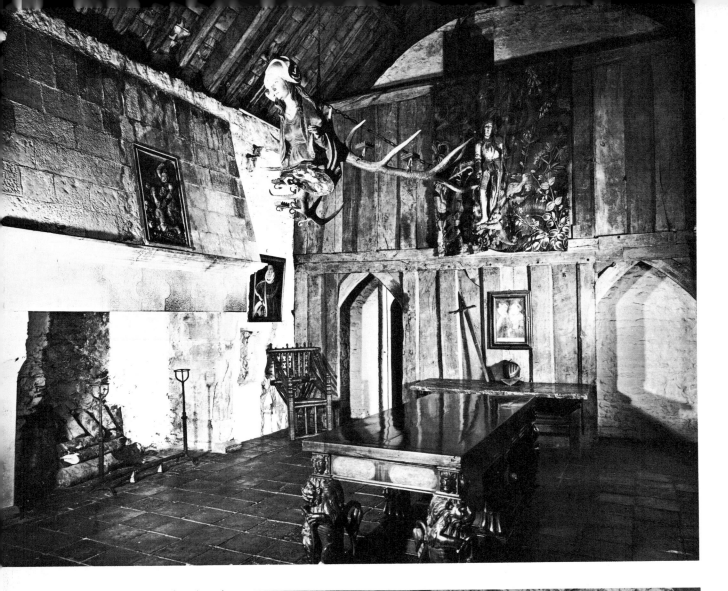

Bunratty Castle: the solar room

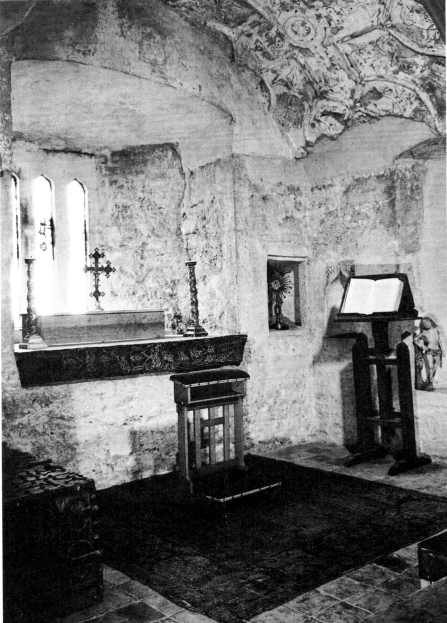

The chapel. Plasterwork from the early seventeenth century still clings to the ceiling

(Far right) The great hall

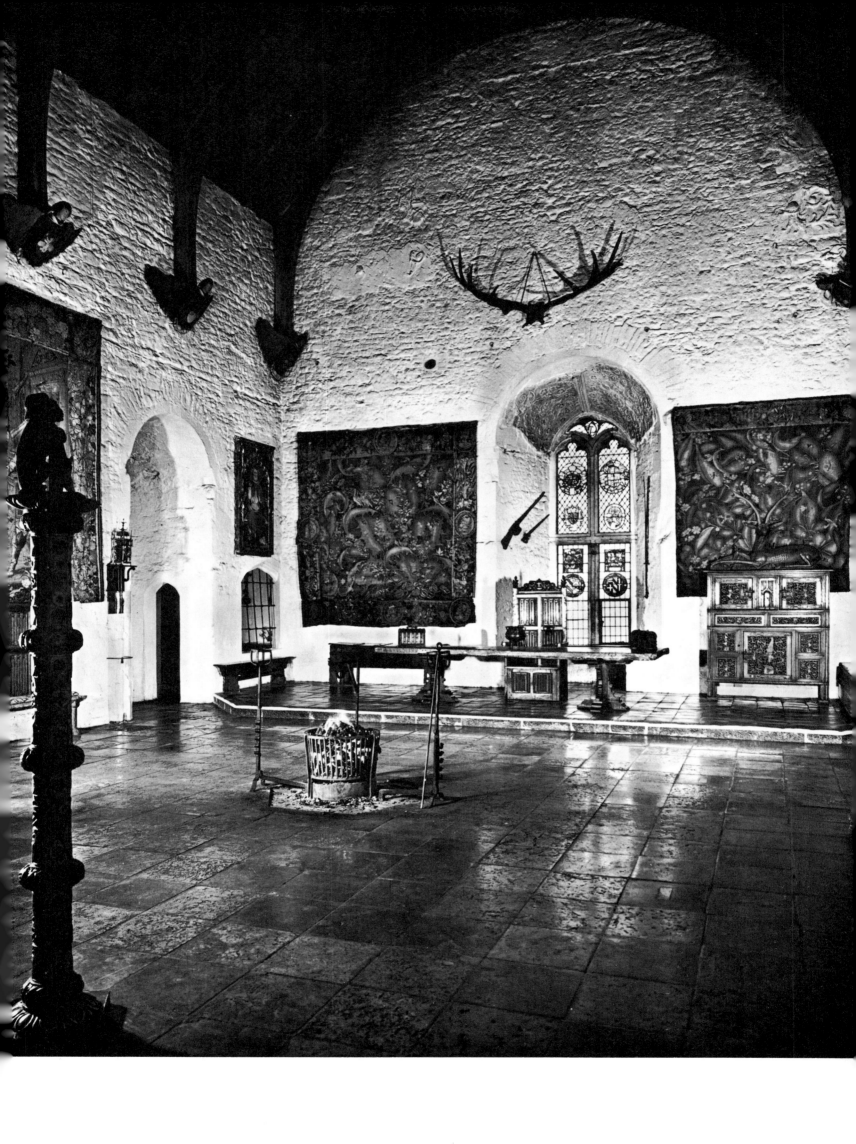

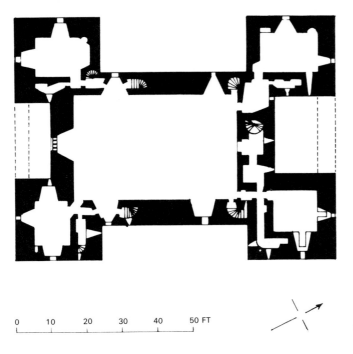

0 10 20 30 40 50 FT

Ground-plan of Bunratty Castle

turn to Thomas Studdert who took up residence there in about 1720 and made use of the seventeenth-century house that appears in engravings and old photographs nestling up against the castle walls. It was subsequently used as a constabulary barracks, and Mr Studdert built himself 'a spacious and handsome modern residence in the demesne'. The Studderts owned Bunratty for over two hundred years. Towards the end of the nineteenth century the ceiling of the great hall was allowed to collapse, an event that was the talk of the countryside.

In about 1850 a singular discovery was made in the castle. During repairs to one of the apartments, the workmen, who were removing part of the floor, discovered a vast chamber underneath. They descended into it, and found it to be hung with magnificent brocaded silk; a quantity of the same rich material was folded up lying on the ground, but fell to pieces on being exposed to the air. In the middle of this subterranean apartment was a skeleton, with a long knife beside it, the handle of which was of massive silver, splendidly chased. The chamber had neither door nor window, nor any apparent means of entrance.

In 1954, Viscount Gort purchased the ruin, and the Office of Public Works set about restoring it so that it could be opened to the public. The seventeenth-century house was removed, the great hall was roofed once more in oak, and battlements were added. Old engravings show the roofline to have been quite different from what it now is, but it must be admitted that the present battlements give a most romantic and pleasing effect. Lord Gort's magnificent collection of medieval furniture and tapestries has found a place there, and the thousands of tourists who visit Bunratty are given a lasting impression of medieval life.

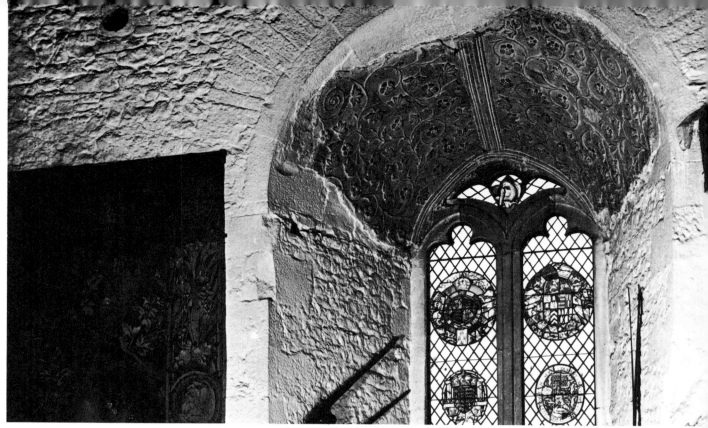

Window in the great hall with vestiges of the original plasterwork

 Most of the contents of Bunratty are of Continental origin, as Irish furniture and hangings of the period simply do not exist. Some of the original plasterwork has survived, however, and still attaches to the walls and splayed windows; there is scroll and floral ornament with the O'Brien arms and female figures emerging from flower and leaf. The chief decoration is on the vaulted ceiling of the chapel. Though somewhat crude, it is, with that at Carrick-on-Suir, the best example of early seventeenth-century plasterwork to survive in Ireland. It was probably by the same hand that executed the stucco crucifixion in Quin Abbey, a few miles away. The whole restoration of Bunratty had been most sensitively carried out and is a monument to the taste and knowledge of its owner, and that of Mr Percy Le Clerc and Mr John Hunt.

Continental oak chest in the great hall

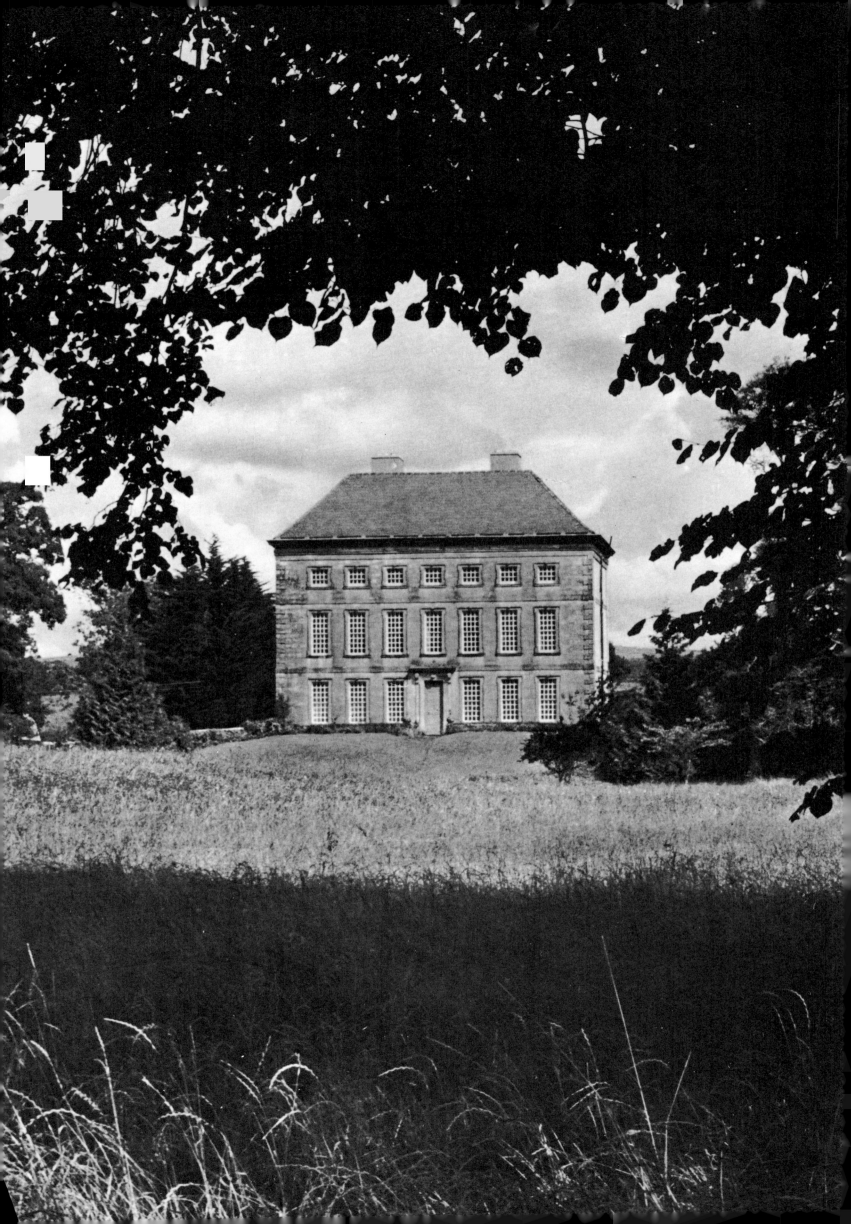

MOUNT IEVERS COURT

SIXMILEBRIDGE, COUNTY CLARE

Squadron Leader and Mrs Norman Ievers

THE COUNTIES OF Limerick and Clare are not as rich in architecture as those nearer to Dublin. Their distance from the influence of the capital means that houses have sometimes been built in an antiquated style giving them the appearance of being older than they really area. Mount Ievers is the finest house of its date in this part of Ireland. Invisible from the road, it stands in its park like a forgotten doll's house, sheltered from the world outside by miniature hills and giant beech trees. The south front is of stone and the north is of Dutch brick, faded by years of sun and rain to an unbelievable shade of pink. The effect of height is greatly increased by tall chimneys reminiscent of the seventeenth century, surmounting the steeply pitched roof, and very much a part of the architectural design. At each floor, the stone band or string-course is cleverly used to conceal the fact that the house becomes narrower by a few inches, again contributing to the impression of height. (*See p. 65*)

Henry Ivers came to County Clare at some time before 1658, and succeeded in amassing a considerable amount of land in the county by virtue of his position as Clerk to the King's Commissioners for settling the quit rents. This was the tax imposed on lands distributed to the settlers by the Government, and those who levied taxes in those days often did well for themselves at the same time. He died in 1691 possessing over 12,000 acres of which about half were deemed 'profitable'. Much of the land in this part of Ireland is very poor – Cromwell is supposed to have complained that there was 'no grass to feed a horse nor even a tree to hang a man from' in County Clare.

Henry Ivers either bought or built the castle illustrated by Dinely, which is typical of the high square tower-forts that are scattered across the Irish landscape. Its name was Ballyrella, but neither builder nor date is known for certain. A stone fireplace dated 1648 was saved from the castle when it was pulled down, and now adorns the entrance hall at Mount Ievers, but the castle probably existed before this. Henry's son John inherited in 1691, and rep-resented County Clare at the Parliament in Dublin for sixteen years; he had a house in St Stephen's Green. It was he who changed the family name to Ievers. He died in 1731 and,

Mount Ievers Court, Co. Clare: the stone front

55

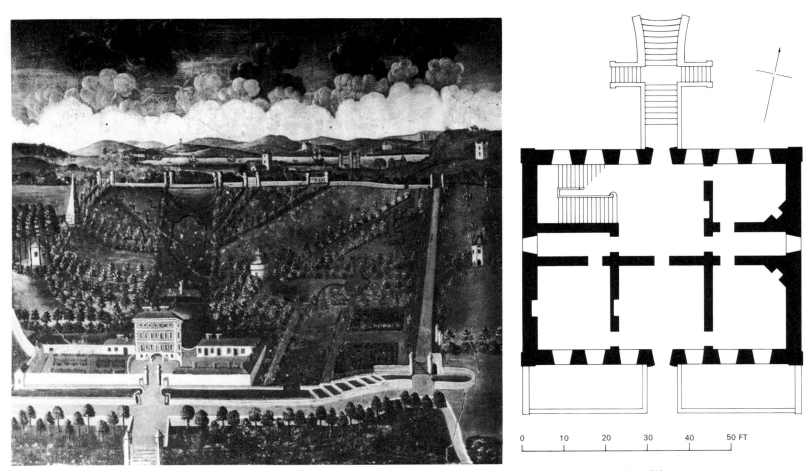

(Left) Painted panel showing the house and grounds as they were in the eighteenth century and (right) ground-plan of the house

shortly after, his son Henry pulled down the old castle, which had no doubt by then been made more commodious than it appears in Dinely's sketch, and began to build the present house.

The architect was John Rothery, and a complete set of building accounts survives showing that when he died in 1736 the house was unfinished. They also show how cheap labour was at that time; masons received five shillings and labourers five pence a week for their work. They were, of course, provided with food, clothing and drink, as well as accommodation in some cases. The building accounts show the total cost of the artisans to have been £1,478 7s 8d, including some extras such as two horses given to the architect. A 'new agreement' referred to in the accounts was a contract with Rothery's son Isaac to complete the building of the house. Dr Craig has found reference to Samuel and William Rothery working as masons and builders in Dublin at the end of the seventeenth century, and Dr Girouard has found a monument of 1722 to the Bury family in Adare church, Co. Limerick, signed *Rothery fecit*. One of the family may have been involved in the building of Castletown Conolly, Co. Kildare, from 1722 to 1724 in which year Pearce returned from Italy, his copy of Palladio in hand. In 1724 a house on the main street of Celbridge is described as 'lately held and enjoyed by Joseph Rothery'. A Jemmy Rothery appears in the Mount Ievers accounts. Isaac was the architect of Bowenscourt, Doneraile Court, and Newmarket, all in County Cork.

The accounts also give interesting details about the materials used. The oak for the roof timbers of the house was brought from the woods at Portumna by boat to Killaloe, whence it was carted the twenty odd miles to Mount Ievers. Thirty-four tons of it were required. The slates cost 9s 6d per thousand, and came from Broadford, eight miles away. The north front is faced with a lovely faded brick and the walls, which are between four and five feet thick are lined with brick also, which was imported from Holland. There was an oil-mill at Ballintlea, Sixmilebridge, that was owned by a certain Robert Pease of Amsterdam, where oil was made from rape-seed, and shipped to Holland, the vessels returning with brick as ballast. The brick was unloaded at the mill, only a mile from Mount Ievers. No mention of the brick appears in the accounts. There are, however, large bills for quarrying and carting the limestone, which came from a local quarry.

The interior is pre-Georgian in style and appears to be unfinished. Some fine marble mantels adorn the principal rooms, but these are later than the house. Several of the rooms are panelled in plaster to resemble wood, and there is an interesting compartmented ceiling on the landing. The staircase is the best feature of the interior and is Queen Anne in style. As at Bowenscourt, there is a huge gallery, dormitory, or ballroom on the top floor – it is hard to say exactly what it was designed for. The windows have the earliest and heaviest type of glazing bar, with four panes across. The first floor of the south front had lost these but the present owner has replaced them. He has done much to ensure the future of the house, and, with the help of the Irish Georgian Society, has given it a new roof.

There is a panoramic wall-painting at Mount Ievers showing the house and grounds in about 1740, with Bunratty Castle and the Shannon in the distance. The garden was formally laid out with rectangular fish-ponds and the painting includes a pigeon house, an obelisk, a fish house and an ice house.

Mantels: (left) drawing room; (right) dining-room

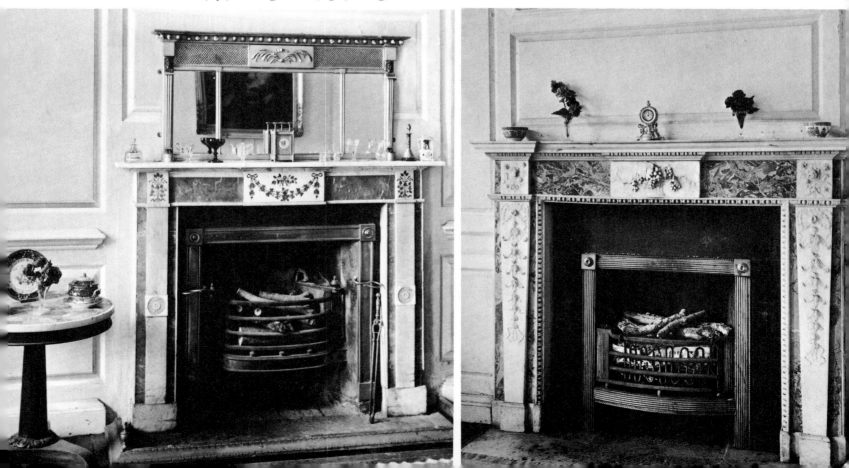

In common with every Irish house, legend has grown up around Mount Ievers. It appears, for instance, that a Protestant was refused a chop at the local inn at Sixmilebridge on a Friday, as there were some prominent Catholic clergy dining there at the same time on fasting fare. He called for a sheet of paper and wrote, in the manner of Swift:

Can any man of common sense
Think eating meat gives God offence;
Or that a herring hath a charm
The Almighty's anger to disarm?
Wrapt up in Majesty Divine
Does he reflect on what we dine?

The landlady handed it to the Catholic Bishop, who told her to give him whatever he wished to eat.

The Ievers were a military family; in the reign of George III John Ievers issued a recruiting poster in England, describing the joys of serving the King in Ireland:

IRELAND is the only Part of His Majesty's Dominions where the Price of Provisions has not been raised. Beef and Mutton are sold at two-pence a Pound throughout the Year, and every other Article proportionably cheap. Vegetebles of all Kinds are in such Profusion, that for one Penny as much may be bought as will serve six Men. His Majesty has been pleased to allow convenient and comfortable Barracks for his Troops in every Part of the Kingdom, and to supply them with Beds, Bedding, Kitchen Utensils, Coals and Candles without any Charge. All Young Men who are inclined to embrace this Opportunity of entering into so desirable a Service, shall meet with every Encouragement and Indulgence that their Officers can grant. They shall have the free Exercise of their respective Trades and Occupations, in a Country where there is the greatest Demand for, and the highest Prices given to Manufacturers, Artificers, and Workmen; and when discharged from the Regiment, they will be entitled to the Privilege of setting up in their different Professions in any Town in GREAT BRITAIN or IRELAND, without Expence, Hindrance, or Molestation.

In 1808, George Ievers died in mysterious circumstances, following a duel that took place in the little churchyard between Sixmilebridge and Ballintlea, between a Mr McNamara and a Mr Hammond. Ievers had agreed to be a second, in spite of the fact that as a magistrate the consequences for him would be grave in the event of one of the parties being killed. Hammond did lose his life and the shock was too much for Ievers who succumbed to a fit of apoplexy, dying a few hours later. It is said that his pack of hounds broke loose from their kennels and ran past the house in full cry on the night of his death.

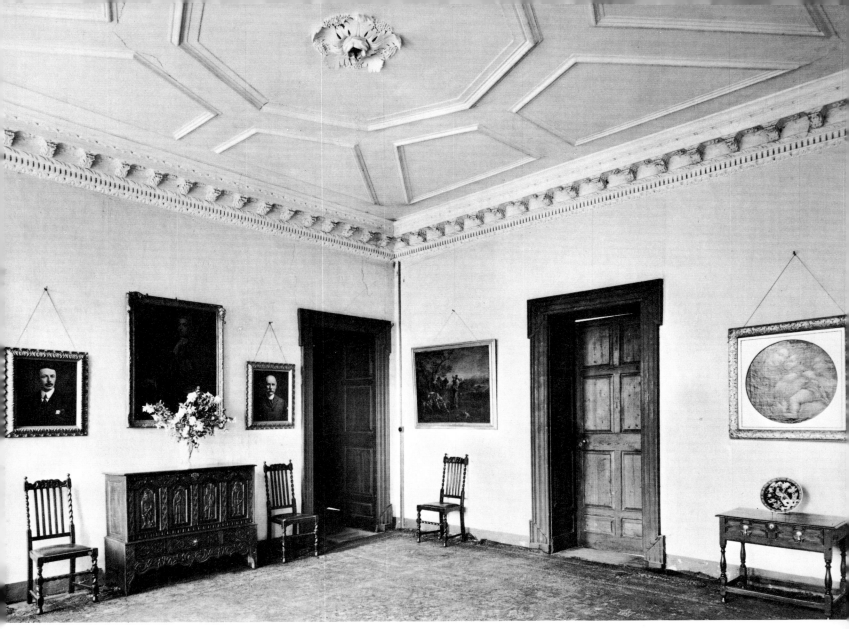

The bedroom landing

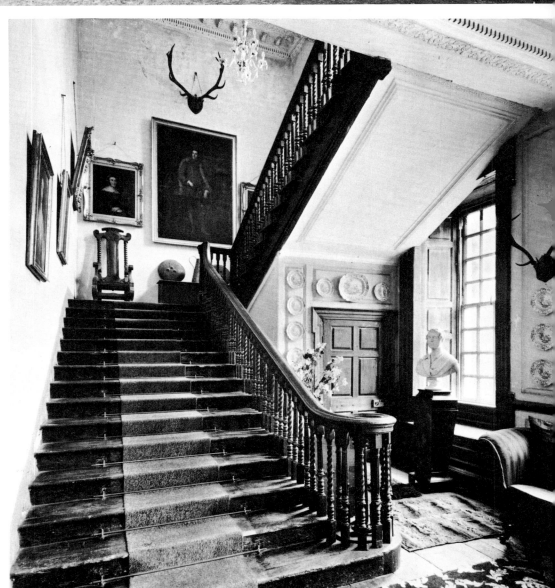

The main staircase

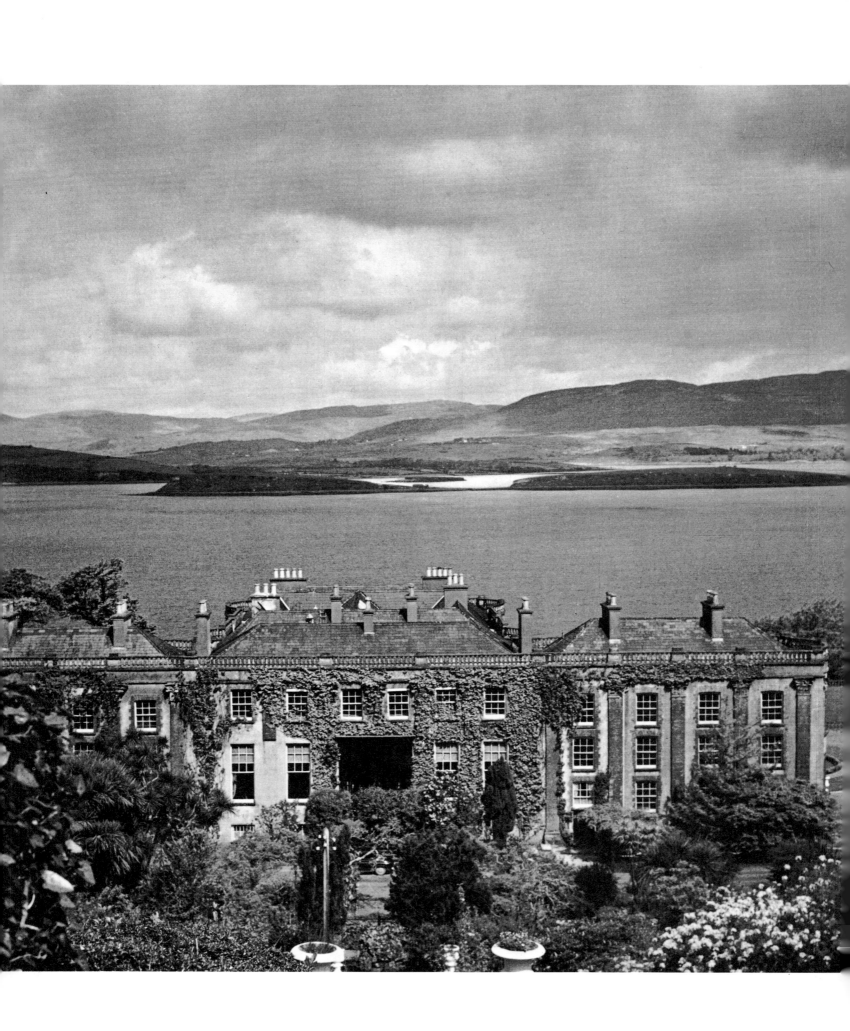

BANTRY HOUSE

BANTRY, COUNTY CORK

Mrs C. Shelswell-White

BANTRY HOUSE stands in a commanding position on the southern shore of Bantry Bay, with a magnificent view across the water to the distant Caha mountains. From the house, the bay looks like an enormous lake, because the exit to the sea is hidden by islands and promontories. Although Ireland is on the same latitude as Newfoundland, the warm waters of the Gulf Stream which pass this southwesterly tip of the island enable semi-tropical vegetation to flourish here. The natural beauty, which rivals that of better-known Killarney, has invariably amazed the visitors and tourists who flock there:

> The mind, filled and overborne by a prospect so varied, so extended, and so sublime, sinks beneath its magnitude; and feeling the utter incapability of adequate expression, rests upon the scene in silent and solemn admiration. The soul must be insensible, indeed, which will not be moved by such a contemplation, to adore the God of nature from whom such mighty works proceed.

A Richard White had come to this region in the seventeenth century, and settled on Whiddy Island in the bay. Subsequently he acquired from the Earl of Anglesey the lands which form the nucleus of the present demesne on the mainland across from Whiddy. His only son, also Richard, studied law and was admitted to the English Bar. He prospered, and in 1765, near the end of his life, he moved from Whiddy Island to Bantry House, which was then called Blackrock. This house, a spacious square building, had been built about 1750, by the Hutchinson family. Richard White's son, Simon, was married in 1766 to Frances Jane Hedges Eyre, daughter of Richard Hedges Eyre of Mount Hedges and Macroom Castle. Their first son was born in 1767 and named Richard.

By the end of the eighteenth century this Richard White had acquired most of the land around Bantry and along the Berehaven peninsula, and was by far the largest landowner in these parts. His grandfather's fortune, augmented by these acquisitions, was by now producing £9,000 per year. Although a strong supporter of the government, he was not prominent in social or political life. Without warning, in 1796, a part of Irish history took place almost on his doorstep, which was to bring him unexpected fame and honours.

Bantry House: the garden front

61

For some time a band of Irish patriots, the United Irishmen, encouraged by the American and French Revolutions, were planning to free Ireland from English rule. They sought and obtained help, as had the Americans before them, from the French Government. In December 1796, a fleet of 43 ships and 16,000 men sailed from Brest to invade Ireland. A tremendous hurricane along the route caused the fleet to disperse, and only 16 vessels, with 6,000 men, managed to rendezvous at Bantry Bay. After waiting several days for the remainder and with no attempt to land in the face of strong northeasterly winds, the fleet sailed back to France. The bitterly disappointed Wolfe Tone, the Irish revolutionary leader, aboard the *Indomptable,* wrote in his diary, 'We were close enough to toss a biscuit ashore'.

From the land, however, this event took on a somewhat different aspect. On 23 December, a number of ships could be seen, riding at anchor across the bay from the point of Bere Island to Sheep's Head peninsula. On the 24th, as no transport ships were evident, suspicions were lulled and many believed the ships to be English. Richard White accordingly sent his pinnace with a crew of ten to find out if the fleet were friendly. Neither pinnace nor crew returned. Moreover, a report arrived to say that 30 transport ships had been sighted off Dursey Island, to the northwest of Bantry Bay. White sent reports to the British headquarters at Cork.

On Christmas Day, the northeast wind blew with increasing violence and snow began to fall. The next day the gale grew even stronger, 'but the rudest blast of the element was as the music of the spheres to the inhabitants about Bantry'. General Dalrymple arrived from Cork. A French naval officer was captured and brought before him at Bantry House; he had been washed ashore while attempting to cross from *Le Résolu* to another of the French fleet. His long-boat was preserved at Bantry House until 1944, when it was kindly presented to the National Museum, Dublin, by Mrs Shelswell-White. During the night of 28 December the French fleet was driven completely out of the bay by the storm. Not a ship was in sight the following day.

Cannonading was heard from Berehaven on the morning of 30 December. At first it was hoped to be the English fleet, under Lord Bridport, that had taken on the French, when a French lugger was sighted standing towards Bantry. At 2 p.m., two merchant ships approached – one American, the *Beaver* of Charlestown, the other the *Sifter* of Liverpool – having put in for safety from the storms only to be fired on by the French, four of which were in pursuit. A landing once more seemed inevitable. On 31 December, 15 French boats, each with 40 men, surrounded the Liverpool trader, plundered and sank her. The French gave a boat to the master and crew, some bottles of brandy, and allowed them to land. After three more days it became apparent that the French ships then in the bay were waiting for the rest of the fleet to appear, and were not the same ships that had previously been seen! On 4 *The library*

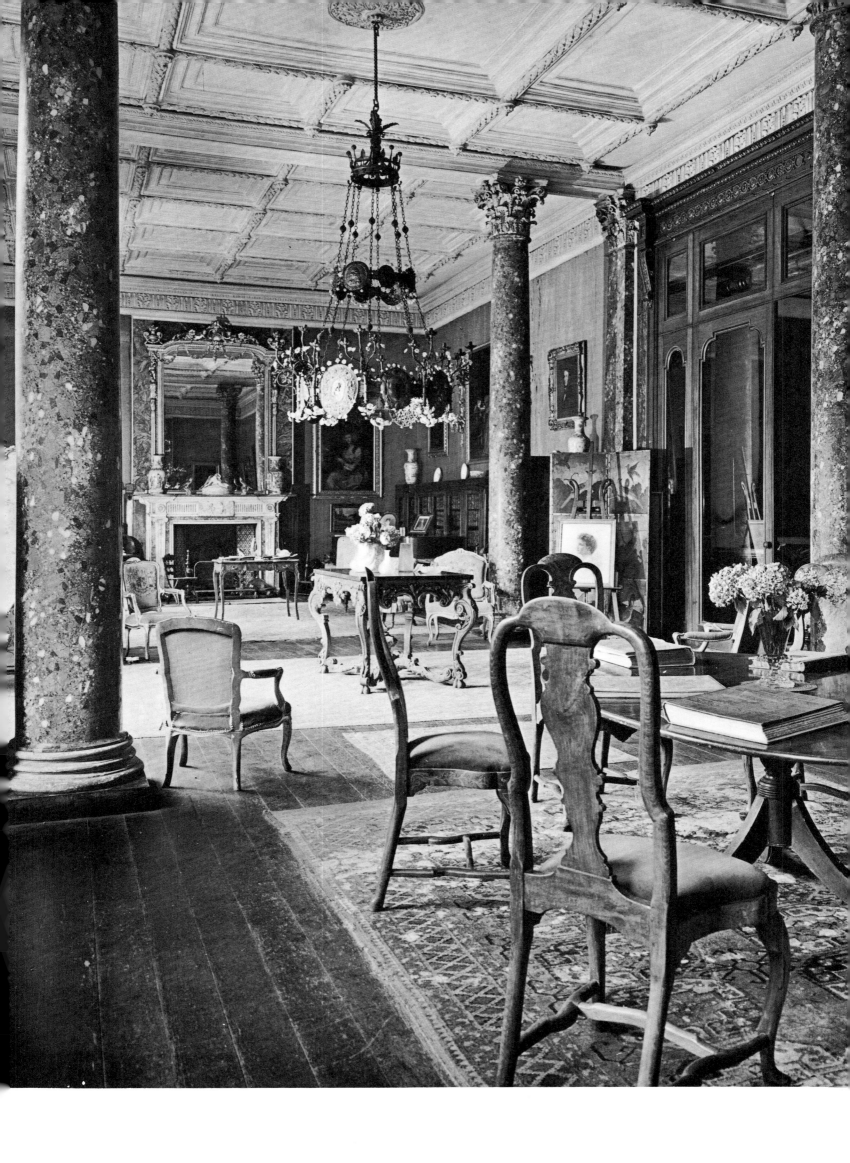

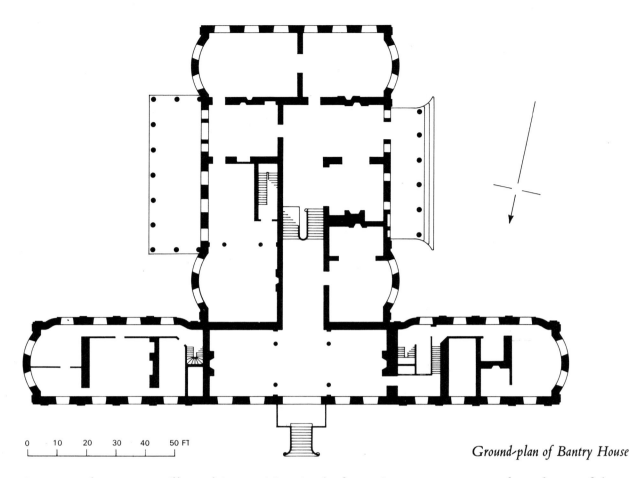

0 10 20 30 40 50 FT

January, there were still 13 ships waiting in the bay. A peasant went on board one of them to sell food. When asked how many troops were on shore for defence, he replied, '20,000 in the neighbourhood of Bantry'. There were in reality only 400 troops, but to a simple person this seemed 'thousands'. He also told the French that Lord Bridport was off the cape, which was generally believed, although the SOS in fact had only reached London on 31 December. The invaders were in a dire state by this time; tossed about, sick, and separated from their commander; it was only with the greatest difficulty that they were prevented from attempting to land. The next day they left and the emergency was over.

Richard White himself would hardly have claimed to have expelled the French fleet. He did, however, show great initiative in obtaining intelligence of the enemy's movements throughout the crisis, organized local defences, and placed his home, then called Seafield, at the disposal of the British General and his staff. In March 1797, he was raised to the peerage of Ireland as Baron Bantry, 'in consideration of the zeal and loyalty he displayed . . . during a period of great trouble . . . for having been the means of repelling the French fleet when they entered Bantry Bay in 1796'. In 1800 he was made a Viscount, and in 1816 Earl of Bantry. Had the weather that Christmas been balmy and mild as it often is at that time of year, the course of history might have been different – England might have lost the Napoleonic wars, from which France never recovered.

(Above) Mount
Ievers Court (1732)
Co. Clare: the
brick façade
(see p. 55)

*Bantry House, Co.
Cork, facing over
Bantry Bay*

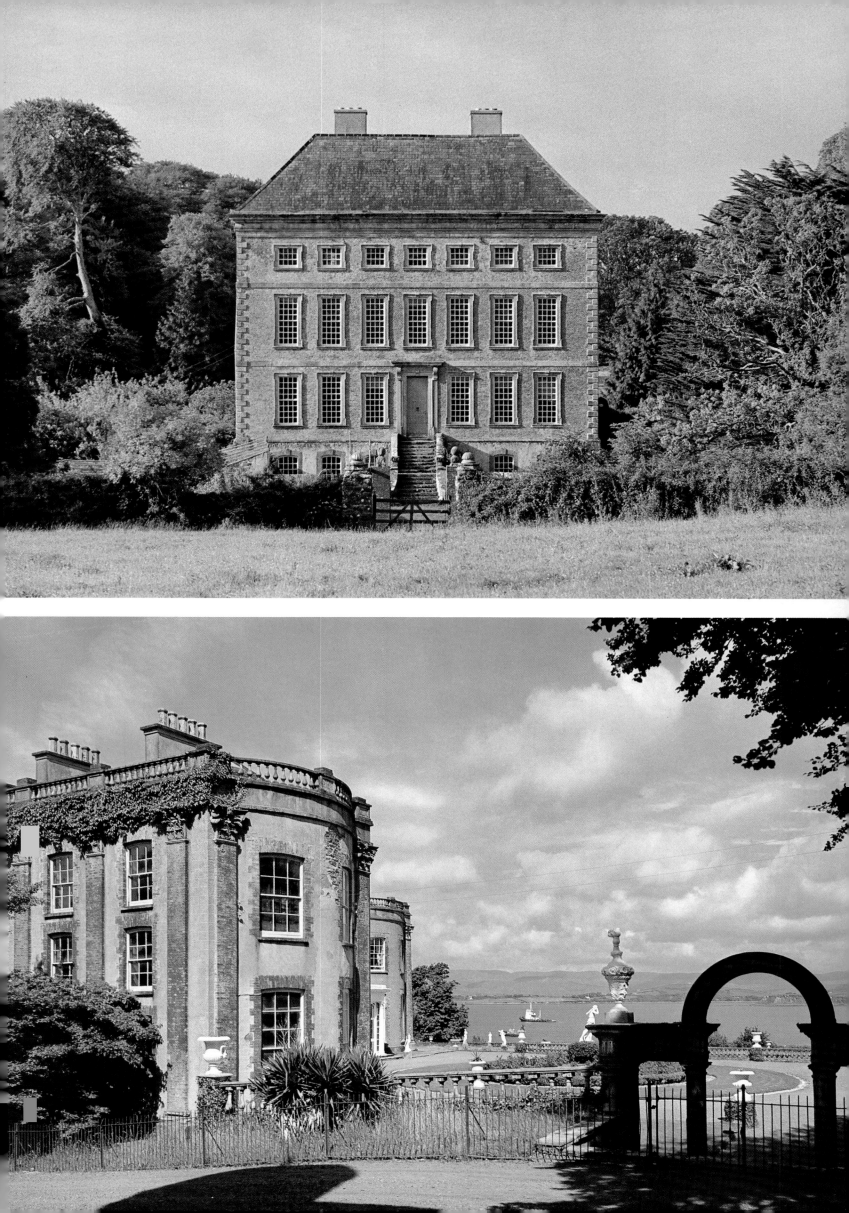

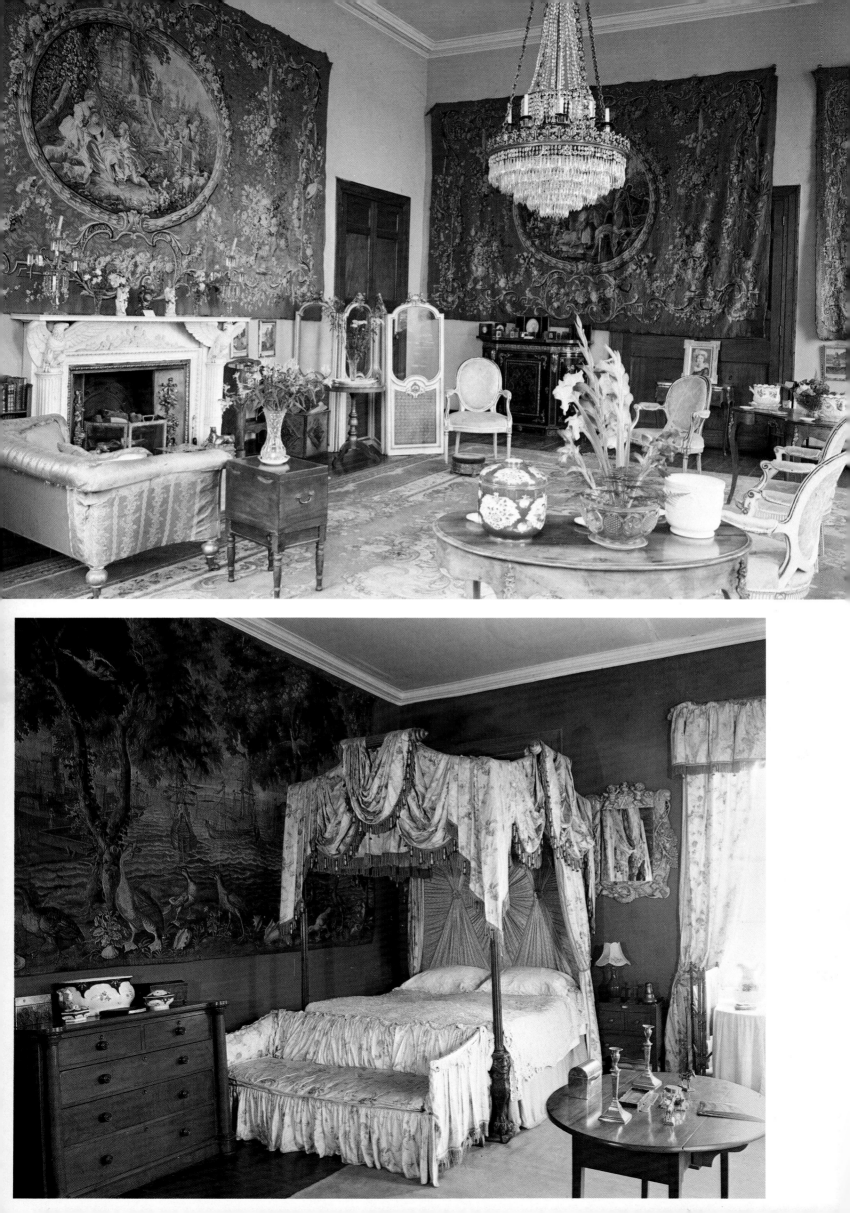

The second Earl of Bantry who travelled on the Continent and made the collection for which the house is famous

Bantry House: the drawing-room hung with Gobelin tapestries and (below) a bedroom

Lord Bantry enjoyed country life and lived contentedly on his estate in a then remote part of Ireland. His eldest son, born in 1800, grew up to have quite a different view on life. From an early age he travelled widely in Europe, visiting countries as far away as Russia and Poland. He was a great collector and constantly added to the remarkable furnishings and *objets d'art* at Bantry House, which he greatly enlarged in 1845, probably to his own design. The collection was so great that it was sometimes called 'the Wallace collection of Ireland'. Even though much of it has been dispersed over the last century, the house still holds many outstanding examples of the second Earl's good taste.

Undoubtedly the oldest item is some tiling from Pompeii bearing the familiar inscriptions *Cave Canem* and *Salve*. Italian art of much later times is represented by stained glass, paintings from a Venetian palace, and plasterwork executed by Italian craftsmen said to have been brought to Bantry expressly for the purpose. From farther afield comes an interesting Russian household shrine containing fifteenth- and sixteenth-century ikons. There is stained and painted glass from Switzerland, France, Germany and Flanders, and specimens of Cork, Waterford, and ruby-coloured Bohemian glass. Among the French pieces, which are the most numerous, those having special interest are a pair of bookcases and a work-table reputed to have been the property of Marie Antoinette, and fireplaces which are said to have come from the Petit Trianon at Versailles.

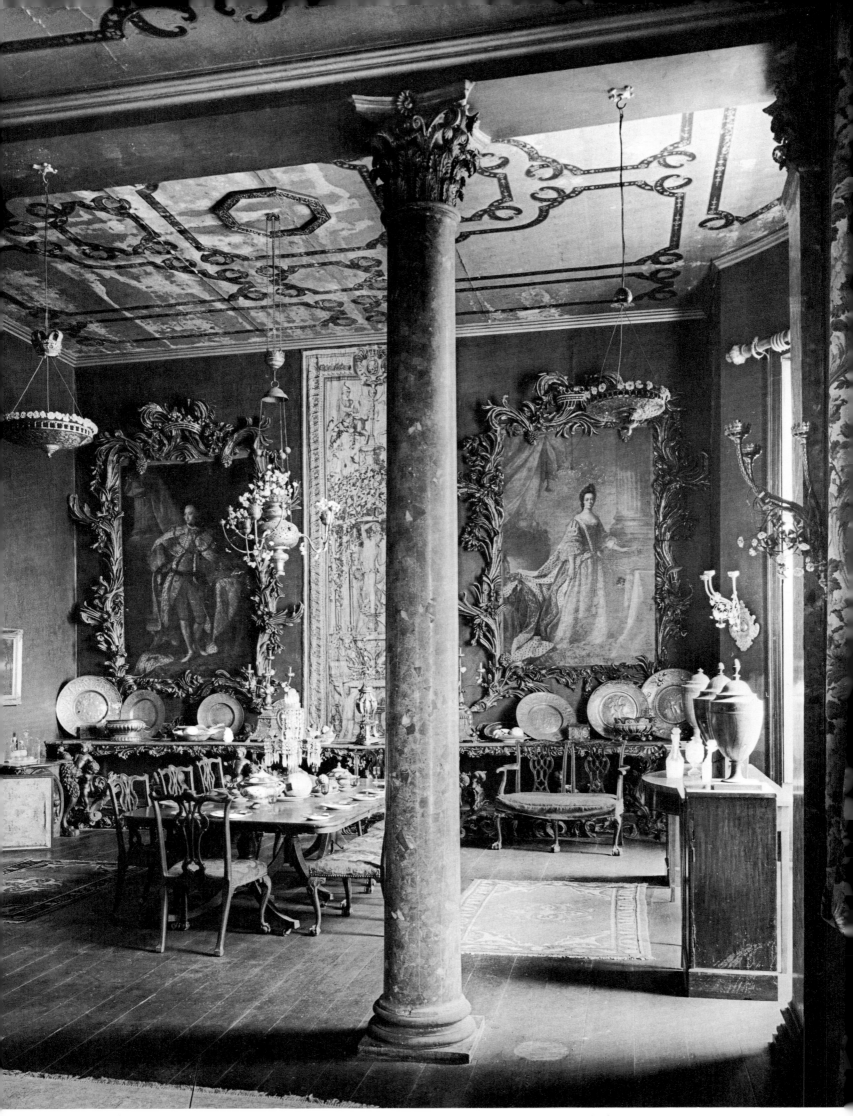

The dining-room is dominated by copies of Allan Ramsay's portraits of George III and Queen Charlotte in astonishingly elaborate frames

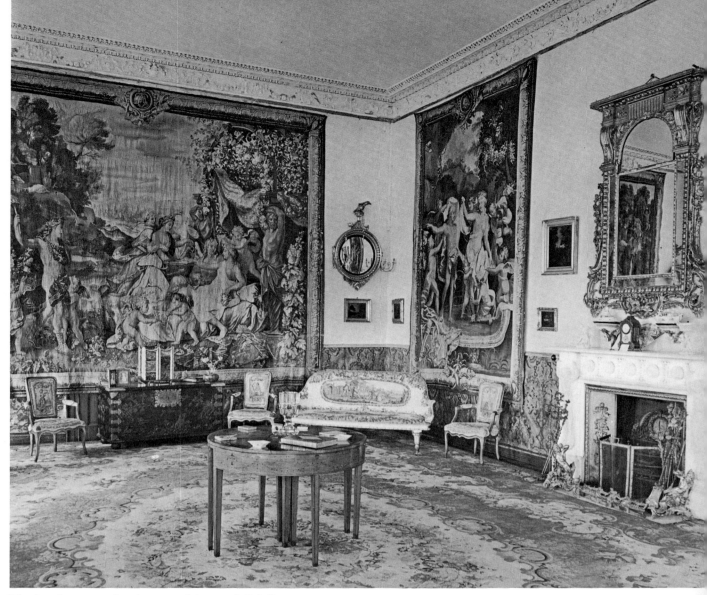

The drawing-room, showing part of the set of Gobelin tapestries

Lord Bantry's outstanding contribution, however, was unquestionably the tapestries which now adorn the walls of several of the rooms. With the exception of a set, seventeenth-century Dutch in origin, the panels are French having come from the Gobelin, Beauvais and Aubusson workshops in the late eighteenth and nineteenth centuries. One Gobelin panel is said to have hung at Versailles and there is a particularly beautiful rose-coloured set of Aubusson tapestries which is said to have been made by order of Louis XV for Marie Antoinette on her marriage to the Dauphin of France. Two other panels formed part of the royal Garde Meuble of the Tuileries.

Mrs C. Shelswell-White, the present owner of Bantry House, descends from the Earls of Bantry in the female line, and enjoys sharing the beauties of the house with others. She was the first owner of a country house in the Republic to open her doors to visitors; Bantry has been open for twenty years. People from all over the world have been welcomed by her at Bantry, and it is an experience that is impossible to forget.

FOTA ISLAND

CARRIGTOHILL, COUNTY CORK

Major and the Hon. Mrs Bertram Bell

THE DEMESNE of Fota covers practically the entire extent of an island situated in the Lee estuary, between Cork and Cobh. The public road skirts the island, following an impressive demesne wall within which are magnificent trees, which frequently signify the approach to a great Irish house. One of the sets of Regency entrance gates which pierce the wall at intervals is inscribed with the family motto, an ancient war-cry, 'Boutez en Avant'. Tradition has it that this was the cry of David de Barry, a Norman adventurer, who won vast estates from the MacCarthys in the neighbourhood. The town of Buttevant is said to derive its name from the old war-cry, but it could equally be possible that the family took their motto from the name of the town where the battle was fought. The ruined castle on Fota Island is an old Barry stronghold.

A barony was conferred on the Barrys as early as the thirteenth century. They took the title of Buttevant; the sixth Lord Buttevant married a daughter of Richard Boyle, the great Earl of Cork, and he was created Earl of Barrymore in 1627.

The fourth Earl purchased Marbury, a property in Cheshire, in the year 1714 and gave it and Fota Island to his younger son. This branch of the Barrys lived principally at Marbury from then on, where they amassed a splendid collection of pictures, many of which are at Fota today. Fortunately, however, they never lost sight of their Irish inheritance; they built a modest-sized house at Fota and planted the trees which make the park there so magnificent.

At the beginning of the nineteenth century John Smith-Barry added to the house, and although it has been further extended since, he left it substantially as it is today. The architects were the Morrisons, father and son, who enjoyed a large country-house practice in Ireland in the early nineteenth century. Their rejected design for a house in the Elizabethan style still survives at Fota. Sir Richard Morrison had rightly anticipated that his son would follow in his footsteps and become an architect, as he was christened William Vitruvius. The Morrisons added the two pedimented extensions to either side of the house, put on a Doric portico, and remodelled the interior so that Fota is now essentially a Regency house. Their

Fota Island, detail from Neale's Views of Seats *(1828)*

71

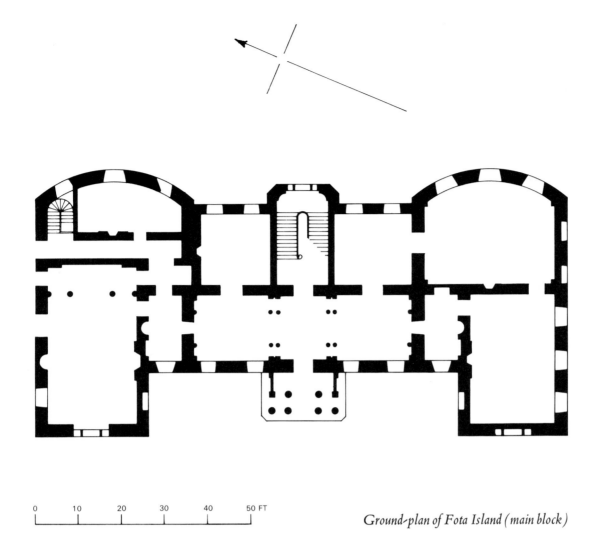

0 10 20 30 40 50 FT

Ground-plan of Fota Island (main block)

finest achievement was the entrance hall, unusually elongated, taking up the entire front of the house, with its handsome enfilade of yellow scagliola pillars. (*See p. 83*)

Fota is remarkable for its old master paintings, one of the best three private collections in Ireland. The works of Van Dyck, Paret, Guercino, Guardi, Lely, Kauffman, Batoni, Gainsborough, and Canaletto are to be found here. In the hall and on the staircase, as befits the house of an ex-Master of Hounds, there are some splendid sporting pictures by Sartorius, Seymour, and Ferneley.

The other great pride of Fota is the garden where, on account of the mild climate engendered by the surrounding salt water, the most astonishing collection of semi-tropical trees and rare shrubs is able to flourish. The specimens have grown here to such exceptional heights that dendrologists the world over are familiar with the botanical achievements at Fota. Fota can boast therefore a great garden, a great collection, and a beautiful demesne; a rare combination indeed.

A corner of the front hall with part of the splendid collection of sporting pictures

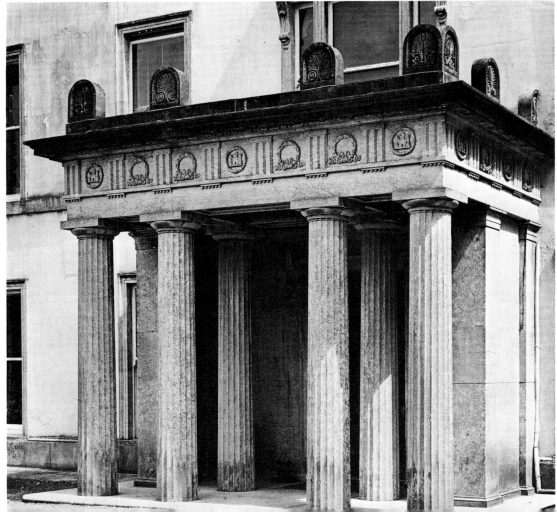

The Doric entrance porch

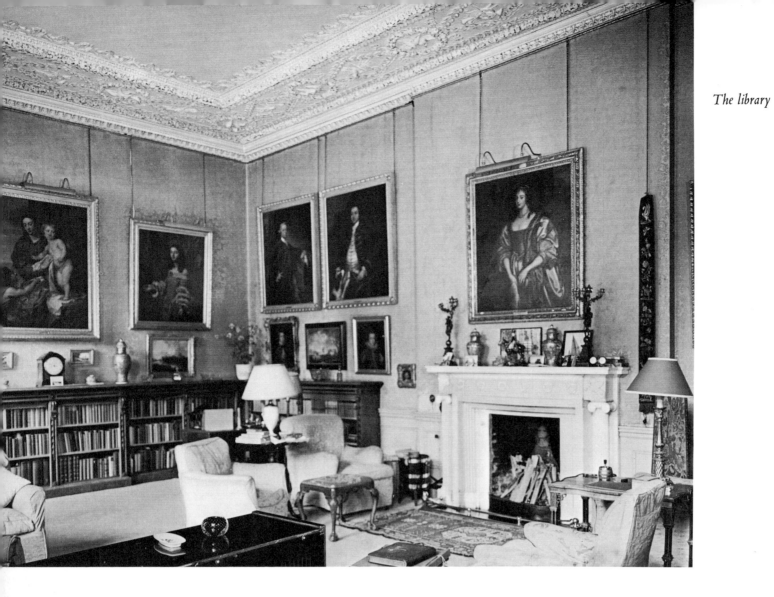

The library

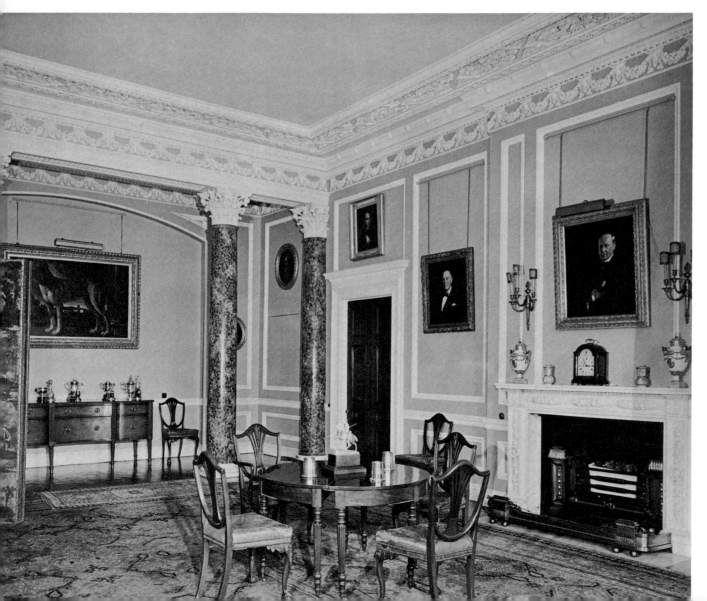

The dining-room

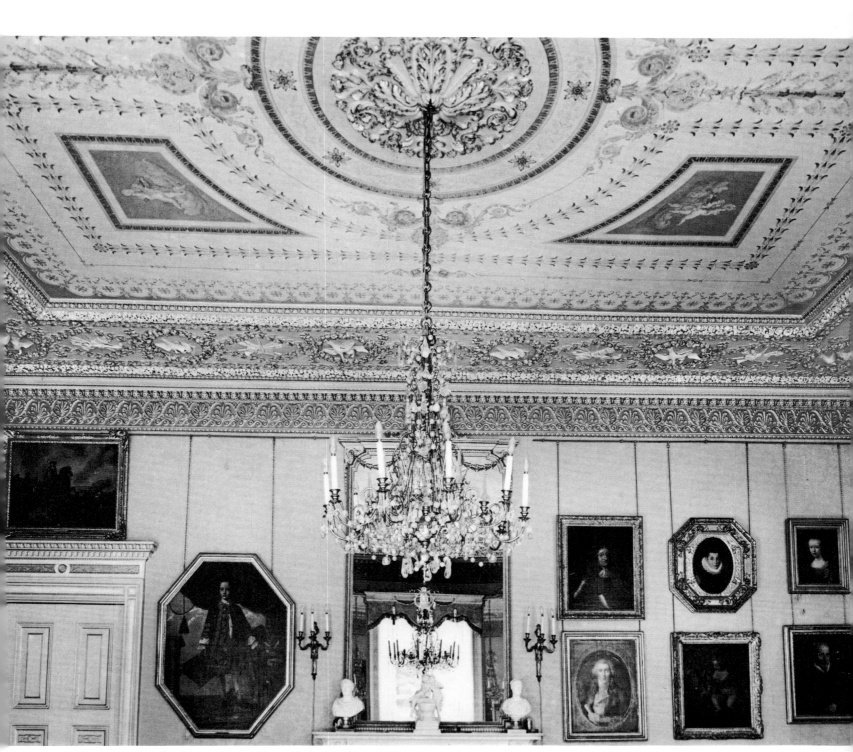

The drawing-room ceiling which dates from the late nineteenth century

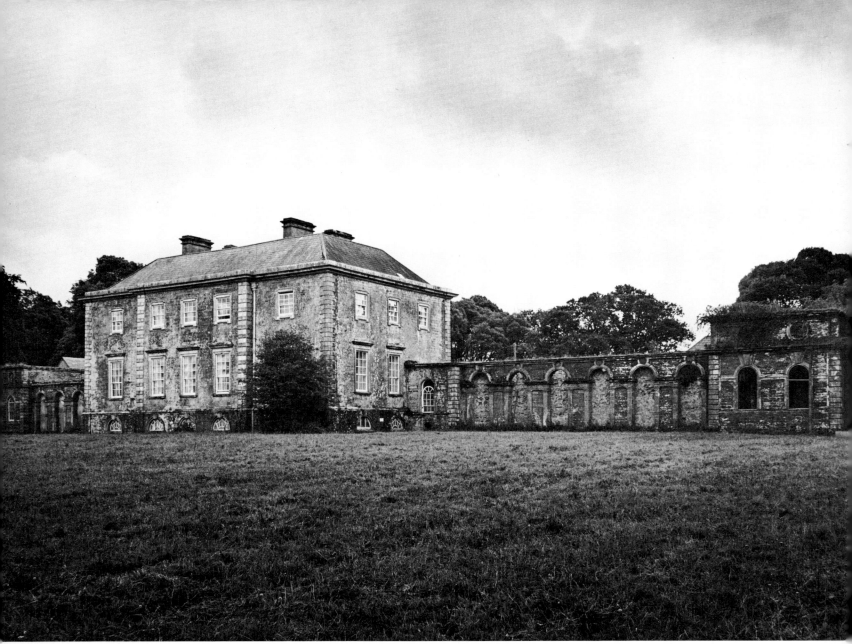

Kilshannig, Co. Cork, designed by Davis Ducart and built in 1765. The back of the house

(Below) The Custom House, Limerick, also designed by Davis Ducart and built between 1765 and 1769

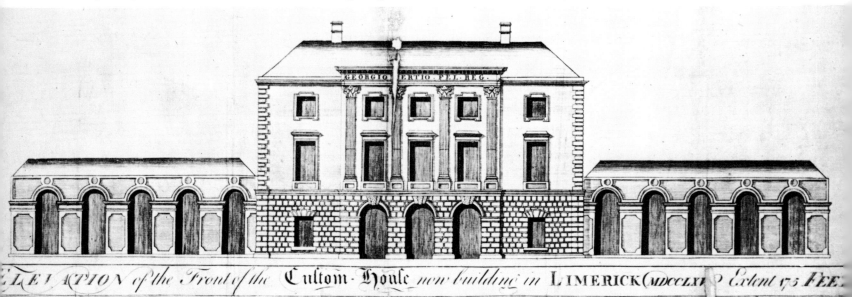

ELEVATION *of the Front of the* Custom House *now building in* LIMERICK (MDCCLXI) *Extent* 175 FEE.

KILSHANNIG

RATHCORMACK, COUNTY CORK

Commander and Mrs Douglas Merry

KILSHANNIG STANDS ON A RIDGE of land overlooking the village of Rathcormack and Knockmealdown and Galtee Mountains; in the other direction it faces down across some undulating country towards the city of Cork, about twenty miles distant. The house was designed by the Italian architect Davis Ducart, in the year 1765 for Abraham Devonsher, who was a Cork banker. Devonsher had no children. He left Kilshannig to his great-nephew John Newenham who added the name of Devonsher to his own. The history of the house following his death in 1801 is hard to trace. At some time in the nineteenth century it is said to have come into the hands of Lord Fermoy; Burke's *Peerage,* however, makes no mention of it. According to one story Lord Fermoy is supposed to have won it at a game of cards. In the 1940s it belonged to the Myles, and in the 50s to the Roses; fortunately the interior has survived intact through the many changes of ownership.

The entrance front of Kilshannig faces south, and is built of a warm, faded-red brick, with curved curtain walls and wings that contain the stables and outbuildings (*see p. 84*). In true Italian style the main reception rooms face north. This side of the house has arcades on either side that lead to pavilions, now ruined because in the last century the copper of the domes was sold to pay debts; it is gratifying to learn that the copper domes are to be put back by the present owners. The northern façade is built of the local limestone, which with age has acquired a purple hue.

The plan of Kilshannig is the reverse of Florence Court, where Ducart most probably added the arcades and pavilions to an existing house. Ducart's masterpiece, Castletown Cox, Co. Kilkenny, also has arcades leading to domed pavilions. Kilshannig must perforce take second place to Castletown Cox in the *œuvre* of Davis Ducart, although its plaster decoration ranks with the finest in Ireland.

The plasterwork of Kilshannig is a late flowering of the Francini brothers, who had decorated the dining-room of Riverstown House, Glanmire, a few miles away, thirty years before. In the meantime they had worked extensively in Ireland and England, and developed their talents fully. The decoration in the dining-room at Riverstown (*see p. 29*) consists of

orderly, rather static and stylized classical deities in plaster panels on the walls – an eccentric enough choice for a Protestant bishop. To be sure, there is a certain amount of movement and life in the ceiling, but the general effect is dignified and serious. The great saloon at Carton which the Francini decorated in 1739 is also somewhat ponderous. In the intervening years between Riverstown (1734) and Kilshannig (1765), taste had gone through many changes. Towards the middle of the century the baroque gave way to rococo, and freedom and lightness reigned for a brief spell; the rococo in turn froze in the grip of the neo-classical movement associated with the names of Adam and Wyatt.

The Francini brothers could not afford to ignore the changing tastes as they pursued their career. It has recently been discovered that they were responsible for the characterless Chambers ceilings at Castletown Conolly, Co. Kildare; there are entries in the Castletown account books in 1765 and 1766 of modest payments to 'Frankiney Stuccoman', and in 1767 there is a reference to a brass handle being fitted to Frankiney's room. What ceilings they might have executed there if only Lady Louisa Conolly had not been abreast of the latest fashions, and if Chambers had not been the favourite architect of the Lennox family! Their work on the staircase at Castletown (1759) is in the best rococo tradition, and as will be seen contains several motifs that are repeated at Kilshannig. It is fortunate that at least in the provinces the Francini were encouraged to work in the manner that was their *forte* as late as 1766, at which time they were at the height of their powers.

It is impossible to say to what extent the stuccodores collaborated with the architect at Kilshannig; all three were Italian and the combination was unusually successful, different ceiling heights being used to the best possible effect. By Irish standards the entrance hall is low and small, its intimacy heightened by the rich rococo plasterwork on the coving, which springs from a series of pillars ingeniously disposed to give an illusion that the room is circular. As at Castletown Cox, there is a caryatid mantel of stone and a black-and-white squared floor.

The front door

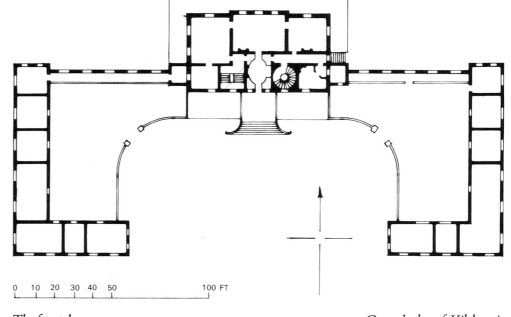

0 10 20 30 40 50 100 FT

Ground-plan of Kilshannig

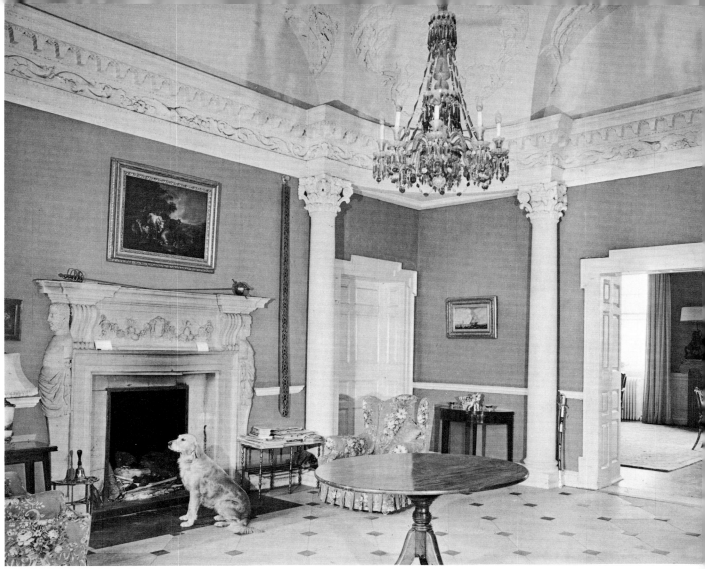

The front hall

The drawing-room, formerly the ballroom (see also p. 80)

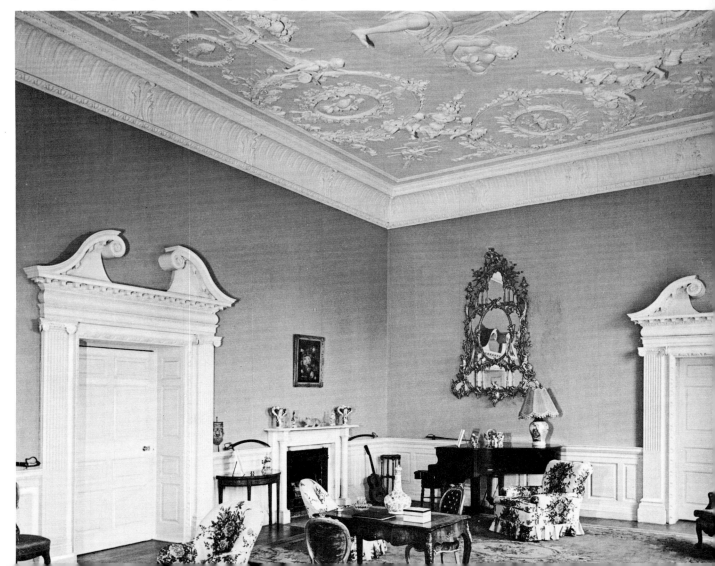

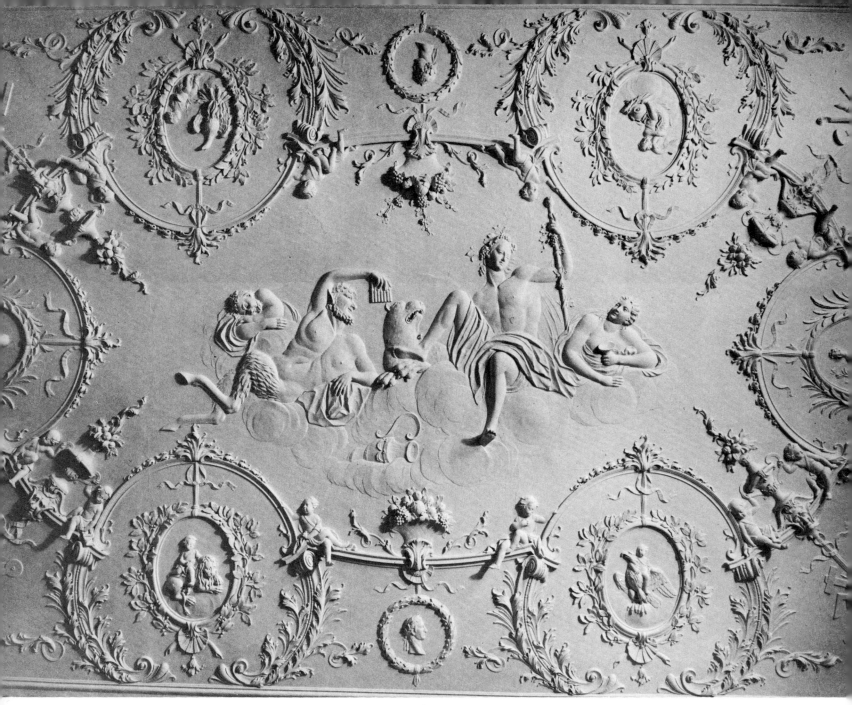

The ballroom ceiling,
dominated by the
figures of Pan,
Bacchus and Ariadne

The axial corridor

Facing the front door is the entrance to the ballroom. Here there is an element of surprise that can hardly be accidental; by judicious use of mezzanine floors the architect has contrived to make the ballroom half as high again as the front hall, an opportunity that the stuccodores were not slow to exploit. They have given it a breathtaking figured ceiling, dominated by the figures of Pan, Bacchus and Ariadne. Pan has been playing on his pipes; Bacchus is depicted with the usual bunches of grapes in his hair, and Ariadne is reclining with a vessel in one hand, while an empty jug testifies that wine has been consumed. Beautifully modelled putti, and figures of Minerva and Justice make up the background, with the four Elements (the lion for Earth, the eagle for Air, the fish for Water, and the phoenix for Fire) in elaborate double frames on the long sides of the room. Leading inward diagonally from the corners are the emblems of the four Arts, and the mask, urn and fruit that surmount them are practically identical with the cherub, urn, and fruit between the windows on the staircase at Castletown Conolly.

On one side of the ballroom is the dining-room, and on the other the library, both of which are of equal height and have equally elaborate decoration. Here is none of the heaviness of the Francinis' early work; they have infused Kilshannig with an Italianate warmth and gaiety. Above the mantel in the dining-room, in the cove, clusters of dead birds, rabbits and hares surround the mask of Diana, as if they were hanging in a game larder. A curious Italian fox gazes mournfully up at them; judging by his expression he doesn't consider himself long for this world either.

The library ceiling is an exquisite variant of the other two. In the centre, a plain circular frame encloses the figures of Diana and Apollo. Diana carries a bow and quiver slung across her shoulder; she looks towards a faun while Apollo serenades her on his lyre. The modelling of the figures is a poem of delicacy and graceful movement. In the four corners the four Seasons are represented in oval frames, and the medallions of female heads in profile, elaborately framed in the coving, are probably portraits of the Devonsher family. The portrait of Tom Conolly at the foot of the Castletown staircase is supported by mermaid-putti of similar design.

The passage is decorated with plaster frames of great elegance, and the black-and-white squared floor carries on from the hall to the side of the house. The staircase is circular, and the only one of its kind in Ireland; at its foot the stone floor forms a black star shape against the Portland stone background. The cantilevered stairs, also of Portland, rise two floors to the top of the house, where there is a domed rococo ceiling.

Commander and Mrs Merry are to be congratulated and thanked, as well as envied, for having taken on the immense task of restoring Kilshannig when they came there in 1960.

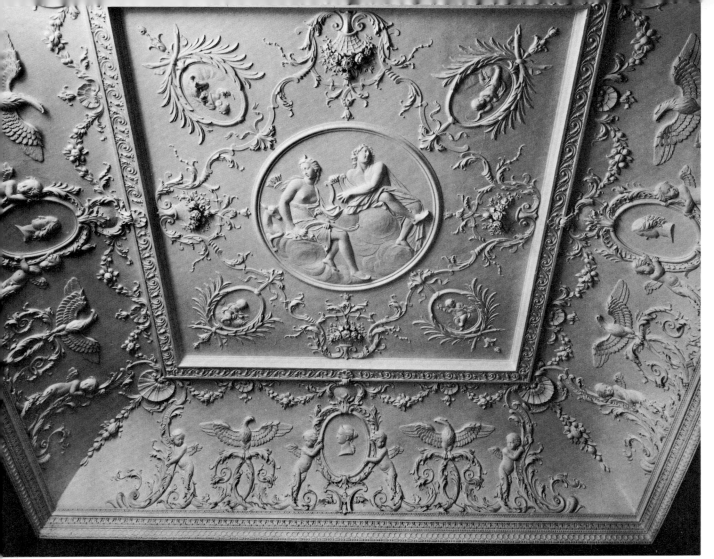

The library. Its ceiling (above) is dominated by the figures of Diana and Apollo. The cherubs in the coving display family portraits of the Devonshers which can be compared to the Conolly portraits in stucco on the staircase at Castletown, Co. Kildare

Fota Island, Co. Cork: the Regency entrance hall (see p. 71)

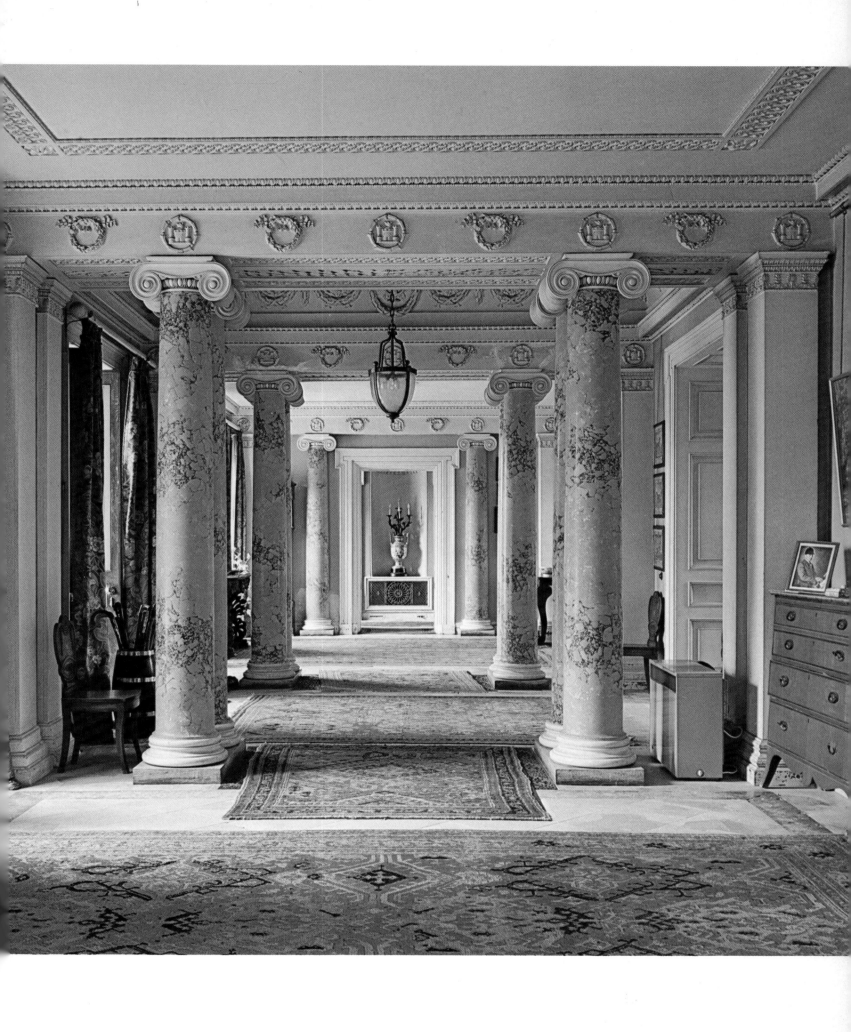

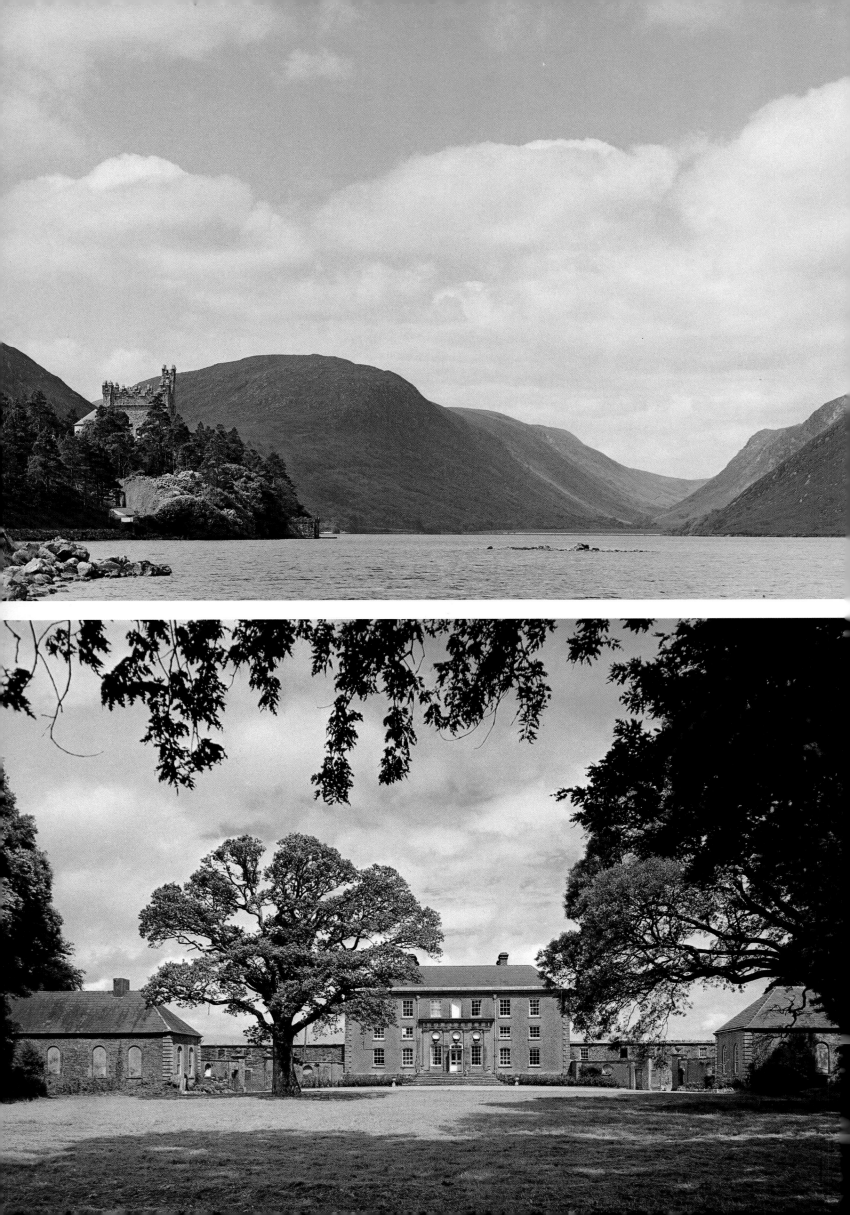

GLENVEAGH CASTLE

CHURCH HILL, COUNTY DONEGAL

Mr Henry McIlhenny

IT IS UNFORTUNATE that in a country so rich in great landscape as Ireland, her country houses should so often be situated in undistinguished surroundings. This was partly because the rents in mountainous districts were small, and also because such regions were rather inaccessible. There was little taste for siting houses in wild landscape in the eighteenth century, and by the time Queen Victoria and the railway train had begun to popularize the highlands of Scotland, in Ireland the Famine had put an end to country-house building. Glenveagh, standing in its breathtakingly beautiful demesne of 22,000 acres, is quite exceptional. The drive winds through mountainous country, with rocks and heather occasionally punctuated by neat stacks of turf, emerging after four and a half miles, between great banks of *ponticum,* at the edge of Lough Veagh. This vast expanse of water is encircled by mountains of the Derryveagh and Glendowan ranges, sometimes ominous with heavy cloud, and at others glistening in the sun after a heavy downpour. Half-way up the valley a promontory juts into the lake, and on it tower the ominous grey battlements of Glenveagh Castle.

This Celtic Elysium was purchased from the Earl of Leitrim in 1857 by Mr John Adair, who in 1870 set about building the castle, to designs prepared by his cousin, Mr I. T. Trench. Originally it was a square Gothic keep; the round tower appears to have been an afterthought. Mrs Adair was an American heiress, Cornelia Wadsworth of Geneseo, and she was a considerable hostess in her day. She entertained Queen Victoria's son, H.R.H. the Duke of Connaught, and his Duchess at Glenveagh, and Edward VII sent her over a stag from Windsor to help start the herd of deer. The early history of Glenveagh, however, was not a happy one. The murder of the Earl of Leitrim is a famous episode in the anti-landlord conflict of the last century. It is less well-known that the agent at Glenveagh was also murdered, and that in revenge, Mr Adair had his tenants evicted in merciless fashion.

In 1929, the property was purchased by Professor Arthur Kingsley Porter, the distinguished American archaeologist who was the author of numerous books on medieval art and

(Above) Glenveagh Castle (1870) and Lough Veagh, Co. Donegal

Kilshannig (1765), Co. Cork: the entrance front (see p. 77)

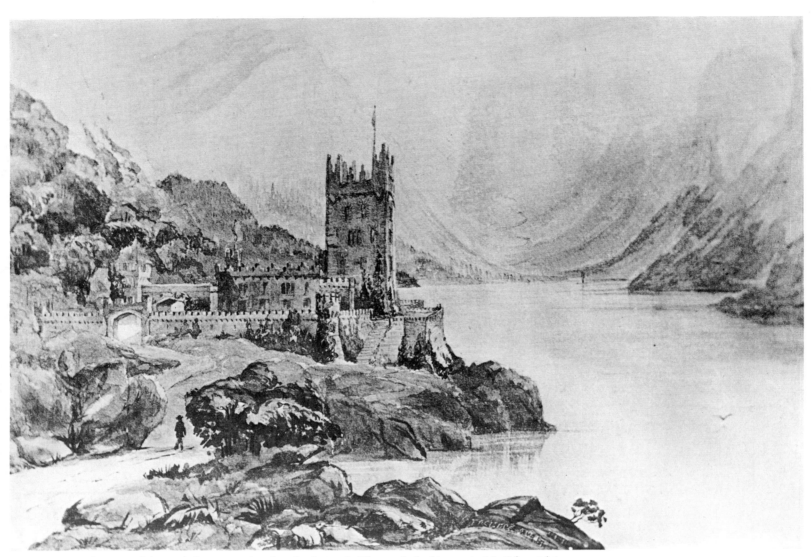

A drawing of the castle by I. T. Trench, who designed Glenveagh for his cousin Mr John Adair

architecture, and Professor of Fine Arts at Harvard University. He and his wife Lucy entertained the literary and artistic luminaries of Ireland during the short time that they owned Glenveagh. On 7 July, 1933 Mr and Mrs Kingsley Porter paid a visit to their cottage on the island of Inishbofin off the coast of Donegal. Next day, at about noon, Mr Porter went off alone for a walk – and vanished without trace. At the inquest he was presumed to have slipped off a rock and drowned, but the enigma of his disappearance, heightened by the inevitable rumours that he had been seen in Paris and elsewhere, is still spoken of in whispers by the local people. Three years later a professor from Princeton, Peter Teigen, died in the 'haunted room' at Glenveagh, because as a Christian Scientist he had refused medical care. Mrs Kingsley Porter had to attend yet a third inquest the following year when her car, driven by a chauffeur, killed a man on one of the many miles of private drive. It was only to be expected that she should have wished to give up Glenveagh, but its past associations might well have deterred even the most intrepid.

Mr Henry McIlhenny of Philadelphia, whose grandfather emigrated to the United States from Milford, Co. Donegal, had stayed at Glenveagh in 1936 and rented it from Mrs Porter

Steps up the hillside-leading nowhere

in 1937. The following year he purchased the estate, and in doing so he became the third American to hold sway over that remote pocket kingdom. Indeed the local post office is by now so accustomed to American ways that recently a telegram addressed to Cambridge was sent (mistakenly) to Cambridge, Massachusetts. Despite his commitments in Philadelphia, where he was for thirty years Curator of Decorative Arts at the Museum of which he is now Vice-President, Mr McIlhenny could not possibly have lavished more love and care on the property. He has made Glenveagh into an oasis of civilization, a byword of hospitality and feudal comfort.

Rare and exotic plants are able to thrive there in the shelter of rocks and trees, as the hillside above the castle faces towards the sun. The soil is particularly suited to rhododendrons and in early June they are almost overpowering in their splendour. *Lady Alice Fitzwilliam, fragrantissimum, falconeri* – some grown now to a height of thirty feet – exude an unforgettable fragrance which mingles with that of the azaleas planted round their feet. A flight of a hundred steps leads up the hillside to a vantage point high above the battlements. Down below there is a *jardin potager,* where ordinary vegetables are planted in rows to the best possible effect. The elegant Gothic greenhouse was designed by M. Philippe Jullian. The statue garden, the rose garden, the wild garden – all have been created by Mr McIlhenny since the Second World War, with the advice and help of Mr Jim Russell and Mr Lanning Roper.

The Gothic greenhouse designed by Philippe Jullian

'The Honeymoon' by Ansdell hangs in the drawing-room

Ground-plan of Glenveagh

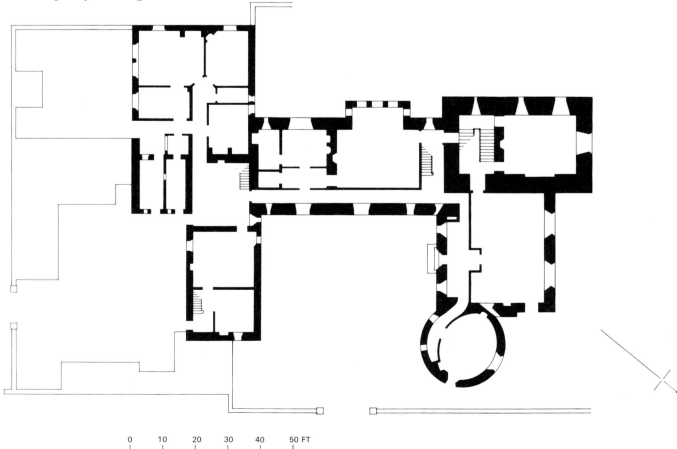

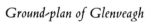
0 10 20 30 40 50 FT

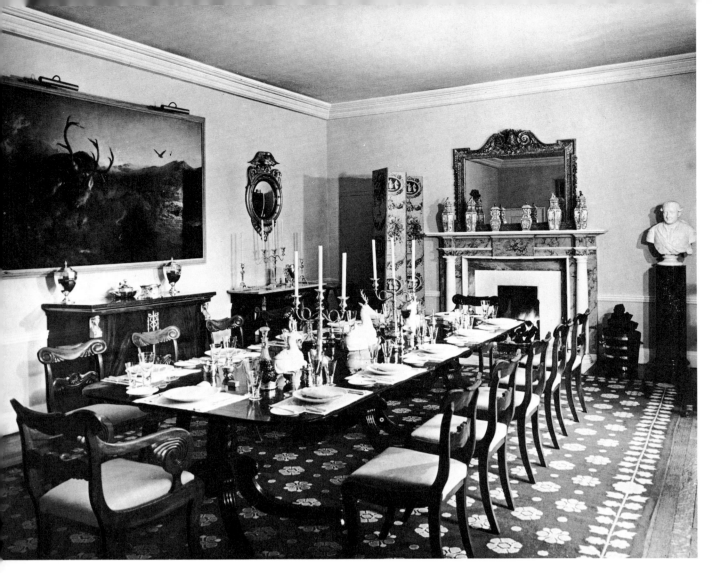

The dining-room. 'Evening' by Landseer hangs on the left

The sitting-room

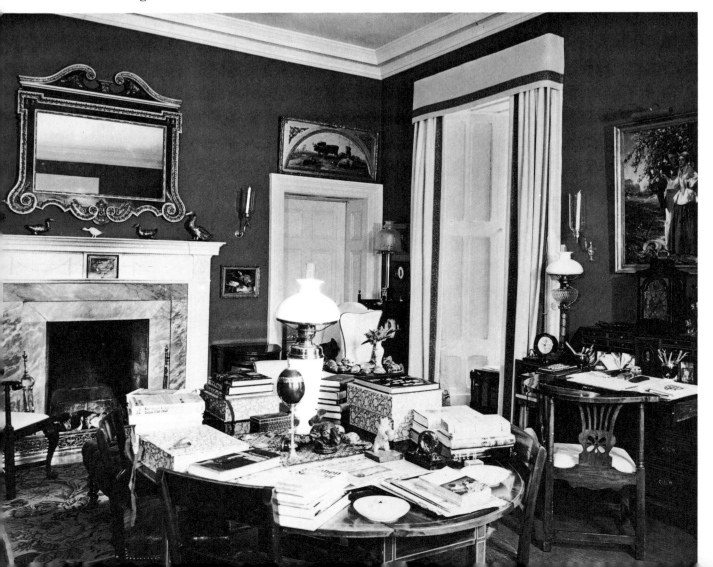

Shell decoration in the vestibule

Between 800 and 900 red deer wander the mountainside at Glenveagh, and to control the numbers about 150 of them are slaughtered every year. They are hung in the game larder which like all the outbuildings is castellated, its doors painted a startling Tuscan green, the estate colour. The keepers wear a tweed that has been specially designed and woven for them in the locality. Antlers are everywhere.

Although the rugged blocks of rough-hewn granite of which the castle is built lend it a forbidding aspect, nothing could in fact be more comfortable and welcoming than Glenveagh. Mr McIlhenny has furnished it in an original but singularly appropriate manner. It is the antithesis of his house in Philadelphia where the art collection includes works by Van Gogh, Degas and Lautrec. At Glenveagh there are paintings by Landseer, Ansdell, Buckner and Æ (George Russell), the Irish writer who is also remembered for his paintings of the faery world. There is some superb eighteenth-century Irish furniture, with Victoriana for light relief. Electricity has only recently been installed; time was when the only light was from oil lamps and candles. Turf fires blaze in every grate, reflected in the plate-glass windows with their rounded heads and polished brass fittings, faintly reminiscent of a Victorian railway carriage.

The day that Mr McIlhenny chanced to go there on a visit, years ago, when he was a young man and still at Harvard, was indeed an auspicious one for Glenveagh.

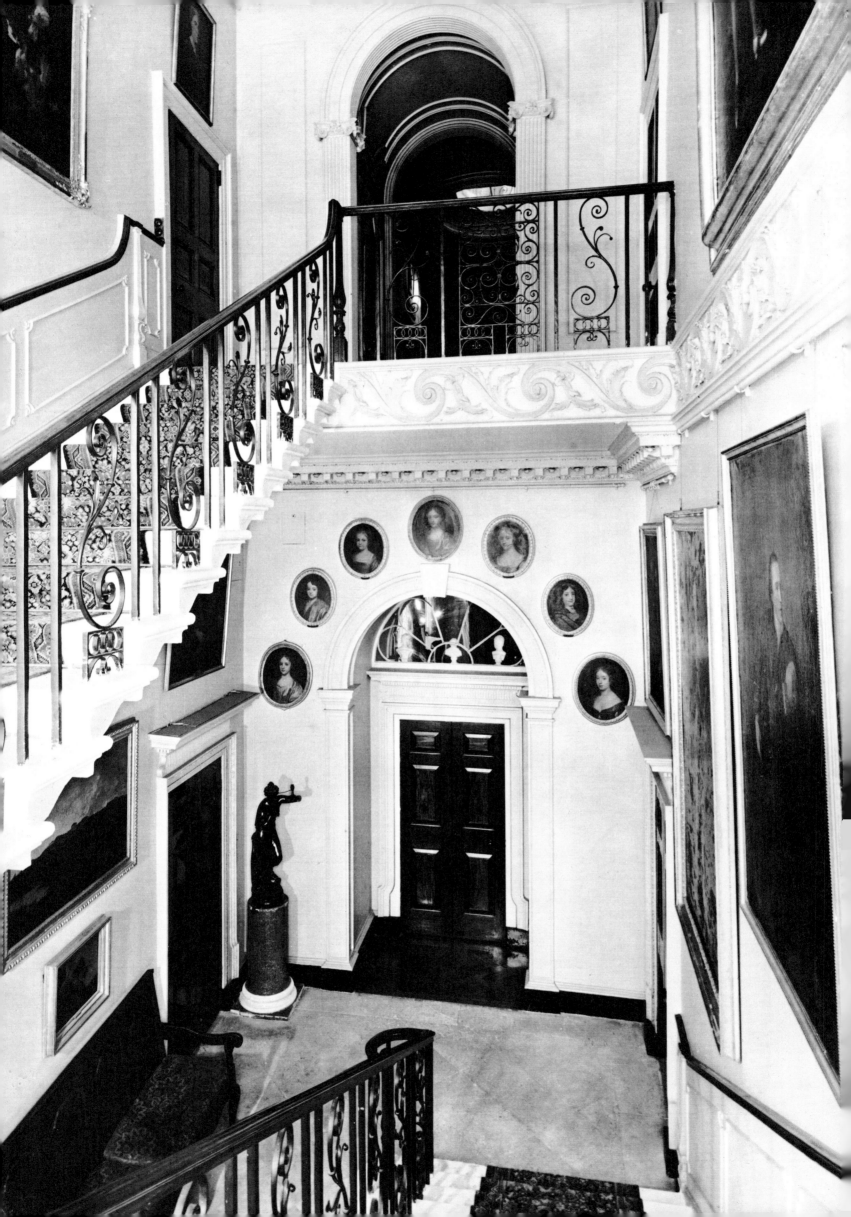

CASTLEWARD

STRANGFORD, COUNTY DOWN

Viscount and Viscountess Bangor

The National Trust (Committee for Northern Ireland)

THE EXISTING HOUSE at Castleward dates from 1765, but the land on which it is built had belonged to the Ward family since 1570. It was purchased in that year by Sir Robert Ward, Surveyor-General of Ireland in the reign of Queen Elizabeth, from the Earl of Kildare. The family prospered, and by judicious marriages increased their estates and consequently their influence in the county.

Michael Ward of Castleward was M.P. for County Down in 1715 and sat for many years as a Justice of the Court of the King's Bench in Ireland. He married an heiress, Anne Hamilton, whose Bangor estates, as well as the pocket borough, came into his possession after the death of her mother. They must have built the house that preceded the existing one, but of this earlier house no trace remains apart from the outline of its formal garden and 'cannall', now known as the Temple Water. Harris refers to it in his *Ancient and Present State of County Down*, 1744, as 'a large and handsome improvement of Mr Justice Ward'. The Judge died in 1759 and the estates came into the possession of his only son, Bernard Ward, M.P. for County Down from 1745 until 1770 when he was raised to the peerage as Baron Bangor, being advanced to the dignity of Viscount in the year of his death, 1781. He married the daughter of the first Earl of Darnley, Lady Anne Bligh, who had already been married to Robert Hawkins-Magill of Gill Hall, Co. Down, by whom she had one daughter, Theodosia.

In 1760, just after they had inherited the property, Mr Bernard and Lady Anne Ward received Dr Delany and his wife, on one of their rare visits to his Deanery in County Down. Mrs Delany, the celebrated eighteenth-century commentator, describes it as 'altogether one of the finest places I ever saw'. It was not long, however, before the Wards decided to rebuild. In 1763 Mrs Delany writes: 'Mr Ward is building a fine house, but the scene about is so uncommonly fine it is a pity it should not be judiciously laid out. He wants taste, and Lady Anne is so whimsical that I doubt her judgment. If they do not do too much they can't spoil the place, for it hath every advantage from nature that can be desired.'

Castleward: Staircase with wrought-iron balustrades

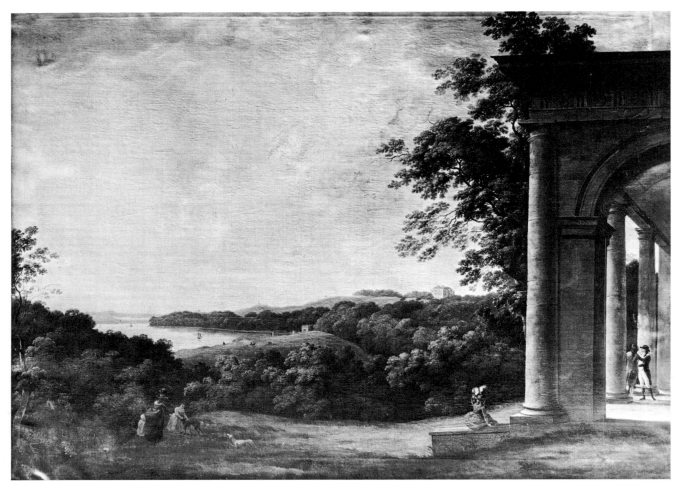

'The Temple at Castleward' by William Ashford. The National Trust has recently restored the temple. (Coll. Viscount Bangor)

The whimsicality of Lady Anne resulted in one of the strangest architectural compromises ever perpetrated. Like many husbands and wives faced with the same problem, they could not agree on a design for their new house. Mr Ward had set his mind on a plain, sober, classical house, but his wife was more adventurous – she wanted something in the Gothic taste in the manner of Walpole's Strawberry Hill, completed about ten years previous, and all the rage in London. Her whims could not be entirely disregarded, particularly as she had brought Mr Ward a handsome dowry. The dispute was settled, and the result is a house that is classical on one side and Gothic on the other. Suitably enough, the Gothic windows face north. The interior of the house reflects their opposing tastes; on 'his' side of the house the rooms have classical decoration and on 'her' side they are Gothic, even down to the marble mantels.

The architect is unknown, and was probably English as there are no particularly Irish characteristics at Castleward, apart from the eccentricity of the whole idea, which can hardly be laid at the door of the architect. Capability Brown and Carr of York have been put forward as possible candidates for the design, and Dr Mark Girouard (*Country Life*, 23 Nov., 61) has suggested that one of two Bristol architects, James Bridges and Thomas Paty, might have been responsible. The Bath stone with which the house is faced was shipped

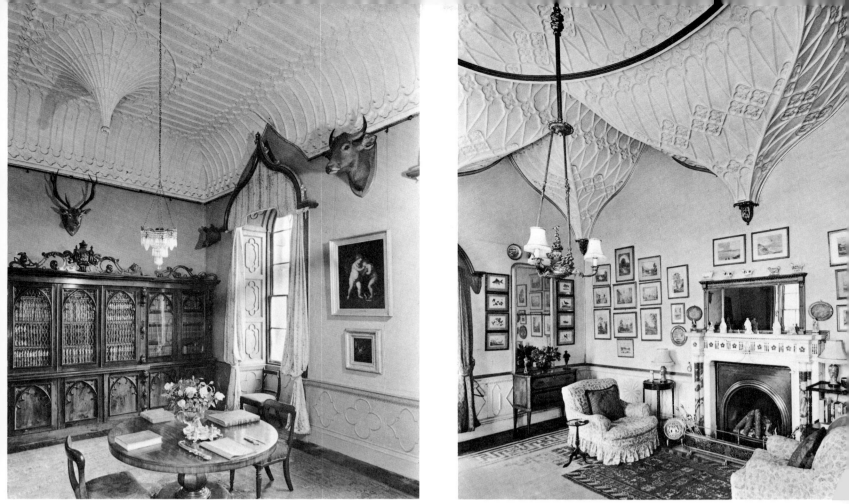

Two Gothic rooms; the library (left) and the sitting-room (right)

from Bristol in Mr Ward's own ships, which transported lead from a nearby mine as ballast on the outward journey.

Sir James Caldwell of Castle Caldwell, Co. Fermanagh, wrote an entertaining account of a visit to Castleward in 1772 (*The Bagshawes of Ford,* by W. H. G. Bagshawe):

Monday, 12th October, 1772. – A little before dinner I got to Castle Ward, Lord Bangor received me with great cordiality, brought me into his room, and signed the address with great willingness; he also asked me to dine and stay all night. This was the greater compli-ment, as his house was full of company, and not quite finished. There was an excellent dinner, stewed trout at the head, chine of beef at the foot, soup in the middle, a little pie at each side, and four trifling things at the corners, just as you saw at Mr Adderley's.

This is the style of all the dinners I have seen, and the second course of nine dishes made out much in the same way. The cloth was taken away, and then the fruit – a pineapple, not good; a small plate of peaches, grapes and figs (but a few), and the rest, pears and applies. No plates or knives given about; we were served in queen ware ... During dinner two French horns of Lady Clanwilliam's played very fairly in the hall next to the parlour, which had a good effect.

* * *

I had time to ride about the improvements, and see the house. It is, I believe, the finest place in this kingdom. The front of the house is 95 feet by 60, all built of Bath stone, brought from Bath to Bristol, and from thence in his own ships. The house consists of an area (basement) and three stories, the pediment supported by four pillars of the Corinthian [Roman Ionic] order. The house from the area to the first story is of blocked hewn stone, and the rest plain, but jointed so as to seem one piece. The windows, highly ornamented with architraves of curious workmanship, and enriched by balustrades under each window; the top of the house is also balustraded and ornamented with Bath urns. The back front, also of Bath stone, is in the Gothic style of architecture. You enter by a magnificent door-case into the hall, which is a room 40 feet by 30, and 18 high. In the middle there are two grand pillars, and the floor all inlaid with oak and mahogany, and diced and kept so smooth with rubbing and beeswax that you are in danger of slipping every moment. From the middle of this salle, or hall, you enter the saloon, a room of 34 feet by 28, and 18 high, fitted out in the Gothic taste. The eating parlour at one end of the salle, 25 feet by 18, is quite too small for such a house, and the rooms at the other end quite small. No pictures or glasses suitable to the place. The view from the windows very fine. A great extensive lawn sloping down from the house; beyond that, through vistas of trees, an arm of the sea forming itself into a river or ferry, and numbers of ships passing backwards and forwards, and the town of Portaferry in view. Beyond this arm of the sea, a very fine improved hilly country, and some ruins. This is the finest thing I have seen, though Fortescue and Sir Patrick say it is greatly inferior to Castle Caldwell.

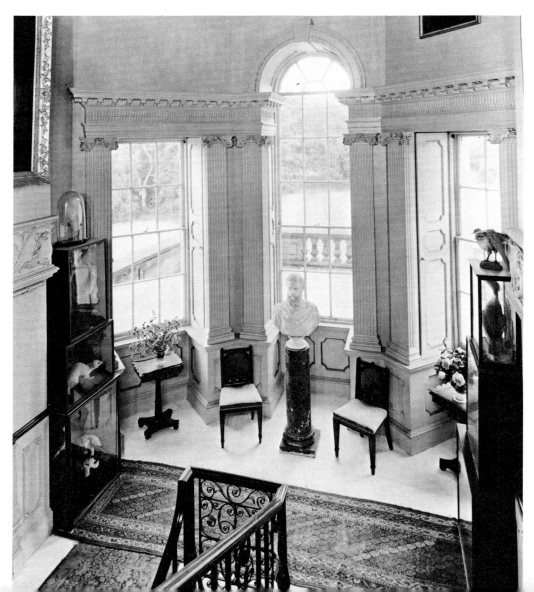

*Castleward:
Venetian window
on the staircase
landing*

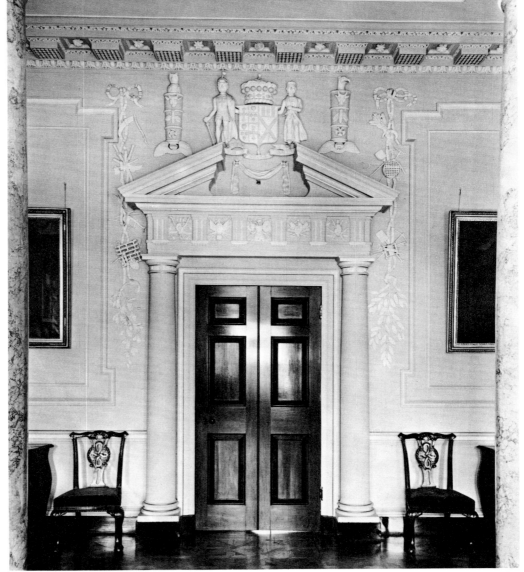

Doorway leading from the music room, originally the front hall, into the Gothic drawing-room

Mantel in the music room on the classical side of the house

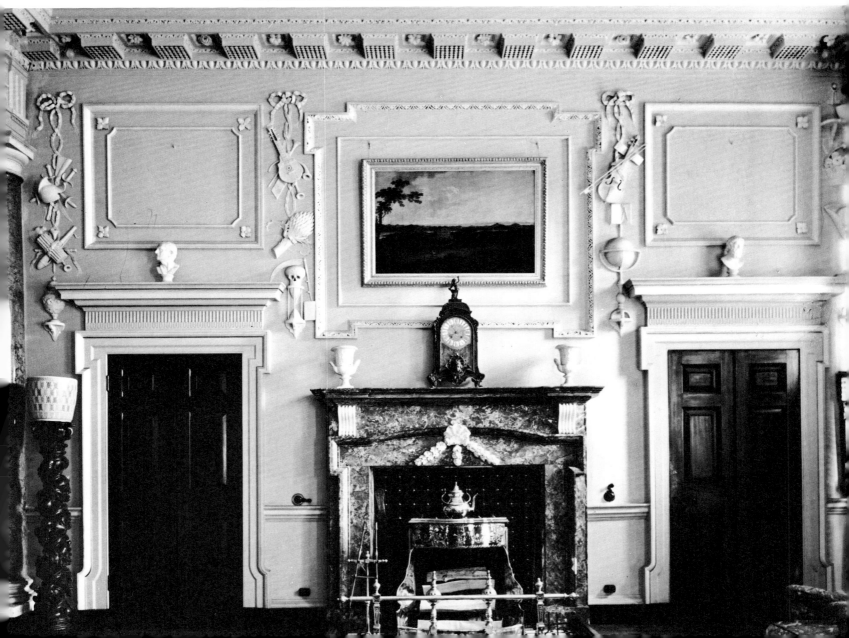

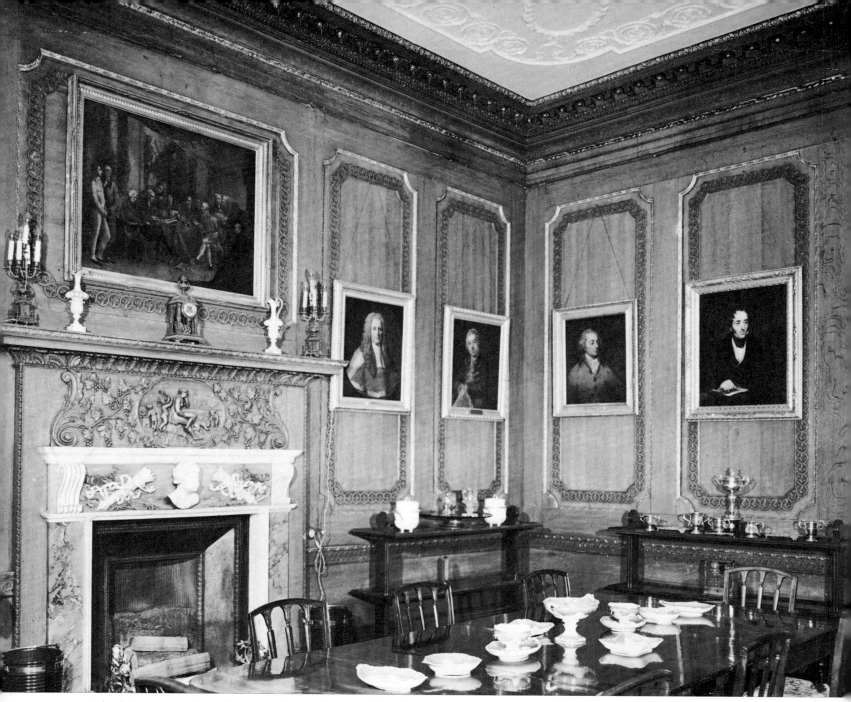

The dining-room with its plaster panels grained to resemble oak

Theodosia Magill, Lord Bangor's stepdaughter, had married Lord Clanwilliam and it was she who provided the French horn players. Perhaps this fashion – it is also referred to at Carton – was the equivalent of the bagpipes played at meals in Scotland.

The top of the house on the classical side has lost the balustrade described by Sir James, although the crenellations on the Gothic front have survived. In 1880 the front hall was turned into a music room, and a porch was added in the pentagonal bay on the east side of the house, beneath the staircase. The music-room floor appears to be a replacement. Very few houses in Ireland have a wooden hall floor; Carton, Belvedere, Charleville, and Russborough are the only other ones in this volume that do, and Carton may have had a stone flagged hall

The drawing-room in the Gothic taste

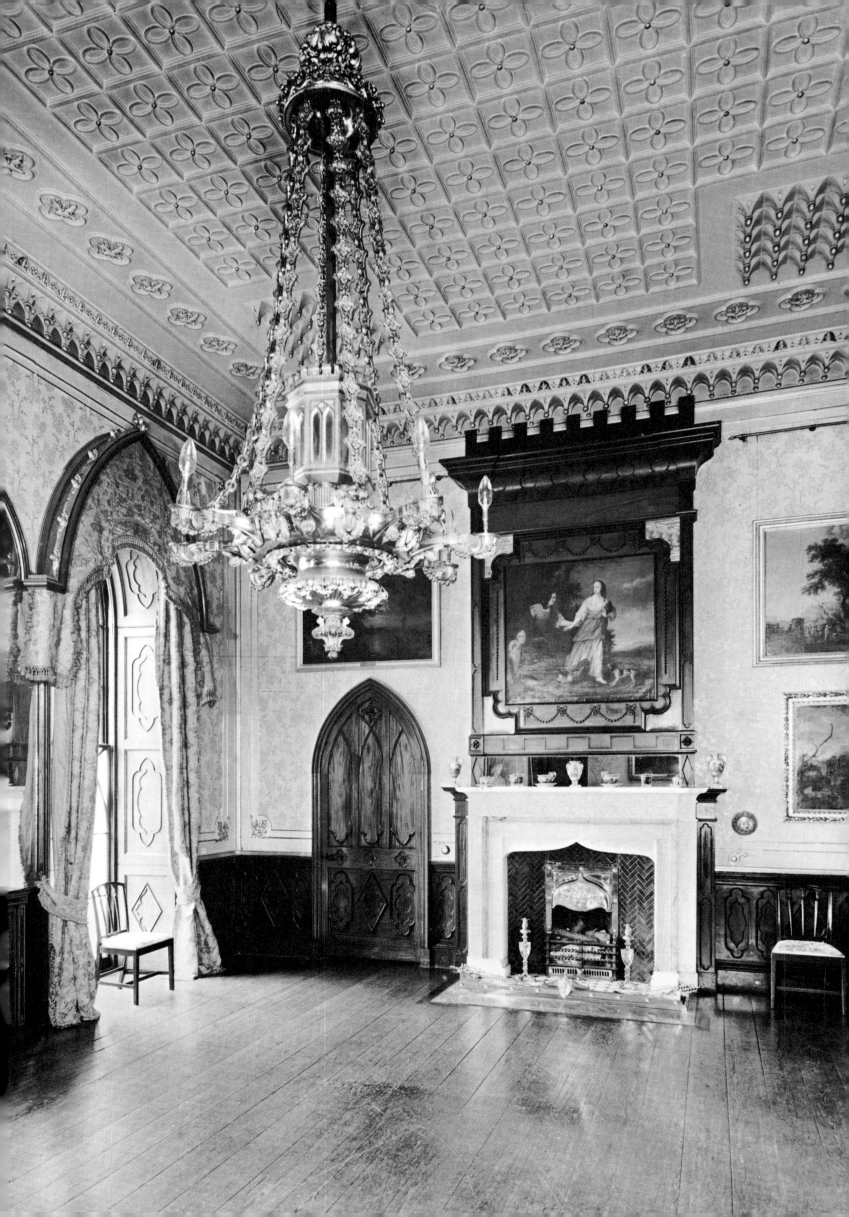

originally. It would be tempting to suppose that the floor in the music room at Castleward replaced a stone floor, if Sir James had not been at pains to describe the oak and mahogany floor and the dangers of slipping upon it.

When the sixth Viscount Bangor died in 1950 the house was given in part payment of death duties to the Government of Northern Ireland, who handed it over, with an endowment, to the National Trust. The present Viscount, the well-known writer and broadcaster, is now resident in England.

The National Trust have interesting plans for the estate. It is their intention to develop the property so that its preservation can benefit as wide a range of interests as possible. The gardens, which are at their best in the spring, are open to the public, and the house is shown to visitors. It has also been used for concerts and receptions of a suitable nature, to benefit the Trust and, at the same time, to bring the place to life. A wild-fowl collection has been established in a forty-five acre area which incorporates the old walled garden; there are ponds to encourage breeding and a predator fence to keep out foxes and the like. This is the educational display area for the Strangford Lough Wildlife Scheme.

A craft centre has been set up in the farmyard, including a pottery in the old mill. The Tower House built by Nicholas Ward in 1610 is still standing in a reasonable state of repair, and being a typical example of the sort of defensible house that was built all over Ireland in the sixteenth and seventeenth centuries, it is of great importance that it should be preserved. Its rugged simplicity makes the perfect foil for the sophistication of the eighteenth-century house.

Ground-plan of Castleward

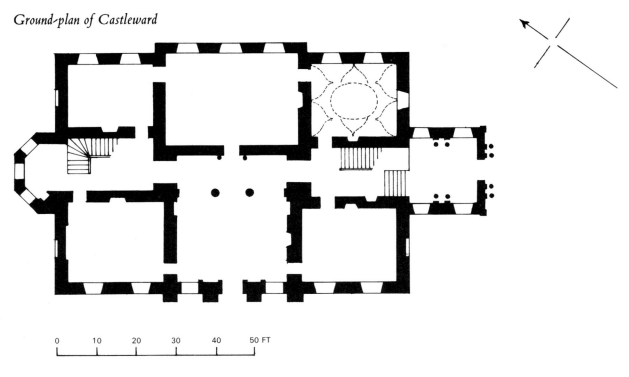

Castleward (1760),
Co. Down: the
classical front (above)
and the Gothic front

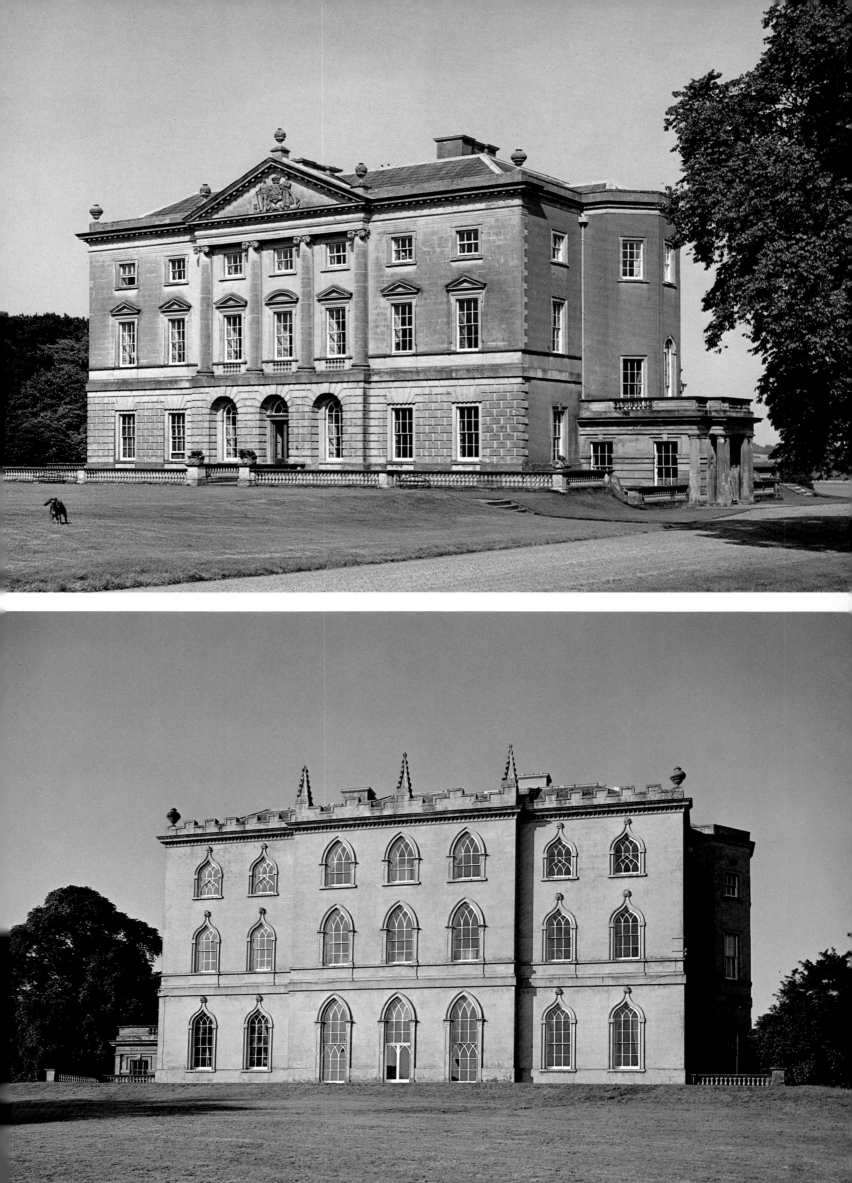

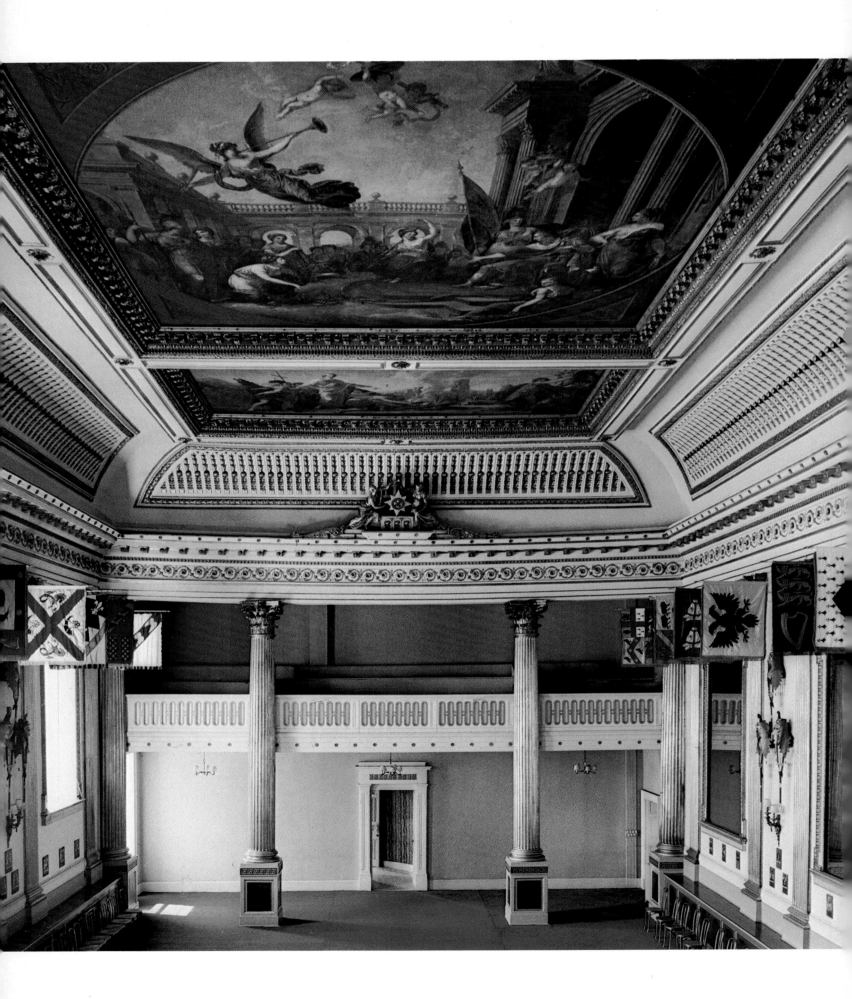

DUBLIN CASTLE

DUBLIN

The State Apartments

DUBLIN CASTLE occupies a commanding site south of the River Liffey where, it is believed, a Danish fortress once stood. The Royal mandate for the building of the Castle was issued by King John on 30 August, 1204, in the sixth year of his reign, and Henry de Loundres, Archbishop of Dublin, is said to have completed the work about 1220. The fourteenth-century Bermingham Tower in the south-west corner and the wall running east from it, beneath St Patrick's Hall, are the only vestiges of the Norman building, though the Georgian façades of the upper yard follow approximately the outline of the old fortress.

Surprisingly, Dublin Castle has had a comparatively uneventful history. The Lords Deputy and Lords Lieutenant of Ireland resided here and State councils and sometimes Parliament and Law Courts would meet here but various plans to attack it were either betrayed or abandoned; it successfully withstood the siege of 'Silken' Thomas FitzGerald in 1534. Its present air of tranquility does not suggest that for 700 years the castle was the centre of English authority in Ireland.

Thomas Phillips was sent to Ireland to survey its fortifications and reported 'the Castle or Chief Seat of the Government being all in Rubbish by the late Fire [1684] and when in Perfection not capable of securing his Majesties' Stores of War without greet hazard of being destroyed by fire, it being so pestered up with houses and other offices.' He recommended that the powder magazine should be separate from the castle, and it was accordingly put in the Phoenix Park. The castle was restored, presumably according to the designs of Sir William Robinson, Surveyor-General; his arcades there are similar to those at Kilmainham, and his design was faithfully adhered to at the time of the rebuilding in the eighteenth century. In fact the existing arcades may well be seventeenth-century, with a Georgian brick wall on top.

Dublin Castle: St Patrick's Hall. The ceiling was painted by Vincent Waldré in 1778

The Office of Arms, now the Genealogical Office, is the most interesting feature of the Upper Yard; the design is borrowed from Lord Herbert's Villa at Twickenham but the date and architect are not known. It is first seen on an engraving by Tudor dated 1752.

Dublin Castle in 1728, from Brooking's Map of Dublin

St Patrick's Hall. Lord Temple, later the Marquess of Buckingham, founding the Order of St Patrick in 1783. The order was modelled on the Order of the Bath (cf the Reynolds portrait of the Earl of Bellamont in the robes of that order, page 44)

The Courtyard, Dublin Castle, from an aquatint by James Malton

Visitors to the Heraldic Museum on the ground floor will be shown the spot where the safe stood that contained the Irish Crown Jewels, which were stolen at the time of King Edward VII's visit in 1907 and have never been traced. The thick stone core of the building is one of the original twin gate towers of the Castle, and it carries the Bedford Tower with its elegant green cupola. The Military Band used to play at parades from behind the pillars in the gallery on the upper floor. The building is flanked by triumphal arches, carrying lead statues of Justice and Fortitude by Van Nost – the authorities are said to have pierced holes in Justice's scales, for when it rained they would tip off balance, inciting sardonic comments on 'British Justice' from the populace.

Facing the Genealogical Office are the State Apartments where once the Viceregal Court was held. The apartments, recently completely restored, are now used for the reception of foreign dignitaries and for the installation of the President of the Irish Republic.

St Patrick's Hall is approached by the Grand Staircase which itself dates from the nineteenth century. When Viceroy, the Marquess of Buckingham commissioned the artist Vincent Waldré, who had already worked for him at Stowe, to paint the immense ceiling (1778). In the centre panel George III is supported by Liberty and Justice. At one end Henry II receives the submission of the Irish chieftains and at the other St Patrick is seen converting the Druids. This magnificent room, now used for the inauguration of the Presidents, was formerly the State Ballroom. After the disestablishment of the Church of Ireland in 1869 it became the place of investiture of the Knights of St Patrick, an order which since 1922 has been allowed to lapse. At the present time it is only held by the Royal Dukes of Windsor and Gloucester. At one end is a musicians' gallery, at the other a gallery for spectators, while the banners and armorial bearings of the Knights of St Patrick decorate the walls.

In the early eighteenth century the Beefeaters' Hall was used for court entertainment: Mrs Delany refers to it twice.

. . . on Monday at eight o'clock went to the Castle. The room where the ball was to be was ordered by Capt. Pierce finely adorned with paintings and obelisks, and made as light as a summer's day. I never saw more company on one place; abundance of finery, and indeed many very pretty women. There were two rooms for dancing. The whole apartment of the Castle was open, which consists of several very good rooms; in one there was a supper ordered after the manner of that at the masquerade, where everybody went at what hour they liked best, and vast profusion of meat and drink, which you may be sure has *gained the hearts* of all guzzlers! The Duke and Duchess broke through their reserved way and were very obliging; indeed it was very handsome the whole entertainment, but attended with great crowding and confusion.

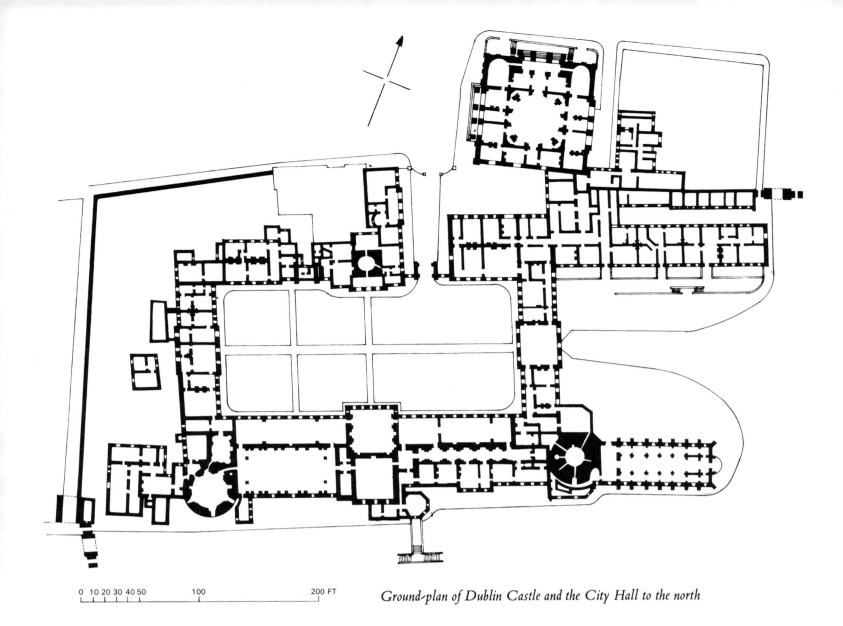

Ground-plan of Dublin Castle and the City Hall to the north

The ball was in the old beef-eaters hall, a room that holds seven hundred people seated, it was well it did, for never did I behold a greater crowd. We were all placed in rows, one above another, so much raised that the last row almost *touched the ceiling!* The gentlemen say we looked very handsome, and compared us to Cupid's Paradise in the puppet-show. At eleven o'clock minuets were finished, and the Duchess went to the bassett table.

The Supper Room, within the old Bermingham Tower, is approached by a curved passage-way. This round room with Gothic tracery plasterwork probably dates from the 1780s. In 1911, when King George V and Queen Mary visited Ireland, the State Dining-Room was added. This is approached through the oval Wedgwood Room with its Phoenix carpet designed by Raymond McGrath. A long, panelled gallery facing the courtyard and lined with portraits of the Viceroys, leads to the Throne Room. This room probably dates from the 1780s though Francis Johnston was probably responsible for the insertion of the mantels and doors about 1800. Restoration of this elegant white and gold chamber has been particularly sensitive, while that of the reconstructed Victorian drawing-room in the part of the castle

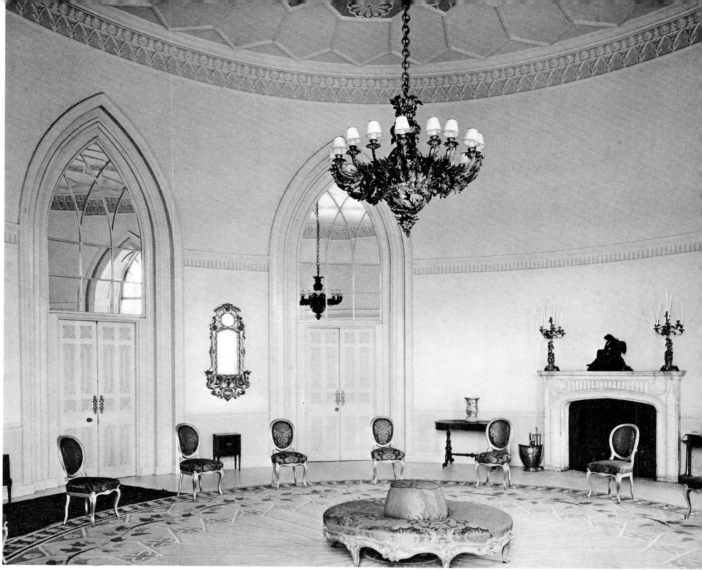

The Supper Room (c. 1780) in the Bermingham Tower

The Throne Room or Presence Chamber, formerly known as Battle-axe Hall

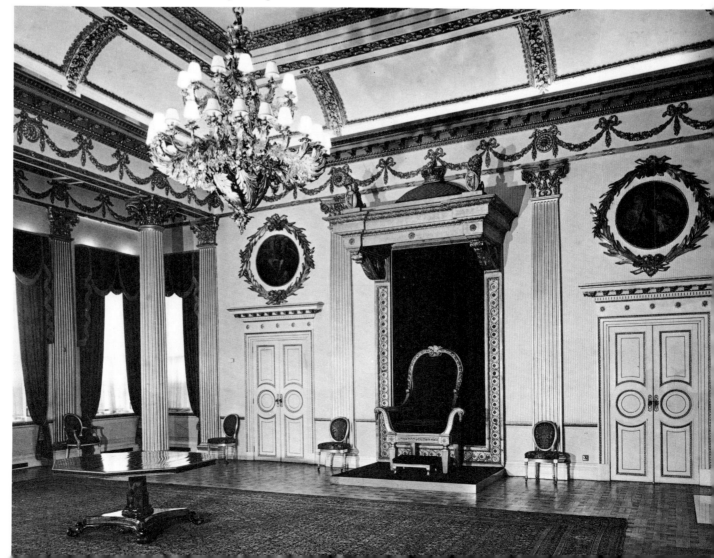

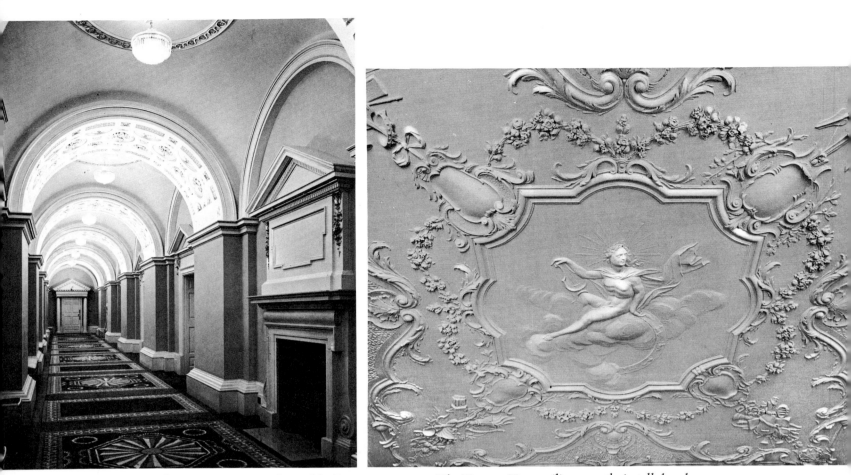

Corridor in the State Apartments designed by Pearce, originally lit by lunette windows in each bay which were blocked up when a storey was added

The Tracton House ceiling, recently installed, and originally in No. 40 St Stephen's Green, Dublin, a house that has been demolished

destroyed by fire in 1941 has been much less successful. From it one reaches the fine, unlighted corridor designed by Sir Edward Lovett Pearce (the 'Pierce' referred to in the letter of Mrs Delany already quoted), Surveyor-General in 1730. Originally, each section of the corridor was lighted from above until an addition storey was put on in the nineteenth century. A similar corridor is to be found in Pearce's Parliament House (Bank of Ireland, Dublin).

Dublin Castle has become the home of some fine examples of stuccowork. The Tracton House ceiling from 40 St Stephen's Green has found a home in a room at the far end of the Pearce corridor. The stuccodore is unknown but the work carries the date 1746, and is decorated with the trophies of Science, Art, War and the Chase. Apollo with his lyre, seated on clouds, dominates the scene. A ceiling removed from Mespil House and dating from 1751 has been put in a room on the Pearce corridor. This ceiling and another from Mespil House, now in Aras an Uachtaráin, have been attributed to Cuvilliés, an artist and sculptor then working in Dublin. That in Dublin Castle depicts Medicine with the Arts, and Science and Minerva introducing the Arts to Hibernia. Dublin Castle makes an ideal home for this example of the stuccodore's craft, which can be seen by all who visit the State Apartments, now open to the public.

ARAS AN UACHTARÁIN

(Formerly the Viceregal Lodge)

PHOENIX PARK, DUBLIN

The President of Ireland

THE VAST EXPANSE OF GREEN which extends to the west of Dublin, bounded on the south by the River Liffey, is known as the Phoenix Park. Its name probably derives from the Gaelic *Fionn-Uisce* (Bright Waters), from a spring located in the parkland – the English christened it Phoenix and the bird rising from the ashes has become the symbol not only of the park, but of the new Ireland herself, the 'harp restrung'.

A priory and hospital of the Knights of St John of Jerusalem was founded here by Strongbow before 1176. In Tudor times the priory and its lands were taken by the Crown; in 1662 they were designated a royal deer park. Charles II wanted to give this valuable estate to his mistress Barbara Villiers (Lady Castlemaine), but owing to strong local opposition it was presented to the City of Dublin, and has been the preserve of her citizens from that time. In 1669 a hospital for old and disabled soldiers was built on a part of the land to the south of the Liffey, and the great seventeenth-century quadrangle of the Royal Hospital, Kilmainham, dominates the skyline south of the river to this day.

Within the Phoenix Park there are other, smaller parks like islands in the sea. The American Embassy was formerly the lodge of the Chief Secretary, who held the key position in the British administration. The Under-Secretary's lodge is now the residence of the Papal Nuncio, an indication of the deep ties that Ireland has with America and Rome; both of these lodges have the privacy of their own parks. The largest demesne within the park is that of Aras An Uachtaráin, the official residence of the President of Ireland. It was formerly the summer residence of the English Viceroy who held court in winter at Dublin Castle, but before it became the Viceregal Lodge the house was privately owned.

The royal deerpark was under the direction of the Ranger and Master of the Game, an appointment of some social and political standing. In 1751, the office was given to one Nathaniel Clements, who was then rising rapidly in power and position under the patronage of Luke Gardiner, the Deputy Vice-Treasurer and Deputy Paymaster of Ireland. In 1755 Clements succeeded Gardiner and, as Mrs Delany writes, 'gathered together by degrees an immense fortune'.

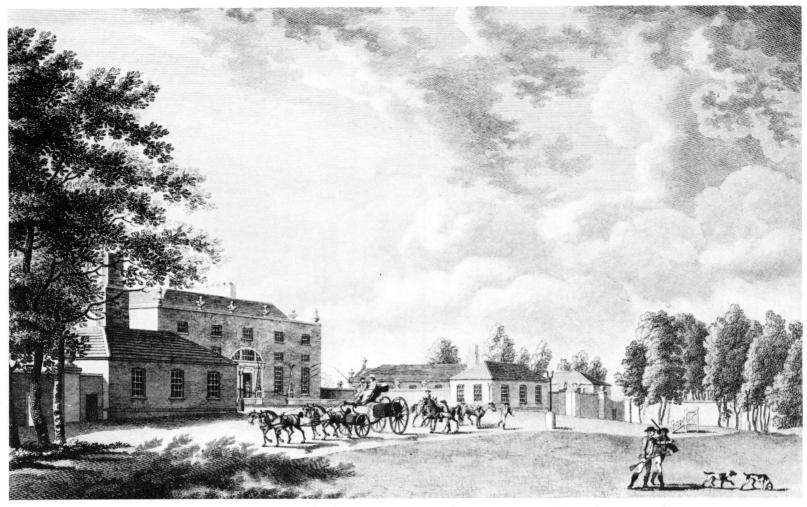

Phoenix Lodge, the house designed by Nathaniel Clements in 1751 as published by Thomas Milton in his Views of
Seats, *1783*

For many years Clements had been involved with Gardiner in the development of Georgian
Dublin, and employed or worked with Edward Lovett Pearce and Richard Castle, both as
a contractor and as a fellow architect. As Ranger of the Park, Clements designed and built
a new residence for himself in 1751–2. Thomas Milton described it in his *Views of Seats* in
1783 thus: 'It is nothing more than a neat, plain brick building, and the rooms within are
conveniently disposed.' The brick façade was indeed plain, its major ornament being a
semi-circular 'therme' window over the entrance and the row of urns that surmount the
parapet in his engraving. Curved curtain walls extend forward at either side in the Palladian
manner, terminating in single-storey wings.

In 1782 the Phoenix Park Lodge, as it was then called, was purchased as an 'occasional
residence' for the Lord Lieutenant, and greatly enlarged. Michael Stapleton, the architect,
who is principally remembered as a stuccodore, is known to have worked on the building in
1787. The wings were raised a storey, a Doric porch was added to the entrance front on the
north side in 1808, obscuring the handsome demi-lune window. Seven years later the house
was extended to the east and west by Francis Johnston who also added the Ionic portico on
the south or garden front which can be seen from the main thoroughfare that crosses the park.

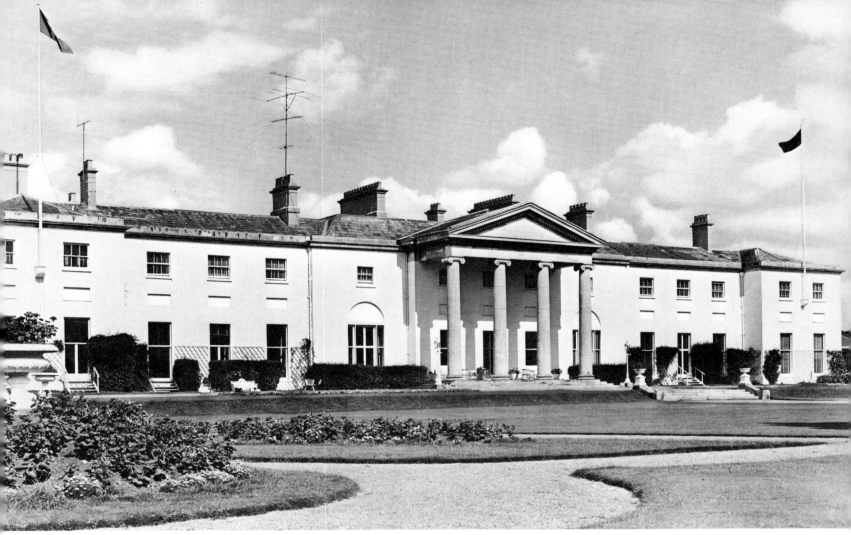

The garden front with its Ionic portico, added by Francis Johnston in 1815

The Phoenix Column beside the gates of Aras an Uachtaráin. It was erected in 1744 by the Viceroy, the Earl of Chesterfield

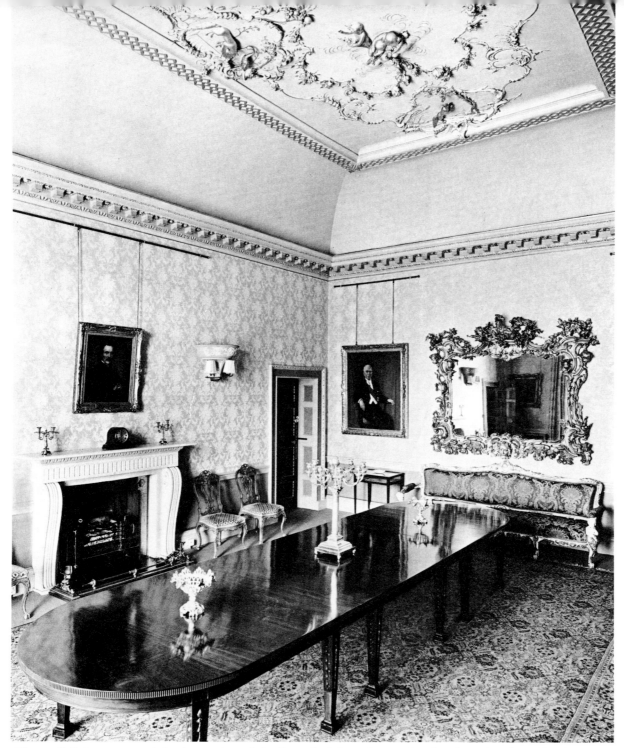

The small dining-room, used for the meetings of the Council of State, has a ceiling based on Aesop's Fables that is original to the house. The ornate Irish mirror and sofa were formerly at Russborough, and are a part of the Miltown Bequest to the National Gallery, Dublin. (Below) Ground-plan of the eighteenth-century core of Áras an Uachtaráin.

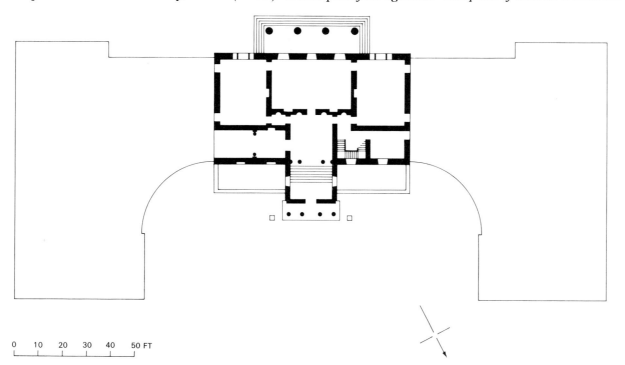

0 10 20 30 40 50 FT

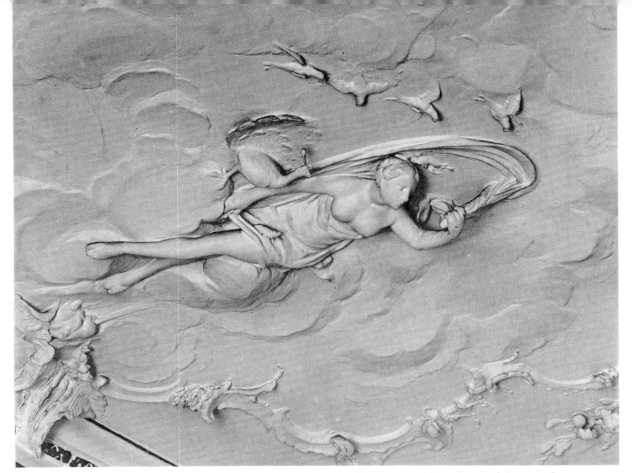

'Air', a detail of the Four Elements ceiling brought here from Mespil House, Dublin, a house of the same date as Phoenix Lodge

On a fine day the stark white portico in its frame of green looks like nothing more than some tropical outpost in the South Seas. Johnston also designed new gates and lodges. At about this time the red brick walls of the Clements house were plastered over. In 1840, Decimus Burton laid out the formal garden and several of the park lodges were designed by him at the same time. The south front was further extended for Queen Victoria's visit in 1849.

After Ireland gained her independence in 1922, the Viceregal Lodge became the residence of the Governor General, and now that the Republic is established it is occupied by the President – 'Aras an Uachtaráin' means literally 'The House of the President'.

Various alterations and improvements have been made of recent years. In 1946–7 the west wing was reconstructed and the house began to take on its present appearance under the supervision of Raymond McGrath, chief State architect, from 1952 onwards. In that year, thanks to the concern of Dr C. P. Curran, the authority on Irish plasterwork and life-long friend of President Sean T. O'Kelly, one of the finest plaster ceilings in Ireland was installed in the President's reception room. It was brought from Mespil House, Dublin, which was demolished by the Pembroke estate to make way for modern flats at that time. It represents 'Jupiter and the Four Elements'. The artist is unknown, but may have been Cuvilliés, a wood-carver whose name appears as an exhibitor of drawings at the Society of Artists, Dublin, in the 1760s. His namesake was the famous Munich stuccodore of the 1730s and it is such an unusual name that it is tempting to jump to conclusions. His work here loses

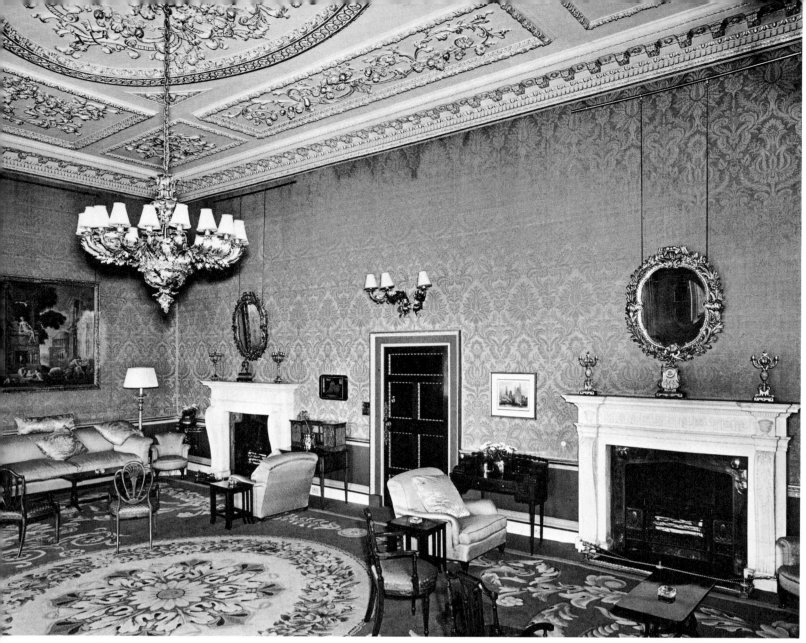

The drawing-room, on axis to the front door. The ceiling is original (1751) and is echoed in the modern Donegal carpet. (Right) The State drawing-room and dining-room beyond. The Donegal carpet, designed by Raymond

somewhat from being in a room with a ceiling about six feet too high for it, but the importance of its rescue far outweighs such considerations.

In 1955, again on the initiative of Dr Curran, moulds were taken from the plaster panels and ceiling of the dining-room at Riverstown House, Co. Cork, (the future of the building then being uncertain) and facsimiles erected here. Riverstown has since been restored and opened to the public by the Irish Georgian Society (see introduction under plasterwork). It is situated about four miles on the Dublin side of Cork City, near the village of Glanmire.

It was originally intended to remove the actual plasterwork, but the decoration on the walls was found to be bedded in the brickwork, so that moulds were taken instead. Riverstown was probably the earliest work in Ireland of the celebrated Italian stuccodores Paul and Philip Francini, whose example had such a happy influence on the native exponents of the art. The elegant, if somewhat rigid wall panels contain figures taken from Greek and Roman

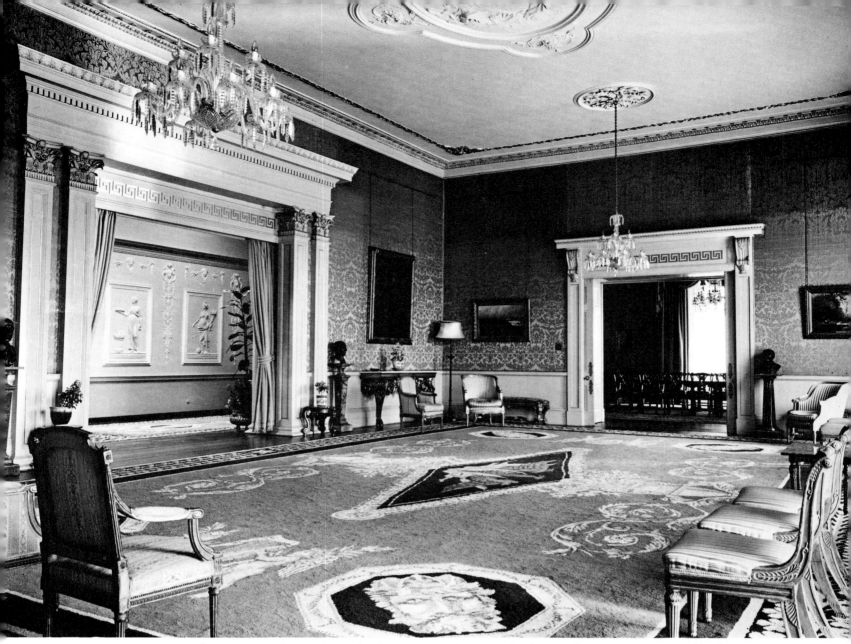

McGrath, incorporates the carved stone heads representing the rivers of Ireland on the Custom House, Dublin, known as the Riverine Heads. Copies of the plasterwork at Riverstown, Co. Cork, can be seen on the ceiling and in the corridor

mythology. The ceiling has more life – it is a plaster transcript of an allegorical painting by Poussin, *Time rescuing Truth from the assaults of Discord and Envy* (Louvre). The copies at Aras an Uachtaráin have been divided between the State drawing-room, where the President receives diplomatic envoys, and a passageway. The Riverstown ceiling looks like a postage stamp in the centre of this vast Victorian room, but the flying horseman looks very well over the mantel. It would of course have been infinitely preferable to have kept all the Riverstown plasterwork in one room of the right proportions.

The many associations linking the Rev. Dr Jemmett Browne, Bishop of Cork and the builder of Riverstown House, Dr Edward Barry, builder of Mespil House, and Nathaniel Clements make the transplant here of the finest elements of the other two houses particularly appropriate. All three houses are of approximately equal date, and they all reflect the developing will to 'improve' Irish architecture and taste.

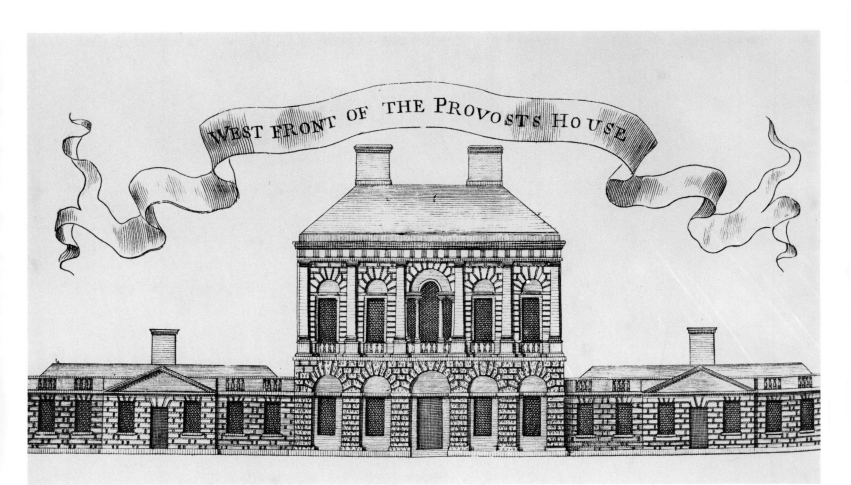

Late eighteenth-century engraving of the Provost's House. (Below) Ground-plan of the central block of the Provost's House

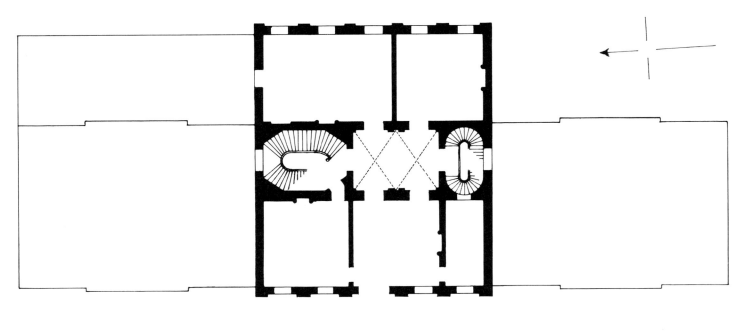

0 10 20 30 40 50 FT

THE PROVOST'S HOUSE

TRINITY COLLEGE, DUBLIN

The Provost of Trinity

THE POET Lord Dunsany wrote of Dublin, 'It is easy to see that a great race has passed through it.' The Anglo-Irish, for all their shortcomings, left the Ireland of today with a capital handsomely endowed with eighteenth-century buildings. There are the Four Courts and the Customs House beside the river Liffey, and the Parliament House which now houses the Bank of Ireland and faces Trinity College, the seat of Dublin University. The town houses of the nobility and gentry were also built on a lavish scale, enlivened with elaborate stucco according to the taste of the period. After 1801, when the Act of Union with England brought an end to the Irish Parliament, these houses fell into other hands. It is sobering to reflect on the quantity of books, pictures, chandeliers, and furniture that they must have once contained. Offices and institutions now occupy the great reception rooms, Powerscourt House is a warehouse, Aldborough House is a Post Office store, and so on. At least it is fortunate that they have survived. Moira House and Molyneux House have gone, but almost all the great stone town mansions are still intact. The lesser Dublin houses were built in terraces of brick, un-Irish in their sober regularity, and often concealing interiors of great splendour behind their uniform façades.

Trinity College was founded in 1592 by Queen Elizabeth for the 'reformation of the barbarism of this rude people'. She wrote, 'many [Irish] have heretofore used to travel into France, Italy, and Spain, to get learning in such foreign universities, whereby they have been infected with Popery and other ill qualities, and so become evil subjects.' Trinity is to this day regarded in some quarters as a Protestant university; although it is attended by 1,400 Catholics, there is no priest appointed officially to look after their souls. Until 1970 the Catholic Archbishop of Dublin used to warn his flock of the dangers lurking here, in his Lenten Pastoral.

No trace remains of the seventeenth-century buildings. The great west front which provides the main entrance on College Green was put up between 1752 and 1758 to the designs of Keene and Sanderson. Francis Andrews was made Provost of Trinity in 1758,

and at once set about his erection of a handsome official residence for himself and his successors. The Provost's House is the only one of the great Dublin houses to have been continuously lived in, and it still serves the purpose for which it was built.

The architect was John Smyth, who took the elevation of the central block from a plate in Colen Campbell's *Vitruvius Britannicus,* published in 1727, of a house designed by Lord Burlington for General Wade in London. The design had been taken by Burlington from a drawing by Palladio in his possession, and now in the Royal Institute of British Architects. The plan is Smyth's own, as are the low-flanking wings which set off the main block to perfection. Smyth was at the time building St Thomas' Church, Marlborough Street, which was destroyed in 1922. This too was based on a design by Palladio, the Church of the Redentore in Venice, to which plan Smyth had added curved quadrants. St Catherine's, Thomas Street, which has the best façade of any church in Dublin, was also designed by Smyth, as was the Poolbeg Lighthouse.

The Provost's House was built for entertaining and the bedroom accommodation is limited, partly because it had been customary for the position of Provost to be filled by a celibate clergyman. If it has a fault, it is that the entrance hall is rather dark; the walls here are of carved wood to resemble ashlar and the mantel is stone, giving a monumental effect. The dining-room faces out over the garden to the back. It is decorated with rope plasterwork, and has a carved pine mantel stained a dark brown; most of the reception rooms have similar mantels, and there is no sign that they were painted at any stage. The parquet floors are

The Provost's House : the front hall

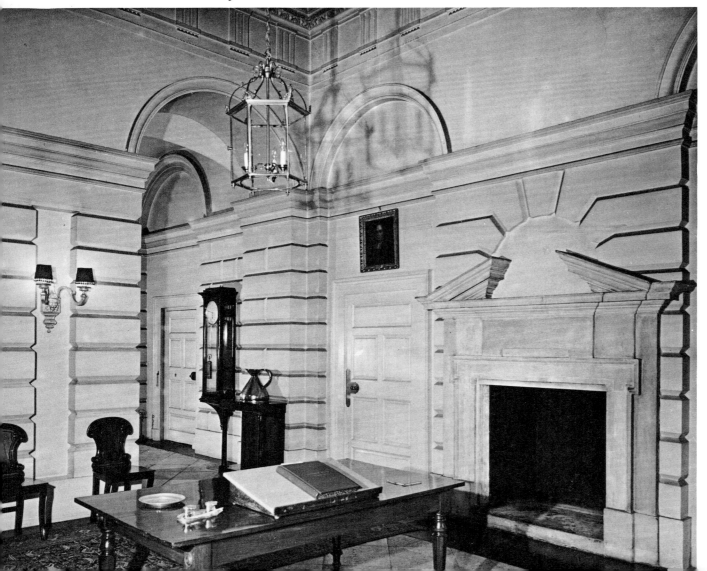

(Above) Provost's House, Trinity College (1758): the library, added in 1774

Lucan House (1780), Co. Dublin: mantel in the round room upstairs, where Mrs Vesey felt like 'a parrot in a cage' *(see p. 131)*

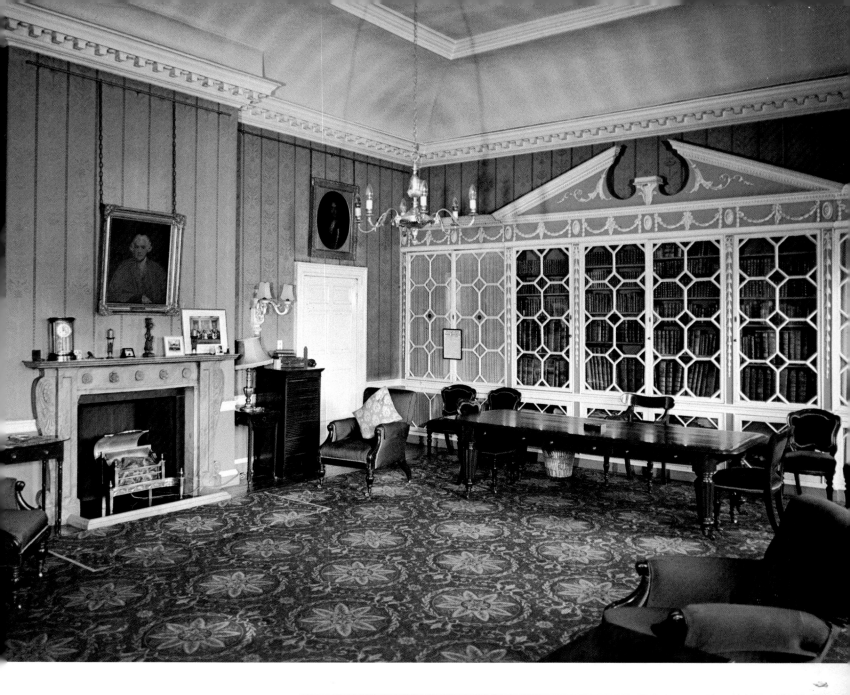

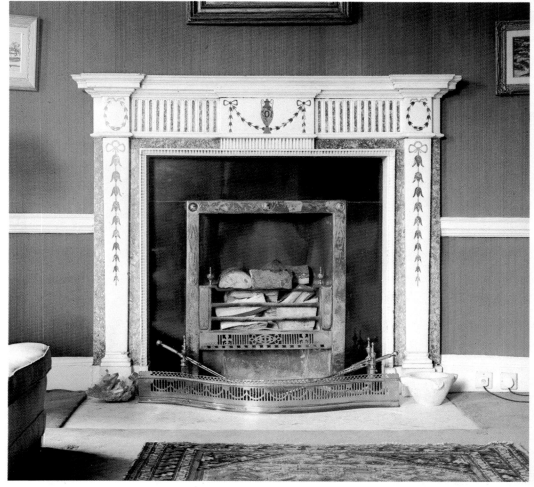

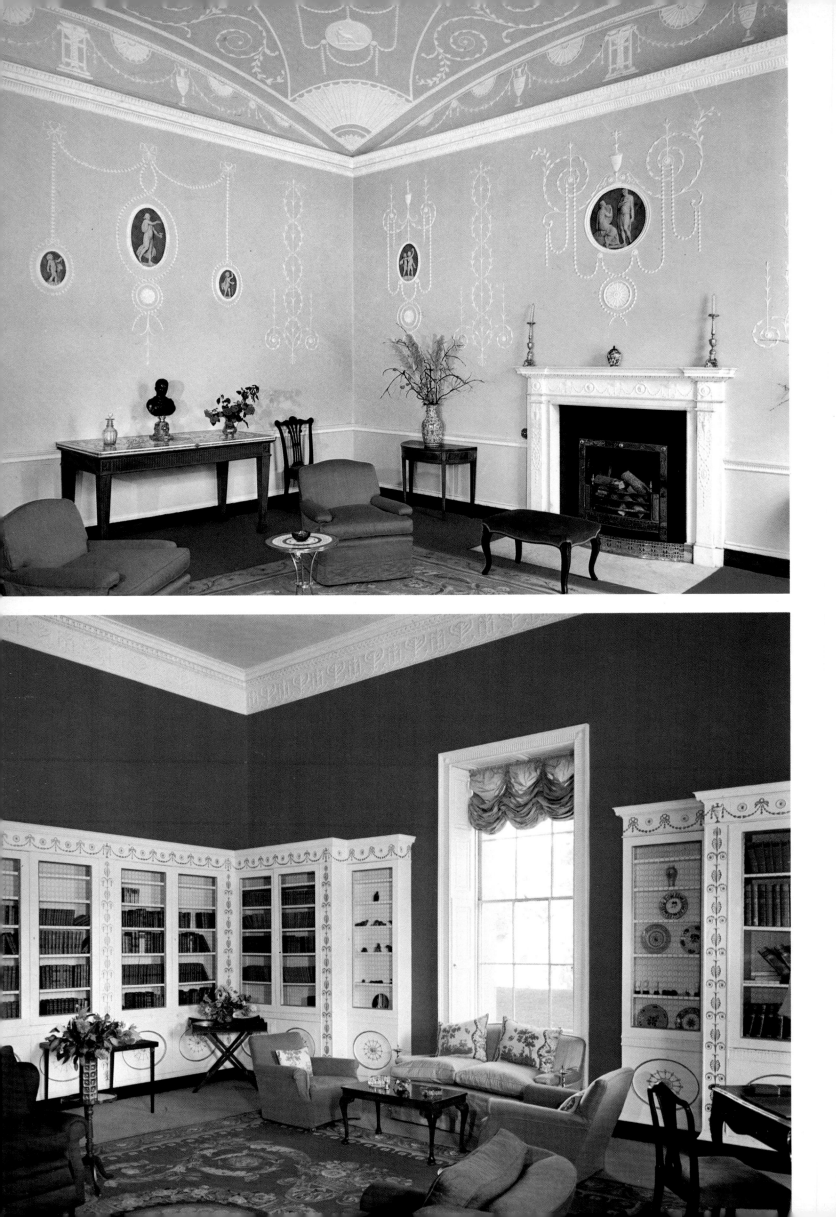

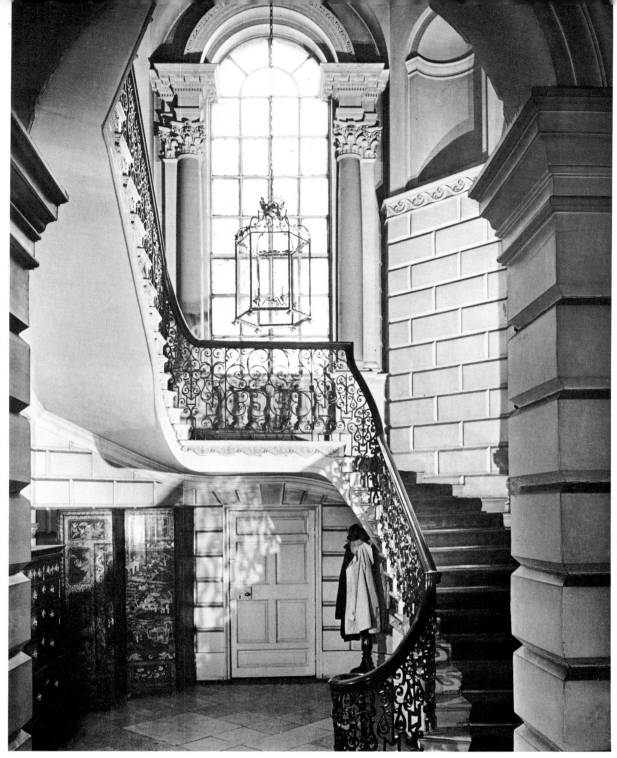

The Provost's House : the staircase

Lucan House : the Wedgwood Room and (below) the library (see p. 131)

unlikely to be original. The ironwork which is such a remarkable feature of the house is first noticed on the staircase, where a lively balustrade forms the perfect contrast to the ponderous ashlar walls. An immense portrait of Primate Boulter by Bindon, in a magnificent carved frame by some Irish follower of Grinling Gibbons, adorns the staircase wall. The stairwell is octagonal, lit by an immense Venetian window, with a protective ironwork grill outside which is rather naively wrought. It opens on to a landing lit from above, the roof-light coming through an elliptical balcony with another iron balustrade, the whole ornamented with rich plasterwork.

The saloon, which takes up the whole width of the house above the front hall, is also distinguished by the quality of the stucco in its coved and coffered ceiling. The name of the artist responsible for this decoration is unknown; there is no mention of him in the college account books, nor does the saloon ceiling bear any close resemblance to other work in the vicinity, except perhaps at Chambers' Casino at Clontarf. It is freehand work; the crisp frieze in the saloon was certainly modelled *in situ* by a practised master of the rococo, whose name may yet come to light. At one end of this noble apartment hangs the full-length portrait by Gainsborough of the Fourth Duke of Bedford, Chancellor of Trinity from 1765, which was given by the sitter to Provost Andrews. Over the twin mantels are portraits of Archbishop Ussher and of Queen Elizabeth I, the latter attributed to Gheeraerts.

No significant alterations have been made to the Provost's House except the addition of an ante-room and a library by Andrews' successor, John Hely-Hutchinson, who found the accommodation inadequate when he moved in with his wife and family in 1774. The Rev. Samuel Madden bequeathed a collection of twenty Italian pictures to Trinity College in 1765, and many of these now hang in the Provost's House, being dispersed throughout the rooms on the ground floor, especially the drawing-room.

In 1952, the house was redecorated with great sensitivity by the present occupant, Dr A. J. McConnell, and his wife, with the advice of Sir Albert Richardson and the help of Mr Ian Roberts, the College architect.

The Provost's House: the dining-room; (right) the saloon

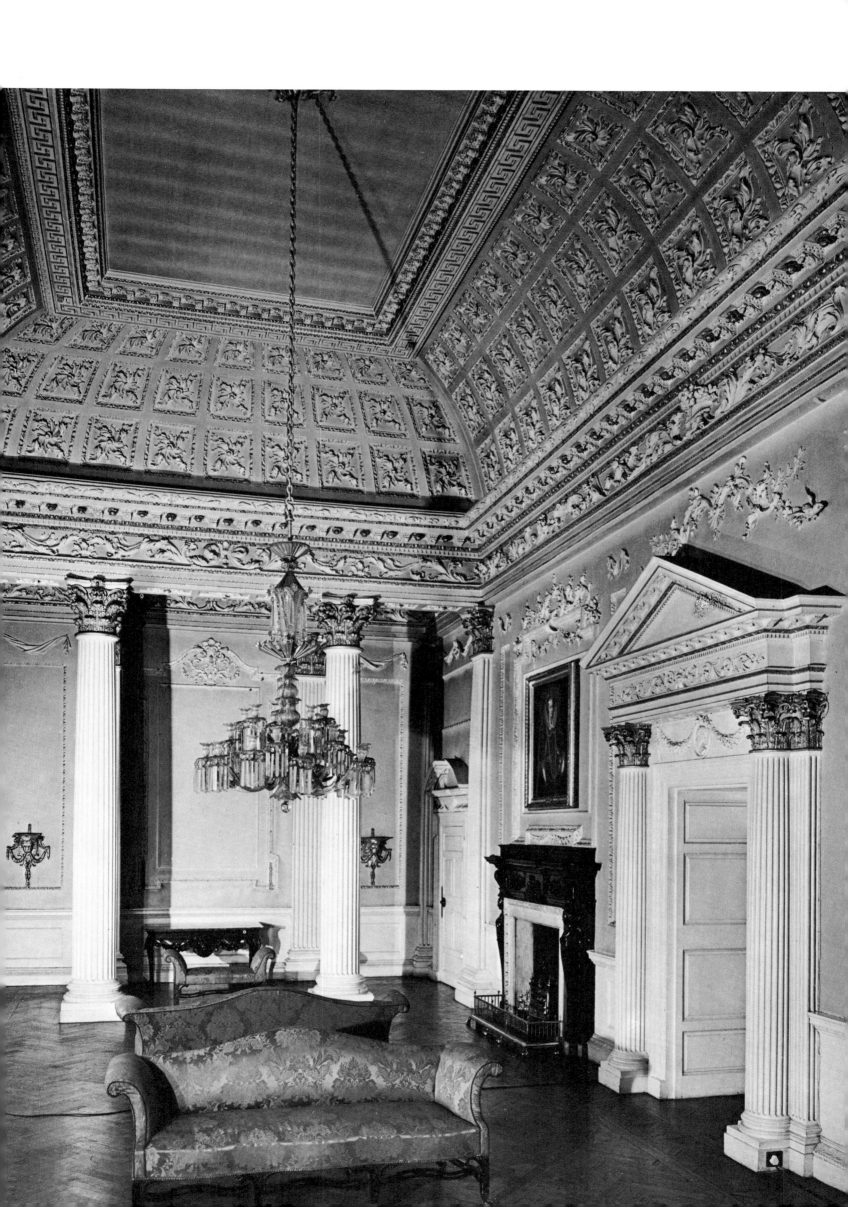

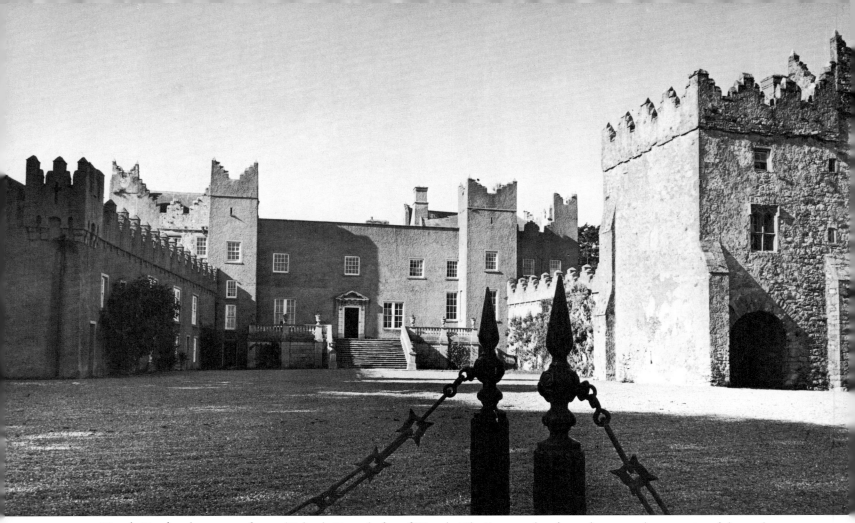

Howth Castle : the entrance front. (Below) Ground-plan of Howth. The Lutyens chapel may be seen at the extremity of the south-east range

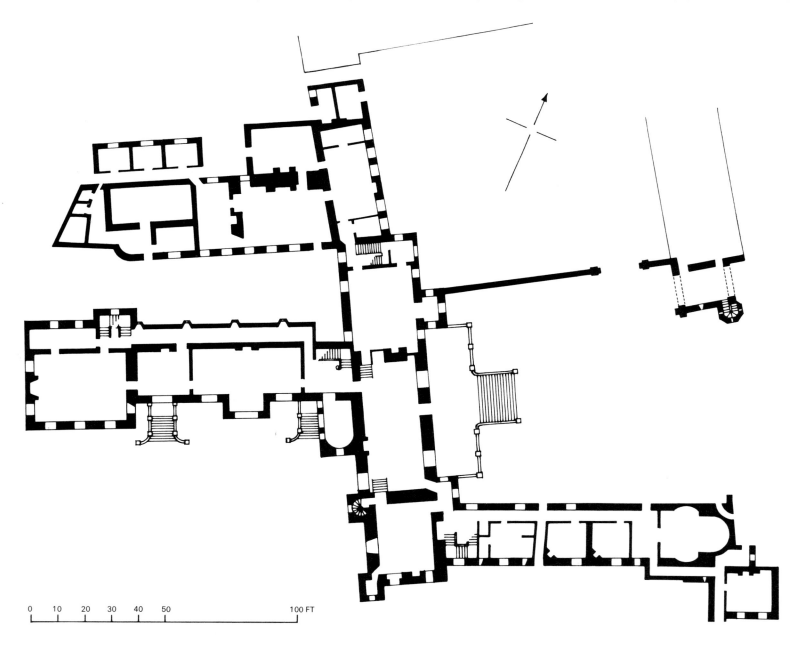

0 10 20 30 40 50 100 FT

HOWTH CASTLE

HOWTH, COUNTY DUBLIN

Mr and Mrs Christopher Gaisford-St Lawrence

THE HILL OF HOWTH, at the end of the long arm of the Howth peninsula, forms the northern side of Dublin Bay. It also forms a little harbour of its own, which was, up to a hundred years ago, the principal port of entry to Ireland from England. Two islands serve to break the violence of the Irish sea, Lambay to the north, and Ireland's Eye, about a mile off-shore, which still belongs to the St Lawrences.

Howth Castle nestles comfortably in the shelter of the hill, its trees and garden apparently unaffected by the proximity of the sea. The St Lawrence family have had their seat here for almost 800 years, and conserve their trust to the present day. There is some argument as to the origin of their family name. It is often related that a Norman knight, Sir Almeric Tristram, won the ownership of the Howth peninsula in battle on the anniversary of the Feast of St Lawrence. Before the conflict he had, as was customary, vowed to that saint that he would assume his name in the event of a victory, and from that day onward he was known as Sir Armoricus St Lawrence. It has also been suggested that in fact the name might have a Norman or French origin – more than one of the followers of William the Conqueror were named St Laurent and had settled in England in the twelfth century.

Of all the legends that have grown up around Howth over the years, the best known is the story of Graunuaile, or Grace O'Malley, the Pirate Queen. The O'Malleys were a powerful tribe in County Mayo, and Grace the undisputed mistress of the many hundred islands and inlets about Clew Bay. Her fame had even spread to London. Queen Elizabeth herself was curious to meet her, and received her most amicably at Court because she had destroyed the remaining ships of the Spanish Armada off the west coast of Ireland. On her return journey to Ireland from this visit her vessel ran short of supplies, and put into the harbour of Howth to replenish. While her men were stowing provision aboard, Grace O'Malley knocked at the gates of Howth Castle (according to some versions, disguised as a beggar woman), in search of hospitality. The family sat at meat, however, and she was refused admittance. In

a fury, she snatched the infant son and heir of Lord Howth from his wet-nurse, and sailed off with him to the wilds of County Mayo. The child was, eventually, reunited with his parents, but only on the strict understanding that the gates of the castle should always be open at mealtimes, and a place be set at table for the head of the O'Malley clan. This custom is rigidly adhered to, even down to the present day.

In the eighteenth century the old keep was modernized and enlarged by William, twenty-sixth Lord Howth, who added the handsome classical doorway, the terrace, and front steps. An inscription beside the hall door, no longer visible, but doubtless still set in the wall beneath the plaster, states: 'The Castle was rebuilt by the Right Honourable William, Lord Baron of Howth, Anno Domini 1738.' The birds-eye view of the castle and gardens painted on the wall above the drawing-room mantel, must date from shortly after these alterations. The figure in black at the bottom left-hand side of this painting represents Dean Swift, a friend of this Lord Howth, for whom he allowed himself to be painted by Francis Bindon. The full-length portrait of the Dean hangs today in the dining-room at Howth. He is represented with the Drapier Letters in one hand, being crowned from on high by Hibernia, while beneath his feet, writhing in agony, is the infamous Wood (of 'Wood's Half-pence'), some of his debased coinage scattered about. In a letter to Sheridan in 1735 Swift writes that he 'has been fool enough to sit for his picture at full-length by Mr Bindon for Lord Howth, and had sat that day for two hours and a half'. The Knight of Glin has suggested that Bindon, an architect as well as a painter (he could scarcely be called an artist), might have been responsible for the alterations to Howth in 1738.

Thomas, twenty-seventh Lord Howth, was created Viscount St Lawrence and Earl of Howth in 1767, and died in 1801. He owed his advancement to a brilliant political career. His grandson, the third Earl, who lived until 1874, was a famous nineteenth-century sporting figure, and one of the set of hunting pictures painted for him by Ferneley is reproduced here. He was responsible for the south-east range of buildings, which form the left hand side of the entrance court, facing the front door. In the year 1909 the ancient title died out with the fourth Earl as no male heir could be traced. The estates devolved upon his nephew Julian Charles Gaisford, who assumed by Royal Licence in 1909 the additional surname of St Lawrence. His mother, Lady Emily, was a sister of the fourth Earl.

The only architect who can with certainty be connected with Howth is Sir Edwin Lutyens, who had also worked at Lambay Island for Lord Revelstoke. He designed the Western Tower, which contains the remains of the famous Gaisford library. Most of the best books were sold in 1890 at Sothebys, the sale lasting five days. Here he installed a curious early eighteenth-century Irish mantel, whose inverted shells became the source of some Lutyens detail on a bank he built in Liverpool. This mantel came from a house named Killester that

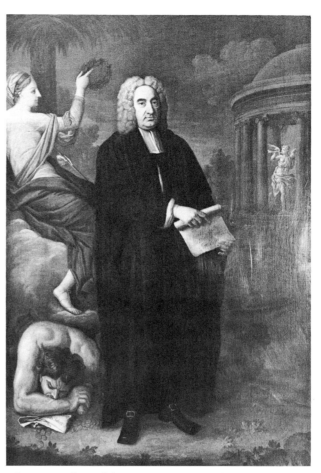

A portrait of Swift by Francis Bindon, which hangs in the dining-room at Howth Castle

Mantel in the drawing-room, with an eighteenth-century perspective of the garden painted on the panel above

The Earl of Howth out hunting, by Ferneley

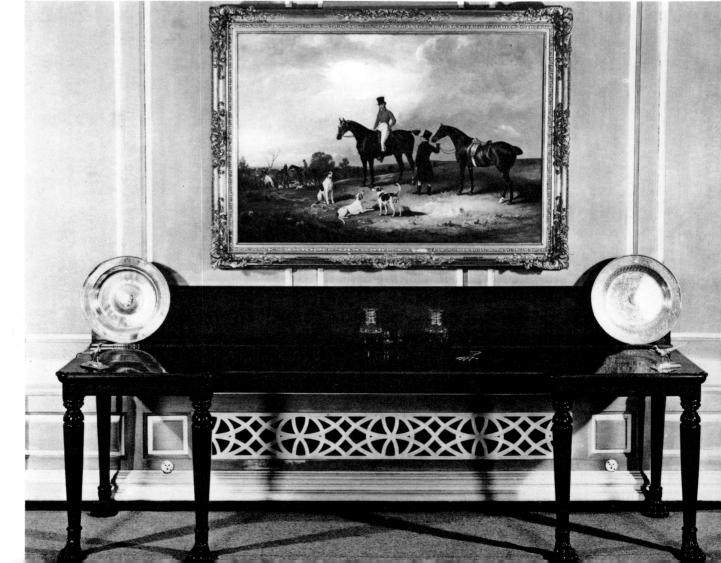

stood on the Howth property, and was being dismantled at that time. Lutyens also designed a loggia, a Roman Catholic chapel in the south-east range, and the present dining-room, formed out of three small, panelled rooms off the hall. At the time of these renovations an old stone fireplace came to light in the entrance hall. Lutyens had it opened up, and framed it with a pilastered timber surround that had originally been a Venetian window at Killester. A curious weather-vane was installed, the wings sprouting out of the chimney-pot. Mr McDonald Gill was commissioned to paint a map of Howth above the fireplace, with the names of the Gaisford-St Lawrence children on the sailing-ships.

Part of the elaborate garden layout shown in Rocque's map of County Dublin still survives. The vistas from Howth towards the islands of Lambay and Ireland's Eye are framed by formal beech hedges, now grown to a height of thirty feet. They were probably planted in about 1720, and although there were many gardens of this kind in Ireland at that time, most of them were swept away later in the century when the taste for the informal garden supervened. This change of fashion was aptly summed up in William Mason's 'The English Garden':

> At the awful sound
> The terrace sinks spontaneous; on the green,
> Broider'd with crisped knots, the tonsile yews
> Wither and fall; the fountain dares no more
> To fling its wasted crystal through the sky,
> But pours salubrious o'er the parched lawn
> Rills of Fertility . . .

Howth Castle : the front hall

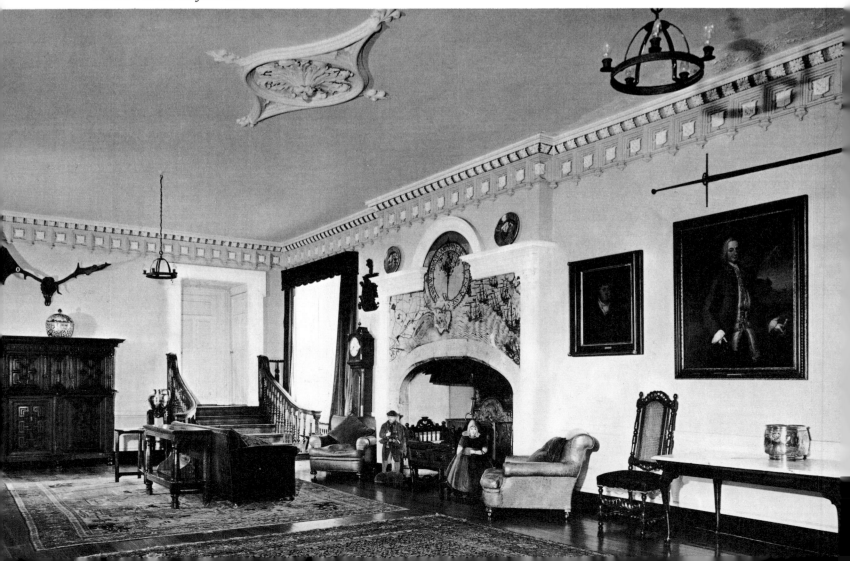

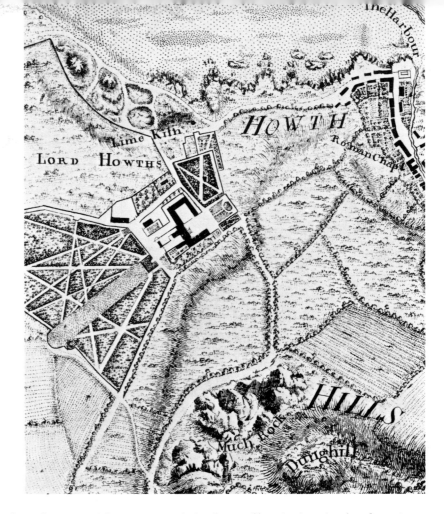

*Detail from Rocque's map of
County Dublin (1760)*

The 'Canal' at Howth, which is shown with swans on it in the wall painting in the drawing-room, is still in existence but the statues and urns have gone. The French 'bosquets' behind the castle, with their angle walks, are no longer there; instead there is a typically English herbaceous garden on the south side which was laid out by Lutyens. High above the castle is the rhododendron garden for which Howth is famous, and which draws so many visitors to the demesne in May and June. Visitors to Howth are also shown the 'family tree', a venerable elm planted in 1585, and the oldest imported tree in Ireland. At present the tree is covered in sprouts; it had always been predicted that when the last branch fell the title would become extinct. Every kind of prop and chain was used to postpone this event for as long as possible, but to no avail.

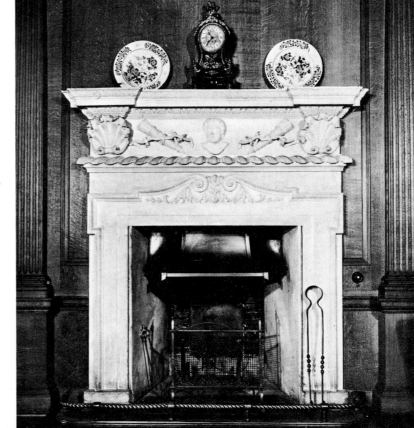

*Early eighteenth-century
mantel in the library*

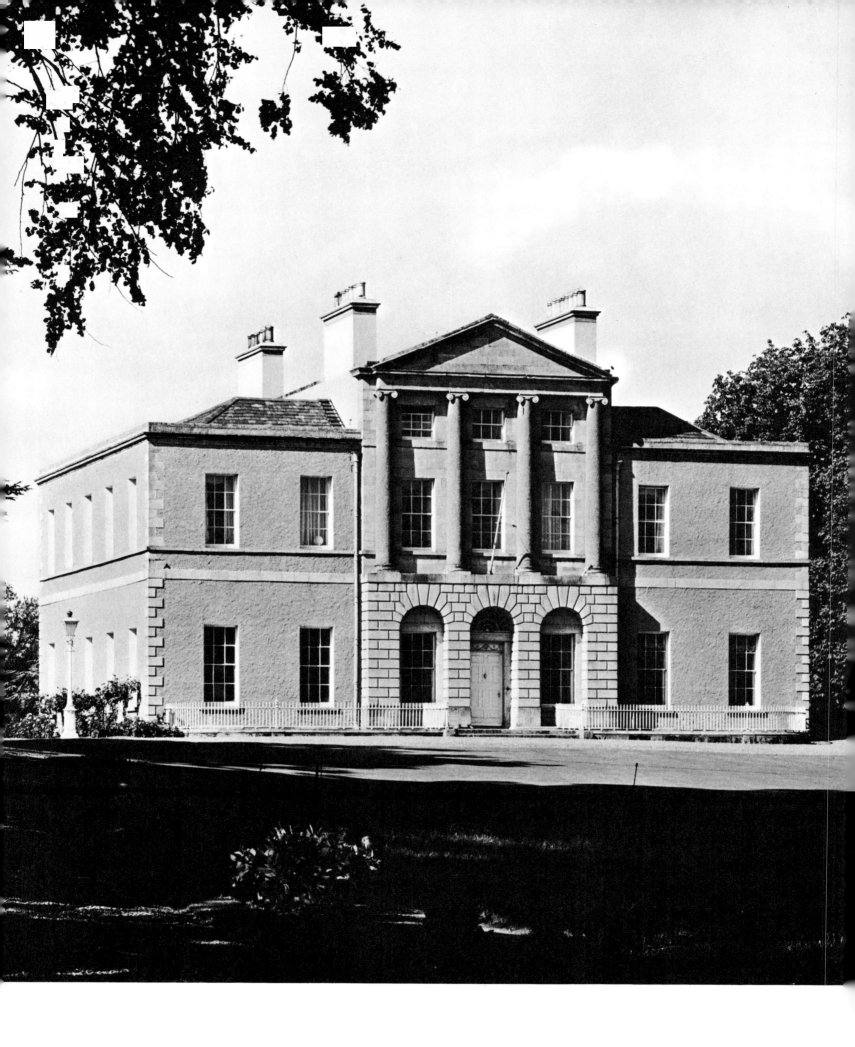

LUCAN HOUSE

LUCAN, COUNTY DUBLIN

The Italian Embassy

THE RIVER Liffey is unrivalled in Ireland in terms of the architectural riches dispersed along her banks. Rising in the Wicklow mountains south of Dublin, she flows past Russborough before plunging down the Poulaphouca falls and turning to the north across the flat plain of Kildare. Her circuitous travels embellish countless demesnes; Castlemartin, Killadoon, Castletown, and Lucan among them, before her course straightens out along the Strawberry Beds on the way to Dublin and the sea, the Four Courts and Customs House standing by to bid her a last, majestic farewell.

The Renaissance came late to Ireland. Even in the seventeenth century, parts of the country were still enmeshed in the tribal customs of the Middle Ages. In 1633, when Sir Thomas Wentworth came to Ireland as Lord Deputy, he found that it was still the custom in the more primitive areas to hitch the plough to the tail of a horse. When the Renaissance finally reached Ireland in the early 1700s, Italian influence was all-powerful. In the same way that Italian taste and Italian craftsmen had swept through Austria into Germany, France, and England in previous years, at last it was the turn of Ireland. There were the architects Galilei and Ducart, the stuccodores Francini and Cramillion, and the wall-painters Zucchi and Gabrielli. There were, too, the mantels of Pietro Bossi. Irish artisans were quick to learn from the Italian example. It is often forgotten that Italy more than England was the original fountainhead of Irish art and architecture in the eighteenth century.

In view of this, it is particularly fitting that the Italian Ambassador should live at Lucan House, a pure Palladian villa on the banks of the Irish Brenta. Most of the Embassies are situated in a part of Dublin that resembles North Oxford – they might so easily have brought to life some of the great town houses that are now used as institutions or warehouses. The Italian Government had the taste and foresight to acquire Lucan in 1944, and provide themselves with the most elegant embassy in Ireland.

The old castle, or what is left of it, still stands beside a small graveyard within the demesne. It was built shortly after the Norman conquest, and had many different owners until in 1386 it became the property of the fourth Earl of Kildare. On the attainder of the tenth Earl (Silken Thomas) it was leased by the Crown to one Matthew King in 1554, 'on condition that he

Lucan House, Co. Dublin (c. 1775). Until the recent restoration, the cut-stone ashlar around the front door was carried on in plaster either side, to the first floor level

inhabited the castle himself or placed in it liege men who would use the English tongue and dress, and hold no communication with the Irish'. Ten years later Sir William Sarsfield is mentioned as being 'of Lucan'. The Sarsfields, an English family who had settled in County Meath and provided Dublin with no fewer than three Lord Mayors, held Lucan until the time of the Commonwealth. As they were a Catholic family, and implicated in the 1641 rebellion, they were thrown out of their home although the head of the house was at the time close on 70 years of age. Lucan Castle (described as 'the fairest house in the County Dublin') was taken over by Sir Theophilus Jones, an officer in the Parliamentarian army. At the time of the Restoration Sir Theophilus was forced to return the Lucan estates to Patrick Sarsfield, the father of the great General Sarsfield, hero of the Siege of Limerick, created Earl of Lucan by James II in 1691. The title died with his son in 1719, and the Lucan property devolved upon Charlotte Sarsfield, the cousin of the second Earl.

A considerable heiress, she married Agmondisham Vesey and it was their son, also Agmondisham, who built the present house. A daughter of theirs married Sir John Bingham, whose son Charles took the title Earl of Lucan when raised to the peerage in 1795. The younger Agmondisham Vesey, who married his cousin, the celebrated bluestocking, was named Professor of Architecture in Doctor Johnson's utopian university. Boswell said of him: 'He understood architecture very well and left a very good specimen of his knowledge in that art by an elegant house built on a plan of his own at Lucan.'

There may have been a house there already as well as the old castle, for in 1700 there is a claim on the 'castle and great white house at Lucan' (D'Alton's *History of County Dublin*) and, in 1775, Lady Louisa Conolly writes, 'the house . . . is almost pulled down, and I hear won't be habitable these two year'. Mrs Vesey laments leaving 'the dear old Castle with its niches and a thousand other Gothic beauties', and there are two references to the house being rebuilt after a fire. Milton, in his *Views of Seats,* 1783, describes Lucan as being finished for the past two years. It seems probable therefore that both the castle and the 'great white house' were habitable and that the house was pulled or burnt down and rebuilt as we see it today.

In keeping with many eighteenth-century amateur architects, Vesey was not above consulting professionals. He writes to Sir William Chambers on 3 January, 1773: 'I have got the Landskip of Lucan and its environs and wish to shew you the Situation and aspects of a place which I am persuaded will receive great Embellishments from your hands.' To this Chambers replies, 'I have been out of town else your Elevation should have been done and Plans altered sooner.' In a later communication, sent with his bill, Chambers mentions that 'the windows do not come perfectly regular on one side but I have contrived it so that the difference will scarcely be perceptible.' John Harris, who discusses the Chambers connection with Lucan House fully in the Irish Georgian Society Bulletin III, 1965, takes this to refer

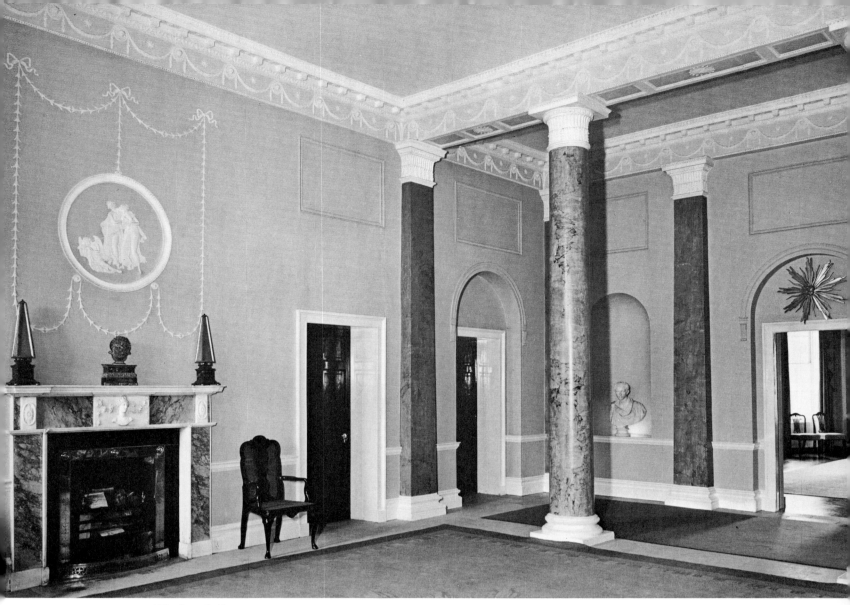

The front hall

to the Liffey front, where the windows are out of balance. This was probably due to the difficulty of fitting the new house into what remained of the old.

A plan of the ground floor of Lucan corresponding exactly with the existing house is in the National Library of Ireland, but it is unfortunately not signed. The same collection of architectural drawings includes designs by Michael Stapleton for plasterwork on ceiling and wall at Lucan, and the ground plan can presumably be attributed to him also. It resembles closely the plan of Mount Kennedy House, Co. Wicklow, and the elevation is not unlike Charleville, Co. Wicklow, both of which are described here.

The interior is one of the finest in the Adam style to remain intact, and was restored in 1960 by Baron and Baroness Winspeare Guicciardi; the architect was Brendan Ellis, and much of the delicate painting work was done by Matthew Daly. They uncovered the yellow marble-painting on the columns in the entrance hall, and improved the drawing-room by opening out two windows that were formerly dummies, giving it a magnificent view up the river. Mr Gorry restored the painted roundels by de Gree in the Wedgwood room, which had

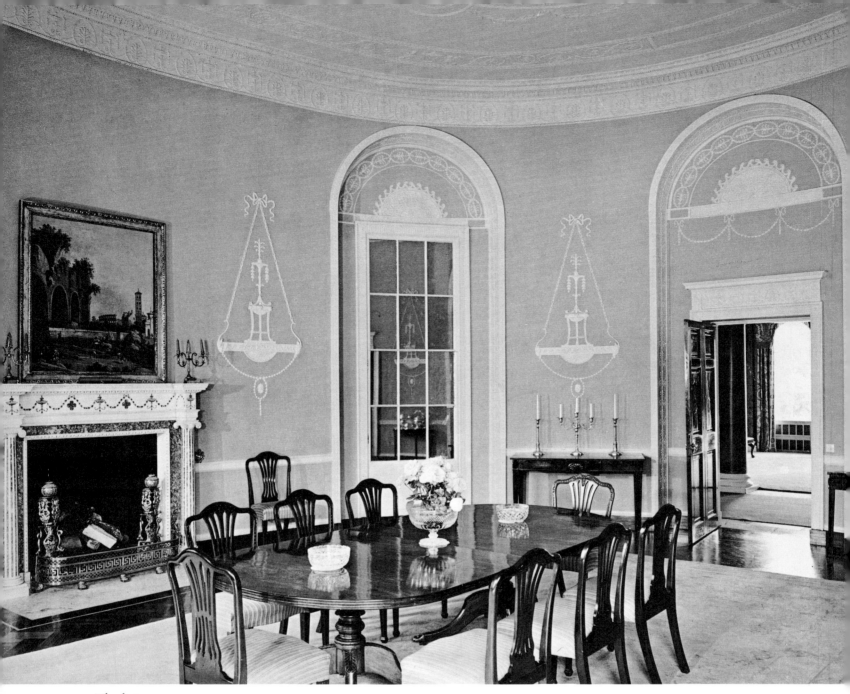

The dining-room

had the background painted out, depriving the figures of the sculptural quality intended by the artist. A similarly shaped room, with the corners of the ceiling pulled down to give a domed, tent-like effect, was provided by Stapleton for Powerscourt House, South William Street, Dublin. Another Vesey house, Abbey Leix, Co. Leix, (q.v.) was decorated by Stapleton and de Gree; patronage of the same artists often went in families.

The elegant staircase leads to an upper landing, at one end of which there is an iron stove shaped like an urn, and now painted white. Off this landing is a circular sitting-room, ingeniously fitted above the oval dining-room, where Mrs Vesey feared she would be 'like a parrot in a cage'. Baroness Winspeare was even able to find some curtains for the room with parrots on them.

In 1932 the Colthurst-Veseys sold Lucan to Hugh O'Conor, The O'Conor Don, whose principal seat was Clonalis, near Castlerea, Co. Roscommon. The O'Conors trace their lineage back to Eochid Morghmeodhin, the grandfather of the first Christian King of Connaught. As President of the Irish branch of the Knights of Malta at the time of the Eucharistic Congress in 1932, the O'Conor Don gave a garden party at Lucan for over a thousand people. It is said that in his day there was never a Protestant leg under the table. His son-in-law, Sir William Teeling, M.P., sold the house to the Italian Government.

Though the house now has its own garden it originally grew stark out of the parkland. In this respect it was typical of the country house of the period. The walled garden, which was approached by a tunnel under the main Galway road, was sold off in the 1930s. By judicious planting, several walks were made along the river and through woods to the Sarsfield Monument and the rusticated cold bath beside the famous sulphur spring. 'The Rt. Hon. Agmondisham Vesey . . . generously permitted the Company to range through his Grounds at Pleasure; but, it is to be lamented, that he soon found cause to repent, and indeed to withdraw the Indulgence he had granted, from the licentious Behaviour of some disorderly Persons, who were no *Water*-drinkers – by circumscribing the Well with a Wall, to prevent such Depredations in future.'

Downstream from the house may be seen the remains of the bridge which inspired Swift's epigram:

Agmondisham Vesey, out of his bounty
Built a fine bridge – at the expense of the County.

Ground-plan of Lucan House

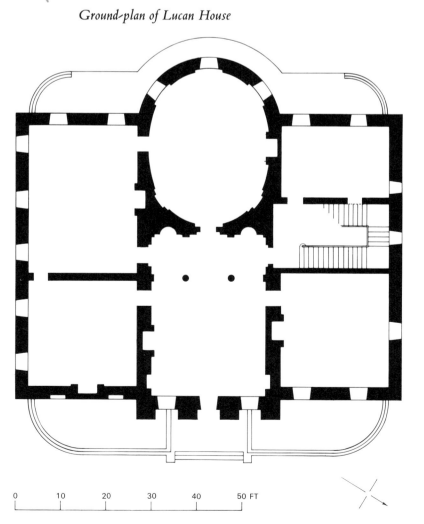

0 10 20 30 40 50 FT

The Sarsfield Monument

Lucan House: rusticated Gothic arch leading to the stable yard, made of natural limestone taken from the bed of the River Liffey
(Below) The stables

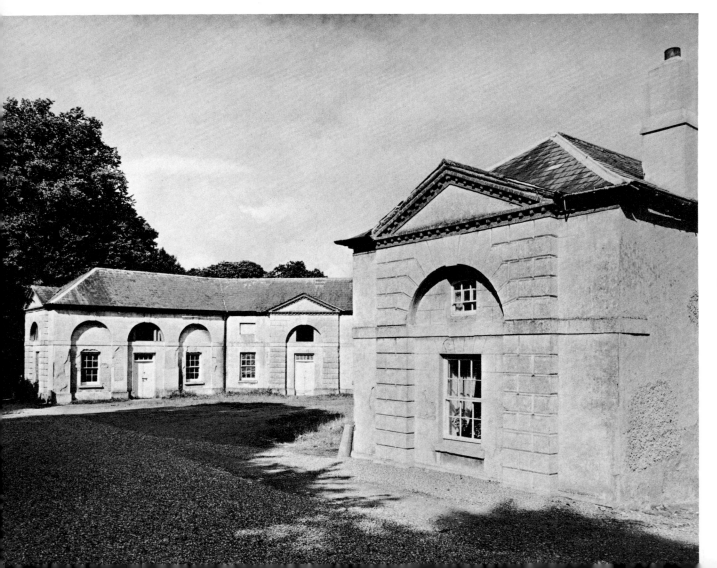

Luttrellstown Castle, Co. Dublin: the Gothic entrance hall, 1800 (see p. 139)

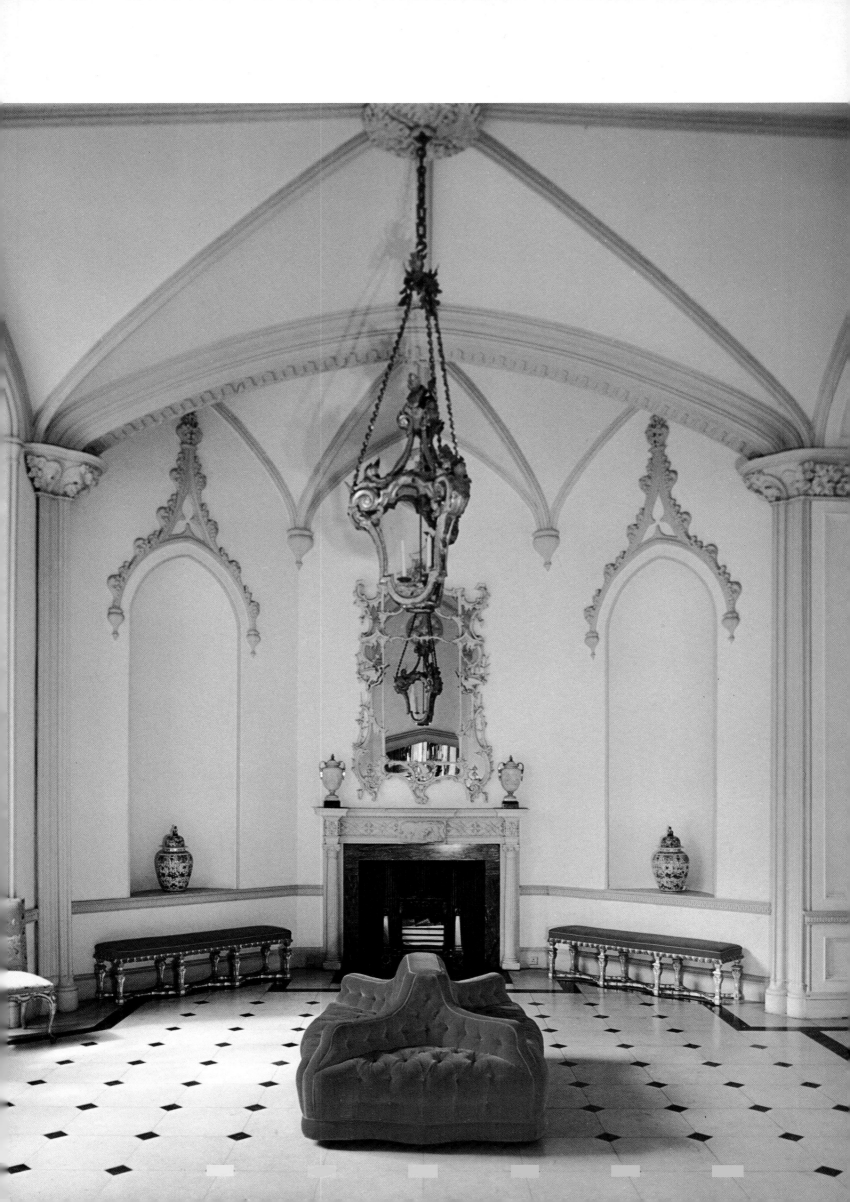

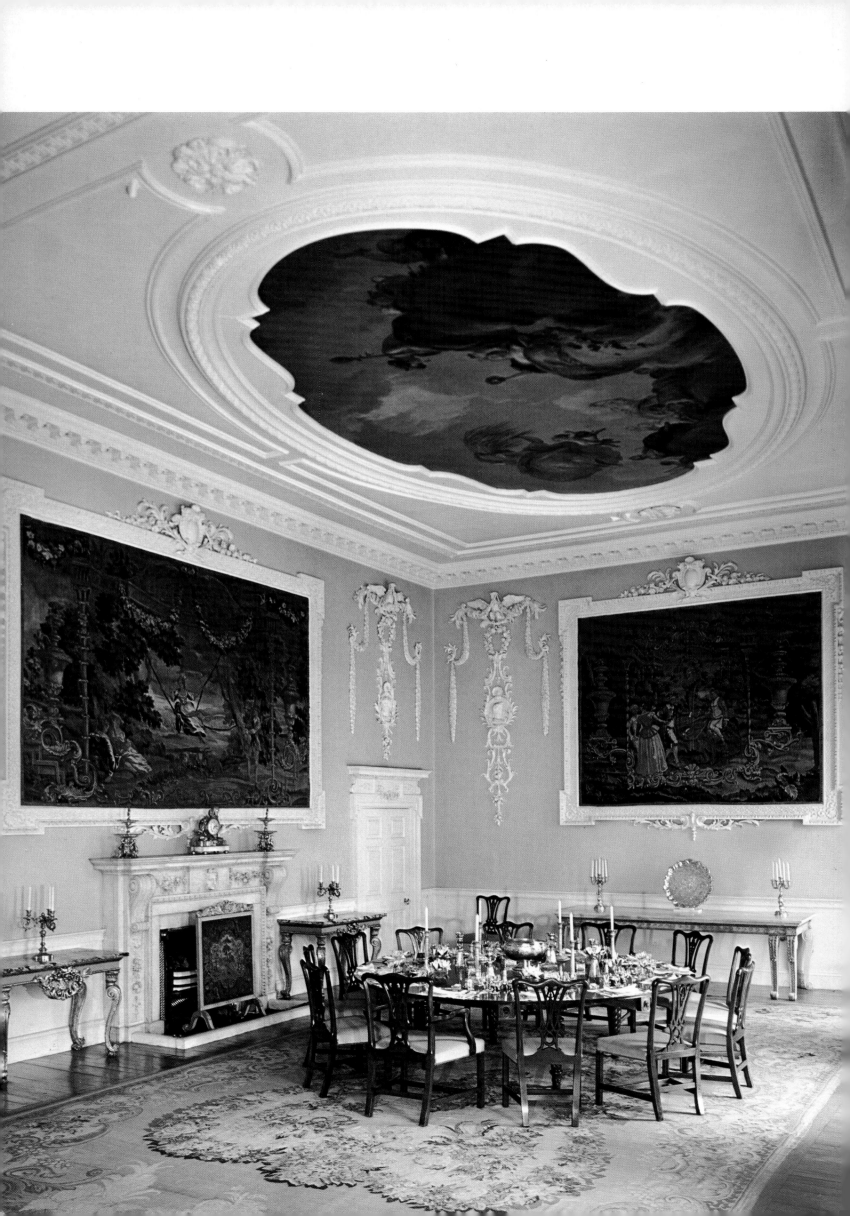

LUTTRELLSTOWN CASTLE

CLONSILLA, COUNTY DUBLIN

The Hon. Mrs Brinsley Plunket

'THE DEMESNE IS MUCH THE LARGEST and most beautiful in the County of Dublin or within the same distance from the city on any side' wrote James Gough, the Quaker traveller, in 1813. Prince von Pückler-Muskau, a grand tourist of the late 1820s, was another visitor who described the park at Luttrellstown in glowing terms: 'The entrance to the demesne is indeed the most delightful in its kind that can be imagined. Scenery, by nature most beautiful, is improved by art to the highest degree of its capability, and, without destroying its free and wild character, a variety and richness of vegetation is produced which enchants the eye. Gay shrubs and wild flowers, the softest turf and giant trees, festooned with creeping plants, fill the narrow glen through which the path winds, by the side of the clear, dancing brook, which, falling in little cataracts, flows on, sometimes hidden in the thicket, sometimes resting like liquid silver in an emerald cup, or rushing under overhanging arches of rock, which nature seems to have hung there as triumphal gates for the beneficent Naiad of the valley to pass through.'

The gushing stream which flows down the glen from the lake joins the Liffey beside one of the entrance gates to Luttrellstown. The drive passes beneath the picturesque sham ruin, where there is a wishing seat, and climbs the glen, following the course of the stream. At the top of the glen the parkland opens out to the left, and to the right the ornamental lake reflects a Doric temple, originally built as a cold bath in the eighteenth century. At this point there stands an obelisk commemorating the visits of Queen Victoria in 1849 and 1900.

The castle is cloaked in an elaborate mantle of early nineteenth-century Gothic, surmounted by an imposing array of turrets and battlements, but the architect is not known (*see p. 264*). Originally a Pale fortress, it belonged to the Luttrells, Earls of Carhampton for 400 years until it was purchased by Mr Luke White, M.P. for Leitrim, in about 1800. The Luttrells had fallen on bad times – one was murdered, another died in debt – and it must have been the millionaire White who gave Luttrellstown (which he renamed Woodlands) the form we see today. He was a self-made man. Having started life peddling books, he went into the lottery business and amassed an immense fortune; he paid £180,000 for the Luttrell property.

Luttrellstown Castle: the dining-room, created by Felix Harbord in 1950

139

Brewer, writing in 1825 (*The Beauties of Ireland*) states: 'The principal parts of the mansion were built 30 years back; but some portions of the ancient castellated pile are still remaining, among which is an apartment fancifully termed King John's chamber. Many augmentations, and improvements, of the buildings have been effected by the present proprietor.' Luke White's fourth son and heir was made Lord Annaly in 1863, and probably gave the house its mock Tudor banqueting hall. This has since been altered by the present owner and her designer Mr Felix Harbord who created the present dining-room in 1950 where it stood. It seems likely that the windows date from the 1850s, and that the porch and tower were added at that time.

The chief glory of the house is the ballroom, which has plaster decoration that could be eighteenth century, but was most likely done for Luke White at the time of his purchase in 1800. The design is unusual and original, and does not fit easily into any particular category of plasterwork; it was probably done by local stuccodores working in a somewhat out-dated manner. It blends in admirably with Mr Harbord's adamesque *grisaille* room, and his magnificent dining-room, with its plaster birds and painted ceiling.

The fine ballroom mantel, which was brought over from England in 1950, may be the work of Sir Henry Cheere. The furniture is mostly French: the Régence chairs are from the Château de Maintenon and the faded blue colour is original. The huge Louis XV *bureau plat*

Luttrellstown Castle : the ballroom

with the Meissen swans on it is signed by Chevalier. A series of hunting views by Paul Tilleman surrounds the walls of the room, which is lit by a set of chandeliers that are eighteenth-century Neapolitan. In keeping with the international nature of the contents of this remarkable room the carpet is Russian, marked 1835 beside the imperial eagle in the border.

The dining-room is the perfect answer to those pessimists who, when looking at some fine eighteenth-century decoration, say 'you could never get that done nowadays'. Mr Harbord used the same eagles at Oving House, near Aylesbury, that he incorporated in the plasterwork here. As a room it succeeds brilliantly. The ceiling is by de Wit, the tapestries are believed to be Mortlake, and the carpet is an immense Bessarabian. The side tables came from Wilton. The enormous round dining-table, which can be made to contract or expand to seat thirty people, was found in the stable when the present owner came to Luttrellstown, which was given to her by her father, Mr Ernest Guinness, on her wedding in 1927.

The entrance hall retains its Gothic character of about 1800, but the mantel and black-and-white floor are recent improvements. It gives on to the staircase hall, which was transformed by Mr Harbord in 1963 when a magnificent painted ceiling by Thornhill, from a house in Suffolk now demolished, was inserted; the staircase and window were altered at the same time.

The grisaille room

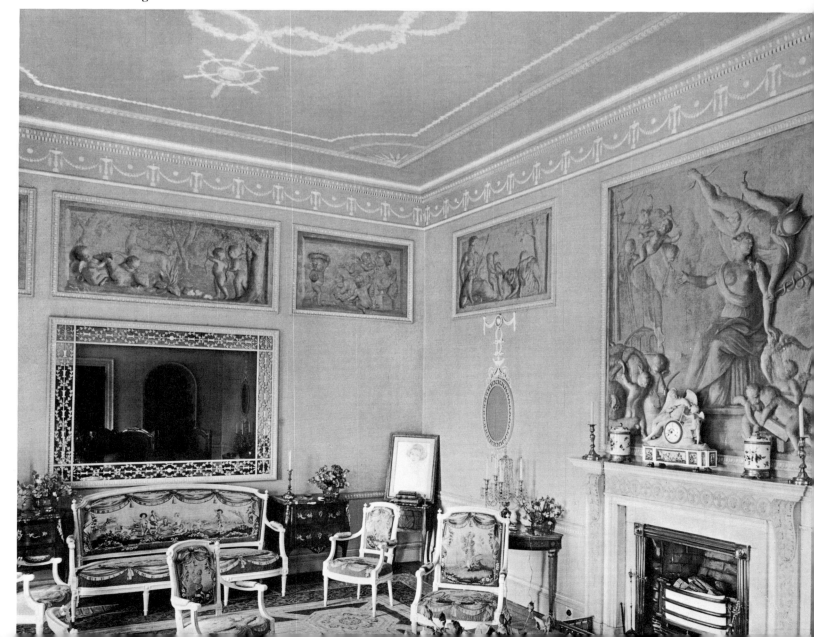

The far end of the ballroom opens into the *grisaille* room, which Mr Harbord has created to take the series of nine *grisaille* paintings by Peter de Gree, one of which, signed and dated 1788, represents Irish trade and commerce. These were originally at Mount Oriel, and later moved to Collon House, Co. Louth, the residence of 'Speaker' Foster. De Gree was a pupil of de Wit, who painted the dining-room ceiling at Luttrellstown, and came to Ireland with letters of recommendation from Reynolds. Examples of his work are to be found at Lucan House, Curraghmore, the council chamber of the Royal Dublin Society, 52 St Stephen's Green, and Mount Kennedy House, Co. Wicklow. The set of chairs covered with Beauvais tapestry, the Aubusson carpet, and the exquisite little Roentgen table are all of the Louis XVI period.

The library, in the centre of the south front, was originally the entrance hall and it has an unusual eighteenth-century plaster ceiling with bow and arrow in full relief. Beyond it there is a miniscule boudoir, containing an unusual set of Piedmontese tapestry furniture, a pair of Lancrets, a Joseph Vernet seascape that has always been in the house, and a recent painting of Luttrellstown by Derek Hill. There is also a tapestry portrait of Catherine the Great and a pastel by Cotes of the Duchess of Agyll, one of the famous Gunning sisters, from whom the present owner descends.

It is not easy to do justice to Luttrellstown in these few lines, but the accompanying photographs will help to complete the picture far better than words are able to. Its hospitality is legendary, and it manages to combine magnificence with comfort, and elegance with intimacy.

Luttrellstown Castle: the library

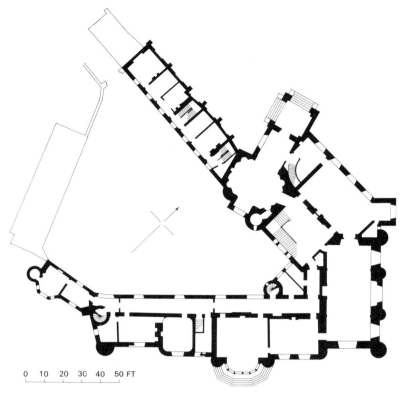

Ground-plan of Luttrellstown Castle

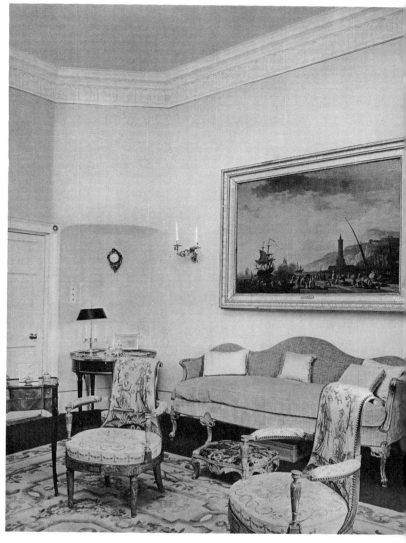

(Right and below) Two views of the boudoir

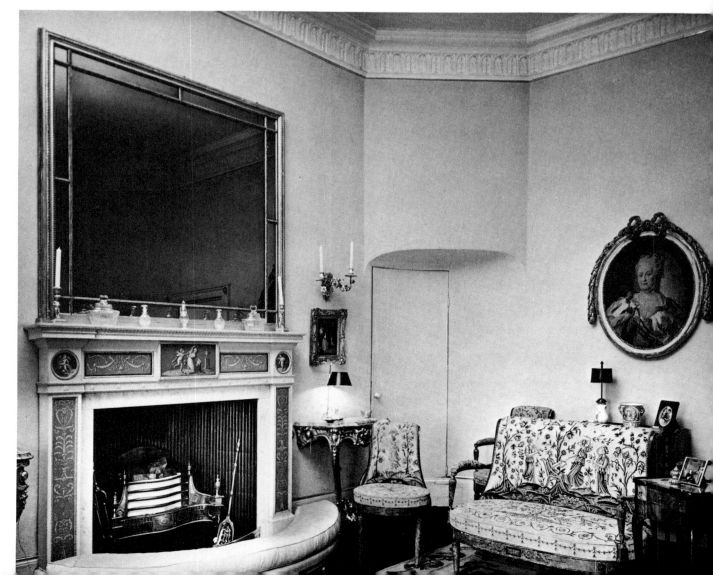

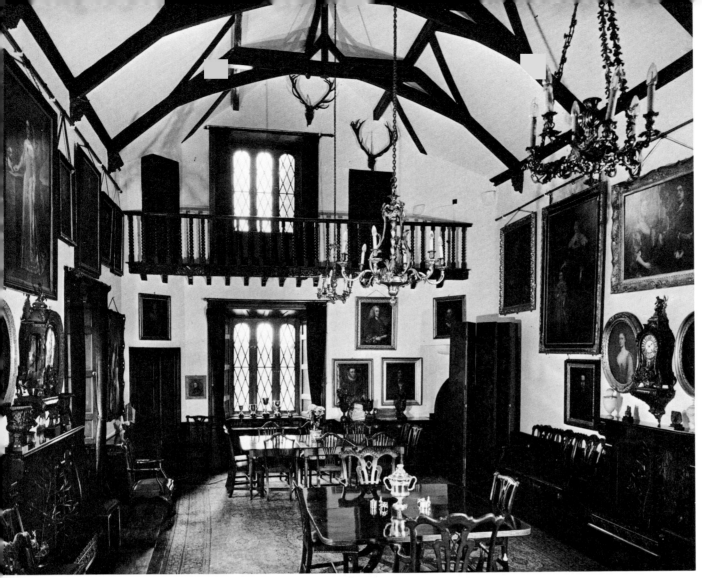

Malahide Castle : the Great Hall, now the dining-room

The Oak Room, which is approached by winding stone steps from the front hall

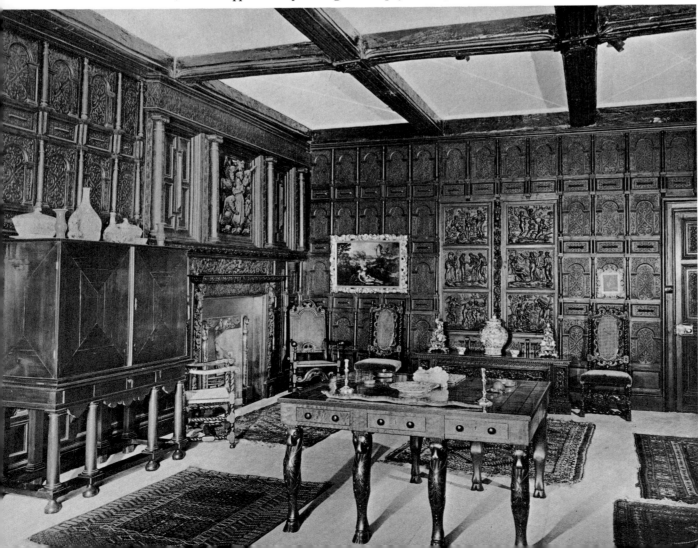

MALAHIDE CASTLE

MALAHIDE, COUNTY DUBLIN

Lord Talbot de Malahide

MALAHIDE HAS REMAINED the property of the Talbot family since it was granted to Richard Talbot in the last years of the reign of Henry II by his son John as Lord of Ireland. Malahide Castle must therefore be one of the oldest dwellings in Ireland, if not the oldest, to have been continuously inhabited by the same family. Its remarkable survival can be attributed to its situation so close to Dublin and consequently well within the Pale. The town and harbour of Malahide are nine miles to the north-east of Dublin, and the Talbots were named Admirals of Malahide and the Seas Adjoining by Edward IV, an hereditary privilege which Strafford when Lord Deputy tried unsuccessfully to wrest from them.

The Great Hall is essentially a medieval apartment, although the timbers have been replaced and the windows, mantels and minstrels' gallery date from the nineteenth century. It would originally have been approached by an exterior stairway, and probably dates from the fifteenth century. It is notable for the magnificent collection of family portraits, which completely cover the walls like postage stamps; men and women in splendid attire, beneath whose expressionless faces so much of Ireland's history lies hidden. The Earl of Tyrconnel, King James's Lord Deputy, is among the Jacobites portrayed; he is the only Irish Talbot ever to have figured in history. An enormous Irish elk head, with a span of eleven and a half feet, dominates the scene high up among the rafters. There is some important Irish 'Chippendale' furniture here, blackened to resemble bog oak, the native wood that was replaced by mahogany in the 1740s. This black furniture is echoed in the black woodwork and rafters, the minstrels' gallery, the superb fire-backs with their marble surrounds – all are black, lending a dignified if somewhat gloomy air to the room.

The Oak Room with its elaborate carved panels, of different dates and collected from different parts of the world, has also been painted black, which lends the woodwork a unity which otherwise it might have lacked. This apartment was extended in the early nineteenth century when the new front hall was created beneath, and it is lit by the mullioned window above the castle door. Over the fireplace with its Regency Egyptian grate there is a Flemish

carving of the Coronation of the Virgin. According to family tradition this carving made a timely disappearance when John Talbot was evicted by Cromwell, who granted the castle to Miles Corbet, the regicide. It was indeed fortunate for the Talbots that he had put his name to the death warrant of Charles I, and he was duly hanged after the Restoration. The Talbots returned to Malahide and the carving miraculously reappeared at the same time. At the end of the room there is a set of six panels depicting incidents taken from the Old Testament; the Talbots retained the old faith until 1779, and this room may well have been used as a chapel during the period of the penal laws.

James Boswell's Ebony Cabinet stands to the left of the fireplace; it contained the famous papers whose acquisition and subsequent publication by Colonel Isham in the 1920s was one of the literary events of the day. The fifth Lord Talbot married the younger daughter of Sir James Boswell of Auchinleck, and eventually purchased Auchinleck and its contents from his sister-in-law. Among the Malahide papers were over a thousand manuscript pages of Boswell's *Life* of Johnson, containing many passages suppressed by Boswell before publication, hence their importance as a literary 'find'.

The two Georgian drawing-rooms, each with its turret room (*see p. 300*), are the glory of Malahide and provide a dramatic contrast to the sombre apartments already described. They

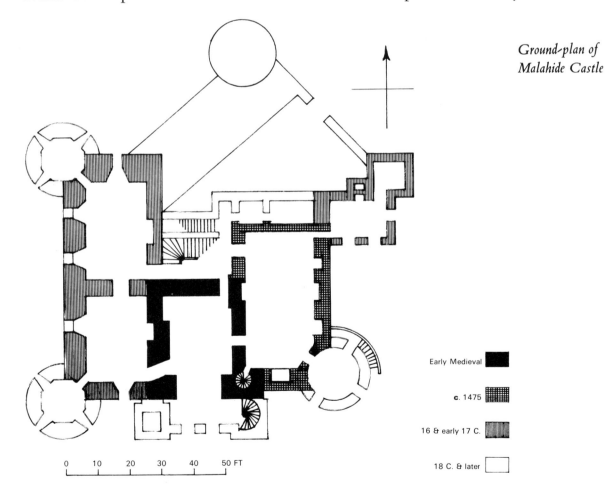

Ground-plan of Malahide Castle

Early Medieval

c. 1475

16 & early 17 C.

18 C. & later

0 10 20 30 40 50 FT

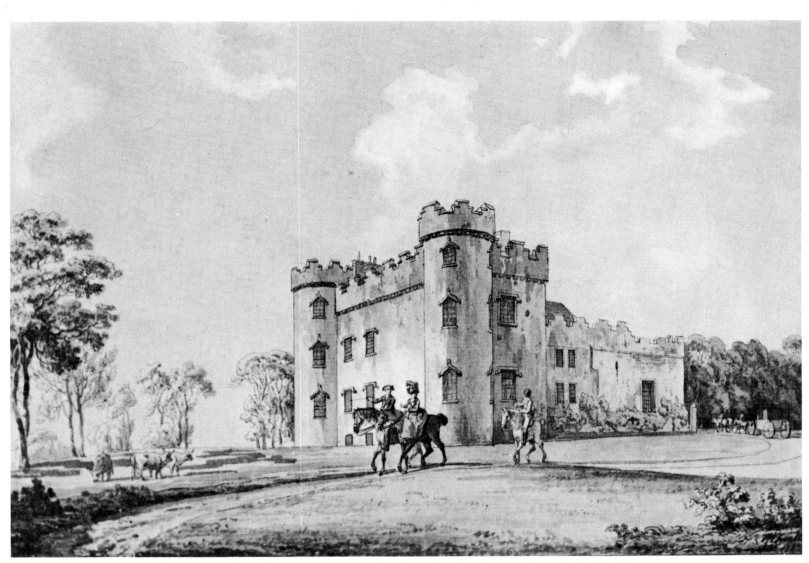

Malahide Castle, from a drawing by Francis Wheatley, 1782. (Coll. Lord Talbot de Malahide)

are painted a subtle shade of orange, a colour that is as hard to describe as it is to copy (although many have tried) and which sets off the gold frames of the pictures to perfection. These rooms were formed after a fire had gutted the west side of the castle in 1760. The enormously thick walls are the only reminder of an earlier origin. The space occupied by these drawing-rooms used to contain four old tapestry-hung rooms, lower in height and lighted by mullioned windows. The rococo plasterwork is attributable to Robert West, on stylistic grounds, and is particularly fine in the small drawing-room where the plaster cockatrices in the coving are incredibly life-like. As is so often the case in Irish houses, the plaster is probably ten years later than it appears to be. The decoration presumably follows on the marriage in 1765 of Richard Talbot to Margaret, eldest daughter of James O'Reilly of Ballinlough, Co. Westmeath (q.v.). She was created Baroness Talbot of Malahide and Lady Malahide of Malahide in 1831, when she had been a widow for forty-three years. A title would have been given to her eldest son, but as his son had already died, she was made a peeress in her own right so that the second son could inherit.

The walls of the small drawing-room are lined with paintings. Of exceptional interest are the two Gascars portraits of the Duke of Richmond as a child in fancy dress, and his mother the Duchess of Portsmouth. There are portraits of Patrick Sarsfield, Earl of Lucan, and Richard Talbot, Earl of Tyrconnel (whose niece married her cousin who lived at Malahide). There are also twin portraits in spectacularly beautiful carved frames of two eighteenth-century Irish actresses, Peg Woffington and Nance Oldfield. (*See p. 227*)

The George II gilt side tables in the large drawing-room, with their elaborately carved aprons and lion masks, may be Irish; it would be highly unusual to find an English table of this period with a japanned top. Inventories and newspaper advertisements have shown that 'Japan' tables continued in vogue in Ireland longer than in England, an example of the time-lag in taste between the two countries. Over the mantel in this room hangs a double portrait of James, Duke of York, and Anne Hyde, by Lely, which may have been given by James II himself to Tyrconnel. Among the many fine paintings there is a Venetian view that has recently been attributed to F. Guardi. There is a little oval table of inlaid wood, with ingenious spring devices, by Roentgen and a leather screen painted with scenes after Hogarth.

The Miniature Room in the turret off the large drawing-room is lit by ogee Gothic windows, and contains a miscellaneous collection of family portraits, pastels by Healy, Downman and Hamilton, whose little ovals are still to be found in so many Irish houses. The staircase and landing are also covered in pictures; the works of Morland, Farrer, Judith Leyster, Terbruggen and Bol are to be found here. There is also a painting by Thomas Patch of Sir Horace Mann, the British envoy, and his coterie in Florence, beside a painting of the historical game of Calcio in that city, possibly by Zocchi. The settee and hall chairs in mahogany and boxwood date from about 1775, and were given to the sixth Lord Talbot by a member of the Shrewsbury family – they bear the Talbot crest and Earl's coronet.

The present owner of Malahide is an enthusiastic gardener and has planted a magnificent array of rare and exotic shrubs here, of which he has collected some four thousand different species and varieties. Owing to the alkalinity of the soil, the low rainfall, the exposure to wind from all sides and the absence of the warming influence of the Gulf Stream, Malahide is far less favoured than many places in Ireland for the making of a garden. Nevertheless, plants from a surprisingly wide range of localities seem to thrive in these conditions. Close to the castle entrance, for example, may be seen specimens from the Mediterranean, North and South Africa, China, Australia, New Zealand, Mexico and South America. The owner likes in particular to grow plants which he has himself collected on his travels, and many of which are probably not in cultivation elsewhere in Europe, except in gardens to which he has distributed them. Indeed, more new introductions of woody plants from the temperate regions of the world may be seen at Malahide than in any other garden in Ireland.

Furniture, bearing the Talbot arms, given to Malahide by the English branch of the family

Armour in the front hall. The original front door is on the left

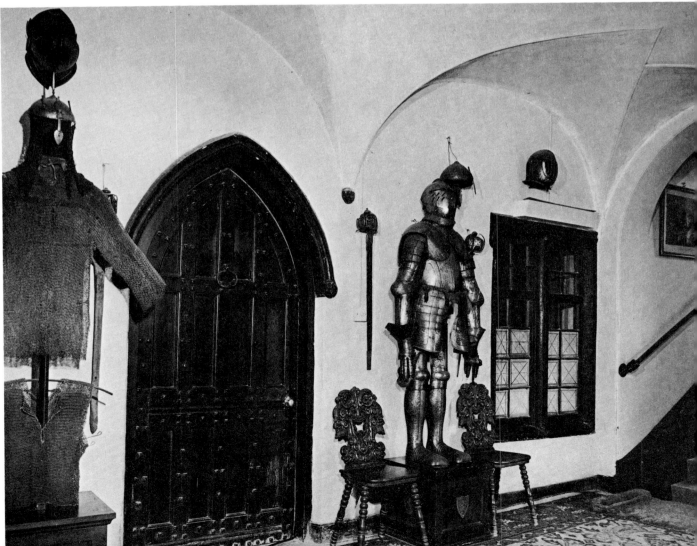

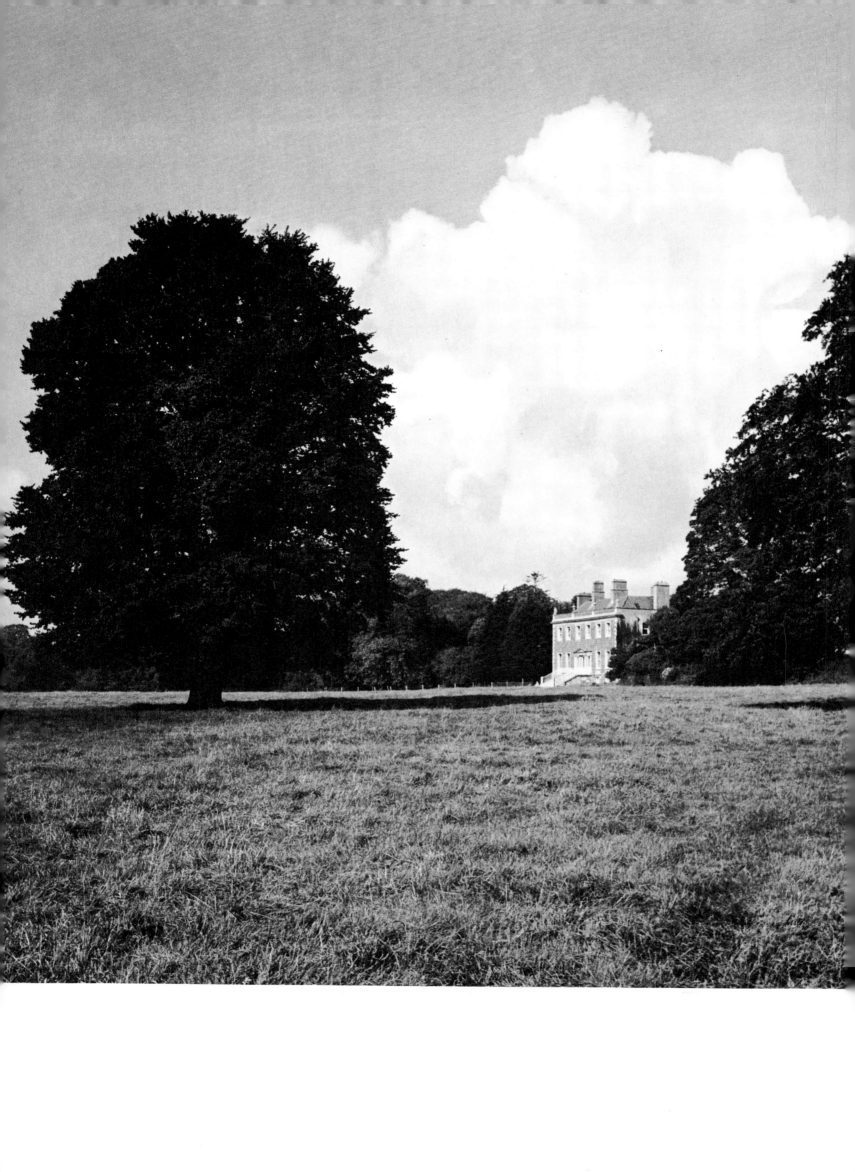

NEWBRIDGE

DONABATE, COUNTY DUBLIN

Mr Thomas Cobbe

NEWBRIDGE AND WESTPORT are the only two houses by Richard Castle to have remained in the possession of the family for which they were built, if Newbridge was indeed designed by him. This seems probable in view of the date, at which time Castle was firmly entrenched as the principal country-house architect of the day. Castle came to Ireland in 1728, and at the untimely death in 1733 of Sir Edward Pearce, with whom he had collaborated at the Parliament House, he more or less succeeded to Pearce's practice. The Rev. Charles Cobbe, eventually to become Archbishop of Dublin, purchased Newbridge on 21 June, 1736 for £5,526 5s 6d and set about building in the following year. At this time Richard Castle had Powerscourt, Westport, and Hazelwood already to his credit and he would certainly have been a likely candidate.

His buildings have a tendency to be rather ponderous both inside and out, in comparison with English work of the same date; perhaps this was a reflection of his Teutonic nature, for he was of German origin. The façade of Newbridge appears to be a modification of the sketch for an elevation reproduced here, which is preserved at Newbridge, together with some interesting bills and account-books – unfortunately these contain no mention of an architect, at least as regards the house.

The Archbishop died in 1765 and was succeeded by his son Thomas Cobbe, who married Lady Elizabeth Beresford, the eighth and youngest daughter of the first Earl of Tyrone. It was they who added the immense drawing-room, (*see p. 155*), 45 feet long, at the back of the original house, and who made the collection of pictures and statuary. The drawing-room has elaborate rococo plasterwork by Robert West, who was commissioned at the same time to adorn the family pew in the little Protestant church at Donabate in a like manner. 'The interior is remarkably neat', writes D'Alton in his *History of County Dublin*. 'The gallery has a handsomely-stuccoed ceiling, and is appropriated for Mr Cobbe's family.' The church also contains a monument to the Archbishop. Thomas Cobbe was succeeded by his son

Newbridge, Co. Dublin. The house seen from across the park

Charles, who was M.P. for Swords at the time of the Act of Union, and was 'almost the only one among the Members of the Irish Parliament who voted for the Union and yet refused either a peerage or money compensation for his seat.'

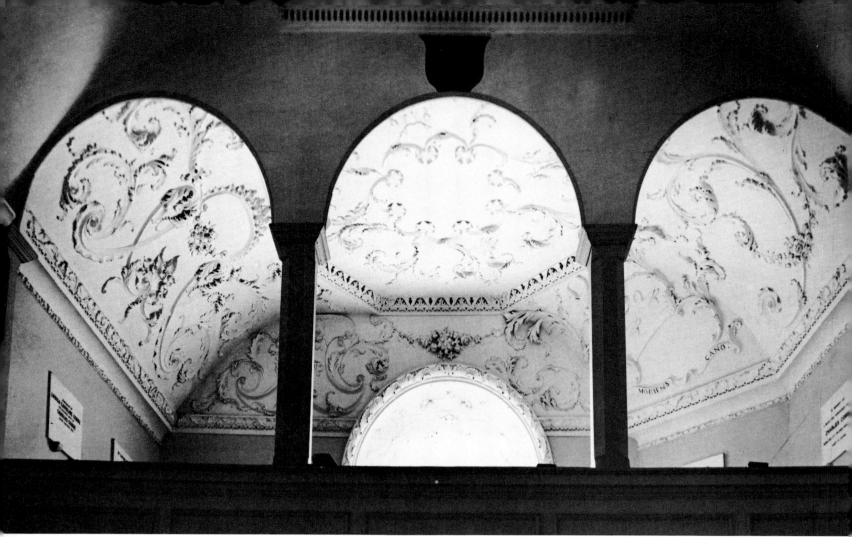

The Cobbe pew in the church at Donabate, decorated by Robert
West, which incorporates swans and the family crest in the ornament

Entrance to the saloon

Newbridge: the front hall

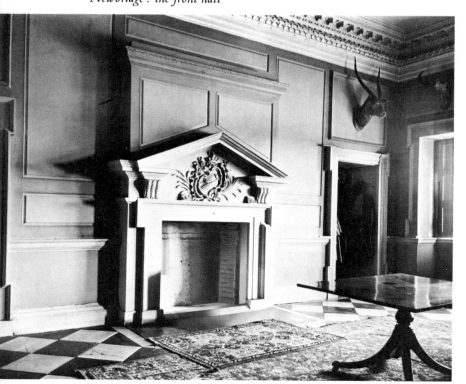

Frances Power Cobbe, grand-daughter of the M.P., writes of growing up at Newbridge in the 1830s and 1840s, and sheds some interesting light not only on country life at the time, but also on the thinking of the Anglo-Irish gentry. Although prominent in the English suffragette movement in her old age, and kindly disposed to those in want (in advance of her time too concerning cruelty to animals) it does not seem to have occurred to her that Ireland deserved the right to self-government. She describes a 'wicked speech' of Daniel O'Connell's, and her friend Mrs Evans, the aunt of Charles Stewart Parnell, tells her, 'There is mischief brewing! I am troubled at what is going on at Avondale' (Parnell's house in County Wicklow).

According to Miss Cobbe the 'society' which existed in Ireland at the end of the eighteenth century 'combined a considerable amount of aesthetic taste with traits of genuine barbarism; and high religious pretension with a disregard of everyday duties and a *penchant* for gambling and drinking which would now place the most worldly persons under a cloud of opprobium.' She recalls the rainy days when, at Newbridge, the card tables were laid at ten in the morning, and the interminable evenings of card-playing following the then fashionable four o'clock dinner. She adds: 'A fuddled condition after dinner was accepted as the normal one of a gentleman, and entailed no sort of disgrace.' She gives an interesting account of the days before the Famine and her recollection of the day the Famine struck.

Newbridge : the dining-room

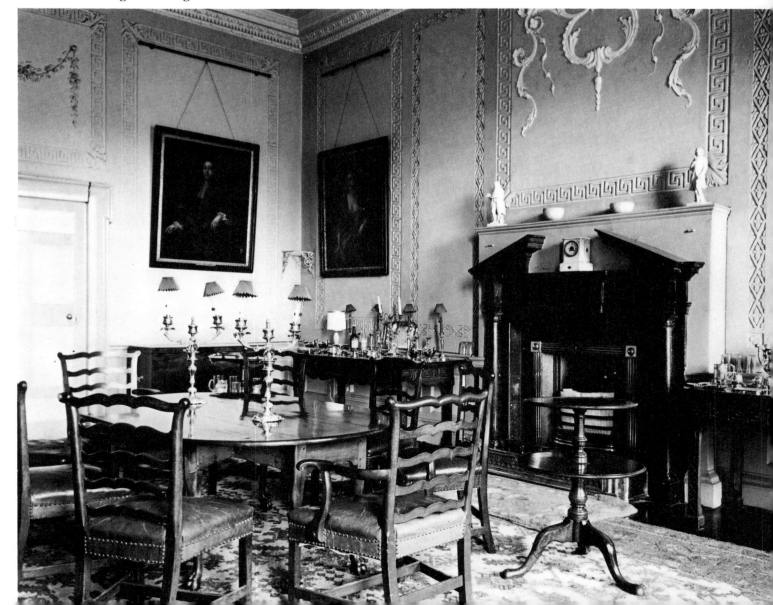

The wages of a field labourer were, at that time, about 8s. a week; of course without keep. His diet consisted of oatmeal porridge, wheaten griddle-bread, potatoes and abundance of buttermilk. The potatoes, before the Famine, were delicious tubers. Many of the best kinds disappeared at that time (notably I recall the 'Black Bangers'), and the Irish house-wife cooked them in a manner which no English or French *Cordon Bleu* can approach. I remember constantly seeing little girls bringing the mid-day dinners to their fathers, who sat in summer under the trees, and in winter in a comfortable room in our stable-yard, with fire and tables and chairs. The cloth which carried the dinner being removed there appeared a plate of 'smiling' potatoes (i.e., with cracked and peeling skins) and in the midst a *well* of about a sixth of a pound of butter. Along with the plate of potatoes was a big jug of milk, and a hunch of griddle-bread. On this food the men worked in summer from six (or earlier, if mowing was to be done) till breakfast, and from thence till one o'clock. After an hour's dinner the great bell tolled again, and work went on till 6. In winter there was no cessation of work from 8 a.m. till 5 p.m., when it ended. Of course these long hours of labour in the fields, without the modern interruptions, were immensely valuable on the farm.

<p style="text-align:center">* * *</p>

I happen to be able to recall precisely the day, almost the hour, when the blight fell on the potatoes and caused the great calamity. A party of us were driving to a seven o'clock dinner at the house of our neighbour, Mrs Evans, of Portrane. As we passed a remarkably fine field of potatoes in blossom, the scent came through the open windows of the carriage and we remarked to each other how splendid was the crop. Three or four hours later, as we returned home in the dark, a dreadful smell came from the same field, and we exclaimed, 'Something has happened to those potatoes; they do not smell at all as they did when we passed them on our way out.' Next morning there was a wail from one end of Ireland to the other.

Her Anglo-Irish heart was warmed by the generosity of the English public. In her view 'the agitators were afraid it would promote too much good feeling between the nations, which would not have suited their game.' A speech she heard by Daniel O'Connell in which he endeavoured 'to belittle English liberality' she found 'as wicked . . . as man ever made'.

In old age she indulges in the privilege of contrasting contemporary manners with those of her youth. She looks back regretfully to the rigours of grouse-shooting in the days of her father when she used to provide plain food, and before the development of 'the whole odious system of *battues*' had made the sport 'unmanly as well as cruel'. The redoubtable Miss Cobbe would be proud to know that the family still makes Newbridge its home, and that the present owner likes nothing more than to go out and shoot a duck for the pot after a hard day's work on the land.

Newbridge (1737), Co. Dublin: the red drawing-room, added c. 1765

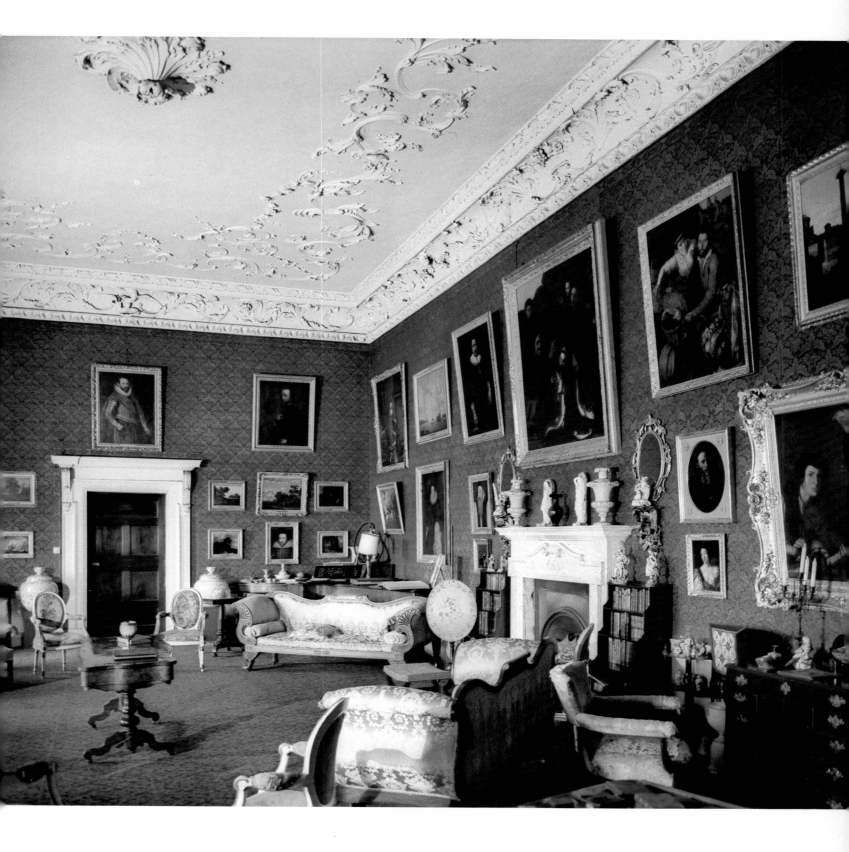

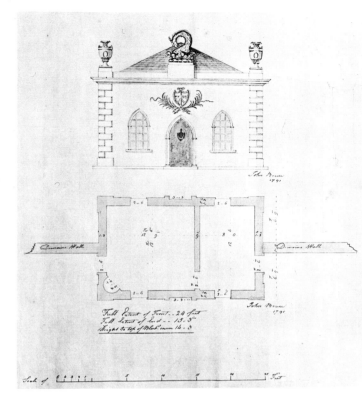

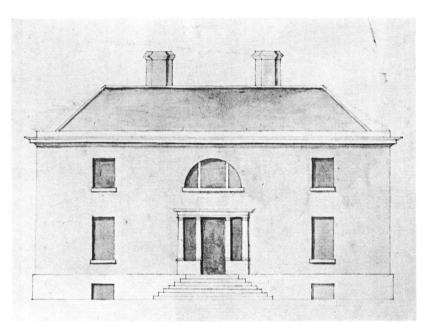

Design for a lodge for Newbridge by John Bruce, 1791.
(Coll. Thomas Cobbe)

Elevation, preserved at Newbridge, and
perhaps Richard Castle's original design for
the house

Ground-plan of Newbridge showing the
additions to the north of the main block

Rathbeale Hall
(1710), Co.
Dublin: the upper
landing. The
decoration appears to
date from 1740
(Below) curious
panelling in a
bedroom which
probably dates from
1710 (see p. 159)

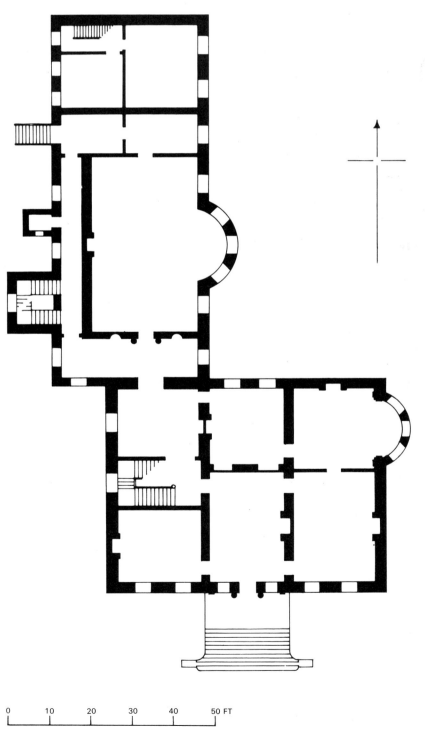

0 10 20 30 40 50 FT

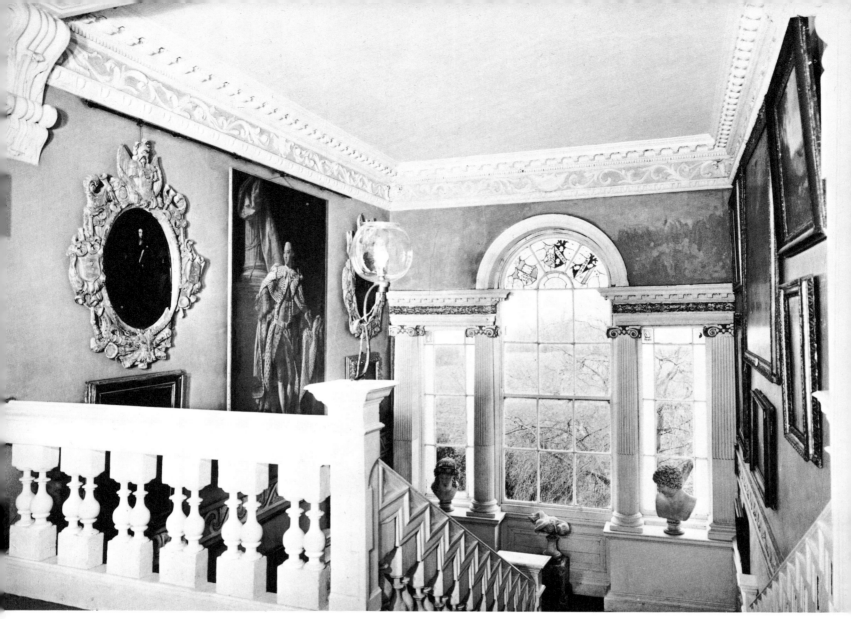

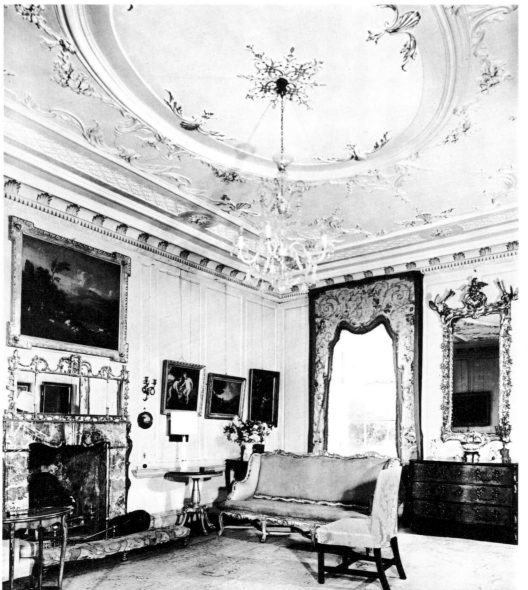

RATHBEALE HALL

SWORDS, COUNTY DUBLIN

Mr and Mrs Julian Peck

RATHBEALE IS AN EARLY eighteenth-century house, built of brick, which incorporates part of a still earlier structure. On Petty's map of 1685 it is called Ricanhore, and evidently the site was inhabited from early times; *rath* is an Irish word meaning a fortified mound. The house stands on an eminence enjoying distant views of the surrounding countryside. It was built in about 1710 by Lt.-Gen. Richard Gorges, whose son Hamilton, on marrying an heiress, Catherine Keating, renamed it Catherine's Grove.

Hamilton Gorges plastered over the brick and added the wings and curved sweeps, about 1740, perhaps employing Richard Castle who would have been the most obvious choice at the time. The handsome carved stone chimney-piece in the front hall dates from this period – the design is borrowed from Gibbs' *Book of Architecture,* and it is adorned with a cartouche quartering the arms of Hamilton Gorges and those of his wife Catherine. Oddly enough, it is not possible to have a fire here, as the wall was too narrow for a proper fireplace, having been inserted after the house was built. Instead, it was fitted up to take the chimney of a stove. The hall is painted a faded blue, the original colour or, at all events, one that has been there for many years, which can only be described as 'magic'. It is relieved by the white plaster tabernacle frames and also the white of the doorcases.

The early eighteenth-century staircase, similar to that at Leixlip Castle (q.v.) has been painted white. It is lit by an elaborate Venetian window which dates from the time of Hamilton Gorges' improvements, and is flanked by Corinthian pilasters. One of the most satisfactory features of the house is the upper landing, which has two symmetrical doorcases on either side, and in the centre of the wall opposite, a niche that in fact is a pair of curved panelled doors leading into a bedroom above the hall door which served until recently as the chapel. (*See p. 156*)

The plasterwork in the downstairs drawing-room and boudoir is of exceptional quality, and appears to date from 1740; it is characteristic of the Francini brothers, and should be compared to their work at Tyrone House, Dublin, and Riverstown, Co. Cork. It is hard to

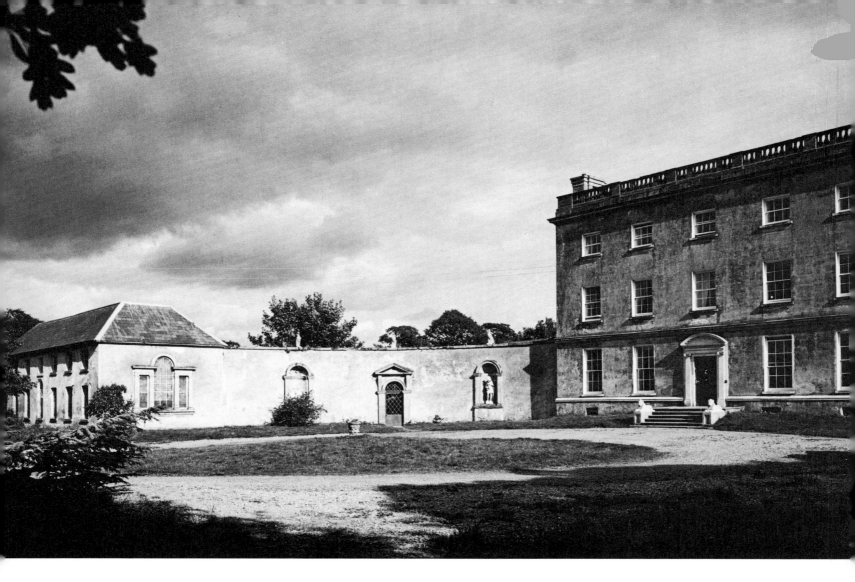

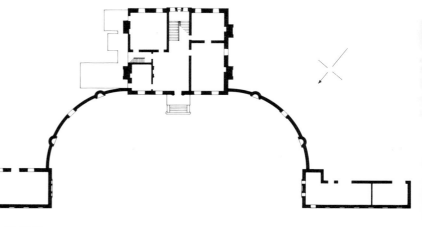

*Rathbeale Hall: the exterior: the house dates from c. 1710
but the wings and quadrants from c. 1740*

*Front hall mantel, decorated with the arms of Hamilton
Gorges quartered with those of his heiress wife, Catherine*

*Ground-plan of Rathbeale Hall; the nineteenth-century
additions to the east of the main block, which include a billiard
room, are outlined*

(Right) The dining-room mantel

(Far right) The boudoir

know what to make of the elaborate altar-like mantel in the boudoir, but the carving is seventeenth-century as is the panelling in the bedroom above.

In 1810, the house was bought by Matthew Corbally, who changed its name back to Rathbeale. This must have remained the name of the house in local usage, because in Rocque's map of County Dublin, 1760, it is called 'Rebaille', although at that time the house was officially called Catherine's Grove.

Lady Mary Corbally was the last of that family to live there, and her son sold the house and land in 1958. It was bought by a farmer who did not, however, take up residence, and after a few years the place, surrounded by a sea of mud, began to look semi-derelict. Fortunately the mantels are not of the fashionable 'Adam' type or they would certainly have been stolen out of the house, as the front door was swinging open and the hall was used for storing old corrugated iron. The interior had not been painted for many a year, and people who were taken to see Rathbeale by the Irish Georgian Society were convinced that it was past rescue.

The present owners, however, have stepped in and taken up the challenge; now the house is safe and restored to its former beauty. Those concerned for the future of Irish houses of the Georgian period owe a debt of gratitude to them for undertaking this formidable task. All the mantels, the plasterwork, the generous black-and-white squared, front hall floor, and some very curious carved woodwork remain intact, and the work of restoration has been patient and understated.

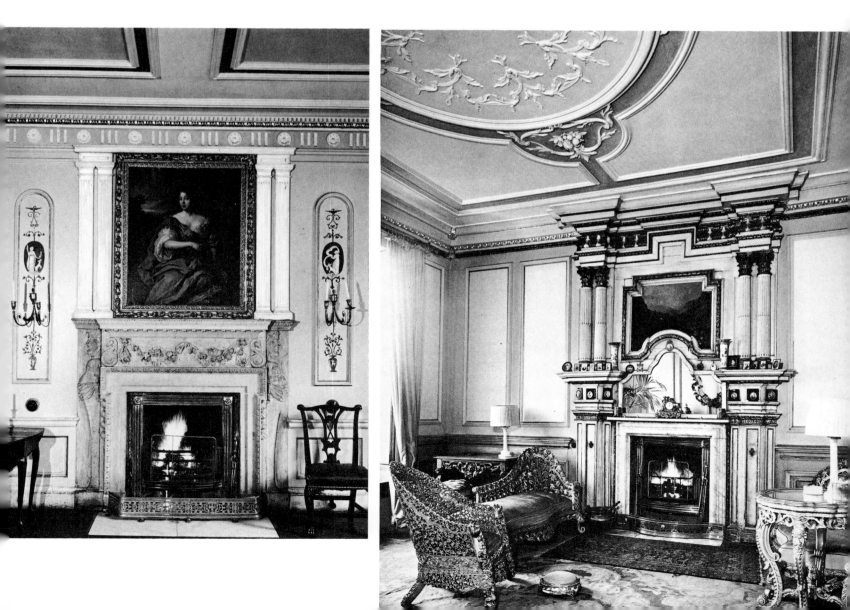

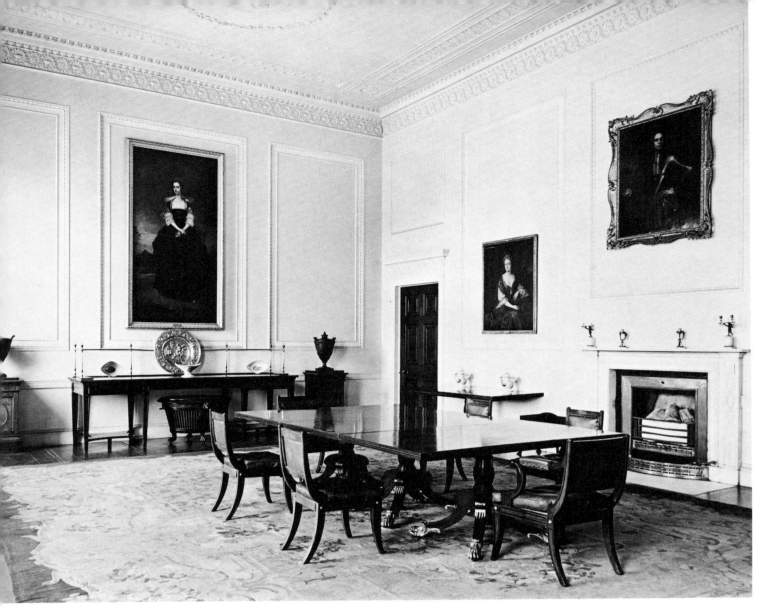

Castlecoole : the dining-room. (Below) The drawing-room

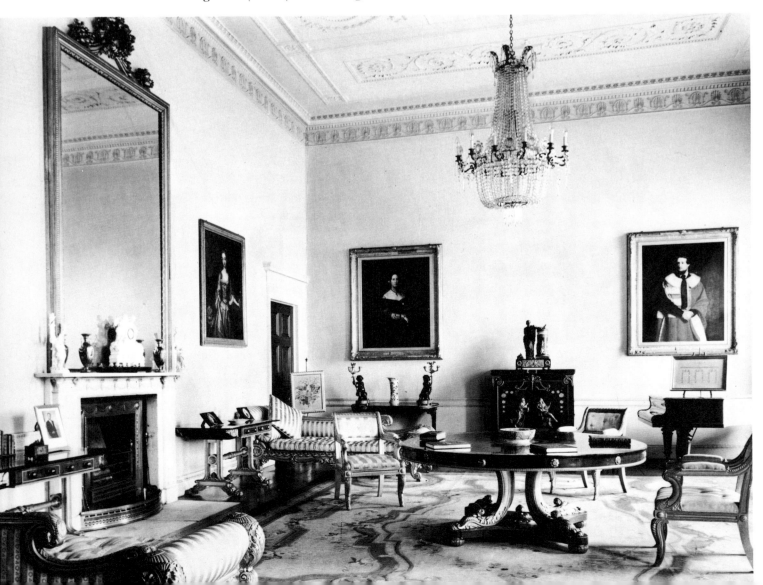

CASTLECOOLE

ENNISKILLEN, COUNTY FERMANAGH

The Earl of Belmore

The National Trust (Committee for Northern Ireland)

AS WE SEE NO REASON why the complimentary title of 'Palace' should be conceded to a Bishop's residence, and withheld from that of a temporal Peer, who has expended a fortune in the erection of a house that does honour to his name and country; and which, in reference to the important appendages of wood, water, prospect, and demesne, far exceed in beauty, value and extent, the generality of those seats which have been created for the accommodation of *spiritual* Peers on the ecclesiastical domains of this country. As we see no reason, we say, why this compliment should be paid to a Bishop's residence (now that the days of ecclesiastical monopoly are passing rapidly away) and withheld from that of a temporal Peer, merely because he is a plain honest Lord, who acknowledges he is a sinner like another man; so in the description of Castle Coole, we shall not hesitate to call Lord Belmore's house a palace, notwithstanding his Lordship may be a sinner and no Bishop

(A. Atkinson, 1833; *Ireland in the Nineteenth Century,* p. 392)

Castlecoole is indeed a palace, and unrivalled as the finest house in Ireland to be built in the restrained Grecian taste of the 1790s. It was built for the first Earl of Belmore by James Wyatt, who probably never saw it, and who left the supervision of the building to his assistant Alexander Stewart. (*See p. 173*)

The estate was purchased in 1656 by John Corry, a native of Scotland, who had become a prosperous merchant in Belfast. He died in 1683, and it was his son Colonel James Corry who built the early eighteenth-century house. His grand-daughter and eventual heiress, Sarah Corry, married Galbraith Lowry in 1733. It was their son, Armar, born in 1740, who was made Baron Belmore of Castlecoole in 1781 and Earl of Belmore in 1797, and who took the name of Lowry-Corry. He married, as his second wife, Henrietta, daughter of the Lord Lieutenant, the Earl of Buckinghamshire. She was described by a contemporary as 'a young lady possessed of youth, beauty, elegance of manner and a fortune of £30,000'.

He adds: 'It affords a pleasing reflection that a native of this country has been destined to enjoy such supreme felicity.'

In the library there is a drawing, by a certain John Curld, for the original house, built in 1709 and replacing two previous houses on the same site. It was a small 'Dutch' house of no pretension, dominated by a rather heavy pediment. In 1797, just as the present house was nearing completion, this earlier house was burnt to the ground when a pan of ashes was accidentally left on the wooden staircase. Presumably the old family pictures and furniture were destroyed at this time, which explains their absence in Castlecoole today.

Wyatt's designs for Castlecoole are based on drawings (on display in the house) by Richard Johnston, the architect of the Gate Theatre in Dublin, and the elder brother of the more famous Francis. Wyatt furnished designs for the ceilings and even for the curtains, which were closely followed. Unlike most Irish houses, a complete set of the building accounts has survived, and when the joiners had finished the doors and windows they turned their attention to the furniture which is still in the rooms for which it was made.

Castlecoole is an uncommonly perfect house. The quality of the cut stonework, carved on the site, is as perfect on the back and sides as it is on the front. The Portland stone of which it is built was brought by sea to Ballyshannon, where a quay was constructed to receive it, and from there it was taken overland to Lough Erne. The massive blocks were then shipped to Enniskillen, and brought the last two miles by bullock cart to the site. In February 1790 a handful of stone-cutters was at work, and by May there were eight masons. The month of June 1791 saw the work at its height; the wages bill was £159 13s 7½d for a force of twenty-five stone cutters, twenty-six stone masons, ten stone sawyers, seventeen carpenters, and eighty-three labourers.

The story that Lord Belmore, in true planter style, wished to use only imported materials in building his new house, is no doubt apocryphal and probably derives from his use of Portland stone. Because none were available locally, English plasterers made the long journey to Castlecoole to execute the ceilings, under the supervision of Joseph Rose, who had worked for Adam at Syon and Harewood. It was not easy to persuade them to come; they had to be bribed with extra wages on account of their fear of being press-ganged. Furthermore, the place had acquired a poor reputation among the decorators. In June 1793 Rose writes to Lord Belmore:

I am afraid I shall have some difficulty in getting the ornament men to come because I understand that there are letters come to London from the last men I sent saying that it is an unhealthy place, that most of them are ill and that there is not lodging for them but in damp rooms. Indeed, my lord, if you should, now or hereafter, be dissatisfied with me for its costing you more money than you expected, I shall wish I had never seen Ireland.

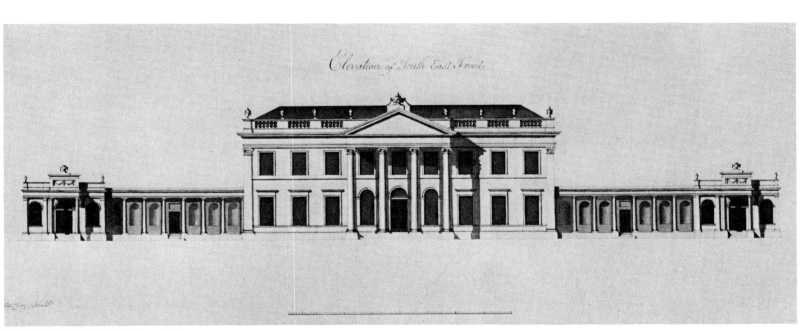

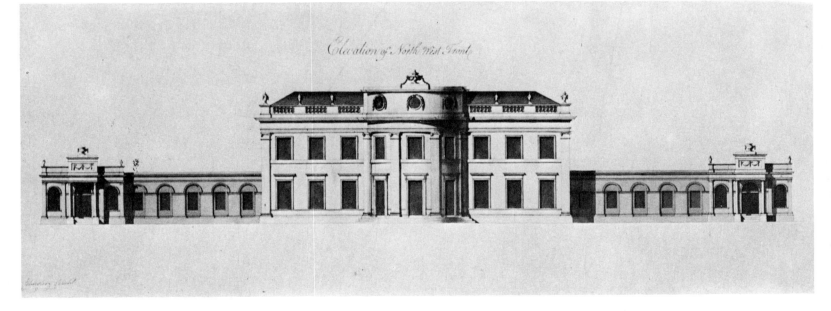

Castlecoole : Richard Johnston's elevation for the entrance front, on which Wyatt's design was based, and his drawing for the north-west front. Both signed and dated, Dublin 1789

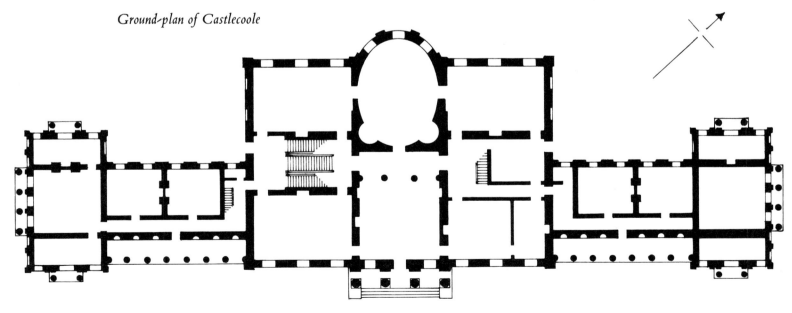

Ground-plan of Castlecoole

0 10 20 30 40 50 100 FT

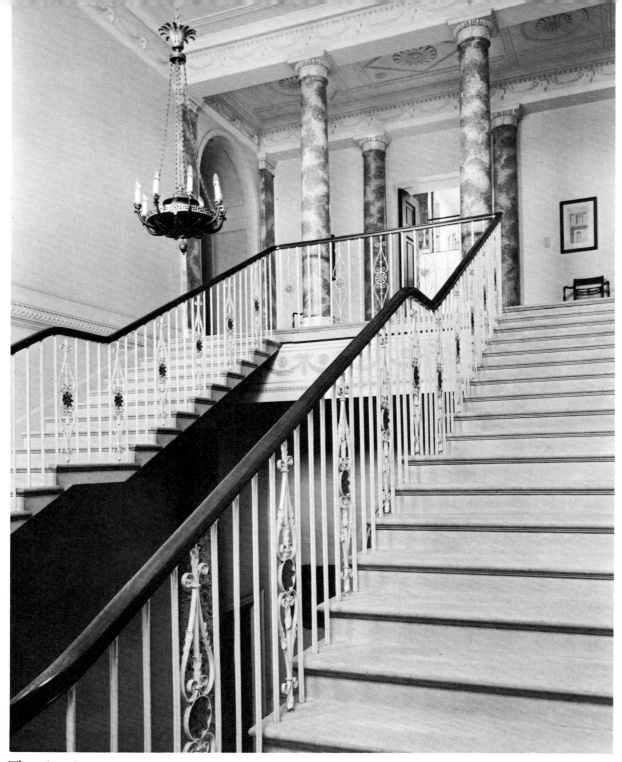

The twin staircase

Six mantels by the English sculptor Westmacott, costing £969 altogether, were shipped to Castlecoole accompanied by two men competent to install them. They were set in position in 1796. The twin mantels in the hall, whose design echoes the frieze around the ceiling, are rather small for that lofty apartment and some attempt to remedy this has been made by the addition of a grey marble surround. The library mantel is particularly unusual, and quite out of keeping with the delicate ceiling ornament; it was carved to simulate festooned drapery, and cost £126.

The Earl of Belmore died in 1802 only four years after the completion of the house, and left debts of £70,000. It was probably for this reason that the furnishing was completed by his son, the second Earl, in the heavy Regency style which contrasts as unhappily with the delicate ornament as do the baroque picture frames of the 1750s. Sir Richard Morrison designed the elegant farm and stable yard in 1820. The house had cost nearly twice the estimated £30,000 to build, and the work had taken ten years instead of five. The accounts show that the austerity and refinement of the plasterwork, so well matched to the Grecian purity of the house, was in part a measure of economy. (*See p. 174*)

The park contains some magnificent timber, much of which is older than the house itself. One of the drives is flanked by an avenue of ancient oak trees which leads to the site of the original house, where traces of an early formal garden can still be seen. Castlecoole is well-known for having on its lake the oldest non-migratory flock of greylag geese breeding in the British Isles. They were introduced by Colonel James Corry about 1700 and are well cared for; legend has it that when they leave Castlecoole, so will the Lowry-Corrys.

The house has been maintained by the National Trust since 1951; the family still own the contents and have the right to reside there.

The first Earl of Belmore, builder of Castlecoole. (Right) The front hall, with, over the mantel, a version of Allan Ramsay's portrait of Queen Charlotte

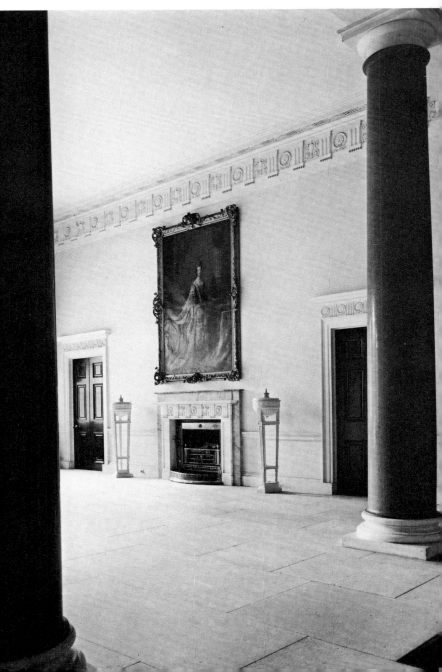

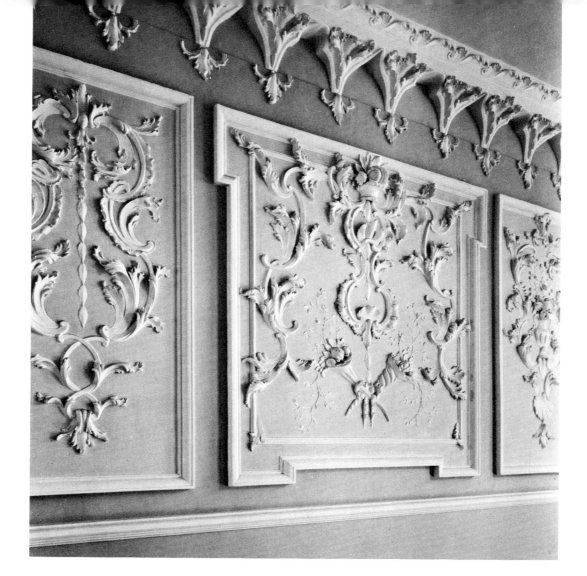

Florence Court:
plasterwork on the
staircase

The front door

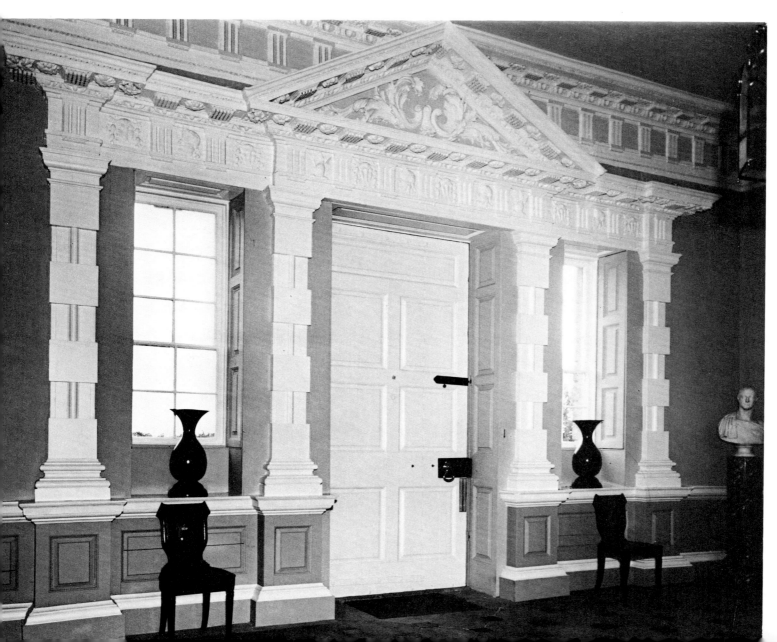

FLORENCE COURT

ENNISKILLEN, COUNTY FERMANAGH

The Earl and Countess of Enniskillen

The National Trust (Committee for Northern Ireland)

THE ORIGINAL DRIVE, which led across the park, left the visitor to Florence Court in no doubt as to the size and beauty of the house. There it was, surmounting a crest ahead of him, like some huge grey bird with wings outspread. Today, however, there is an element of surprise. A long straight avenue leads through dark woods, and it is not until the last moment that it takes a sudden turn and rounds the side of the house (*see p. 173*). Then the mountains of Benaughlin and Cuilcagh spring into view to the south, forming a dramatic blue back-drop far away in the distance.

As is the case with so many Irish houses, even those that have not changed hands, neither the architect nor even, in this case, the date are known. In 1723 the burning of Crom is said to have been observed by its owner during the course of a house-warming party in Florence Court. If this legend is accurate, the central block must have been built by John Cole (d. 1726). At all events, the general opinion is that it was built at two periods, the central block first, the arcades and wings being added later in the eighteenth century. For all its beauty, the façade of the main block has a certain naive quality which is half its charm. The architectural detail is more professionally handled in the arcades and wings, although they succeed in blending happily with the central block.

The architect of these additions, and of the curved sweeps and wings at the back of the house, may very well have been the Sardinian Davis Ducart. He designed at least three other eighteenth-century buildings in Ireland with straight arcades on either side of the central block, namely Kilshannig, Co. Cork; Castletown, Co. Kilkenny, (both of which are illustrated in this volume) and the Customs House in Limerick. Kilshannig, like Florence Court, has arcades on one side of the house and curved sweeps on the other. Ducart had an interest in some collieries in County Tyrone which would have brought him to Ulster in the 1770s. The legend that Florence Court was designed 'by Italians', which is given as the reason it faces east (Italian houses fearing the sun), may stem from Ducart's association with

the house, and when the *Post Chaise Companion* of 1806 states that it was built 'about 24 years' it may be referring only to these additions. To add credence to this theory, there is an estate map dated 1768 which shows the house without its arcades and wings.

On the other hand, the central block may have been built at some time during the life of John Cole, M.P. for Enniskillen, who inherited the property at an early age in 1726, married Elizabeth Montgomery in 1728, and was elevated to the peerage of Ireland in 1760 as Baron Mountflorence of Florence Court. He died in 1767 and it would have been his son William who added the arcades and wings to the house. Mrs Delany mentions having seen 'Mr Cole (£5,000 a year and just come from abroad) – a pretty, well-behaved young man', at a ball at Mount Panther in 1758. In 1789 he was created the first Earl of Enniskillen; he voted against the Union, and died of influenza in 1803 on a visit to his sister at Hazelwood, a magnificent house near Sligo by Richard Castle that still survives.

On stylistic grounds the main block would appear to date from the 1750s. It is true that the panelled doors on the bedroom floor with their central division are of a type that had gone out of fashion in Dublin by 1740, but after all Fermanagh is a long way from the capital. The rococo plaster decoration, which is extremely lively, appears to date from 1755 and resembles the work of Robert West, the Dublin architect and stuccodore.

After the house was given to the National Trust, much of the plasterwork was destroyed when it caught fire in 1955. The National Trust under the direction of Sir Albert Richardson

Fire at Florence Court, 1955; the fire was caused by a spark from a blowlamp

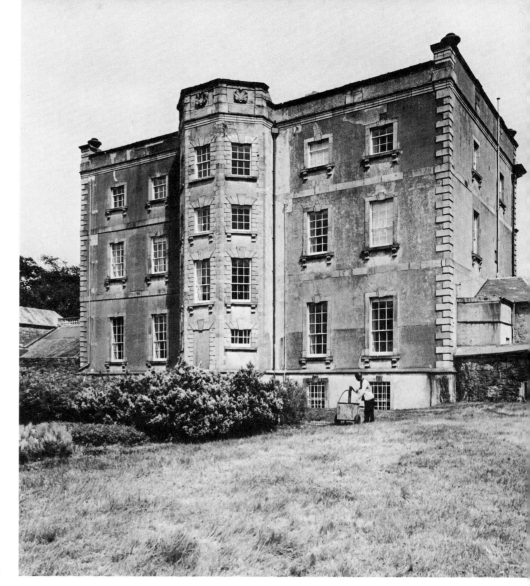

The back of the house

replaced as much of the plasterwork as was possible and at the same time restored the archi-tectural features of the interior to their original form, thus making the house rather more formal than it was previous to the fire. For the restoration of the plasterwork Sir Albert was able to make use of photographs published, in *Georgian Mansions in Ireland,* as long ago as 1915. Unfortunately no photographic record was ever made of the unique plaster ceiling in the nursery on the top floor, where drums, rocking horses, and other toys had been incorporated in the ornament, and to avoid expense no restoration was done on this floor. At the time of the fire, which was caused by a spark, Mr Bertie Pierce (of Henry Pierce & Sons, builders) in charge of the building repairs for the National Trust, lifted some floorboards in the room above the dining-room and drilled holes through the plaster ceiling beneath, so that the water, poured into the house from the fire engines, could escape. It is the best ceiling at Florence Court, and had it not been for this action, it would without doubt have collapsed from the weight of the water.

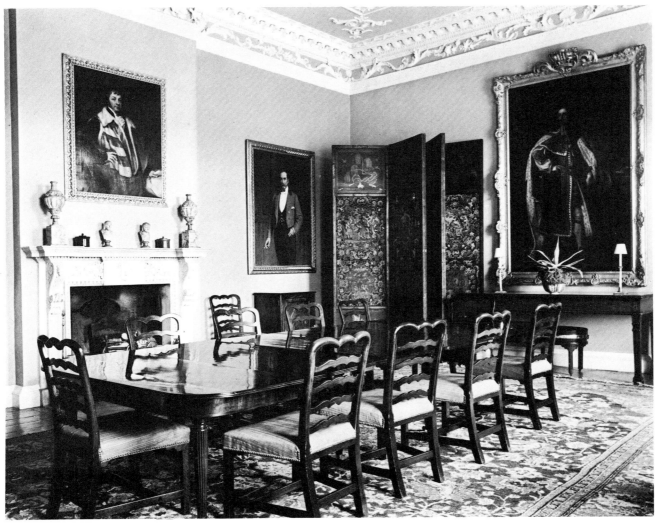

Florence Court: the dining-room

Captain Sir William Cole Kt. was the first of the family to settle in Ireland. He was granted lands at the time of the Plantation of Ulster by James I as a reward for service in Holland, and for having raised a regiment of horse in his native Devonshire for Queen Elizabeth's campaign in Ireland. At first Sir William lived in a 'good timber house, after the English fashion' beside the fort in the town of Enniskillen. When the status of that town was raised to that of a Municipal Borough in 1612, he was made its first Provost, and he was knighted in 1617. The town was protected by 'a fair strong wall newly erected, of lime and stone, twenty-six foot high, with flankers and a parapet, and a walk on top of the wall, built by Captain William Cole.' It was not considered safe to live outside the town until the eighteenth century. Rebellion and murder were forever in the air, smouldering in the breast of the dispossessed Irish by whom the settlers were surrounded. In 1641 Sir William managed to avert the massacre of several of the principal men of the district, including himself, while they were dining nearby at Crevenish Castle.

Florence Court, Co. Fermanagh. The central block dates from about 1730 and it is thought that the arcades and wings were added in 1770

Castlecoole, Co. Fermanagh: the entrance front, designed by James Wyatt and begun in 1790. (See p. 163)

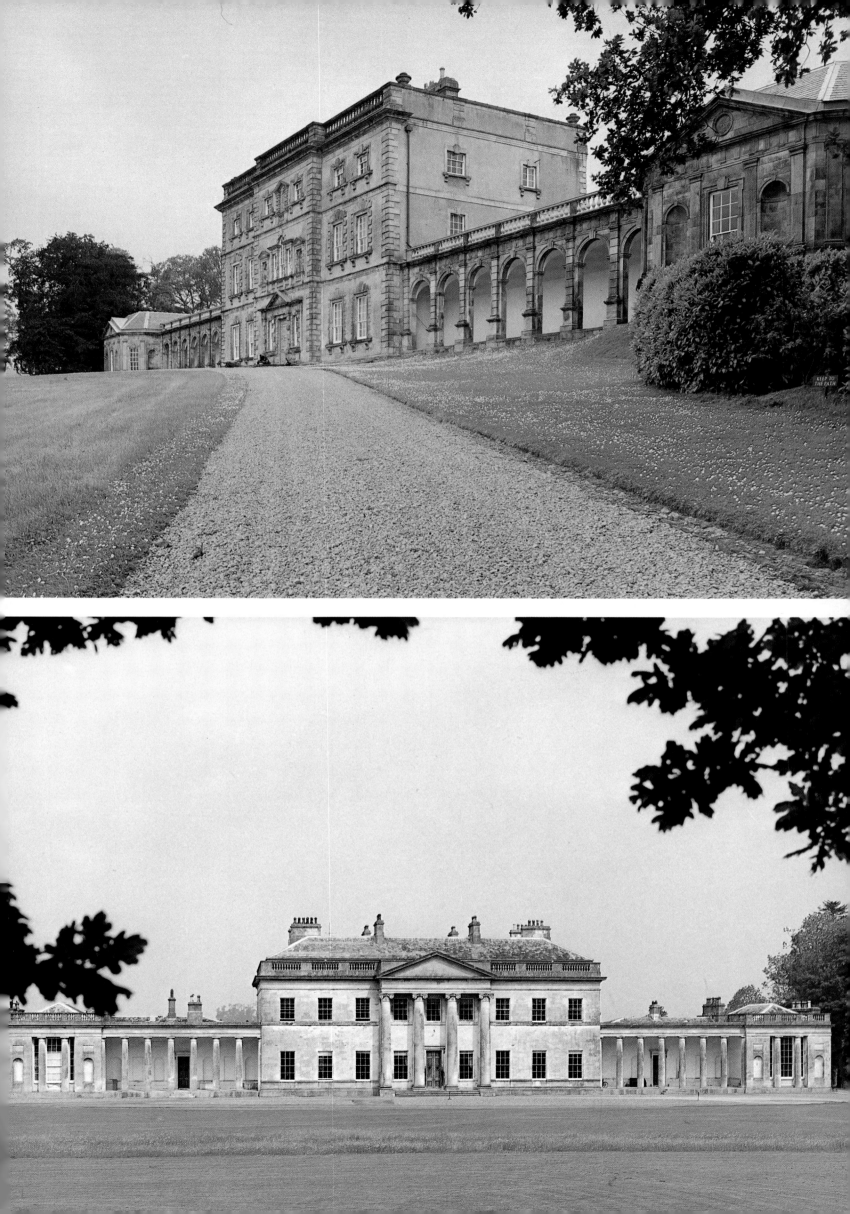

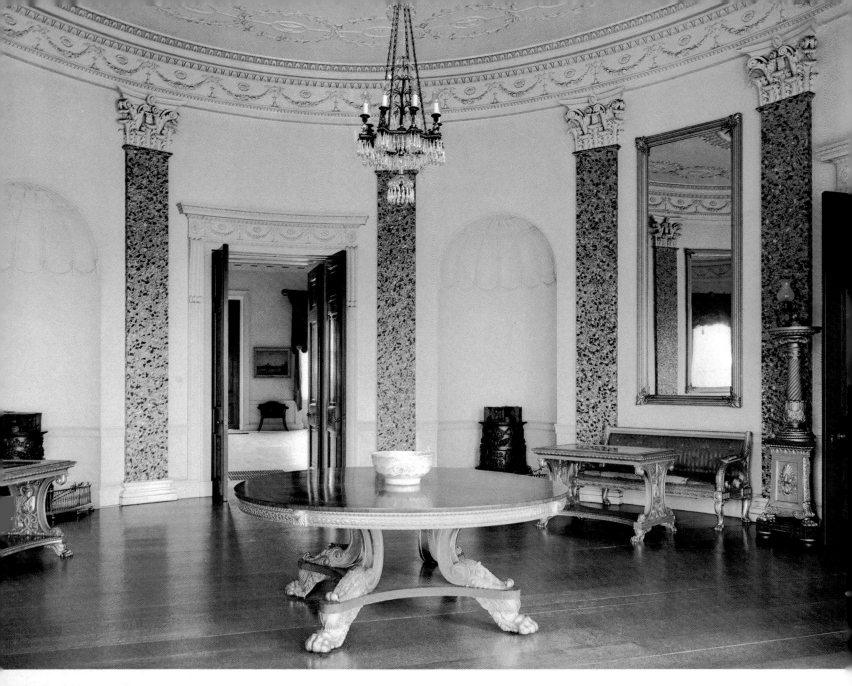

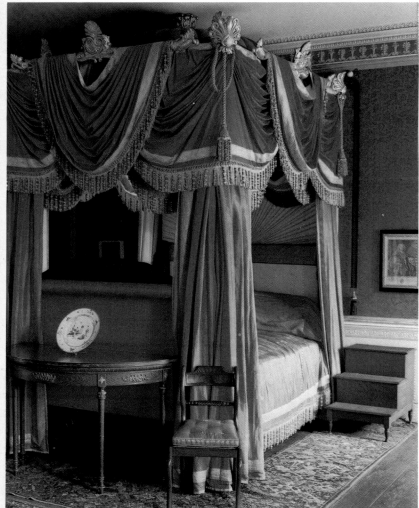

Landscape, by an unknown artist, at Florence Court, depicting Devenish Island on Lough Erne

The family prospered in this wild and remote corner of County Fermanagh, so different from their native Devonshire. In 1710 the property descended to John Cole of Florence Court, M.P. for Enniskillen, who, three years before, had married Florence Bourchier-Wrey, 'a virtuous young lady of great renown'. They built a house which was named for her after the fashion despised by Swift in his essay on 'Barbarous Nomenclature'. It may have been no more than a shooting lodge – the early panelled doors in the present house might have been saved from it when it was pulled down. He died in 1726 and his son and namesake was, as we have seen, perhaps the builder of the main part of the present house.

It was in 1953 that Florence Court was presented to the Committee for Northern Ireland of the National Trust by Viscount Cole, son of the fifth Earl of Enniskillen. An endowment was provided by the Government of Northern Ireland for its restoration and maintenance. Viscount Cole died unmarried in 1956. After the death of the fifth Earl in 1963, the house was occupied by his nephew, the sixth Earl, and his wife.

Castlecoole (1790), Co. Fermanagh: the ballroom and (below) the state bedroom (see p. 163)

Lough Cutra Castle : John Nash's elevation for the front, signed and dated October 1811
Ground-plan of Lough Cutra Castle ; Nash's original castle is shown in black

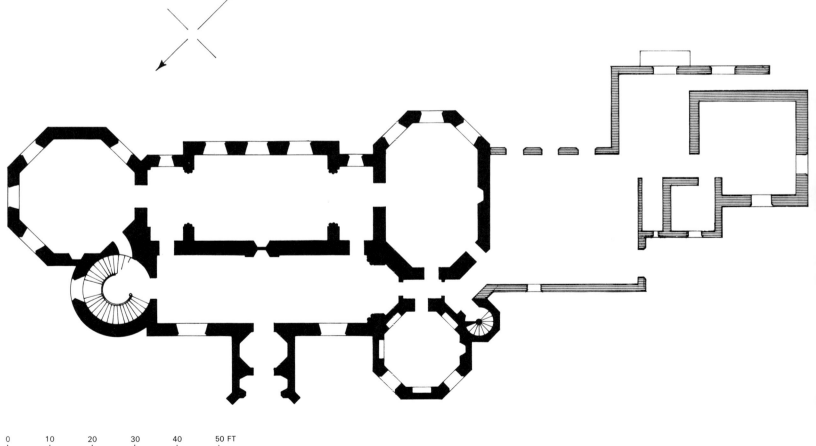

0 10 20 30 40 50 FT

LOUGH CUTRA CASTLE

GORT, COUNTY GALWAY

Mr and the Hon. Mrs Paneyko

JOHN NASH BUILT at least four Gothic castles and designed or added to as many classical houses in Ireland. His pupils the Pain brothers who were sent over by him to execute his commissions, set up in practice on their own and, among other buildings, Dromoland Castle was theirs. Nash is best remembered for his work as George IV's protégé at Brighton and Buckingham Palace, and for the elegant, white, pilastered terraces he put up beside the Regent's Park. His own taste was for the classical. 'I hate this Gothic style,' he was heard to complain; 'one window costs more trouble to design than two houses ought to do.'

> Augustus at Rome was for building renown'd
> And of marble he left what of brick he had found;
> But is not our Nash, too, a very great master?—
> He finds us all brick and he leaves us all plaster.

Nash has often been accused of slipshod workmanship, and on occasion he substituted wooden battlements for stone or plaster as an economy. His pupils James and George Richard Pain used the best building materials on Lough Cutra; as it stood empty for forty years, from 1928 to 1968, this was indeed providential. Less fortunate was Nash's habit of hiding down-pipes by putting them between the wall and the plaster – over the years, of course, they became blocked up and overflowed causing extensive damage to the fabric. Thanks to the courage and initiative of the present owner, Lough Cutra has been rescued from a state of near ruin and restored at the eleventh hour. Nash's Gothic *œuvre* in Ireland has not fared well. Shanbally Castle, Co. Tipperary, has gone, as has Kilwaughter Castle, Co. Antrim; Killymoon Castle, Co. Tyrone, is however in good hands. Of his classical buildings in Ireland, Rockingham, Co. Roscommon, was destroyed by fire, but Caledon, Co. Tyrone, to which he made additions, survives. Gracefield Lodge, Co. Leix, is a small 'cottage orné' and can be classed with Lissan Rectory, Co. Londonderry.

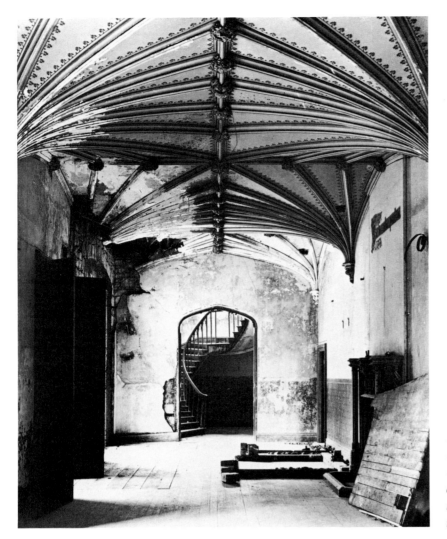

Lough Cutra has been rescued at the eleventh hour by the present owner when most would have considered it past saving. Rooms of the castle before and (facing) after restoration

The lake here is named for a Firbolg chieftain, 'Cutra', who must have been established on its shores. The Firbolg originated on the Continent, and were one of the Celtic tribes that invaded Ireland about 600 BC. The lake is eight square miles in extent. Its surplus waters vanish underground about two miles from here at a place called 'The Ladle'; after reappearing and disappearing several times they empty into the lake of Coole, and from there flow underground to join the sea.

The territory hereabouts was not without strategic importance, as the road from Connaught to Munster goes through it, between the mountains and the sea. For centuries it belonged to the O'Shaughnessys, whose principal stronghold was at Gortinchegorie, where the town of Gort now stands. Sir Dermod O'Shaughnessy's estates here were seized by Cromwell, and restored in 1678 to his grandson Sir Roger; eleven years later they were forfeit again, to William of Orange. In 1690 Sir William O'Shaughnessy, the son of Sir Roger, fought as a captain, though only 15 years old, for the Jacobite cause and followed Lord Clare to France where he pursued a brilliant military career, attaining, in 1734, the rank of Maréchal de Camp.

William of Orange gave the O'Shaughnessy estate to one Thomas Prendergast in 1697 as a reward for exposing a plot against his life. In 1709 he was further rewarded with a baronetcy. The property descended to his great-nephew John Smyth in 1760, who took the name Prendergast-Smyth. In 1782 he became Colonel of the Limerick Independents, one of the first Volunteer regiments to admit Catholics to their ranks. He was an opponent of the Union. In 1810 he was made Baron Kiltartan of Gort, and in 1816 Viscount Gort of the City of Limerick. He died in 1817, and in accordance with the special remainder the title passed to his sister's son, Col. Charles Vereker.

Vereker was something of a local hero. He had defeated the French General Humbert at Coolooney in 1798; Humbert said of him on surrendering his sword to Lord Cornwallis, 'I met many generals in Ireland, but the only soldier among them was Colonel Vereker.' It is said that he made his small body of 300 men seem more numerous by putting red petticoats round the shoulders of local people and marching them about. He was offered a

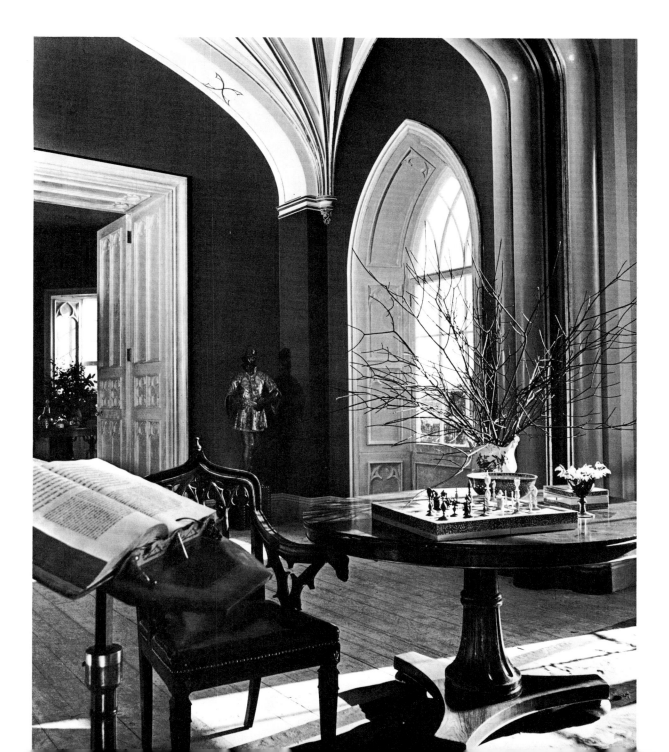

peerage but as this would have meant voting for the Union he turned it down, saying, 'Having defended my country with my blood, there is nothing that could tempt me to betray it with my vote.' His popularity increased still further when he rescued a man who was being publicly scourged in Limerick, running through the offending officer with his sword.

Vereker was given the Lough Cutra portion of his uncle's estates in 1810, and commenced the building of his sham castle by the shores of the lake in 1811. The style was suitable for a military man. It was based on Nash's own castle, East Cowes, on the Isle of Wight, which had been seen and admired by Vereker, and which, oddly enough, was eventually to become the property of the Gorts also. The design consists of three towers linked by low horizontal castellated blocks, set among enormous beech trees and rare flowering shrubs in a landscape of great beauty.

The third Viscount Gort inherited in 1842 and was ruined by the Famine, when he refused to collect rents and gave large sums to charity, including £5,000 to the poor-house. As a result Lough Cutra was sold in 1851 to the Sisters of Loreto, who in turn sold it to Field-Marshal Viscount Gough in 1854. Lord Gough came from a Limerick family, and like so many others connected with Lough Cutra was a great soldier, having distinguished himself in the Peninsular War, India, China, and so on. He added the Clock Tower, and employed Crace and Co. to redecorate the interior embellishing it with war emblems and Latin mottos. A specially made wallpaper, printed in a variety of colours, was used in the main rooms, incorporating viscount's coronets, Union Jacks, and battle honours in the design. Messrs. Cole, the wallpaper manufacturers, had kept the original wood blocks and have been able to reproduce the Lough Cutra paper today. In 1900, his grandson put on an unwieldy extension to accommodate the family collection of military trophies; this has, rightly, been removed.

The present Lord Gort is well-known in Ireland for having restored Bunratty Castle (q.v.) to contain his magnificent collection of medieval furniture, which he has bequeathed to the State. He is a brother of Field-Marshal Viscount Gort, v.c. of First World War fame. On purchasing the estate he commenced farming operations, but it was not until the present owner, his great-niece, was given the property that restoration of the castle was embarked on. Mrs Paneyko's mother was Jacqueline Vereker, the daughter of the Field-Marshal, and her father is Viscount de L'Isle and Dudley, v.c. The restoration has cost in the region of £50,000 and has been done by local craftsmen without an architect or contractor. The estimate made professionally for the Shannon Development Co. was for £120,000. The Government have contributed £6,000 towards the cost on the understanding that Lough Cutra will be open to the public. Mrs Paneyko deserves the thanks of all for having undertaken the formidable task of restoration.

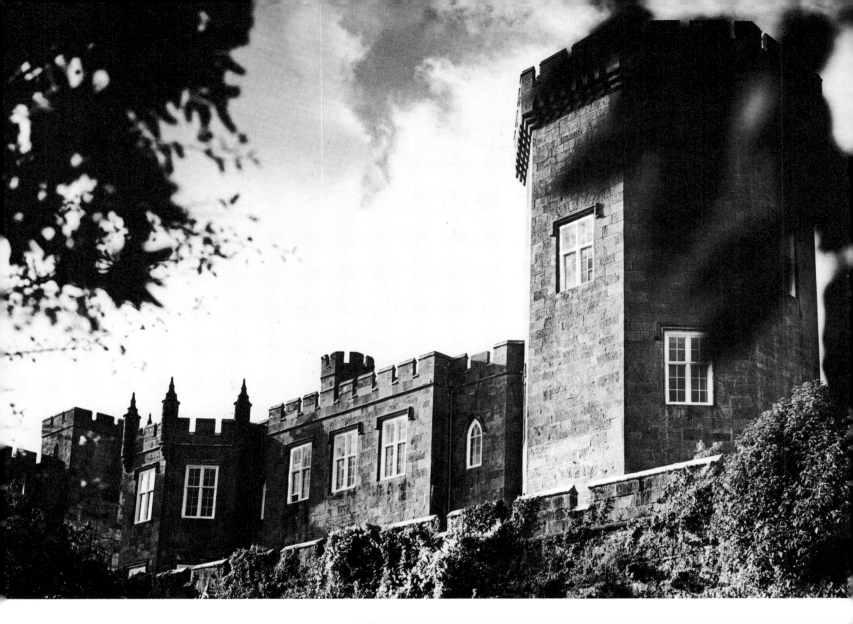

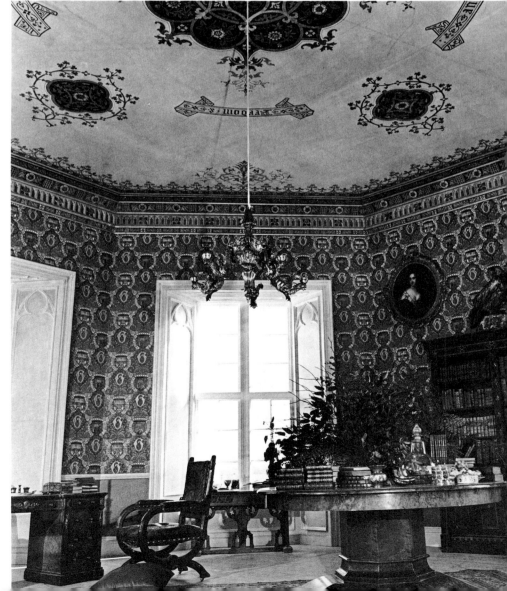

The restored exterior and interior show no sign of the previous dilapidation. The Cole wallpaper (right) incorporates Lord Gough's coronet, cypher and battle honours

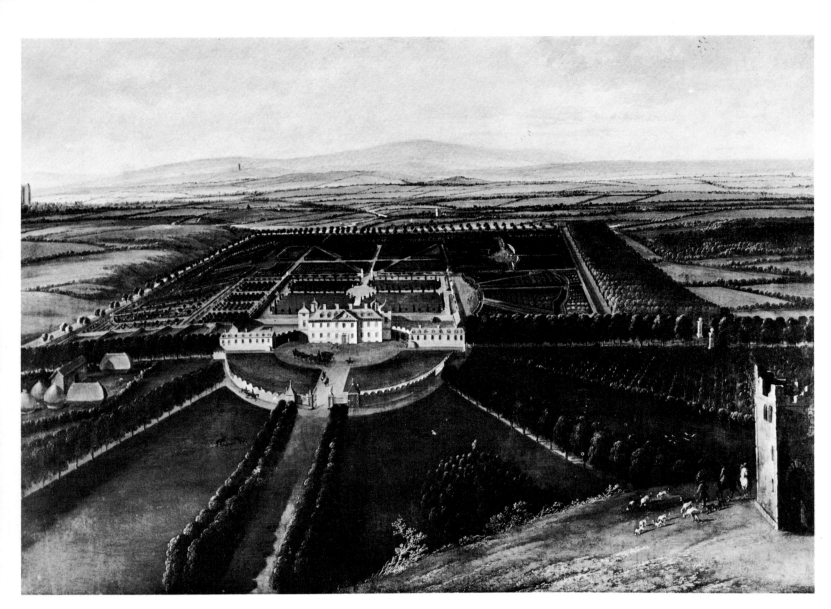

'Carton before 1738', a painting by Van der Hagen that hangs in the front hall

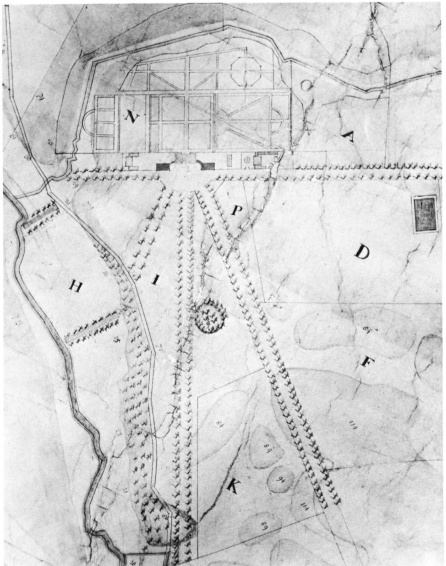

A plan of the house and park in 1744, that has recently come to light at Carton

CARTON

MAYNOOTH, COUNTY KILDARE

The Hon. David and Mrs Nall-Cain

THE ORIGINAL HOUSE at Carton was built at some date early in the seventeenth century by a cadet branch of the Talbots of Malahide. Sir William Talbot, Bart., Recorder of the City of Dublin, had obtained a lease of the lands of 'Caretowne' in 1603 from Gerald, fourteenth Earl of Kildare. Sir William was M.P. for County Kildare in 1613. The Talbot family were Catholic at that time, and it is interesting in view of the family ties that were to link Carton and Castletown in the following century that Sir William's daughter Mary should have married her neighbour, Sir John Dongan, Bart., of Castletown, who was of the same faith.

Sir William's youngest son, Col. Richard Talbot, eventually Duke of Tyrconnell, died at Limerick in 1691, having fought with James II at the Battle of the Boyne, and been the King's principal adviser during his disastrous stay in Ireland. The Duke was attainted the year he died and his lands at Carton were forfeited to the Crown. In the Book of Forfeited Estates at the time of William of Orange, 'Carrtown' is described as 'a very fine House with all manner of convenient offices and fine gardens'.

In 1703 the house was sold at auction and was purchased by Major-General Richard Ingoldsby, who was Master-General of the Ordnance, and one of the Lords Justices of Ireland at the time of his death in 1711. It is probable that he tacked on to the old house (described in 1654 as being ruined and decayed) the handsome Dutch-Palladian façade which can be seen in the painting by Van der Hagen entitled 'Carton before 1738'. Richard's son Henry Ingoldsby, M.P. for the City of Limerick, died in 1731 and his cousin and heir Thomas Ingoldsby sold the reversion of the lease back to the nineteenth Earl of Kildare, on the 27 January, 1739, for £8,000.

Lord Kildare's original intention had been to make habitable the ancient stronghold of the Geraldines, Maynooth Castle, but this was found to be impracticable on account of its ruinous condition. The German architect Richard Castle was called in to convert the existing house into a larger and more convenient dwelling. The heavy cornice running above

the ground floor windows on the north front, and the surprisingly thick interior walls are the only traces of the previous structure.

Castle lengthened the body of the house by two bays and raised it a storey, connecting it by curved colonnades to wings, one containing the kitchen and the other the stables. The great glory of the house is the saloon (*see p. 191*), with its baroque ceiling representing 'the Court⁄ship of the Gods', the work of the Francini brothers. Monkeys may be seen in the plaster frieze, because they are the supporters of the Kildare crest. According to the legend, John Fitz Thomas, afterwards first Earl of Kildare, then an infant, was in the castle of Woodstock when it caught fire. In the confusion the child was forgotten, and when the servants returned to search for him, the room in which he lay was found to be a smouldering ruin. Soon after, a strange noise was heard on one of the towers, and on looking up they saw an ape, which was usually kept chained, carefully holding the child in its arms. Out of gratitude for his escape the Earl afterwards adopted twin monkeys as supporters to his crest. The original account⁄book, giving the expenditure, labourers' wages, etc., of the works in progress in 1739, gives the cost of the saloon ceiling as £501. It also states, in connection with Portland stone imported from England, that 'the cost of the first cargoe being taken by ye Spaniards in 1739 came to £41 15s 1d'; and that the sum of £39 1s 8d was received from a London insurance company in compensation for the loss. In the pediment over the hall door (which today faces the garden) are the nineteenth Earl's arms impaling those of his wife – the O'Brien coat, in connection with which appears the following entry: 'To carving the familie Arms, by John Houghton and John Kelly, in ye Pediment in Ardbracken Stone, with other decorations of Boys, Cornucopias, etc. – £60.' The building materials consisted of 'home⁄made bricks, Ardbracken stone, blackstone from the Leixlip Quarry, Mountmellick flags, Portland

The south front, originally the entrance front. The curved sweeps that linked the house to the wings were removed in 1815, and extra rooms were added on either side of the central block

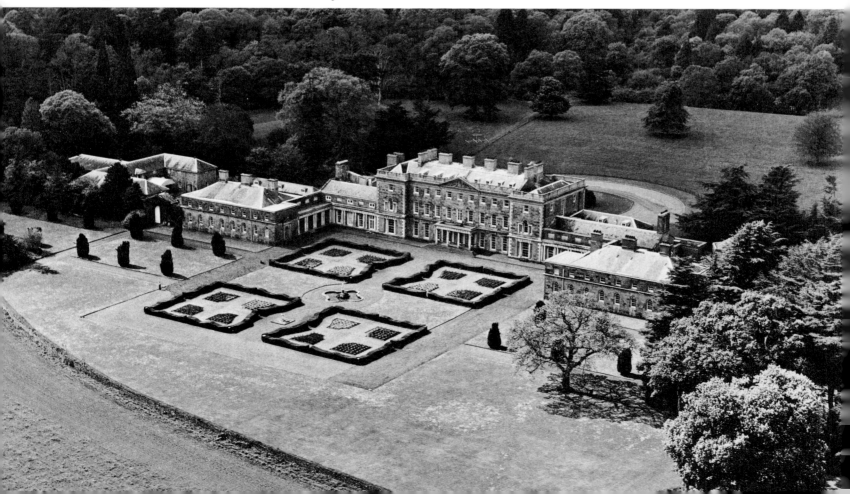

The Chinese room, photographed in 1936, when it contained the state bed used by Queen Victoria. The paper was put up in 1759. (Right) James, twentieth Earl of Kildare and first Duke of Leinster, by Allan Ramsay. His father, the nineteenth Earl, rebuilt Carton in 1739. (Coll. The Hon. David Nall-Cain)

Stone, Mountain Granite, Palmerstown Stone, and stone from the Carton, Moygaddy, and Maynooth Quarries'. The total cost of the alterations at Carton amounted to upwards of £21,000.

Robert, nineteenth Earl of Kildare, was, according to the art-historian Matthew Pilkington (1761), an 'effeminate, puny little man, extremely formal and delicate, insomuch, that when he was married to Lady Mary O'Brien, one of the most shining beauties of the world, he would not take his wedding gloves off when he went to bed'. According to another informant 'he raises pyes, and cuts paper etc., is always at home in a clean pair of gloves, with his hands before him, and a whipt sillibub wig like my Lord Huntingdon. He and his Countess are both the pink of courtesy.' He died in 1744 leaving Carton to his widow, but as it was one day to belong to their son James, she made it over to him directly the furnishing was complete.

James, twentieth Earl of Kildare and from 1766 first Duke of Leinster, married Lady Emily Lennox, the daughter of the second Duke of Richmond, in 1747. He employed Richard Castle to build an enormous town house in Dublin, Leinster House, which was begun in 1745, but he did not make any major alterations at Carton. He and his wife embellished the park and, in 1759, created the Chinese Room which has fortunately survived;

there is also mention of a Print Room which probably resembled the one at Castletown, but has since disappeared. It is with Emily, Duchess of Leinster, that Carton will forever be associated, because of her abiding love for the place. She came there as a young bride, and it was her home for thirty years. In 1747, while expecting her first child, she writes: 'It grieves me to think how long I shall be before I see what's doing at Carton, and I am doubly impatient now, for Lord Kildare has cut down the avenue, which I am sure makes it charming, and has made a very fine lawn before the house, which I think is the greatest beauty a place can have.' Three years later she confesses in a letter to a 'passion for spotted cows'. 'You have no notion what a delightful beautiful collection of them I have got in a very short time, which indeed is owing to my dear Lord Kildare; who, ever since I took this fancy into my head, has bought me every pretty cow he saw. It's really charming to see them grazing on the lawn.' It is interesting that as early as 1747, when she was only sixteen, Emily should have had an instinctive passion for the informal landscape.

In 1762 Lord Kildare visited Capability Brown, the great English landscape designer, at his house at Hammersmith and urged him to come to Carton. According to Walpole, he was offered £1,000 on landing in Ireland, in addition to the cost of the work he was to do, to which Brown replied haughtily, 'I haven't finished England yet.' The park was deformalized, the avenues swept away, and trees were planted in clumps to enhance the natural beauty of the land. It was the eighteenth-century ideal, a park where 'art and nature in just union reign'. It will be seen from the plan of the park made in 1744 how the gardens were disposed in relation to the house; the Rye Water was at that time a small stream, with two fishponds lying beside it. This was made into a lake in the 1760s, and by an ingenious series of dams, widened to look like a broad river as it meanders through the park on its way to join the Liffey at Leixlip. The bridge, designed by Thomas Ivory, the architect of the Blue-Coat School in Dublin, was built in 1763; the balustrade in the original drawing has been replaced by a solid parapet. At the highest point in the demesne there rises a prospect tower, which was probably at one time the entrance to a church. Emily's mother, the widowed Duchess of Richmond, died in 1751 leaving a young family to be brought up, and so it was that Lady Louisa Lennox and her sister Sarah came to Carton aged eight and seven respectively. Both of them were to live in Ireland for most of their lives, Louisa marrying Thomas Conolly of Castletown (q.v.) in 1758, thus echoing the family link that had been forged between the two properties in the previous century.

A graphic account of life at Carton has come down to us in the letters of those who stayed there. It was a house where many people came and went, and Emily and James had no fewer than 23 children, of whom 6 died young. The best known and best loved of these was Lord Edward FitzGerald, who, imbued with French ideals, was one of the leaders of the

The serpentine 'sheet of water', behind the walled garden, painted by Thomas Roberts in 1776. The second Duke of Leinster and his Duchess are about to cross in a boat. (Right) Lord Edward FitzGerald, the patriot, by H. D. Hamilton

rebellion of 1798, and gave his life for Ireland. In 1778, by which time the first Duke of Leinster had died and his son William Robert was Duke, Lady Caroline Dawson was writing:

Everything seems to go on in great state here, the Duchess appears in a sack and hoop and diamonds in an afternoon; French horns playing at every meal; and such quantities of plate, etc., that one would imagine oneself in a palace. And there are servants without end. That morning they drove us all over the park, which is really very fine; though all done by his father – therefore no wood of any growth. But there is a fine river with rocks, etc. . . . It is not the fashion at Carton to play cards. The ladies sit and work, and the gentlemen lollop about and go to sleep – at least the Duke does, for he snored so loud the other night that we all got into a great fit of laughing and waked him. They asked me if I liked cards, and I pretended I did much more than I really do, for the sake of getting a card table. When there is a great many people sitting in that manner it's very tiresome; so I had a party at whist every night. But they seemed to think it very odd that a young woman should like cards.

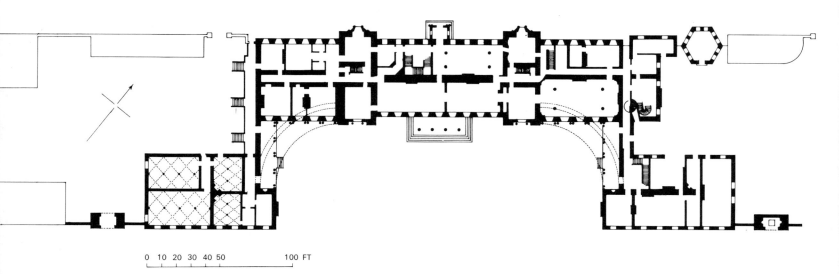

Ground-plan of Carton. The siting of the original colonnades, which were removed in 1815, is shown by dotted lines on either side of the central block

Another visitor, a young lady called Miss Sandford, who was at the house in 1779, also gives her impressions:

> The house is crowded, a thousand comes and goes. We breakfast between ten and eleven, though it is called half-past nine. We have an immense table – chocolate, honey, hot bread, cold bread, brown bread, white bread, green bread, and all coloured breads and cakes. After breakfast, Mr Scott, the Duke's chaplain, reads a few short prayers, and we then go as we like; a back room for reading, a billiard-room, a print-room, a drawing-room, and a whole suite of rooms, not forgetting the music-room. We dine at half-past four or five; courses upon courses, which I believe takes up two full hours. It is pretty late when we leave the parlour. We then go to tea; so to cards about nine; play till supper-time – t'is pretty late by the time we go to bed. I forgot to tell you the part you would like best – French horns playing at breakfast and dinner. There are all sorts of amusements. The gentlemen are out hunting and shooting all the mornings.

The third Duke of Leinster carried out extensive alterations to Carton, when he gave up Leinster House in Dublin, having sold it to the Royal Dublin Society in 1815. He removed the curved colonnades, and substituted extra rooms in rather ponderous Regency taste, designed by Sir Richard Morrison. The flat roof-lines of the additions to either side of the central block, being of about the same height as the wings, combine to produce too strong a horizontal accent for the house to be a really successful architectural composition. The most attractive room to come out of this rearrangement was the small library, with its spiral staircase and balcony, so that books could go up to the ceiling. It was probably at this stage that the windows were brought down to the ground, and some of the new doors and shutters are decorated with the rope pattern motif, which had become popular after the battle of Trafalgar.

The Regency dining-room added by the third Duke

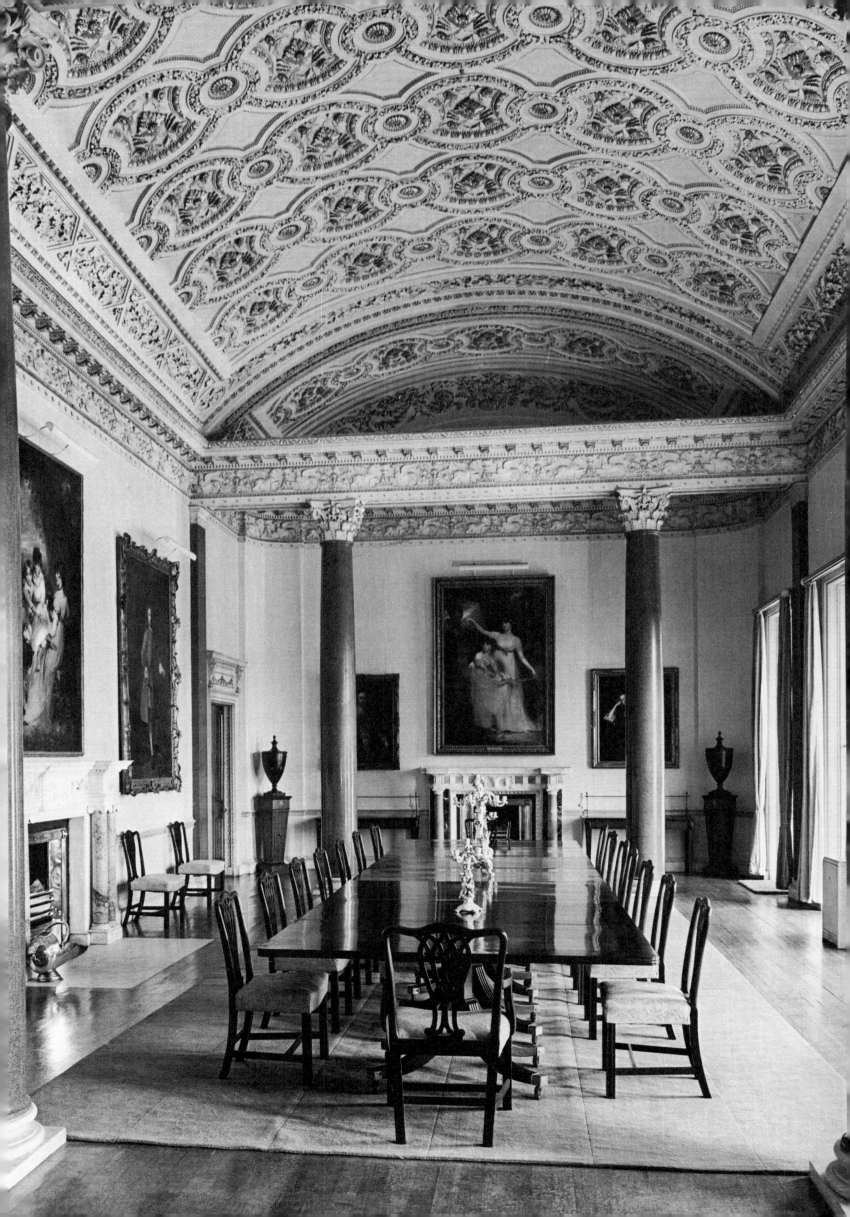

Like Castletown, Carton seems to have been lived in for more than twenty years without a central staircase, as a plan drawn by William Richards in 1758 shows. Since the house had no corridors the stairways at the ends provided adequate circulation. By the time that Morrison planned the additions which replaced the curved colonnades, however, the house had been rebuilt, with a new entrance on the north front and adjoining grand stairs, and the disposition of the rooms in the main block was essentially as it is today.

In the early years of the present century, Edward, the seventh and present Duke of Leinster, who was the third son and unlikely therefore to inherit the Dukedom or the property that went with it, sold his birthright. One of his elder brothers, Lord Desmond FitzGerald, was killed in the First World War, and the other died young. As a result the family have had to sever their long and happy connection with the Carton estate.

In 1949 it was purchased by the late Lord Brocket, who redecorated and modernized the house, and who purchased a number of paintings that belong there. He also managed to save the paper and giltwood embellishments in the Chinese Room, although they had been inadvertently sold at the auction. He established two fine herds at Carton, and Emily would certainly have enjoyed looking at his spotted cows.

His son David now lives there, and in an effort to meet the ever-rising cost of maintenance, he has made the house open to the public at weekends in summer.

Carton, Co. Kildare. The saloon ceiling was executed by the Francini brothers in 1739

Carton: the shell cottage, at the far end of the lake, and the ornamental dairy, c. 1770

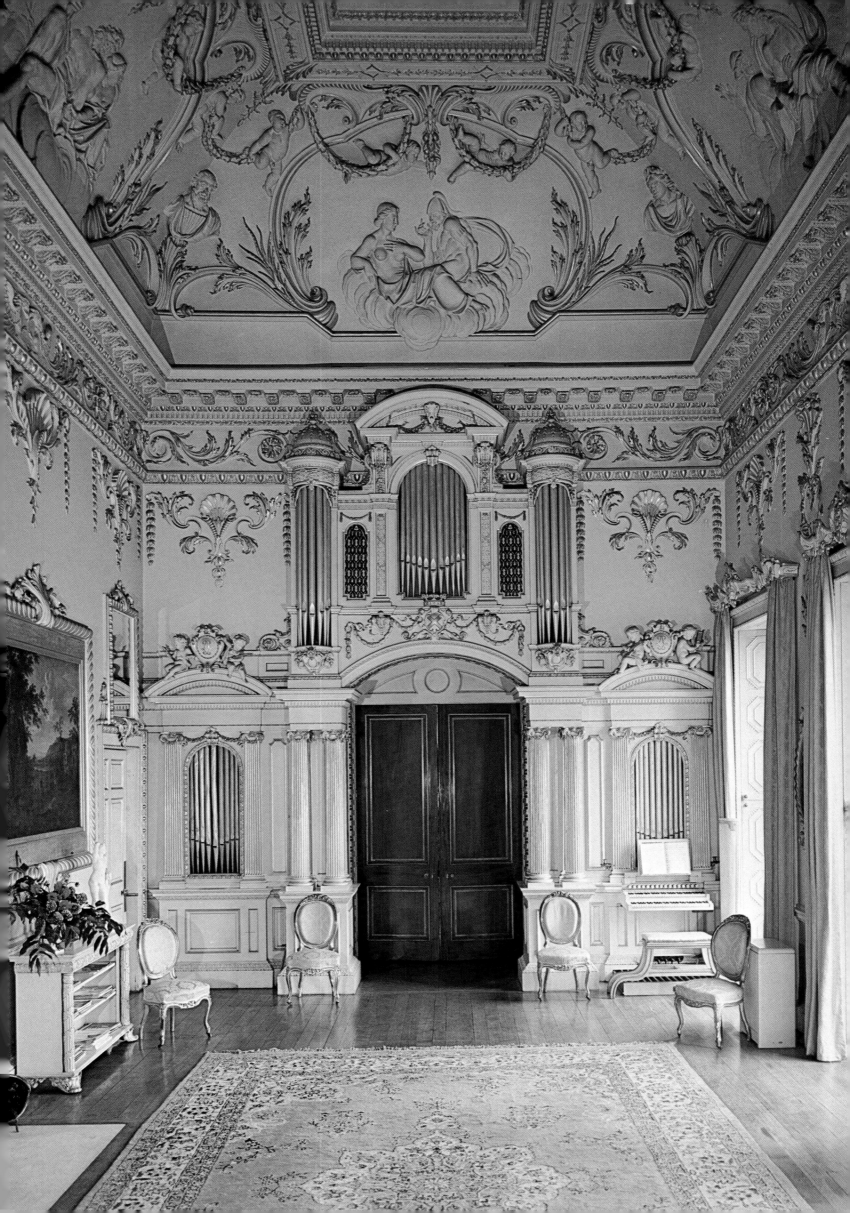

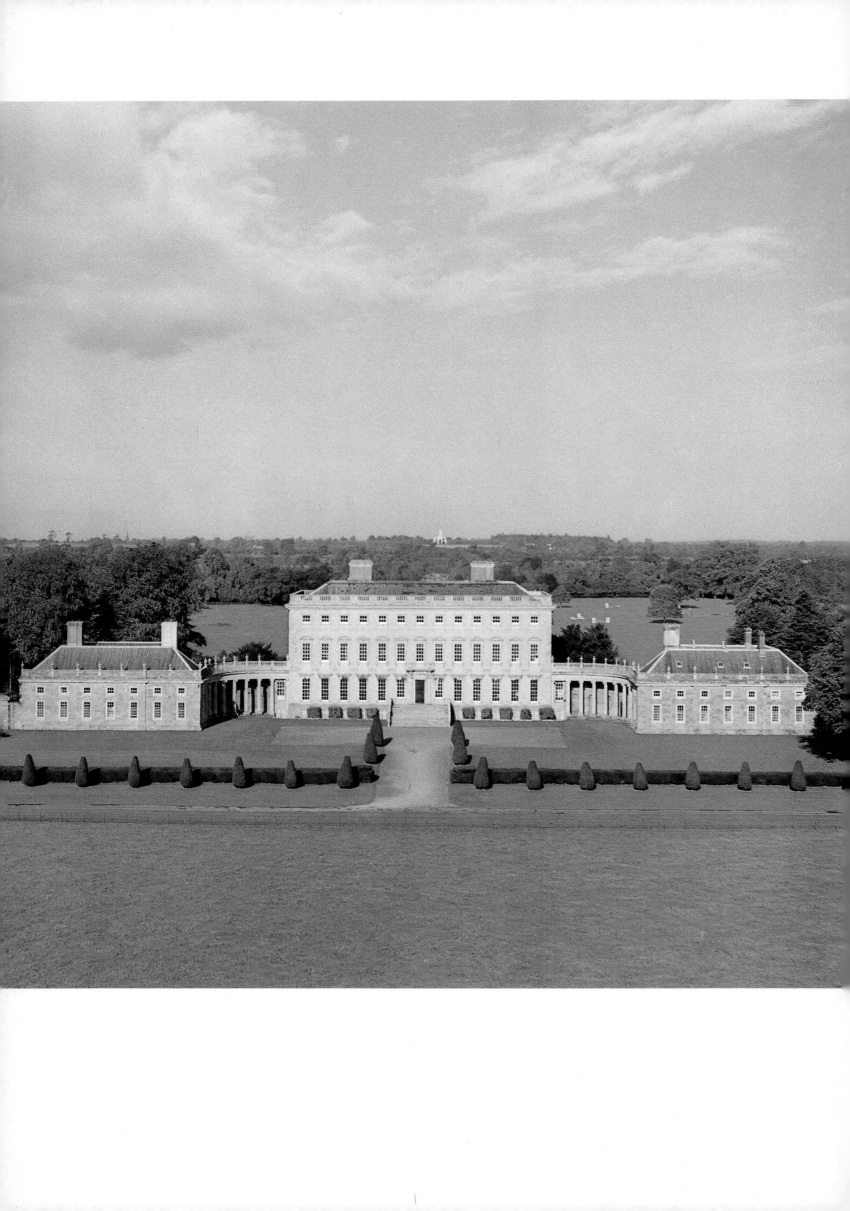

CASTLETOWN

CELBRIDGE, COUNTY KILDARE

The Irish Georgian Society

CASTLETOWN IS THE FIRST great Palladian house to have been built in Ireland. It was begun in 1722 for 'Speaker' Conolly, so named because he was elected Speaker of the Irish House of Commons in 1715, a position he relinquished only shortly before his death in 1729. He was generally acknowledged to have been the richest man in Ireland in his day. Having started life as an attorney, he amassed his great fortune by dealing in forfeited estates after the Battle of the Boyne in 1690. In 1692 he was elected Member of Parliament for Donegal, and in 1709 was made Commissioner of the Revenue. He regarded himself as Irish (which indeed he was) rather than English and never took a title – proud, as were his descendants after him, to call himself plain 'Mr Conolly of Castletown'.

Castletown has had a considerable influence on Irish country-house design. The idea of the central block being linked to wings by colonnades, or curved curtain walls, that stretch out to greet the visitor, was copied in both large and small houses throughout the country. The wings of these houses frequently contain utilitarian farm buildings, and are not really part of the house. They differ in this respect from houses of similar design in England where the wings might contain a chapel, or a library – part of the house, not the farm. The Irish idea has something in common with the Palladian villa and its attendant *barchesse,* and stems from Palladio's Villa Badoer with its curved sweeps on either side.

Bishop Berkeley writes to his friend Sir John Perceval (later Earl of Egmont) in July 1722:

> Your Lordship knows this barren bleak island too well to expect any news from it worth your notice. The most remarkable thing now going on is a house of Mr Conolly's at Castletown. It is 142 feet in front, and above 60 in the clear, the height will be about 70. It is to be of fine wrought stone, harder and better coloured than the Portland, with outhouses joining to it by colonades, etc. The plan is chiefly of Mr Conolly's invention, however, in some points they are pleased to consult me. I hope it will be an ornament to the country.

Castletown (1722), Co. Kildare. The Conolly Folly can just be seen on the skyline on axis to the house

In September of the same year:

> On the 7th September I shall then give you the best account I can of Mr Conolly's House, in the meantime you will be surprised to hear that the building is began and the cellar floor arched before they have agreed on any plan for the elevation façade. Several have been made by several hands but as I do not approve of a work conceived by many heads so I have made no draught of mine own. All I do being to give my opinion on any point, when consulted.

The architect of Castletown has for long remained a mystery, but thanks to the researches of Dr Ilaria Toesca (*Alessandro Galilei in Inghilterra*), Dr Maurice Craig and the Knight of Glin some light has at last been thrown on the subject. It has now been established beyond reasonable doubt that Castletown was designed by the Italian architect Alessandro Galilei whose best known work is the façade he added to St John in Lateran, Rome. He had returned to Italy before the building work on Castletown actually began, hence the 'many heads' mentioned by Berkeley. Mr John Cornforth has recently discovered, among the papers at Alnwick Castle, the following entry in the diary of the Countess (later Duchess) of Northumberland, whose husband was Lord Lieutenant in Ireland from 1763/5:

> To Castletown it stands on a flat the shell of the house is good it was designed by Gallini the Pope's architect who after built the Pope's Palace on Mount Palatine at Rome it is built of stone not good house within Hall a Cube of 30 F built by Speaker Conolly Brass Rails to Staire Gallery above unfurnished. Ldy Louisa's Dressing Room a number of pretty Pictures Books and Ornaments Bedchr but half furnished. Closet fitted up in a very pretty taste. Bed rooms below stairs dingey and dark. The wood cut prettily with walks a Moss House.

It is an indication of the general lack of interest in architecture in Ireland that his name had been forgotten in the nineteenth century. It is strange, also, that neither in the voluminous correspondence relating to Castletown 'to which all travellers resort', nor in the many references to the house by the writers of tours, is there any reference to an architect.

In August 1722, Sir John Perceval writing to Bishop Berkeley refers to Conolly's undertaking:

> I am glad for the honour of my country that Mr Conolly has undertaken so magnificent a pile of building, and your advice has been taken upon it. I hope that the execution will answer the design, wherein one special care must be to procure good masons. I shall be impatient until you send me a sketch of the whole plan and of your two fronts. You will do well to recommend to him the making use of all the marbles he can get of the production of Ireland for his chimneys, for since this house will be the finest Ireland ever saw, and by

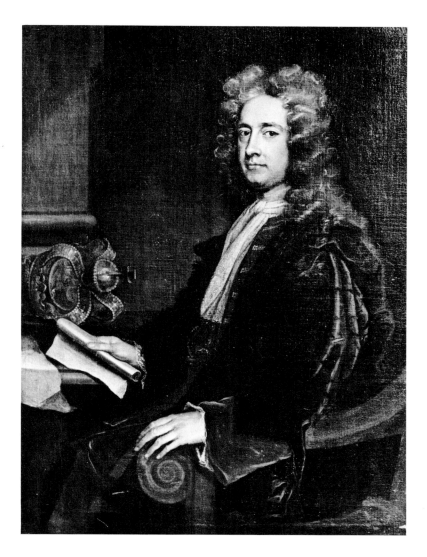

*William Conolly, Speaker of the
Irish House of Commons and the
builder of Castletown, painted by
Charles Jervas. (Coll. The
Hon. Desmond Guinness)*

your description fit for a Prince, I would have it as it were the epitome of the Kingdom, and all the natural rarities she afford should have a place there. I would examine the several woods there for inlaying my floors, and wainscot with our own oak, and walnut; my stone stairs should be of black palmers stone, and my buffet adorned with the choicest shells our strands afford. I would even carry my zeal to things of art; my hangings, bed, cabinets and other furniture should be Irish, and the very silver that ornamented my locks and grates should be the produce of our mines. But I forget that I write to a gentleman of the country who knows better what is proper and what the kingdom affords.

It is not known who was in charge of the buildings for the first two years; Galilei was in Italy and so also was (Sir) Edward Lovett Pearce, then a young man of 23 or so, who must however have had a hand in the design when he returned to Ireland in 1724, because three drawings relating to Castletown have turned up among his papers. The architect or master mason may have been John Rothery, who built Mount Ievers, Co. Clare, (q.v.) as there was a Rothery living in Celbridge at that time, and the two houses have much in common, at least as regards the exterior. The interior of Mount Ievers appears to be ten or twenty years

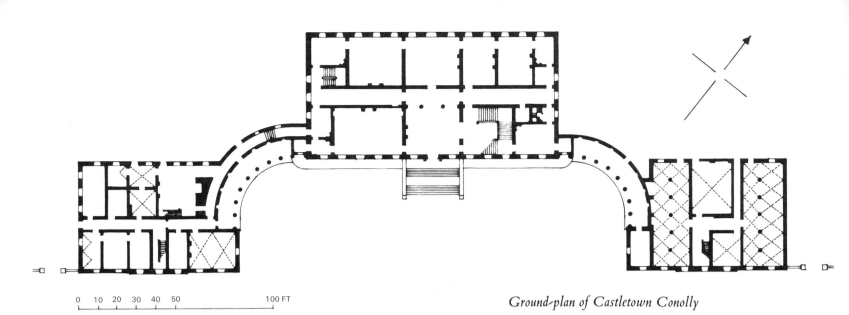

older than that of Castletown, instead of ten years later as it was in fact. Assuming that Pearce, fresh from the Continent, was responsible for the correct classicism of the front hall at Castletown, it would not be surprising to find Rothery continuing in his provincial ways at Mount Ievers.

The plan of Castletown is a simple one. A lofty coved corridor divides the house exactly in two, running from end to end. Leinster House, Dublin, has a similar plan, as does the White House in Washington, which was designed by the Irish architect James Hoban and is acknowledged to derive from Leinster House. Castletown, therefore, can claim to be the grandfather of the White House.

John Loveday, an Oxfordshire squire, who made a tour of Ireland in 1732, writes:

Just out of Kildroghan is much ye grandest house We have seen in Ireland – Castle-Town, Mrs Conolly's, built in 1725, of a bastard Marble dug-up about 15 Miles hence, but being unpolish'd It looks like a fair white Stone; This very lofty & deep house, taking up a great deal of Ground, stands upon Arches, has no less than 13 Windows in front, too many either for Beauty or Strength; on each side wind in a circular manner Stone Cloisters supported on Columns of ye Ionic Order; Butting ye Extremities of ye Cloisters are built of a darker Stone, and something higher than ye Cloisters, – on one side, ye Kitchen & Offices; on t'other, ye Stabling. The Rooms are large & well proportion'd, & as well furnish'd, tho' ye Inside be not finish'd throughout, for ye great Staircase is not yet begun, & some of ye Rooms have no Furniture, as ye long Gallery, proportionably wide . . . There are a large number of Prints here, & some antique Seals taken-off in Wax, & put into Glass Picture-Cases. No Tapestry, but What was made at Dublin, ye figures are small, ye Colours very lively. The Garrets, or rather Rooms in ye uppermost Story, are exceeding good Apartments, All wainscotted & well furnish'd, ye Chimney-pieces of ye Marble ye House is built of, which polish'd gives a grey cast. The Liffy flows below ye Fruitery.

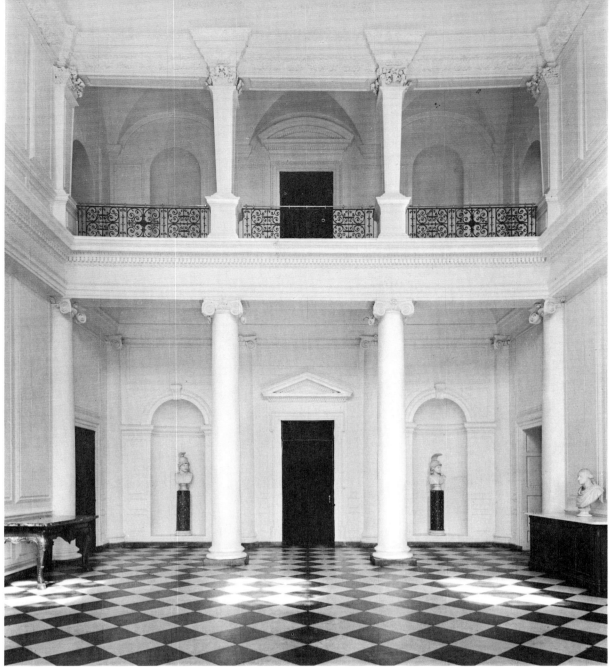

The entrance hall designed by Sir Edward Lovett Pearce

The closest thing Mr Loveday had seen to a classical colonnade at that date was evidently the cloister in a monastery.

In 1734 Lady Anne Conolly, who had married William Conolly, the nephew and heir of Speaker Conolly, writes:

> I wish you would take a trip in the spring over here, and I daresay you would like Leixlip. As to Castletown, it is so very unfinished without doors, I don't think the place very pleasant, though the house is really a charming one to live in. The front is quite without ornaments of any sort, not even so much as pediments over the windows, and the offices are separated from it by a very handsome colonnade, that altogether it looks very well; at least here it does, where there are but few places any way like a seat, and too they have all one fault, and that is the want of trees, by which every place looks terrible, raw and cold.

It is hard to know what to make of Lady Anne's description. She was no idle traveller recording the impressions after a busy day and forgetful of the details – Castletown was to be her home, and she was staying there, or next door at Leixlip, when she wrote the letter. Was she right in describing the front as being 'quite without ornaments of any sort, *not even so much as pediments over the windows*'? Could these have been added by Vierpyl when he lowered the windows on the ground floor by twenty-one inches in the 1760s? At this time the glazing was changed from four panes across with heavy sash bars (still to be seen in the basement and at either side of the house on the top storey) to the more common three panes across with delicate glazing. Again Mount Ievers comes to mind, with its four pane windows and lack of pediments.

After the Speaker's death in 1729, his widow commissioned Thomas Carter the elder, a then unknown London statuary, to carve a superb monument to him. It stands in an un-lighted mausoleum or 'death-house' in a wing of the old Protestant church in Celbridge, most of which was destroyed in the rebellion of 1798. A pediment containing the Conolly arms rests on four marble pillars, framing life-sized statues of the Speaker and his widow, as if in conversation with each other. Behind the figures, the Speaker's virtues are inscribed in Latin on a huge marble plaque.

Mrs Conolly lived on in great state at Castletown until 1752 without ever finishing the interior of the house: even the main staircase was not put in until after her death. She did, however, erect three remarkable outbuildings, all of them on axis to her great house, and the first two of them with charitable intention. Speaker Conolly had bequeathed £500 and an endowment of £250 a year for the erection of a Charity School on some land of his the far side of the village. It was probably designed by Thomas Burgh of Oldtown, Naas, who had preceded Pearce as Surveyor-General, and who is best remembered as the architect of the great library at Trinity College, Dublin. The Collegiate School (as it is now called) is on axis to the west of Castletown, although there is no evidence that an avenue or vista ever led in that direction.

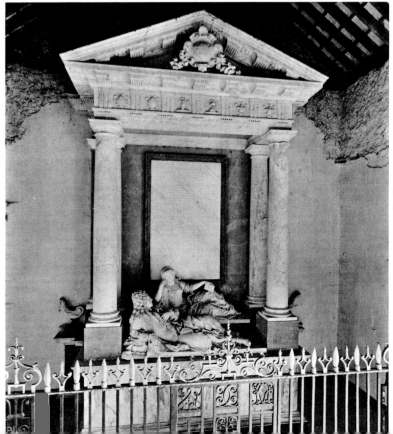

The monument to Speaker Conolly in the Death House at Celbridge, by Thomas Carter the elder (d. 1756)

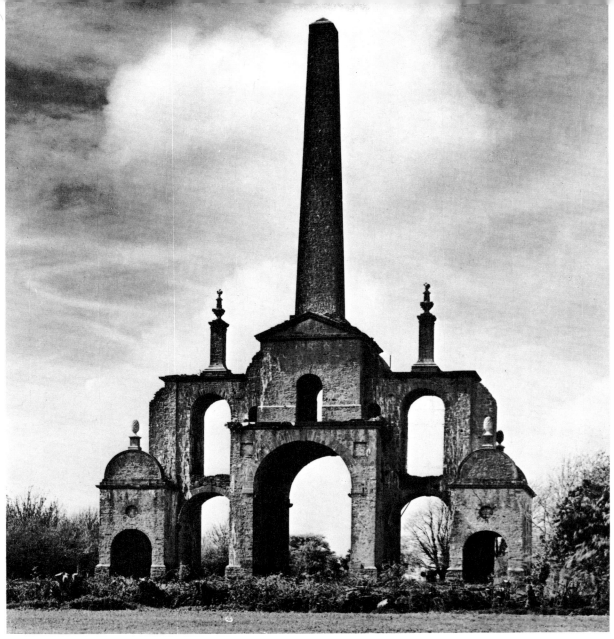

The Conolly Folly, 140 feet high, that closes the vista at the back of Castletown at a distance of two miles from the house. It was built in 1740 by the widow of Speaker Conolly

In 1740, Mrs Conolly built a remarkable eye-catcher to close the vista to the 'rere' of Castletown, the famous hunting landmark known as the Conolly Folly. She built it to give employment, for great hardship had resulted from the severe winter of 1739. The Folly was probably designed by Richard Castle, who was working at Carton at that time, a couple of miles away. He may have been inspired by Pearce's obelisk on a rusticated arched base at Stillorgan, Co. Dublin, or possibly by that at Wilhelmshöhe in his native Hesse-Kassel. It consists of an obelisk supported on arches, and is ornamented with immense pineapples and beautifully carved urns surmounted by eagles. It has of course to stand at the highest point at the back of the house, but the land in fact belonged to the Earl of Kildare, who was rebuilding Carton (q.v.) at the time. It was only in 1968 that an American benefactress, Mrs Rose Saul Zalles, purchased the Folly from the Carton estate and presented it to Castletown. In 1960 the Irish Georgian Society undertook the repair of the Folly, replaced the

carved stonework that was lying on the ground, and repaired the shaft which was being eaten away by the weather, having suffered from the storms of two hundred years. The restoration has cost ten times the amount Mrs Conolly spent on building the Folly, when the wages for relief work were a halfpenny a day. In March 1740, Mary Jones writes: 'My sister is building an obleix to answer a vistow from the bake of Castletown House; it will cost her three or four hundred pounds at least, but I believe more. I really wonder how she can dow so much, and live as she duse.'

In 1743 Mrs Conolly built the Wonderful Barn to close the vista to the east of Castletown. The barn is a corkscrew-shaped building similar to one on the Conolly's property at Rath-farnham, and was used for storing grain. The centre of each floor was pierced with a hole large enough for a sack to pass through. The grain could be spilt out on the different floors to dry, and then put back in sacks for winter storage. It was safe in the barn from the O'Byrnes and O'Tooles who inhabited the Wicklow hills, and were wont to descend on the plain of Kildare in winter in search of food. Each of the rooms is vaulted in brick, of remarkably fine workmanship. A plaque bears the inscription: '1743 EXECUT'D BY JOHN GLINN'. Mrs Conolly died in 1752. Mrs Delany writes:

We have lost our great Mrs Conolly. She died last Friday, and is a general loss; her table was open to all her friends of all ranks, and her purse to the poor. She was, I think, in her ninetieth year. She has been drooping for some years, but never so ill as to shut out company; she rose constantly at eight, and by eleven was seated in her drawing-room, and received visits till three o'clock, at which hour she punctually dined, and generally had two tables of eight or ten people each; her own table was served with seven courses, and seven and a dessert, and two substantial dishes on the side-table; and if the greatest person in the king-dom dined with her, she never altered her bill of fare. As soon as dinner was over she took the ladies to the drawing-room, and left the gentlemen to finish as they pleased. She sat down in her grey cloth great chair and took a nap, whilst the company chatted to one another, which lulled her to sleep. Tea and coffee came exactly at half an hour after five; she then waked, and as soon as tea was over, a party of whist was made for her till ten, then everybody retired. She had prayers every day at twelve, and when the weather was good took the air, but has never made a visit since Mr Conolly died. She was clever at business, wrote all her own letters, and could read a newspaper by candlelight without spectacles. She was a plain and vulgar woman in her manner, but had very valuable qualities.

After the death of Mrs Conolly her nephew William moved into Castletown with his wife and seven children. They had been living at Leixlip Castle nearby, which remained in the Conolly family until 1914, and of which there is a mural painting over the front hall mantel

The Wonderful Barn, built on axis to the east of Castletown in 1743, and used for storing grain, and the inscription above the entrance

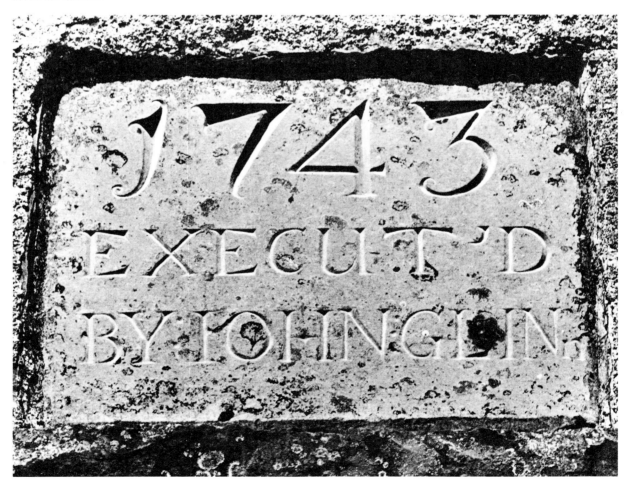

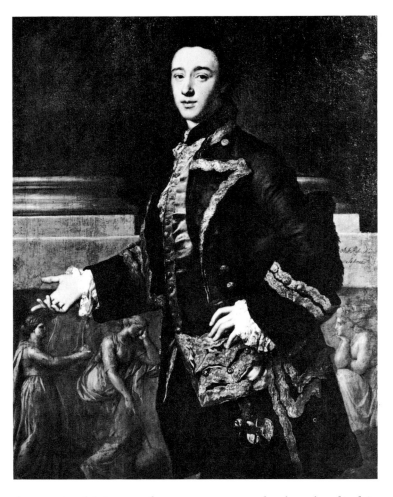

Tom Conolly, great-nephew of the builder of Castletown, painted in Rome in 1758 by Anton Mengs. (Coll. The Hon. Desmond Guinness)

at Castletown. William Conolly only survived his aunt by two years, and when he died in 1754 his widow, Lady Anne, removed to their house in Staffordshire. Castletown was shuttered up. 'A huge house, now empty and forlorn, that used to be crowded with guests of all sorts when last I saw it', writes Mrs Delany.

Tom Conolly, the heir, returned to Castletown when he came of age, and in 1758 he married Lady Louisa Lennox, the daughter of the second Duke of Richmond. Both her parents having died when she was eight, Louisa had been brought up in Ireland by her elder sister, Emily, Countess of Kildare and later Duchess of Leinster, who lived at Carton, a few miles distant. Although she was only fifteen when she married, Louisa immediately set about finishing the interior of Castletown, and was to make many alterations and improvements to the house during the sixty years she was mistress of it. When she died, in 1821, she was seated in a tent which she had had erected on the lawn in front of Castletown. It had been her wish to die looking at the house she loved so much.

The interior of Castletown is practically unaltered since Louisa's day. The only Victorian 'improvement' was the conversion of the rooms above the stables in the east wing into elaborate bachelors' quarters in 1871. Louisa writes from London to her sister at Carton in 1759: 'Mr Conolly and I are excessively diverted at Francini's impertinence and if he charges anything of that sort to Mr Conolly there is a fine scold in store for his honour.' This refers to the magnificent rococo decoration on the staircase done by the Francini brothers,

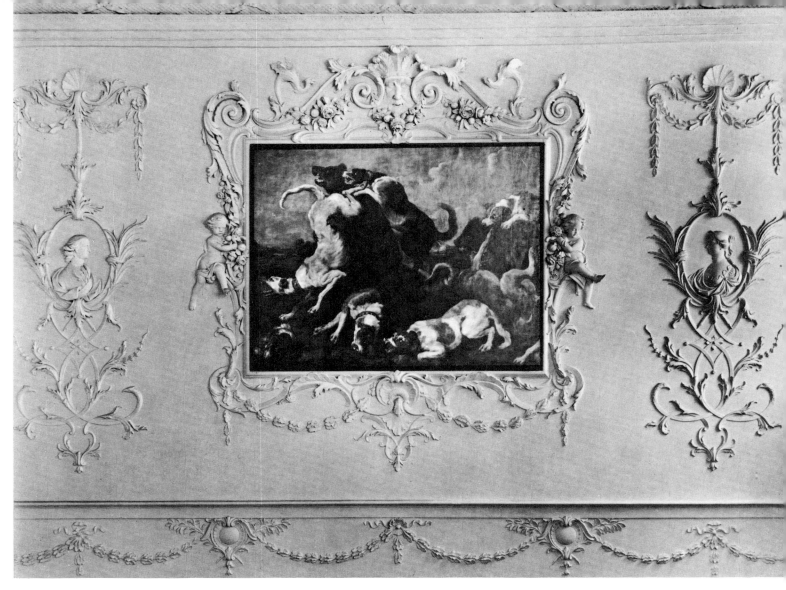

'The Boar Hunt' by Snyders dominates the staircase hall, framed in elaborate plasterwork by the Francini brothers
(1759). Family portraits are incorporated in the plaster decoration
The stairs, signed A. King, Dublin, 1760. (Right) Detail of the plasterwork between the windows on the staircase

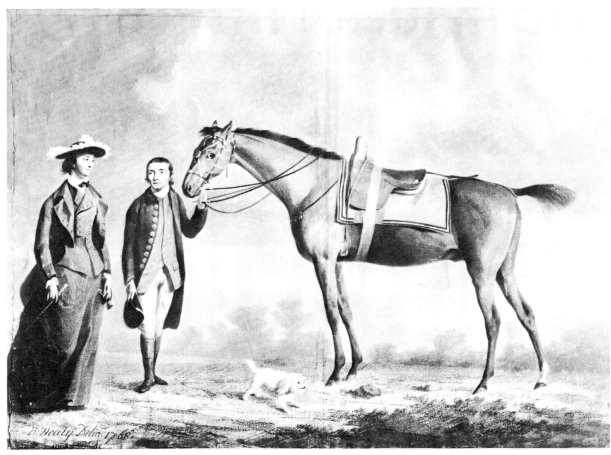

Lady Louisa Conolly with groom and horse; grisaille by Robert Healy, 1768. (Coll. The Hon. Desmond Guinness)

in that year. The decoration is, incidentally, a repeat of that on the staircase at No. 9 St Stephen's Green, Dublin. Family portraits are included in the plaster decoration, pride of place being given to Tom Conolly, wearing a floppy hat, at the foot of the stairs. Louisa had first admired the stucco work of Paul and Philip Francini at Carton, where they had executed the elaborate ceiling in the saloon in 1739. Her quarrel with them must have soon blown over, for the account books show 'Frankiney stucco man' being paid rather small sums from 1765 onwards, presumably for the plasterwork in the rooms being redecorated at that date.

The Portland stone cantilevered staircase was inserted in 1760, and it is evident that the plasterwork antedates it, as the line of the staircase does not follow the same line as that of the decoration on the walls, nor do the plaster head and attendant swags sit square beneath the second landing. Simon Vierpyl was paid £230 in 1760 for his work on the staircase. He was a stone-mason of exceptional talent, a protégé of Sir William Chambers, who put him in charge of the erection of the Marino Casino at Clontarf for Lord Charlemont. At this time Vierpyl lowered ten of the ground-floor window cases on the entrance front, the two on either side of the front door remaining at the original height.

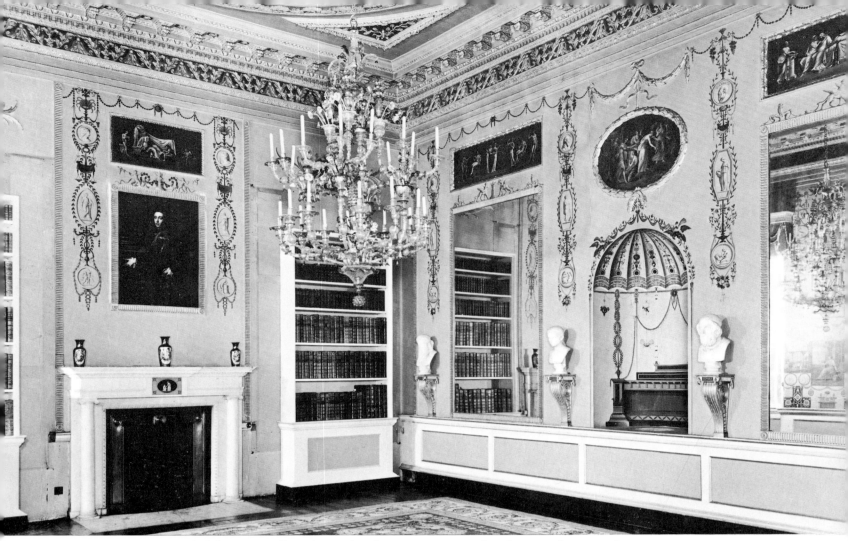

One end of the Long Gallery, decorated in the Pompeian manner by Thomas Riley in 1776

The design of the entrance gates at Castletown, with their 'two sphynkes' carved by John Coates, stone-cutter, Maynooth, is taken from Chambers' *Treatise on Civil Architecture* (1759). Louisa's brother patronized Chambers, as did her sister Emily at Carton and Leinster House, although he never actually came to Ireland. Mr John Harris, Chambers' biographer, believes on stylistic grounds that the principal reception rooms on the ground floor at Castletown were redesigned by him. These were the dining-room (originally two rooms), and the red and green drawing-rooms. Louisa did not care for panelling and had it covered up or removed whenever possible. (*See p. 209*)

Her most spectacular achievement was the decoration of the Long Gallery in the Pompeian manner. This extraordinary room is situated on the upper floor at the back of the house, and its eight tall windows look up the two-mile vista to the Conolly Folly. The ceiling is of the early type, similar to that in the entrance hall, and dates from about 1725 but it has been painted in subtle Pompeian colours to tie in with the redecoration. Originally there were doors at either end, with handsome doorcases at either side of the mantels, and the walls were panelled in stucco as the hall is to this day. In 1776 these were removed – Louisa writes of new sketches that make 'the stucco panels look so very bad that are going to be knocked

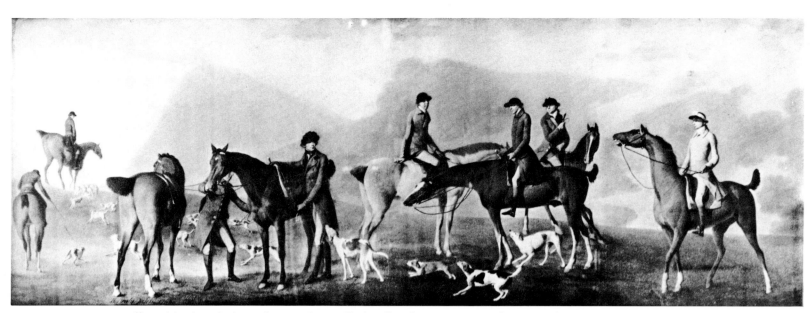

Tom Conolly and his hounds, by Robert Healy, 1768. (Coll. The Hon. Desmond Guinness)

off smack smooth'. The artist, who was a pupil of Reynolds, and had also worked at Good-wood for Louisa's brother, was 'a little deformed delicate man' named Thomas Riley. He incorporated monograms of Louisa and her relations into the wall decoration at the end of the room nearest her portrait, and did the same for Tom Conolly at the opposite end.

Lady Caroline Dawson, on a visit to Carton in the 1770s, paid a visit to Castletown and describes it thus:

> On Saturday they asked me if I should like going to Castletown, Mr Conolly's, and upon my answering in the affirmative, we set out in the coach and six with all due state. I was very much entertained, as it is a very pretty place, though flat; but there's very fine wood, a fine river, and the views of mountains from every part of it, so the flatness does not strike one so much, and I never saw any place kept so neat and nice. They first carried me to the cottage, for you must know it is quite the fashion in Ireland to have a cottage neatly fitted up with Tunbridge ware, and to drink tea in it in the summer.
>
> We then went to the house, which is the largest I ever was in, and reckoned the finest in this kingdom. It has been done up entirely by Lady Louisa, and with a very good taste. But what struck me most was a gallery, I daresay 150 feet long, furnished in the most delightful manner with fine glasses, books, musical instruments, billiard table – in short, everything that you can think of is in that room; and though so large, is so well filled, that it is the warmest, most comfortable-looking place I ever saw. They tell me they live in it quite in the winter, for the servants can bring in dinner or supper at one end, without anybody hearing it at the other; in short, I never saw anything so delightful . . . Lady Charlotte is so fond of it that she would have me go into every hole and corner of that great house, and then made me walk all over the shrubbery, so that by the time we had finished I was completely tired.

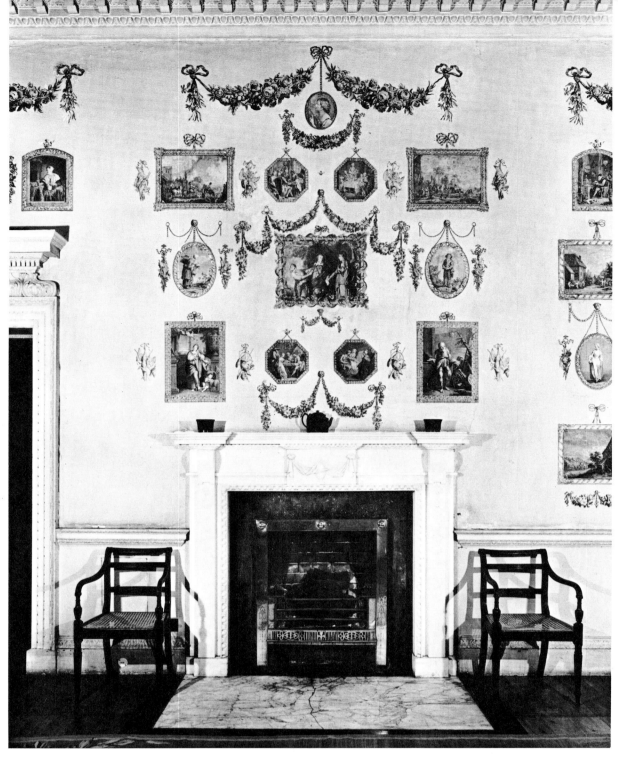

The Print Room, made by Lady Louisa Conolly and Lady Sarah Napier c. 1775

Louisa created a print room at Castletown which is the only one to survive in Ireland, although it is known that there were others, for instance at Carton. A sketch for disposing the prints which may be in Louisa's hand, has survived and is preserved in the room – unfortunately there is no date on it. She was already collecting prints for it in 1762, as she writes to her sister, Sarah, 'I always forget to thank you my dear for the prints you sent me. I hope you got them of Mrs Regnier . . . I have not had time to do my Print room yet.' She and Sarah may have stuck up the prints themselves as a wet-day pastime: the engraving after Reynolds' portrait of Sarah takes pride of place on the wall facing the windows.

The Batty Langley lodge, taken from a design first published by Langley in 1741

Castletown remained in the Conolly family until 1965 when it was sold by Lord Carew, whose mother was a Conolly. It was bought for splitting up and development. For two years the house stood empty – lead was stolen off the roof, windows smashed. In 1967 the house and 120 acres were purchased by Mr Desmond Guinness, founder-president of the Irish Georgian Society, for its headquarters. The Society is at present restoring the house so as to ensure its preservation for posterity, and has also opened it for the enlightenment and enjoyment of the public.

Castletown, Co. Kildare : the red drawing-room contains furniture that has always been in the house. (Below) The long gallery, painted in the Pompeian manner in 1776

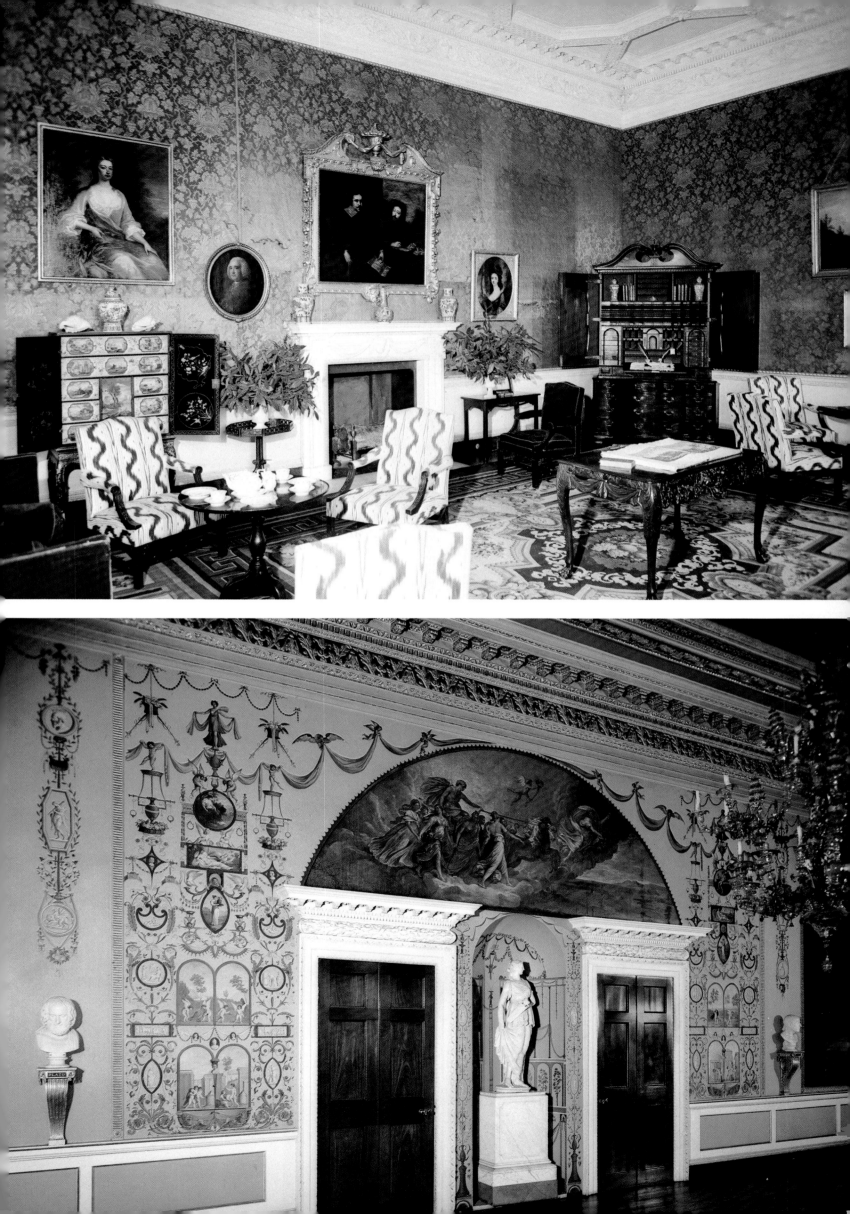

LEIXLIP CASTLE

LEIXLIP, COUNTY KILDARE

The Hon. Desmond and Mrs Guinness

THE 'BLACK' CASTLE of Leixlip was built high on a rock, in a position of commanding importance at the junction of the Rye Water with the River Liffey. The name comes from the Danish *Lax-hlaup* (salmon leap) which refers to the famous leap a quarter of a mile up the Liffey, now submerged by an electric power dam. In old pictures of the castle the Salmon-leap is often represented as being below the castle walls. Leixlip is in the barony of North Salt, a corruption of *Saltus Salmonis,* the Latin translation of the Danish place name. Of recent times the name Leixlip has been translated into Irish as *Leim an Bhradain.* Documentary evidence for the development of the castle is scarce; the only evidence is that supplied by paintings and engravings.

The first stronghold was built soon after 1170 by Adam de Hereford, a follower of Strong-bow. Leixlip was a castle of the Pale, the ring of castles that surrounded the rich lands north and west of Dublin. At the close of the thirteenth century the de Herefords were succeeded at Leixlip by a family called Pypard, and in 1317 Edward Bruce, the brother of Robert, encamped at Leixlip for four days during their invasion of Ireland, 'during which time they burnt part of the towne, broke down the church and spoiled it, and afterwards marched on toward the Nas'. In 1494, Henry VII decreed that only Englishmen should be appointed to the office of Constable of the King's Castles of Athlone, Carlingford, Carrickfergus, Dublin, Greencastle, Leixlip, Trim, and Wicklow. The same King Henry granted Leixlip to Gerald, eighth Earl of Kildare, but in consequence of the rebellion of 'the silken Thomas', tenth Earl, in 1534 it was taken back by the Crown. In 1569 the Manor and Castle of Leixlip were granted to Sir Nicholas Whyte, Master of the Rolls, whose descendants remained in possession for almost two hundred years.

The Whytes were Catholic Loyalists, and had no intention of joining the rebellion of 1641. After it broke out, on October 23rd, 'Sir Nicholas Whyte, of Leixlip, Lord Dunsany, Patrick Barnewall, of Kilbrew, Sir Andrew Aylmer, and several other leading men in the Pale, in obedience to the king's proclamation, surrendered themselves to the Lords Justices Parsons and Borlace, in order to show they neither took part in the rising, nor sympathized with it. These men, though their loyalty was beyond doubt, were imprisoned in Dublin

Leixlip Castle, Co. Kildare : the red drawing-room and (below) an 'Egyptian' bed, made in England c. 1830

Leixlip Castle 1792, aquatint by Jonathan Fisher

Castle, without having been granted so much as an interview with the Lords Justices. They were examined by insolent subordinates, threatened, insulted, and, in some instances, as in the case of Patrick Barnewall, put upon the rack. Without being permitted to call witnesses, they were charged with high treason, and kept for a long time in prison. It may seem passing strange that the Lords Justices, who were the king's representatives in Ireland, should treat his loyal subjects in such a manner; but the explanation is that Parsons yearned to get hold of confiscated lands, and as the lands of the Pale were far richer than those possessed by the native Irish, his wish was to drive the men of the Pale into rebellion, in order that their lands should be forfeited, in which case he would be sure to get the lion's share.' (*Kildare Archaeological Society Journal,* Vol. II, p. 400).

Several members of the Whyte family are buried in Leixlip Church, including Sir Nicholas Whyte, Kt., who married Lady Ursula Moore, daughter of the first Viscount Drogheda. In June 1728, Speaker Conolly of Castletown purchased from John Whyte, for £11,883, the manor, town and lands of Leixlip etc. and three years later his nephew and heir, the Rt. Hon. William Conolly, purchased the castle, garden, and outhouses which had previously been excepted. Speaker Conolly died in 1729 and his widow, Katherine, lived on

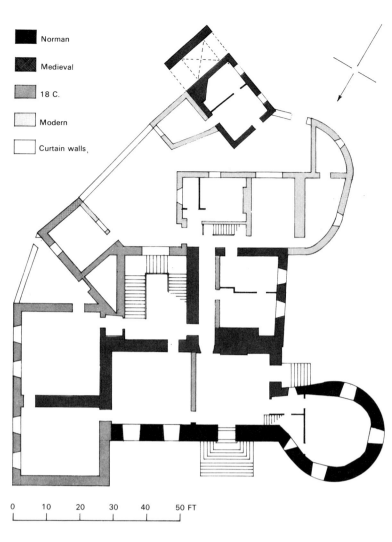

Norman

Medieval

18 C.

Modern

Curtain walls

0 10 20 30 40 50 FT

Ground-plan of Leixlip Castle

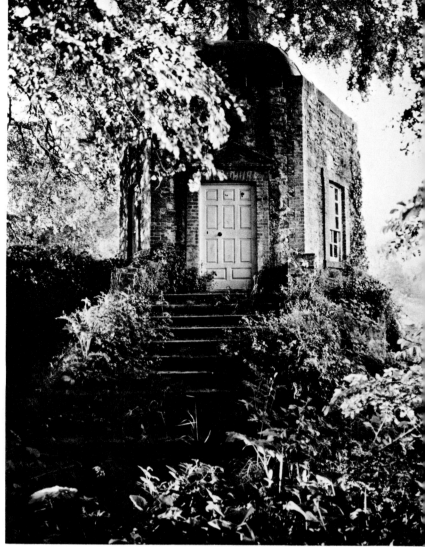

The boat-house at the junction of the Rye Water and the Liffey

alone at Castletown until her death in 1752. Her nephew William lived at Leixlip and it was here that his son Tom, 'Squire' Conolly, was born. The Conollys owned Leixlip until 1914. It was let to a succession of different tenants: Primate Stone, the virtual ruler of Ireland, used it as an occasional residence from 1752 onwards. Lady Kildare, better known as Emily, Duchess of Leinster, visited him in April 1759, and writes: 'The Primate was all com-plaisance, very easy, and it was altogether more agreeable than I expected. There were several amusing people there. Unfortunately Lady Drogheda walked herself into a fit of the gout . . . There is a fine bed of double jonquils in bloom. You know I have a passion for them.'

From 1767 the Viceroy, Lord Townshend, rented Leixlip as a summer residence during his five-year term of office. He used to throw open the grounds on Sundays and mingle incognito with the visitors who had driven out from Dublin to admire the Salmon Leap and take the waters at Lucan Spa. His visitors would often criticize government policy, never dreaming that they were speaking to the Viceroy himself. Legend has it that one day a poor journeyman-cutler, named Edward Bentley, offered Lord Townshend half-a-crown for his pains in showing all the beauties of the demesne, and was astonished when his tip was refused. 'The fellow at the gate-lodge demanded half-a-crown before he would let me in at all,' he said.

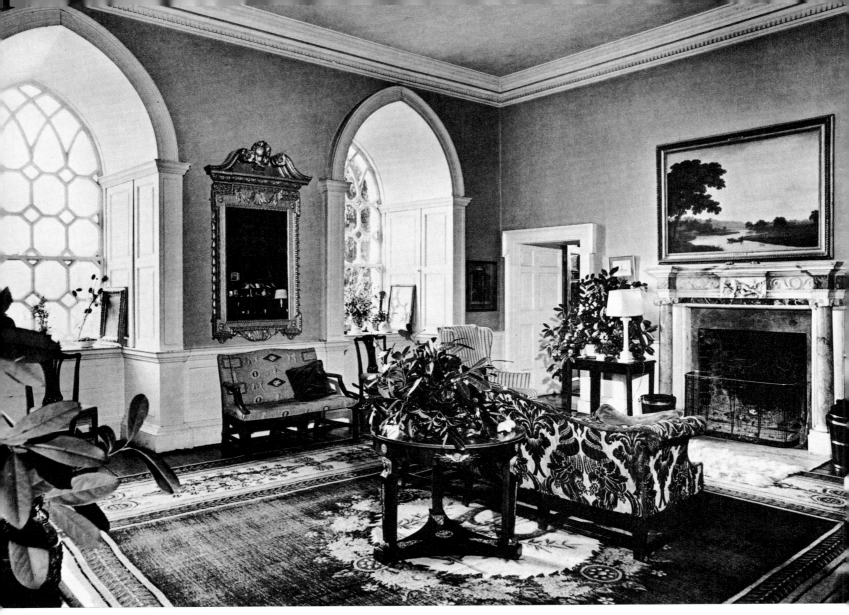

The Gothic room

Lord Townshend showed his new friend out. At the lodge he accused the keeper of disobeying his orders by accepting money. The unfortunate man dropped to his knees and begged forgiveness, at which the journeyman-cutler did likewise. Lord Townshend drew his sword and lay it on his friend's shoulder, saying, 'Arise, Sir Edward Bentley.' The newly made knight was forthwith appointed Cutler to His Excellency!

The Salmon Leap must have been an amazing sight. In his *Tour through Ireland,* 1780, Luckombe describes it thus:

> To a traveller unused to scenes of this kind, it is really a most diverting kind of entertainment to see the many unsuccessful efforts of these large and beautiful fish to gain the top of the fall before they succeed. I have often been highly diverted for an hour or two in the middle of the day, at this salmon-leap. When they come up to the foot of the fall, you will frequently observe them to leap up just above water, as if to make an observation of the height and

distance, for by fixing your eye on the spot, you will generally soon see the fish leap up again, with an attempt to gain the top, and to rise perhaps very near the summit, but the falling water drives them forcibly down again; you will presently observe the same fish spring up again, and rise even above the fall; – this is as unsuccessful as the not rising high enough, for dropping with their broadsides on the rapid curvature of the waters, they are thrown back again headlong before they can enter the fluid. The only method of succeeding in their attempts is to dart their heads into the water in its first curvature over the rocks, by this means they first make a lodgment on the top of the rock for a few moments, and then scud up the stream and are presently out of sight. One would imagine there was something instinctive in this inclination of the salmon to get up the fall; for this is the point they are observed, by the direction of their motion, generally to aim at; and the force of the stream, on the top of the precipice, is undoubtedly less at the bottom of the water, and close to the rock, than it is on the surface of the rapid curvature. 'Tis almost incredible, to a stranger, the height to which these fish will leap; I assure you, I have often seen them, at this very fall, leap near 20 feet.

The Gothic windows with which the immensely thick walls have been pierced appear to date from the middle of the eighteenth century, probably from the time of the second William Conolly. Their solid proportions suit the thick walls of the castle better than the more delicate Gothic of the 1780s. The pattern of their diamond panes may be compared to an original window in the Batty Langley lodge at Castletown which was probably built at much the same time. Perhaps the windows at Leixlip were put in by Primate Stone or, at least, for his tenure. One of the fortunate results of the many different lettings is that Leixlip has escaped being much altered since about 1750. The battlements, which do not appear in eighteenth-

The front hall. (Right) the 'Chapel' with its eighteenth-century doll's house

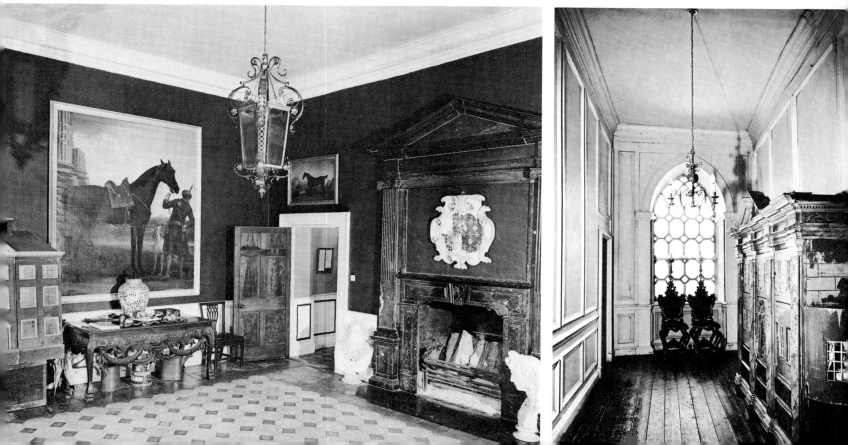

century engravings, were however added by a tenant, probably the Hon. George Cavendish, in 1837. So the wheel had come full circle – the castle had turned into a house, and now it was transformed into a castle once again.

In 1856, Baron de Robeck took Leixlip while Gowran Grange, his house near Naas, was rebuilding. He went down to watch the salmon leap while the waters were in spate, missed his footing and was swept away and drowned. In 1914 the fifth Lord Decies purchased the castle and demesne from Major E. M. Conolly of Castletown. Lady Decies was heiress to an American railway fortune. She set about modernizing the interior and altered some of the windows, but the uprising of 1916 and the First World War, followed by the Treaty in 1922, prevented too much being done. Lord Decies put Leixlip on the market in 1923 but was unable to sell it and once more there was a succession of different tenants; for a time it served as the French Embassy. In 1945 Lord Decies' son sold it to a Dublin builder who, in 1958, disposed of it to the present owners.

The village of Leixlip is steeped in Guinness history. Archbishop Price, who died in 1752 and is buried beneath the aisle of the church, left '£100 to his servant, Richard Guinness' and a like sum to Richard's son, Arthur. Tradition has it that he also left a secret recipe for brewing a very dark beer. In 1752, Richard Guinness set up his brewery on the main street of Leixlip and seven years later his son Arthur bought an existing brewery in Dublin which bears his name to this day.

Leixlip was for ten years the nerve centre of the Irish Georgian Society, which is dedicated to the preservation of art and architecture in Ireland, with particular emphasis on the years 1700 to 1830. The Society was born at Carton in 1958 with sixteen members, and it now has six thousand spread throughout the world. The headquarters have now moved to Castletown, Co. Kildare, (q.v.) about four miles away.

The rooms at Leixlip have unusual shapes and sizes which lend themselves to varied treatment. A twisted stairway serves the three round rooms in the tower, supposedly built by John, Earl of Morton (later King John) when Lord of Ireland. The front hall and 'King John's Room' above are the core of the old castle of Adam de Hereford. The castle has been added to many times; unlike most Irish houses it has more rooms than is at first apparent. The contents consist in the main of furniture and pictures of local interest except for the carpets which are French. (*See p. 210*)

In the evenings at sundown the sky goes black with rooks, circling and cawing until they find their resting place among the tall beech trees. Sometimes when there is a storm, the very fabric of the castle seems to shake with the violence of the wind and rain. More welcome is the peculiar sound of flying swans as they pass the battlements, following the course of the river in the direction of Lucan and the sea beyond.

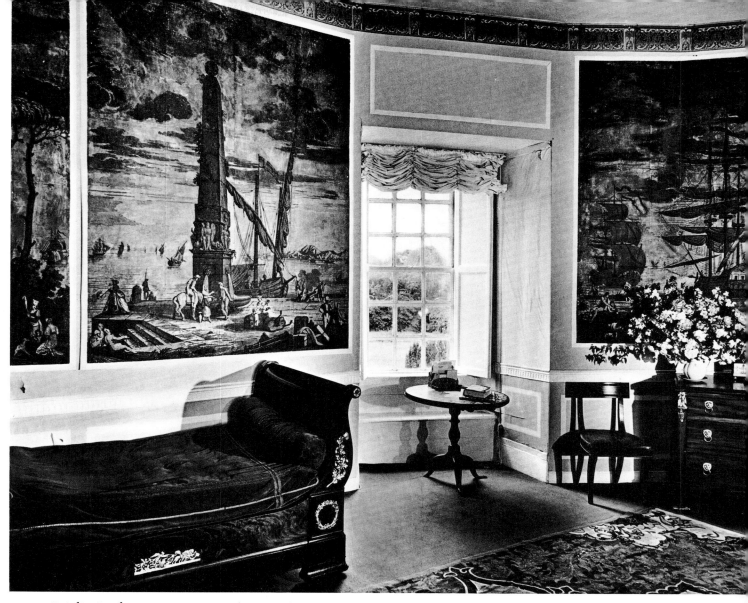

Leixlip Castle: top tower room, with a paper by Dufour, 'Vues d'Italie' (1825) The dining-room in the round tower

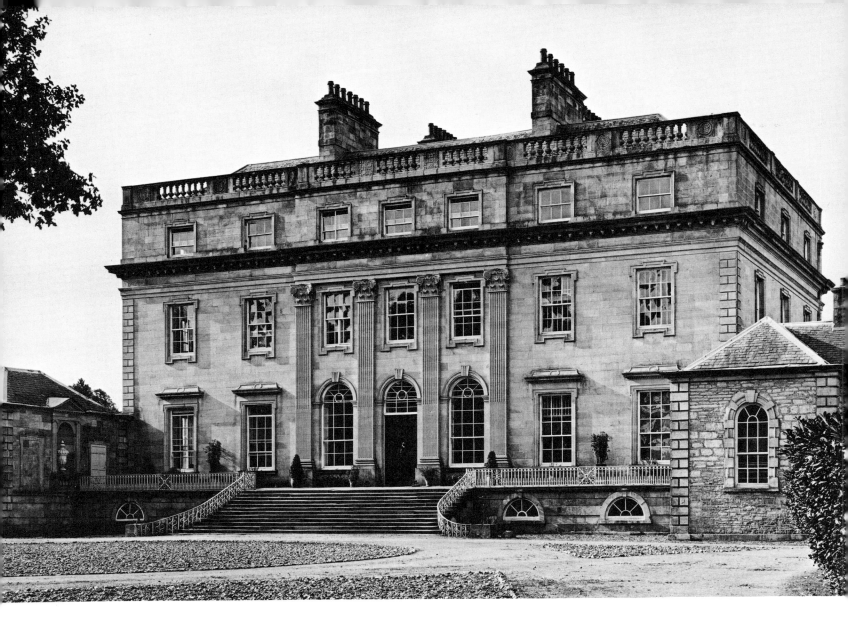

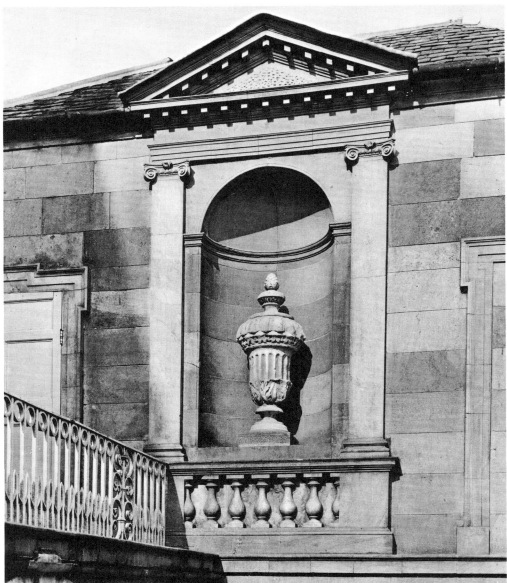

*Castletown (1767), Co.
Kilkenny; the entrance
front*

*Urn in niche to the right of
the front door*

CASTLETOWN

PILTOWN, COUNTY KILKENNY

Mr and Mrs Charles Blacque

CASTLETOWN, Co. Kilkenny, was built in or about the year 1767 by the Sardinian architect Davis Ducart for Michael Cox, Archbishop of Cashel. To avoid confusion with the Castletown in County Kildare, it is often referred to as Castletown Cox. Both in scale and in quality of design and execution, it ranks as one of the five or six most important houses in Ireland.

Archbishop Cox was the fifth and youngest son of Sir Richard Cox of Dunmanway, Co. Cork, who had been made Lord Chancellor of Ireland in 1703 and a baronet in 1706. Sir Richard obtained a lease of the Castletown estate, a few miles from Carrick-on-Suir, from the Duke of Ormonde and he either sub-let or sold it to Edward Cooke of Cookestown. On the death of Cooke in 1751 it became the property of Michael Cox, because he had married Anne Cooke, Edward's sister, as his first wife. Although Anne Cooke brought him the property it is the arms of Cox's second wife, Anne O'Brien, impaling his own, that ornament the garden front of Castletown. She was the daughter of the Hon. James O'Brien, M.P. for Youghal, and the grand-daughter of the third Earl of Inchiquin. They were married in 1744 and she died in childbirth in 1746, although fortunately the infant son survived. Cox, who was at the time Bishop of Ossory, ordered a life-sized female statue, representing Piety leaning on an Urn, from the fashionable London sculptor Scheemakers. The statue is still in Kilkenny Cathedral although the urn was smashed, probably as a result of its removal to one side of the transept from its original position almost in the centre of the aisle. Cox left room for his own epitaph to fill up the space underneath hers. When he died, however, in 1779, his family were slow to have his inscription carved, calling forth the following lines from the celebrated wit, Edmund Malone:

> Vainest of mortals, hadst thou sense or grace,
> Thou ne'er hadst left this ostentatious space,
> Nor given thine enemies such ample room
> To tell posterity, upon thy tomb,
> A truth, by friends and foes alike confess'd,
> That by this *blank* thy life is best express'd.

The omission was soon rectified by the family and the Archbishop's epitaph may now be seen in the 'ostentatious space' below that of his wife. Cox would probably have been admired in the Ireland of his day less for the building of his magnificent house than for the fact that he laid out a race-course within the demesne. The story that he was left a large sum of money for the erection of a church, and spent it instead on building Castletown, can of course be disregarded.

The architect Davis Ducart or Daviso de Arcort is a no less shadowy figure than the Archbishop. Almost the only source of information regarding him is his will, dated 1780, and proved in 1786 by which time, therefore, he must have died. The will states that he had been employed as engineer for the Newry canal, and the Tyrone and Boyne navigation; that he had designed 'a difficult roof' at Castle Mary, Co. Cork, for Richard Longfield and Kilshannig, Co. Cork, (q.v.) for Abraham Devonsher; and rebuilt a house in County Cork for 'Mrs Wallis, now Mrs Mercer' which has not been identified. He disposes of property at Drumrea, Co. Tyrone, and there are legacies to friends in France and Italy. The researches of the Knight of Glin have revealed that his *œuvre* includes the Customs House, Limerick (1765); the Mansion House (now the Mercy Hospital), Cork (1766); Brockley Park, Co. Leix, (1768) for Lord Roden, since demolished; Lota, Co. Cork (1768); and (on stylistic grounds alone) Coole Abbey, Co. Cork. It has also been suggested that he may

The front hall

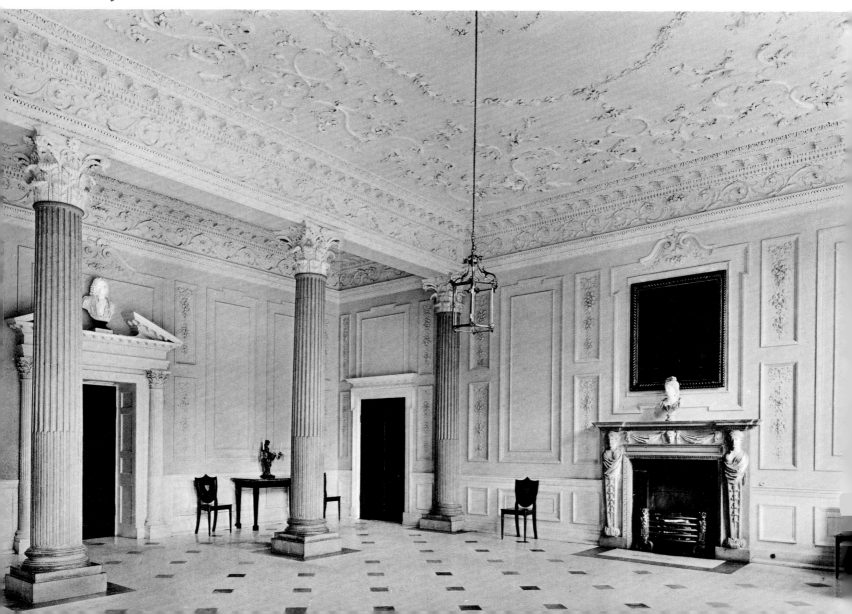

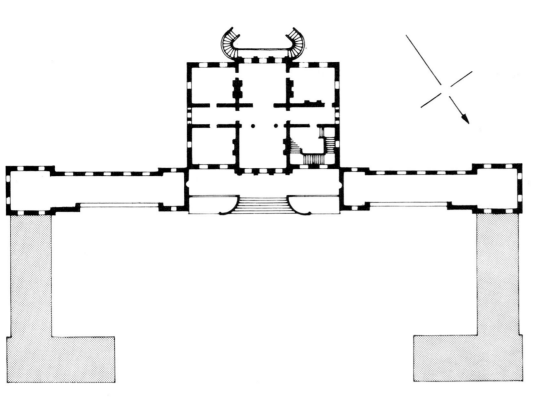

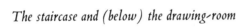

Ground-plan of Castletown Cox

0 10 20 30 40 50 FT

The staircase and (below) the drawing-room

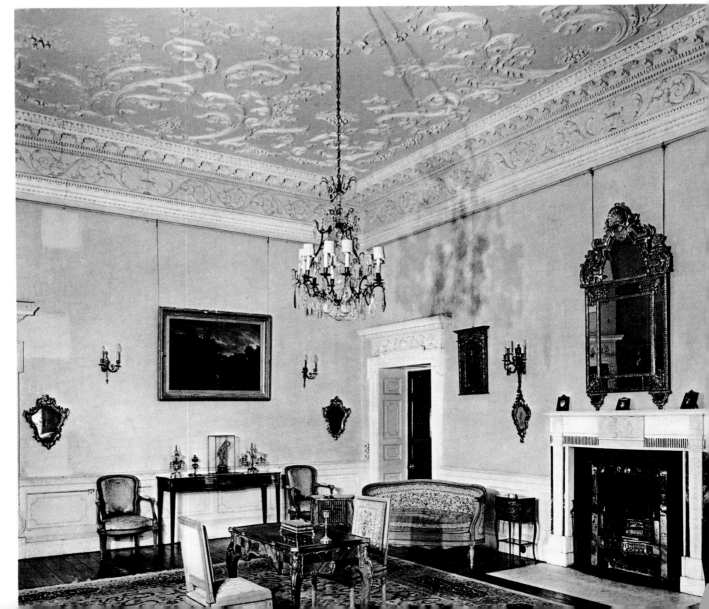

have added the arcades and wings at Florence Court, Co. Fermanagh, (q.v.) as they appear to be later than the house. Credence is lent to this theory by the fact that an estate map at Florence Court shows the central block without wings.

Castletown, Co. Kilkenny, is Ducart's masterpiece. The house is built of dressed sandstone and unpolished Kilkenny marble, very finely cut – the same quarry must have produced the gigantic fluted monolithic columns in the entrance hall. An unusual feature is that the ashlar dressings at the four corners of the house are all of equal length instead of alternately long and short. This motif is carried on to lend an orderly air to the rough stone wings, which were probably rendered in the eighteenth century (cf. Mellerstain). They provide a pleasant, rustic contrast to the sophisticated formality of the main block. As in so many Irish houses, on one side there is the kitchen courtyard and on the other the stables. It is said that the twin cupolas were originally roofed in copper, which was sold in about 1800 to pay debts (Hussey, *Country Life*, 1918). This may be a confusion with Kilshannig where the copper-domed pavilions no longer survive; nothing could have a more pleasing texture than the little fish-scale slates, beaten by the weather, with which the cupolas are now roofed. (*See p. 282*)

Castletown, Co. Kilkenny : the box garden

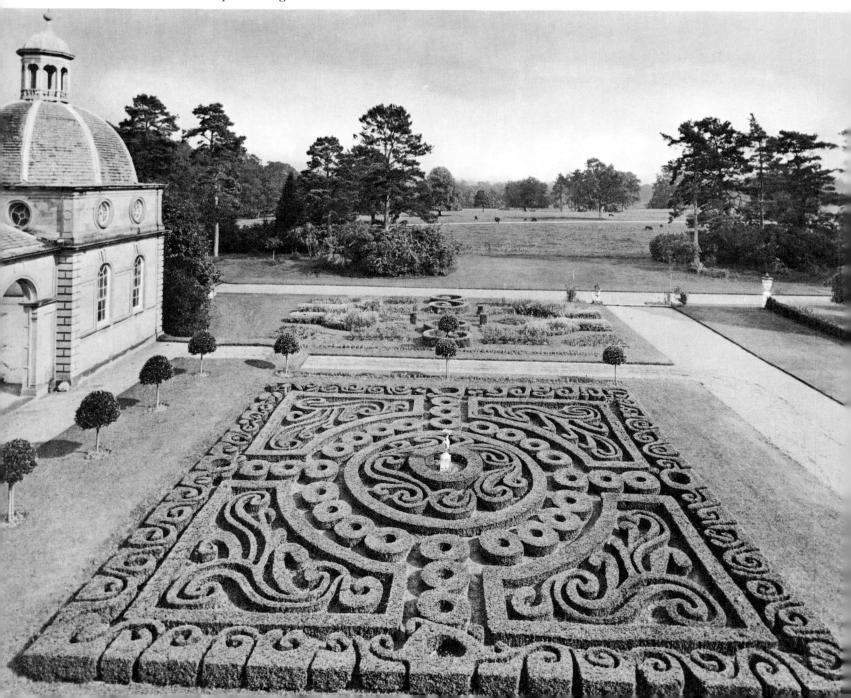

*One of the fish-scale domes
from above*

The interior is embellished with elaborate rococo plaster decoration which would no doubt be dubbed 'Italian', as such work is usually considered to be in Ireland, were it not for the existence of a complete set of accounts. Such documents are extremely rare; this is particularly interesting as it shows the cost of every detail of the ornament. The total cost came to £696 10s 5d. Patrick Osborne was probably a Waterford plasterer, and it is indeed fortunate that the name of such a distinguished Irish craftsman has been rescued from oblivion.

Castletown remained in the Cox family until 1909, when it was sold to Col. W. H. Wyndham-Quin, the heir to the Earldom of Dunraven and to Adare Manor, Co. Limerick. The formal parterre with its beautifully-kept box garden was laid out during his occupancy and he also imported the statuary from Clearwell Court, Gloucestershire. The property was later bought by Major-General Edmund Blacque whose son Charles, Master of the Kilmoganny Harriers, now lives there with his wife and family.

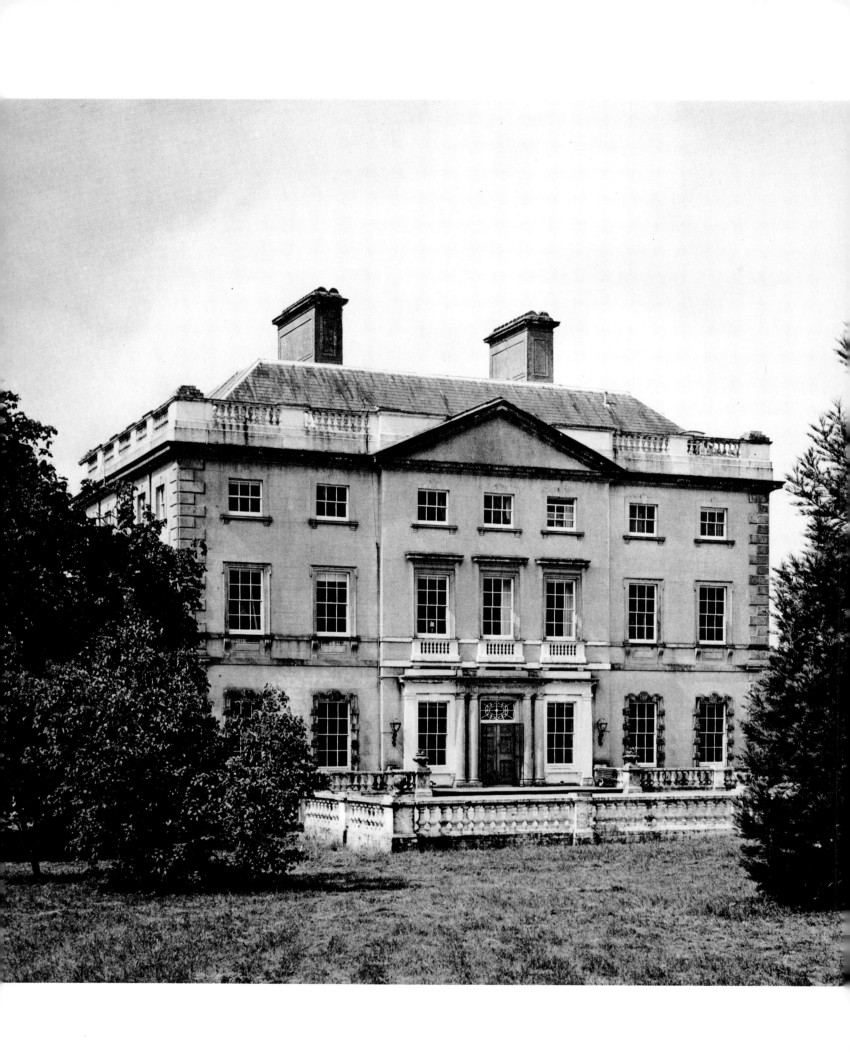

ABBEY LEIX

ABBEYLEIX, COUNTY LEIX

Viscount and Viscountess de Vesci

IN THE SPRING the long drive through ancient woods to Abbey Leix is at its best; the effect of the sunlight falling between the giant trees on to the young saplings is one of exceptional beauty. The oaks here are part of an original primeval forest, and the trees are naturally regenerated.

Abbey Leix takes its name from an old abbey 'de lege dei', which was founded by Conogher O'More in 1183. It is possible that it occupied the site of a still earlier abbey, established in the year 600. There is mention of its existence in the *Annals of the Four Masters* in 1417. Two tombstones of the O'Mores are still preserved at Abbey Leix, one of which reads 'Malachias O'More Lassie Princeps Requiescat In Pace. Amen. MCCCCLXXXVI' (Malachy O'More, Prince of Leix, May He Rest in Peace. 1486)

At the time of the dissolution of the monasteries by Henry VIII, the abbey lands of 820 acres became Crown property. They were granted to Thomas Butler, Earl of Ormonde, in 1562, but there is no evidence that he provided himself with an establishment here. Abbey Leix remained Butler property until 1698, when Thomas Vesey obtained an assignment of the grant and established the present demesne.

Thomas Vesey was the eldest son of John Vesey, D.D., Archbishop of Tuam. Living in the remote province of Connaught, the Archbishop was subject to considerable danger and hardship during the Jacobite wars. He had finally been obliged to flee to London with his family but little else, and had to survive a difficult year in England on a lectureship which brought in only £40 annually. He was attainted by the Irish Parliament of James II, but restored to his diocese after 1690, and from that time on he resumed his place in Irish affairs.

His son Thomas Vesey was made a baronet of Ireland at the early age of 25, and since this was during his father's lifetime, the honour was probably in part recognition for the vicissitudes the family had endured. Following the calling of his father and grandfather, Thomas took holy orders, and was consecrated Bishop of Killaloe in 1711, and Bishop of Ossory in

Abbey Leix built in 1773 to the designs of James Wyatt

1718. He died in 1730 and was succeeded by his son, John Denny Vesey, second Baronet, who was elevated to the peerage of Ireland as Baron Knapton in 1750. A sister of Baron Knapton married her cousin, Agmondisham Vesey, who built Lucan House on the Sarsfield estate which he had inherited from his first wife; there are many similarities between the two houses.

John Denny Vesey died in 1761, twelve years before his son and successor, Thomas Vesey, began to build the house at Abbeyleix. James Wyatt was the architect; his plans for 'a house in Ireland for the Baron Knapton' are in the collection of architectural drawings of the National Library, Dublin. In 1773, Wyatt, only 27 years old, was still fresh from his triumph as the designer of the Pantheon in London, and, after Robert Adam, the most popular and fashionable architect of the day. Plasterwork designs for the ceilings at Abbey Leix have recently come to light in a volume of drawings by Wyatt, now in the Metropolitan Museum in New York. The front hall, drawing-room, staircase, and a lobby running centrally from one side to the other of the house still retain their eighteenth-century character. The dining-room and library have been altered from time to time but have that indefinable warmth and charm which is imparted by family continuity. (*See p. 228*)

Thomas Vesey, second Baron Knapton and builder of Abbeyleix house, was created Viscount de Vesci in 1776, taking for his title the ancient Anglo-Norman form of the family name. He was an 'improving' landowner; one of his first acts upon succeeding his father was to plan and build a new town of Abbeyleix with a wide, tree-lined main street and a good water supply. The old town on the bank of the Nore, being dank and boggy, was demolished. In the centre of the new town stands a grand, monumental fountain, which makes a suitable memorial to its builder.

Life at Abbey Leix must have been very pleasant, as a letter written in 1778 from Mrs John Dawson, who lived at Emo Park nearby, to her sister indicates:

Now I must give you an account of Lady de Vesci's. I am quite in love with her and with their manner of living. It is without form, everybody doing as they please and always a vast number of people in the house. Lady Knapton, his mother, lives with them, and seems no restraint upon anyone, she is so good humoured. We were about six or seven ladies and as many gentlemen divided into different parties about the room, some reading, some working, some playing cards, and the room being very large and very full it had a most comfortable appearance. It opens into the Library on one side and the Dining-room on the other.

In another letter, thirteen years later, she writes warmly of the family-life she observed at Abbey Leix.

Malahide Castle: the large drawing-room and (below) the small drawing-room (see p. 145)

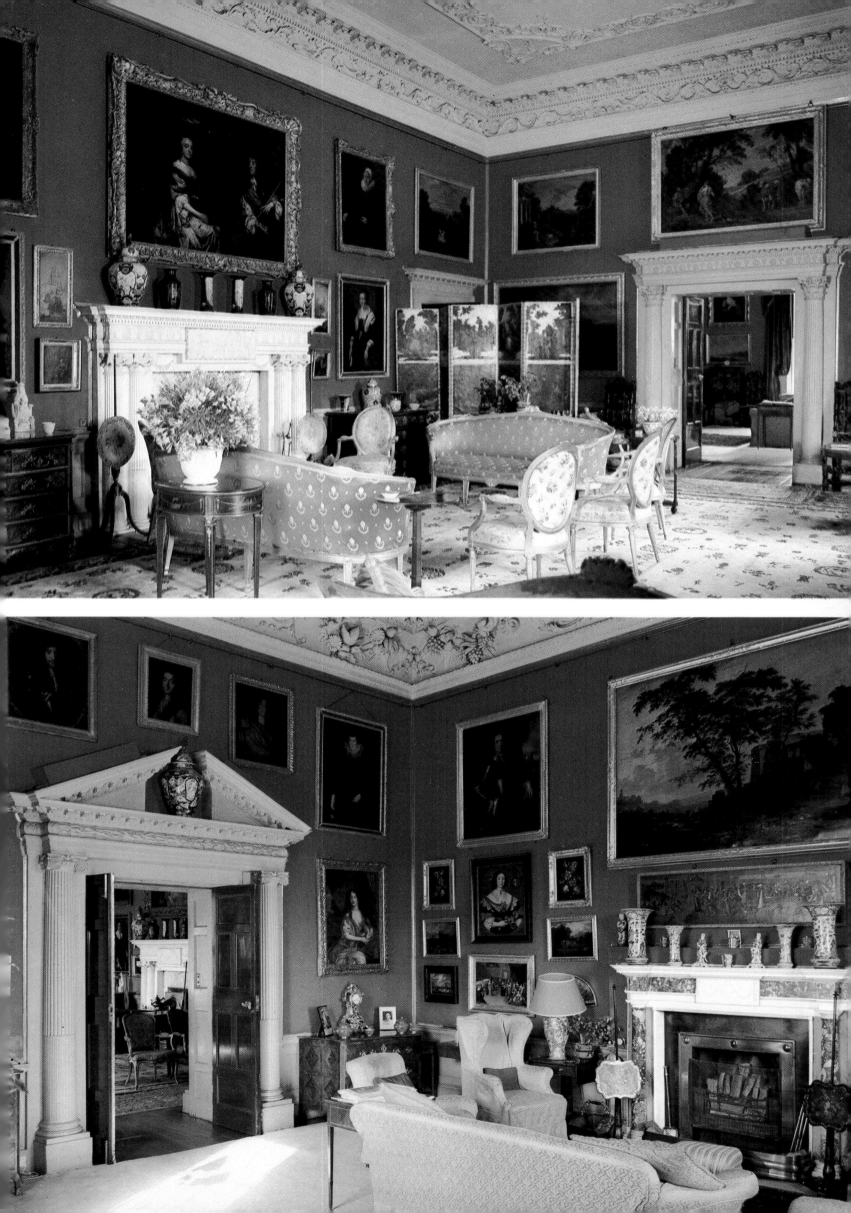

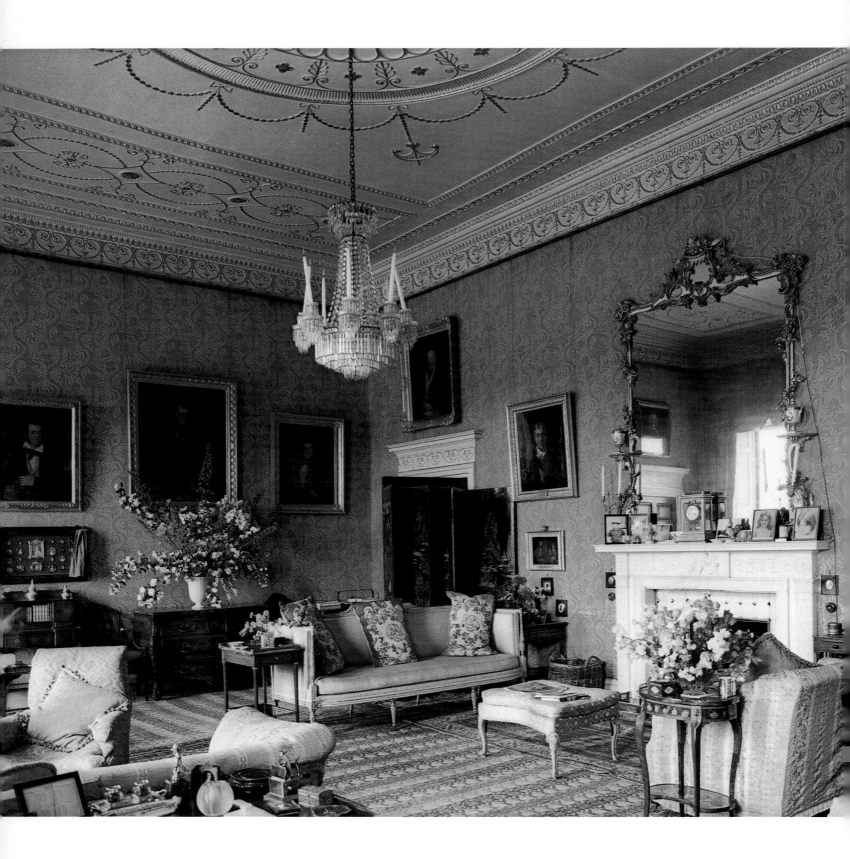

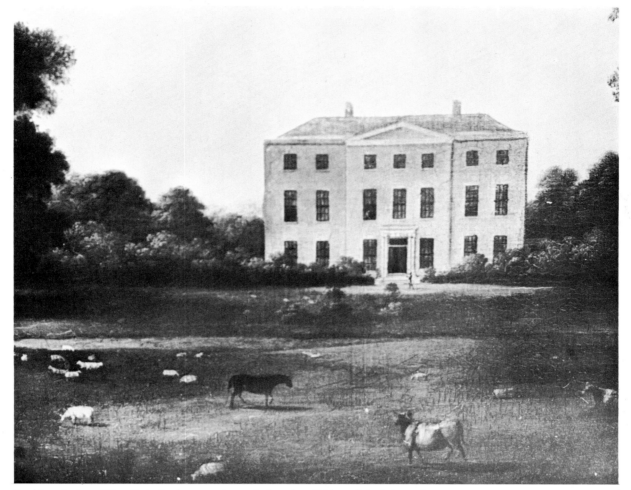

In this painting Abbey Leix is shown as it was before the addition of the balustrade

Abbey Leix (1773), Co. Leix : the blue drawing-room. The wallpaper is over a hundred years old

At Abbeyleix we sat down two and twenty at table all inmates in the house. Mr and Mrs Brownlow, with five children – two daughters and a son grown up, the others children; Lady de Vesci, two sons and a daughter grown up. I wish you could see the sort of comfort all these families have in each other. You would then think a large family a blessing. I must admire the Irish manner of bringing up children, for in all the families I have happened to know there seems the most perfect ease and confidence, and, except from their attention to each other you would never find out which were fathers and mothers, and which were sons and daughters, everyone amusing themselves in the manner they like best, and nobody expecting any particular respect or attention. Mr and Mrs Brownlow have a great fortune and have been used to live as well as anybody could wish, and from his being perfectly independent you might suppose there would be pride, as we have seen; but though he looks stiff and old, his daughters run up to put their arms round his neck to bid him good night and he looks at them with a satisfaction that is quite enviable.

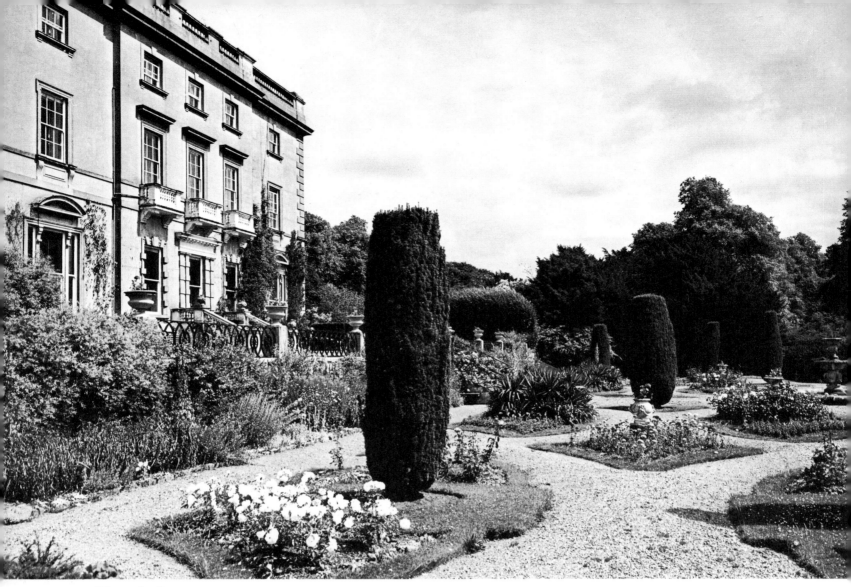

The garden front

The native woods at Abbey Leix have been supplemented with many rare and exotic specimens to form an exceedingly beautiful park extending along the banks of the river Nore. In *The Beauties of Ireland* (1825), Brewer described it as 'very extensive, and greatly enriched with woods, of a fine and venerable growth, which are, in several parts, formed into ornamental, and truly noble, avenues. But this territory is entirely indebted to art for its beauties. Its situation is low, and the contiguous country is naturally one vast extent of bog. So judicious and persevering have been the efforts of the munificent family of De Vesey, that a tract, utterly cheerless and unpromising whilst it remained under the sway of the O'Mores, now smiles in extensive cultivation, and constitutes a domain worthy of the noble owner.'

Nothing could be more unlikely than that a villa on the shore of the Black Sea, near the southern tip of the Crimea, should have inspired the remodelling of a house in the centre of Ireland. The transformation of Abbey Leix from the severely plain block built in 1773 to the fancifully decorated building it is today was done in fond recollection of the Villa Aloupka, the country seat of the Counts Woronzow of Yalta. The third Viscountess de Vesci, who

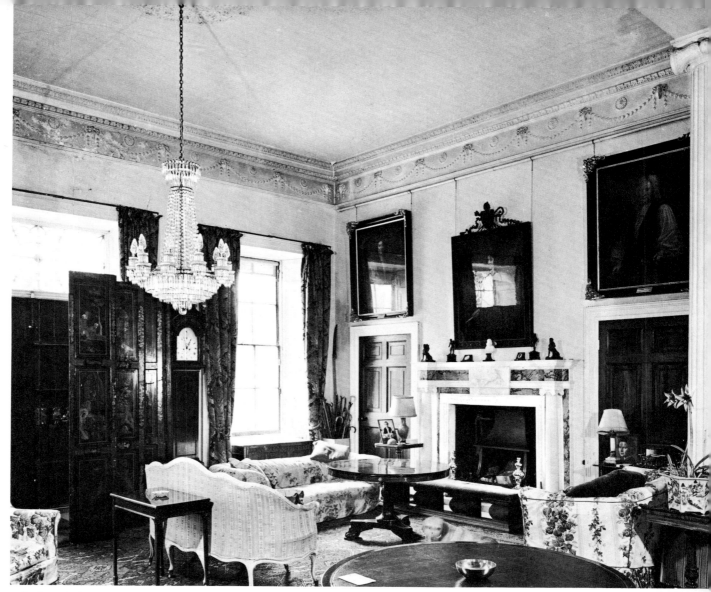

The front hall

was responsible for the additions to the house and for the design of the terraced gardens, was the grand-daughter of Count Simon Woronzow, Russian Ambassador to the Court of St James during the Napoleonic period. Catherine, his daughter, married the eleventh Earl of Pembroke, and their daughter, Emma, became the wife of Viscount de Vesci in 1839. A set of watercolour views of the terraces and gardens at the Villa Aloupka is still in the house; these sketches may have been the basis for the plan of the gardens at Abbey Leix, as it seems unlikely that Lady de Vesci could have had much first-hand knowledge of that remote spot.

Under the Wyndham Act in 1903, when the great Irish estates were divided up among the tenantry, woodland and town property were excepted. Apart from the ornamental trees, the commercial woods at Abbey Leix are extensive and well-managed – there are enough trees to justify an estate sawmill; some are cut and as many replanted every year. The present proprietor, the sixth Viscount, has recently opened the gardens to the public; as they are on the main road from Dublin to Cork they will undoubtedly attract many visitors.

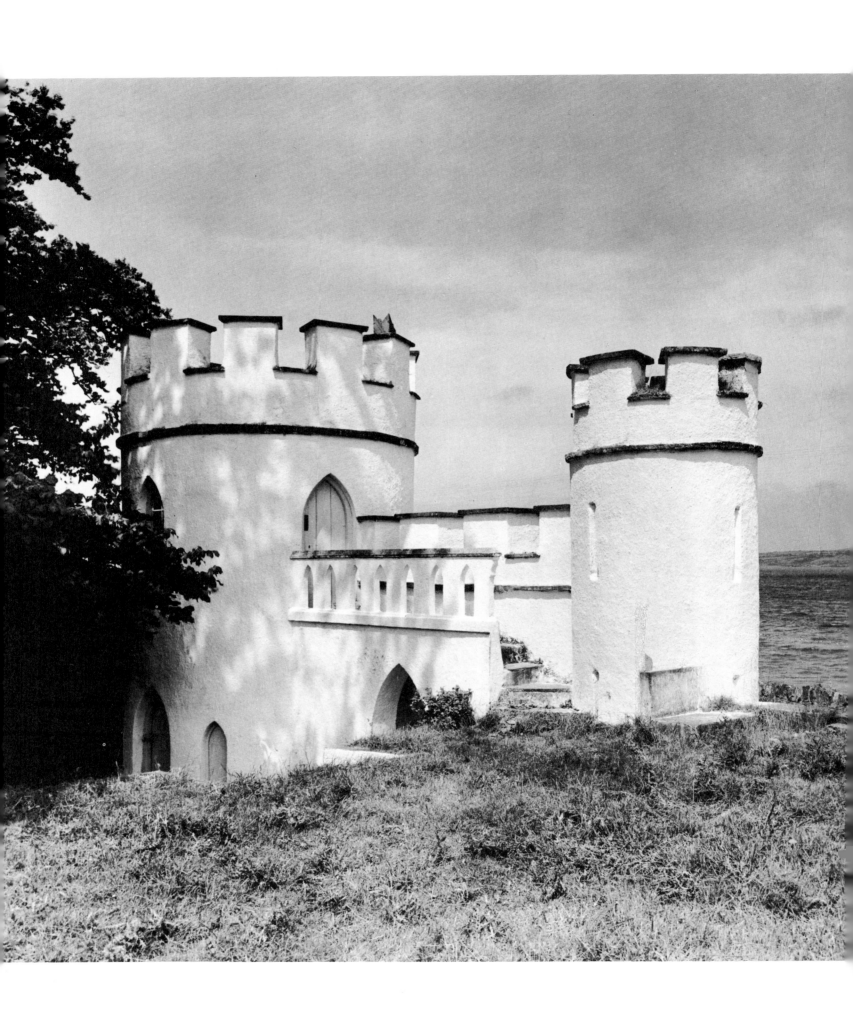

GLIN CASTLE

GLIN, COUNTY LIMERICK

The Knight of Glin and Madam Fitz-Gerald

> My humble muse awake and sing the praise
> Of lovely Glin in simple artless lays . . .
> Near yonder mount whose sloping sides are crowned
> With forest trees and ever-greens around
> There, on the margin of a stately wood
> With ancient oaks coeval with the flood
> Stands the proud castle of our present Knight
> Whose sterling virtues I would fain indite
> Unlike our Absentees who now devour
> The vitals of our country . . .

SO WROTE MICHAEL STACPOOLE, a tutor in the early nineteenth century to the Knights of Glin, whose gleaming white castle stands facing north across the Shannon Estuary thirty miles or so west of Limerick. There is something rather unreal about Glin; it looks like a toy cut out of cardboard, and the illusion is only heightened by the little battlemented lodges, resembling castles in a game of chess, that protect the demesne. In spite of the usual series of massacres, attainders, and confiscations, the Knights of the Glen, or Valley, have somehow managed to retain their land here for the last seven hundred years.

The origin of their romantic title has baffled genealogists and hostesses alike over the years. It most likely derives from custom rather than from law. Dr Graves, an authority on the Irish septs, has written: 'The nature of the hereditary Knightly titles borne by several branches of the Desmond Geraldines cannot be explained by the usages of the feudal system. That the honour of Knighthood should be inheritable is contrary to all the principles of chivalry. It was a strictly personal honour only to be won by deeds of valour and daring in the field.' But it should be remembered that there are many other titles peculiar to Ireland, such as The O'Conor Don, The O'Connor Kerry, The O'Grady, The Fox, The McGillycuddy of the Reeks, and so on, like those that are found in Scotland, which refuse to be categorized.

Glin Castle: one of the pepper-pot lodges with the Shannon Estuary beyond

The family of the Knight of Glin stems from John FitzThomas Fitz-Gerald, commonly known as John of Callan, as he was slain there in 1261. By his first marriage he was the

ancestor of the Earls of Desmond, who held more or less complete sway over the south and west of Ireland up to the reign of Elizabeth. 'Desmond' is a corruption of the Irish 'Diese Munt', meaning literally 'South Munster'.

By his second wife Honora, the daughter of The O'Connor Kerry, John of Callan had three sons: Gilbert FitzJohn (FitzGerald), the ancestor of the White Knights; John FitzJohn (FitzGerald) the ancestor of the Knights of Glin, otherwise the Black Knights; and Maurice FitzJohn (FitzGerald) ancestor of the Green Knights or the Knights of Kerry. Maurice, the last of the White Knights, died in 1608 without male heirs. The Knight of Kerry took a baronetcy in 1880 so that the older title has now been swallowed up – the present representative is the twenty-third of his line, but Glanleam, the last of his estates in Ireland, is no longer in Fitz-Gerald hands. Fortune has favoured the Knights of Glin.

According to the 'Geraldine Records', a suspiciously detailed and highly romanticized account dating only from 1638, King Edward III had sought the aid of the Irish in his war on Scotland. The Earl of Desmond had come to his assistance with a sizeable army, in which his three cousins were officers, each at the head of a division of 2,000 men. It was the prowess of this Irish contingent that turned the battle of Hallidon Hill in favour of Edward, who in return demanded that the leaders be brought before him 'armed as they had fought in the battle, each of them being somewhat wounded, and the blood yet flowing afresh'. The King is then supposed to have knighted them on the spot, according to the colour of the armour they were wearing. Burke, in his *Commoners of Great Britain and Ireland,* has a different version of the origin of the three titles. He would have it that John of Callan, by virtue of his royal seigneury as a count palatine, created the three sons of his second marriage knights, and that their descendants have been so styled ever since. It would have been normal practice to differentiate between the different branches of this numerous clan by calling them 'FitzGerald of Glin' and so on, and it is conceivable that the usage may have sprung up in this way.

In 1572 the Knight of Glin was possessed of four main castles, namely Castletown, Beagh, Cappagh, and The Vale (Glin), as well as the towns and lands that went with them. The remains of the old castle of Glin can still be seen in the village. It was largely destroyed in 1600 when it was besieged by Sir George Carew, Lord President of Munster, with an English force of fifteen hundred men. The contest was fierce, as is plainly shown in the engraving from Pacata Hibernica (1633) in which the unfortunate defenders can be seen hurtling from the battlements to their death below. This map gives a good idea of what the castle looked like. It was then surrounded by a moat formed out of the river deep enough in those days for boats to tie up beneath the castle wall. The Knight and a few of his men can be seen in the top right-hand corner of the engraving, watching the conflict from a safe distance. G. Holmes, in *A Tour in Ireland,* gives the following account of the action:

Here we found the shell of an old castle, formerly the seat of the knights of the Glin, a branch of the Desmond family. It was besieged by Sir George Carew, anno 1600, who encamped between it and the Shannon. The knight of Glin came to the camp with a flag of truce, but refusing the terms offered him, was commanded to depart. The bombardment began, when the knight's son, who had been detained as an hostage, was placed in the front of the breast-works, in order to terrify the besieged; notwithstanding which, the constable of the castle declared he would point his guns against the camp. [At this, an onlooker cried out, 'The Knight can have more sons!'] A breach was made under the hall of the castle, and Captain Flower commanded to enter, supported by Captain Slingsby: they gained the first flight of stairs, where the constable was slain in its defence. Here they remained all night, and next morning they gained the tower, on which the garrison retreated to the battlements, where most of them were put to the sword.

Map from 'Pacata Hibernica' (1633) showing the old castle of Glin which was largely destroyed in in 1600

After this disaster the Knight's son was packed off to Spain with several other of the Irish nobility, but the Knight himself remained in Ireland as a fugitive and a rebel. In 1615 he was allowed to return to the remains of his castle. He must have constructed some sort of dwelling house at this time or else made the old castle habitable again – an old stone, dated 1615, which has been reset into an arch beside the eighteenth-century castle, bears the inscription 'Edmond Gerald, Knight of the Valley, Onner Carthy, his wife. Fear God always, and Remember the Poor. I.H.S. A.D. 1615.' In 1628, Edmund was succeeded by his son, who was nicknamed the 'Spanish Knight' on account of his education at Compostela.

The family remained true to the old faith until the eighteenth century when the four surviving sons of Thomas Fitz-Gerald each conformed, one after the other, as they inherited the titles and estates from one another. The eldest of the four, John, himself a Gaelic poet, dropped dead at the feet of his bride at his own wedding ball in 1737, 'as if struck by a thunderbolt'. On entering a room full of company Richard 'the duellist', the third brother, would cry 'Is there a Moriarty in the house?' This was a reference to the betrayal of the Earl of Desmond by the Moriartys in 1582, when the Earl was murdered and his head sent to Queen Elizabeth. Richard was an accomplished swordsman; once, when fighting a duel

Glin Castle: the front hall. The painting by Highmore shows the Knight being handed the challenge to a duel

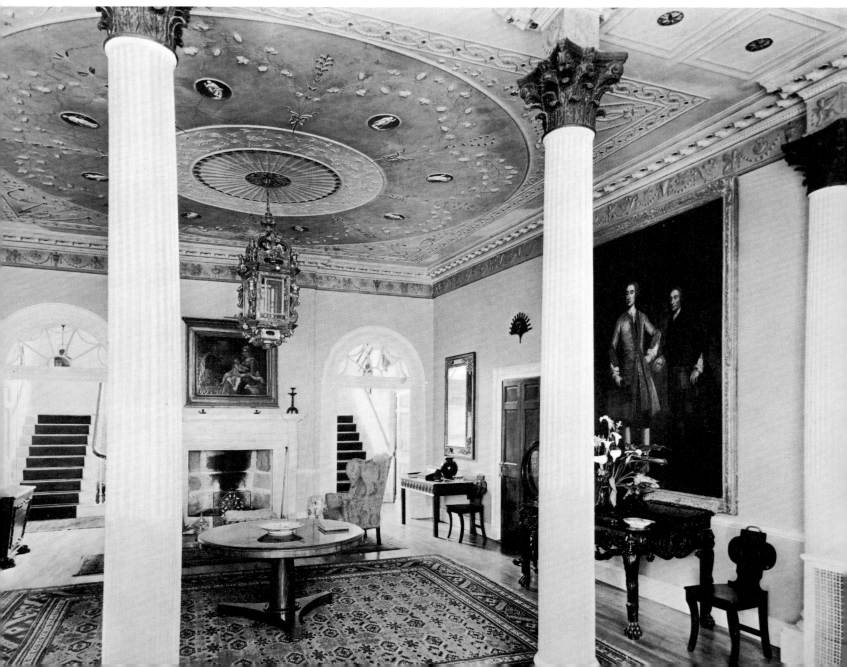

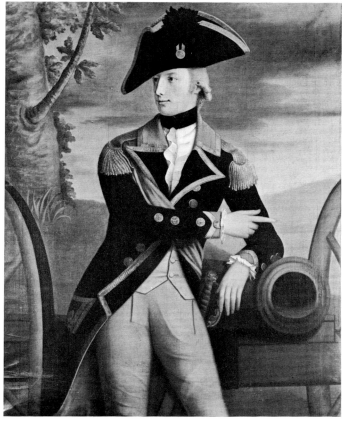

John Bateman Fitz-Gerald, Knight of Glin, in his uniform as Colonel of the Royal Glin Artillery, c. 1780

(Below) The staircase ceiling; a detail showing the family arms and motto, the war-cry 'Shanid-a-Boo', and a naive representation of Hibernia

with a Spaniard, and unable to get his sword home, the day was saved by his servant who cried out 'Stick him where they stick the pigs, Knight.' The Spaniard was pierced through the throat, and was afterwards discovered to have been wearing chain mail under his shirt. A painting in the front hall at Glin, by Highmore, shows the Knight being handed the challenge for this duel by his servant.

The duellist's nephew, John Bateman Fitz-Gerald, twenty-fourth Knight of Glin, whose portrait in uniform as Colonel of the Royal Glin Artillery is reproduced here, married Margaretta Gwyn of Forde Abbey, Dorset, in 1789. The gradual transition from chieftain to squire was complete. Very soon after their wedding they built 'Glynn-house' which is described in the *Post-Chaise Companion* of 1806. The plasterwork in the hall incorporates their arms in the decoration. This work is by an unknown hand; all the family papers were destroyed by the 'Cracked Knight' in 1860. It has great charm and a certain naivety which probably indicates its Irish origin, and which is absent from the decoration in the drawing-room; this appears to date from the same period but is by a less sensitive hand. (*See p. 245*)

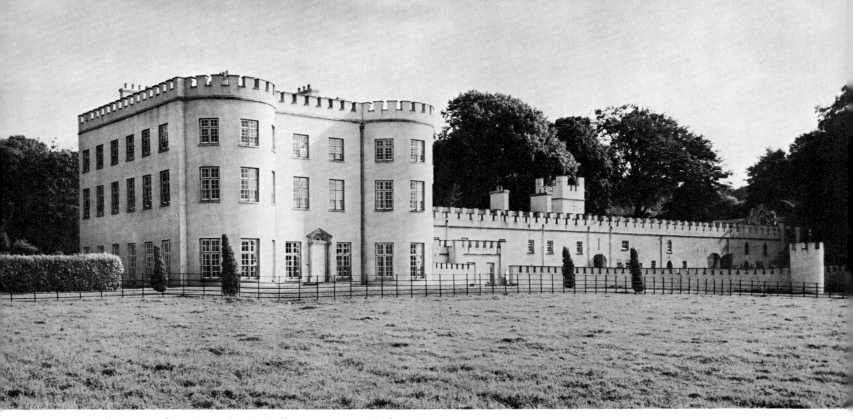

The entrance front (1790). The battlements were added after 1812

Both the Knight and his wife died young, in 1803 and 1801 respectively, and their only son John Fraunceis Fitz-Gerald, born in 1791, inherited when still a minor. It is doubtful whether the demise of John Bateman caused the widespread distress felt in the neighbourhood at the passing of his much loved ancestors, for among the Irish State Papers there is an affidavit of one John Dillon, dated 1800, referring to the Knight of Glin as 'the terror and dread of that Country . . . whose very name made the poor . . . tremble'.

John Fraunceis married in 1812, and soon after added the battlements to the house, turning it into a castle. It has scarcely been altered since. He even gothicized the wing and farm buildings to the west of the main block, leaving them in rough stone, complete with arrow slits and crenellations. In the 1820s and 30s he built the three Gothic lodges. The entrance lodge represents the second family crest – 'a castle of two towers argent' though the fancy was not completed by 'issuing from the sinister a knight in armour argent holding a key'. He also built a hermitage and a Gothic folly beside the Shannon.

John Fraunceis was nicknamed the 'Knight of the women' by the local people. In spite of this dubious nickname he was a member of the Royal Irish Academy, and also a noted horseman. In an election broadsheet of 1830 he was lampooned as follows:

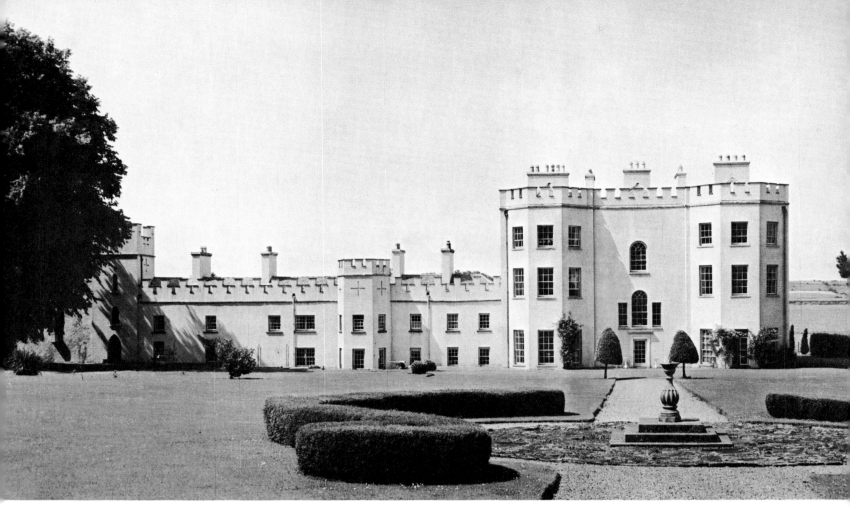

The garden front

This hoary old sinner, this profligate rare
Who gloats oe'r the ruin of virtuous and fair
In gambling and drinking and wenching delights,
And in these doth he spend both his days and his nights.
Yet, this is the man who's heard to declare
'Gainst O'Grady he'll vote if the priests interfere.'
But the priests and O'Grady do not care a pin
For the beggarly, profligate, Knight of the Glin.

His vices have made, and still make him, so poor
That Bailiff or Creditor's ne'er from the door
But deep tho' in debt, yet he's deeper in sin
That lecherous, treacherous Knight of the Glin.

The present Knight of Glin is the twenty-ninth holder of the title. During his tenure the property has been restored by his Canadian step-father, Mr H. R. Milner, from entrance lodge to castle battlement; it is well prepared now to withstand the storms of another hundred years.

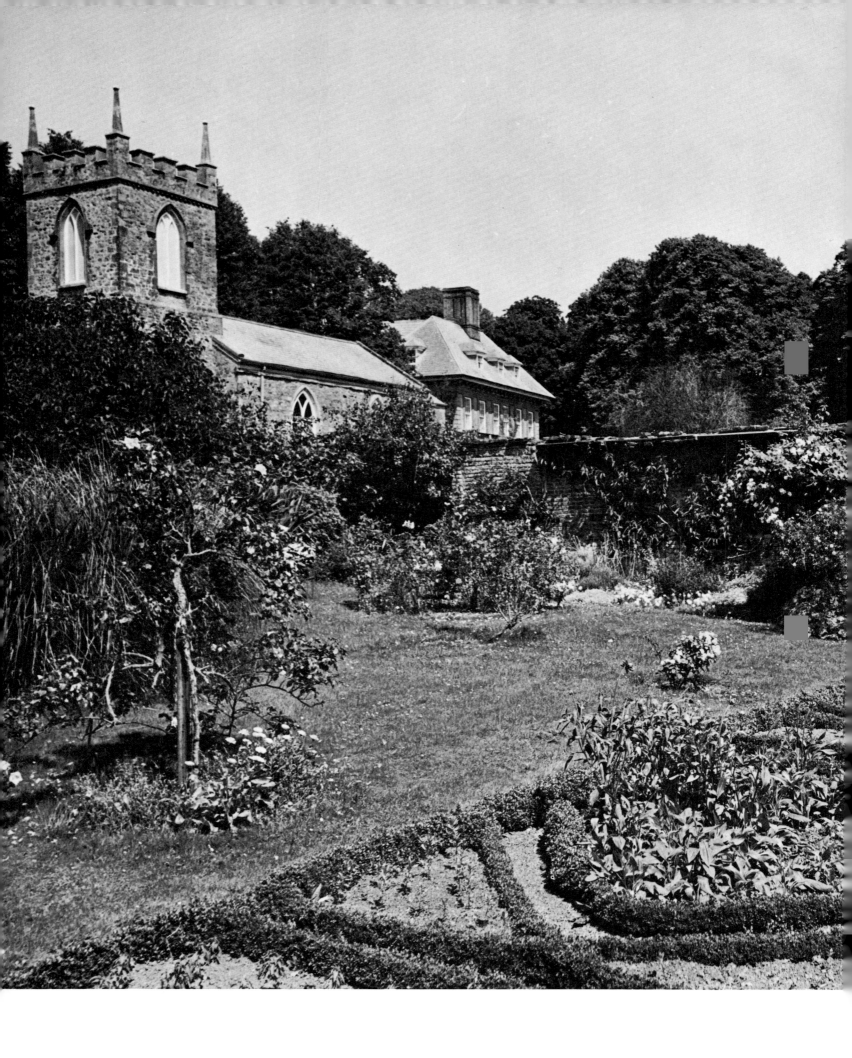

BEAULIEU

DROGHEDA, COUNTY LOUTH

Mr and Mrs Nesbit Waddington

FEW ESTATES IN IRELAND have existed for nearly eight hundred years, and fewer still have been occupied by only two families in that long span of time. Beaulieu is one, having been established by the Plunkett family some time after the Norman invasion, and remaining their home until approximately 1650. The estate was declared forfeit in 1642 by an act of the Long Parliament, in retaliation for William Plunkett's participation in the rebellion of 1641, but the family must have remained in residence as Plunkett died there in 1644.

There is a family tradition that Sir Henry Tichborne, who led the troops that captured Beaulieu in that war, obtained the property by payment from the Plunketts, but the deed of transfer has recently been destroyed. Henry Tichborne was living at Beaulieu at least as early as 1650. He petitioned Cromwell in 1654 for a grant of the estate in settlement of debts he had incurred on the government's behalf, but his application was only partially successful, and he remained a tenant there for the duration of the Commonwealth. When Charles II was restored to power, Sir Henry Tichborne became Marshal of the Irish Army.

William Tichborne, son of Henry, was confirmed in occupation of Beaulieu by the Act of Settlement of 1662, which also stated that he had expended £450 on buildings and improvements. No doubt it was he that was responsible for building the present house, traditionally dated to between 1660 and 1667; his father would have been a very old man by that time.

Beaulieu is situated on the banks of the River Boyne, a few miles downstream from Drogheda, and within easy reach of Dublin by sea, a great convenience in early days when communication on land was both difficult and hazardous. Today the house, which is approached by an avenue of lime trees, looks across terraced lawns and old trees to the Boyne estuary. There is a small Protestant church built in 1807 beside the garden a few hundred feet from the house.

Beaulieu: the Pro-testant church in the grounds, and part of the garden

One of the most interesting aspects of Beaulieu is that it completely lacks any defensive features, and is one of the earliest houses in Ireland to do so. From Elizabethan times an

241

unfortified wing providing comfort and convenience was frequently added to an older castle, as at Carrick-on-Suir, but the occupants could always retreat to the tower in case of attack. As late as 1641, new houses such as Burntcourt Castle, Ightermurragh and Coppinger's Court were being constructed with shot holes, corner turrets, corbelled galleries or machicolations, and angled walls for cross protection. After the twenty years of turbulence that started with the Eleven Years War and ended with the Restoration, a period of quiet and prosperity began in which military action seemed unlikely. Even so it was remarkable that a country house in the English style should have been built twenty-five years before the Battle of the Boyne, and so soon after the hideous massacre wrought at Drogheda by Cromwell, in the name of God.

An 1830 engraving of Beaulieu in D'Alton's *History of Drogheda,* however, shows a twelve foot hedge or palissade surrounding the house and completely obscuring the view from the ground floor windows; presumably this was added for safety rather than convenience.

Beaulieu : the front hall. A landscape of Drogheda may be seen painted on the wall in the upper tier of the mantel

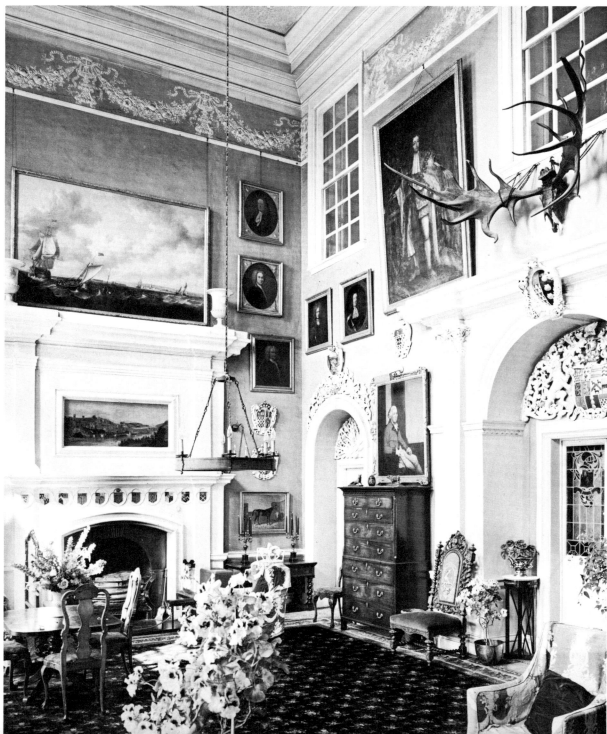

The style of Beaulieu is one which Sir John Summerson has described as 'Artisan Mannerism'. It arose in the second and third quarters of the seventeenth century from practical designs of master masons, joiners, carpenters and bricklayers, quite separately from the Court Style simultaneously being developed by Inigo Jones. The 'Artisan' style reflected the contemporary architectural fashions of France and the Netherlands. In Ireland the nearest house to Beaulieu both in date and style is Eyrecourt, Portumna, Co. Galway, built by a Cromwellian officer, Colonel John Eyre, soon after 1660, and of recent years derelict and semi-ruinous. The cantilevered eaves, and the hipped roof surmounted by tall, symmetrical chimneys at Beaulieu are typical of the 'Artisan' style of a decade or so earlier in England. The original windows were very likely of the mullioned casement type. The effect of the whole composition at Beaulieu is one of solidity, warmth, and quiet repose. (*See p. 246*)

A substantial part of the original interior decoration still remains in the house, in spite of minor alterations. The imposing two-storey chimney-piece, the great arched doorways and

The drawing-room, with its painted ceiling in the style of Verrio ; late seventeenth century

the monumental cornice of the entrance hall are all typical of the last half of the seventeenth century. The drawing-room and dining-room both have bolection-moulded panelled walls and plaster ceilings in which a huge oval floral garland is the central feature. The garland in the drawing room is further embellished by a perspective painting of a gallery and cupola, a decoration frequently found on the Continent but rarely in Ireland. A major structural change occurred in the early eighteenth century when the principal staircase was replaced by one in the lighter more elegant Georgian style. Probably at the same time a corridor at the first floor level was added, lighted by interior sash windows opening into the upper wall of the hall. This may also have been the occasion for replacing casement windows with sash throughout the house.

At about this time several delightful, elaborate woodcarvings were added to the arches over the doors in the hall. Sir William Tichborne, son of the builder of the house, had been created Baron Ferrard of Beaulieu in 1714. The carvings, which bear the Ferrard arms, must have been installed after this date but presumably before Sir William died in 1731. The magnificent trophy of arms over the entrance door may be of slightly earlier date. The frieze of lincrusta swags in the hall is modern.

The present owner is Mrs Nesbit Waddington, the ninth-generation descendant of Sir Henry Tichborne who purchased Beaulieu from the Plunkett family. Mr Waddington was for several years manager of the Aga Khan's stud farm in Ireland, and now runs his own stud at Beaulieu.

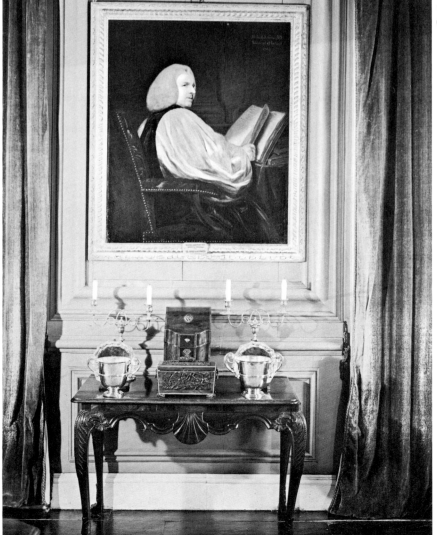

Primate Robinson by Reynolds (1765) in the dining-room at Beaulieu

Glin Castle (1790), Co. Limerick: the library. Over the mantel hangs a romantic view of Glin by J. H. Mulcahy. (Below) The drawing-room. The portrait (1740) over the mantel is of Celinda Blenner-hasset of Riddlestown, who was the only lady member of the Limerick Hellfire Club (see p. 233)

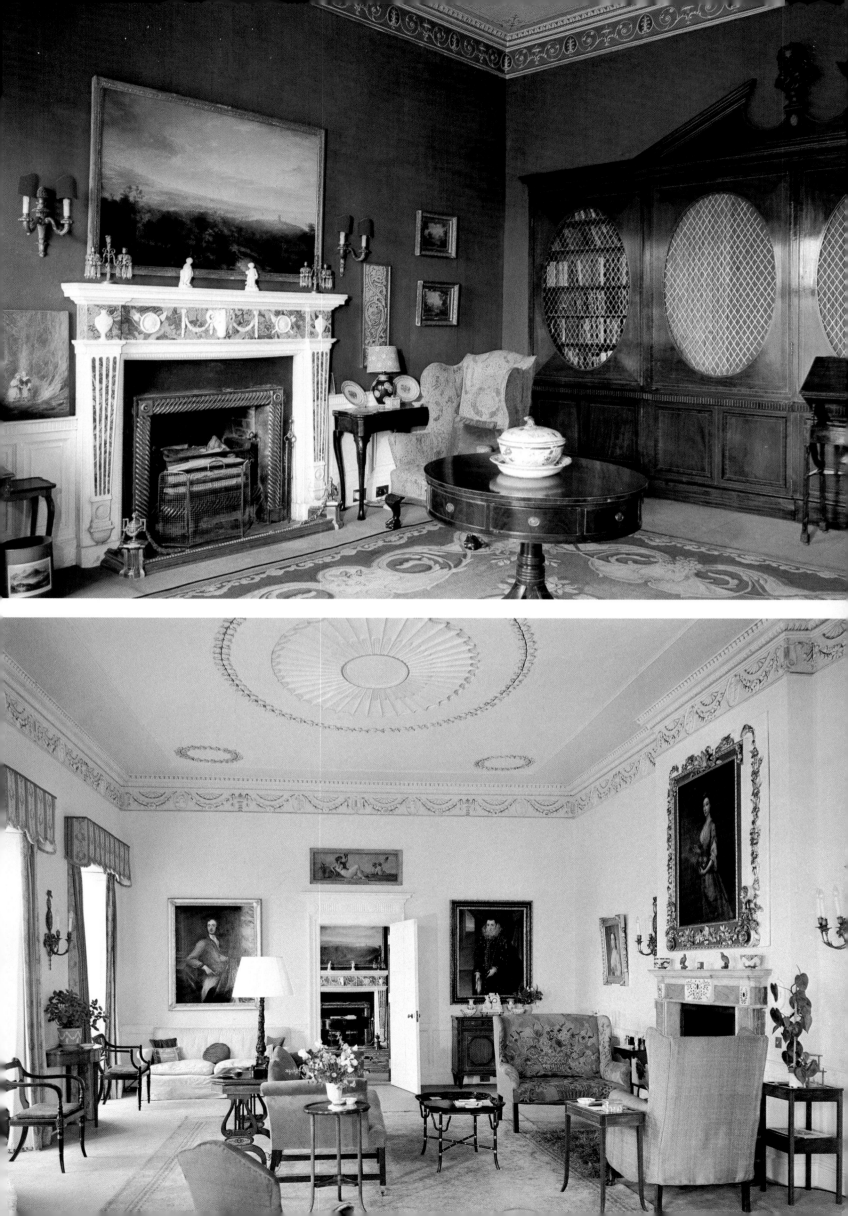

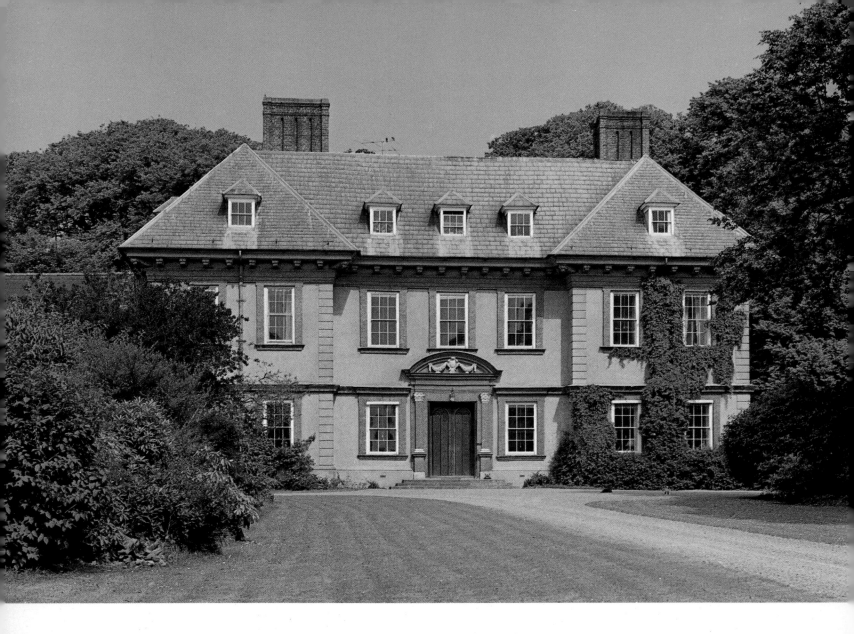

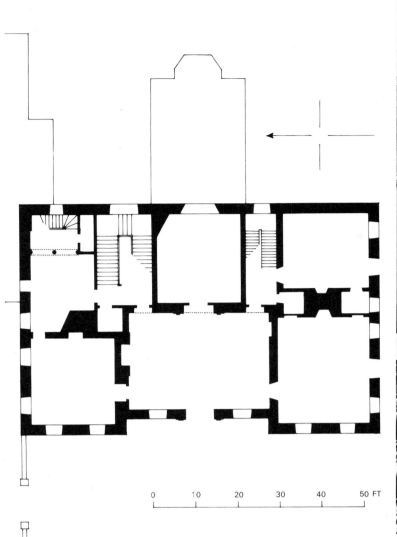

*Ground-plan of Beaulieu which has a modern
billiard-room to the east of the main block*

The staircase (1720)

Military trophies in carved wood above the front door (c. 1720)

*Beaulieu (c. 1660),
Co. Louth: the
entrance front and
(below) a portrait of
William of Orange
at the Battle of the
Boyne hanging above
an Irish table of c.
1750 at one end of
the hall*

0 10 20 30 40 50 FT

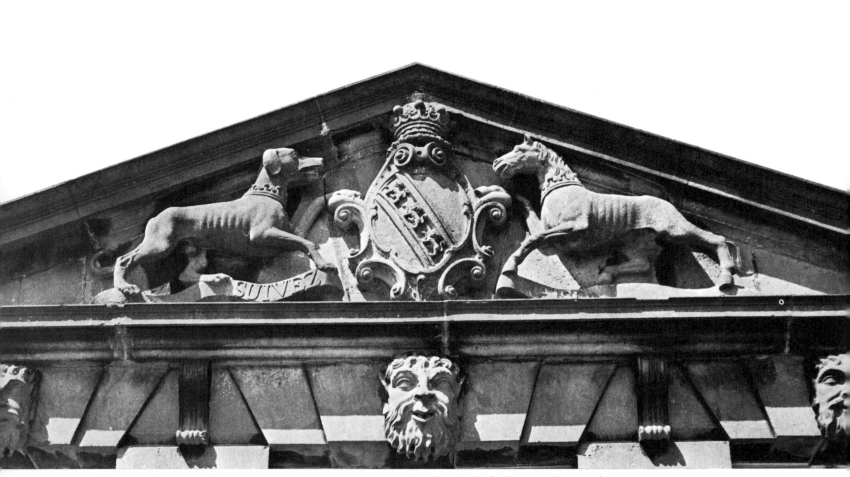

Westport House: the front door is surmounted by the arms of the first Earl of Altamont (c. 1771)

The façade. The house was designed by Richard Castle in 1731

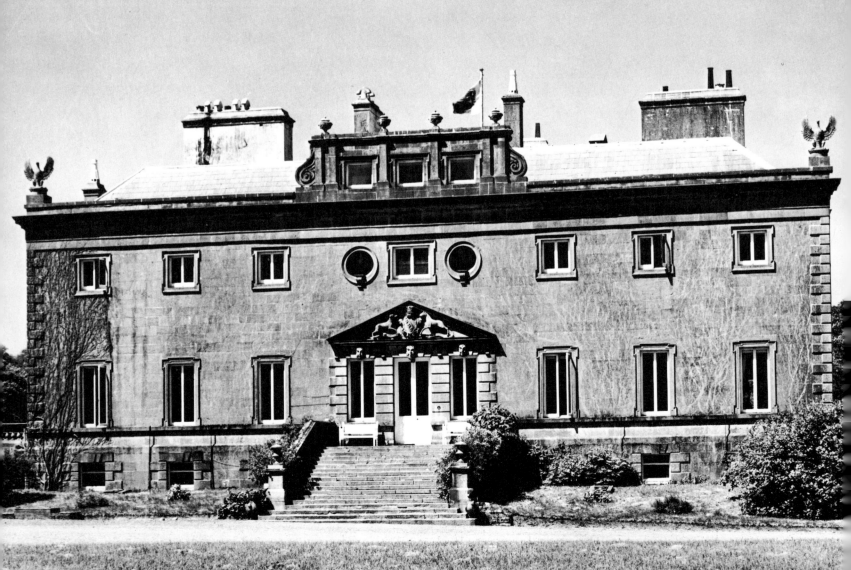

WESTPORT HOUSE

WESTPORT, COUNTY MAYO

The Marquess and Marchioness of Sligo

WESTPORT STANDS IN a 'natural' park, looking out across a man-made lake to the waters of Clew bay, and the far Atlantic (*see p. 263*). It was designed in 1731 by Richard Castle, for John Browne, later the Earl of Altamont, and it is the most important country house west of the Shannon. The original John Browne had settled at The Neale in County Mayo in the reign of the first Elizabeth, when this part of Ireland was under the sway of the Burke and O'Malley chieftains. 'I am', he writes in 1585, 'the first Englishman that in the memory of man settled himself to dwell in the County of Mayo. While I was Sheriff here [1583] for sundry disorders committed by Mac William and his bad sons, and by Edmund Burke, the tanist, and his rebellious sons, I took them both prisoners at one time, and made them deliver me their sons for pledges to Her Majesty for their good behaviour; since that, they never loved me, but I thank God the dutiful people do love me ever; and I doubt not but to do well there.'

The Brownes were a Catholic family and supported James II, an allegiance that was to cost them the larger part of their new-won estates. Colonel John Browne, the grandfather of the builder of Westport (whose father-in-law, Viscount Bourke, was shot by Cromwell in 1652) raised two regiments to fight for King James in Ireland. The defeat of James at the Boyne was the ruin of John Browne's fortunes and he spent the rest of his days in financial difficulties. He is said to have ridden continuously between Westport and Dublin, remaining no more than two days in either place, so as to avoid being arrested for debt. Colonel Browne (1636–1711) founded the Westport estate out of O'Malley territory, and his wife, Maud, was the great-great-grand-daughter of Grace O'Malley, the legendary pirate queen.

His grandson, another John Browne, married Anne Gore in 1729 and soon after set about building a new house. He chose Richard Castle, the German architect who was later to enjoy such a successful practice in Ireland but who had at that time only just arrived in the country and must have been practically unknown. The entrance front of Westport is much as Castle left it, a rather austere nine-bay façade with winged eagles at either end of the cornice that are part of the family crest. In the pediment above the front door are the arms of the Earl

of Altamont – John Browne was made Baron Mount Eagle in 1760, Viscount Westport in 1768, and the arms must have been inserted after 1771 when he received the Earldom.

There is a three bay attic room over the hall door, not unlike the 'observatory' that surmounts Powerscourt House in South William Street, Dublin. According to the much travelled bishop Richard Pococke, who visited Westport in 1752, this was a sort of dormitory.

> Mr Brown's house is very pleasantly situated on the south side of the rivlet over which he has built two handsome bridges, and has form'd Cascades in the river which are seen from the front of the house; which is built of Hewen stone, a course marble they have here; It is much like Bedford House in Bloomsbury Square, except that it has a pavilion in the middle over the Attick story in which there is a large convenient Bed chamber for the young people, of the size of the hall, the design is with nine windows on a floor and for five rooms; one of which a back wing is not built: It is an exceeding good house and well finished, the design and execution of Mr Castels: Mr Brown designs to remove the village and make it a Park improvement all round; there are fine low hills every way which are planted and improved, and the trees grow exceedingly well: the tyde comes just up to the house; the Cascades are fine Salmon leaps. In the house are handsom chimney pieces of the Castle bar marble, which are a good black without any white in them like the Touchstone, which the Italians call Paragone and value very much.

Moore's two paintings show the façade or east front as it was in 1760 and the west front as it would have been if both of the 'back wings' had been completed. The asymmetry of the fenestration as shown in his painting of the west front would seem to indicate that Castle was, as at Powerscourt, Co. Wicklow, having to incorporate the thick walls of an old castle or fortress into a classical house. Westport stands on the site of an old O'Malley castle, whose dungeons may still be seen.

The paintings have a naive charm, and give some idea of the superb setting in which the house is placed. The layout of the park is informal, but the trees still appear to stand in rows, like soldiers in a regiment unwilling to drop out of line. The terraces and balustrades were laid out by the sixth Marquess of Sligo in 1913. Thackeray admired the view of the holy mountain and the bay beyond scattered with little islands, that he likened to 'so many dolphins and whales basking there'. He wrote in his *Irish Sketch Book* (1842): 'the most beautiful view I ever saw in the world I think . . . The sun was just about to set, and the country round about and to the east was almost in twilight. The mountains were tumbled about in a thousand fantastic ways, and swarming with people. Trees, cornfields, cottages, made the scene indescribably cheerful; noble woods stretched towards the sea, and abutting on them, between two highlands, lay the smoking town . . . Hard by was a large Gothic

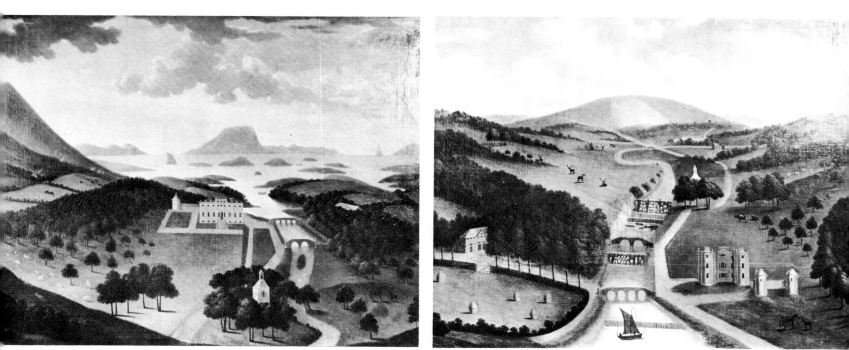

Paintings at Westport by George Moore show the front (left) and back (right) as they were in 1760

Chinese paper in a bedroom, c. 1780

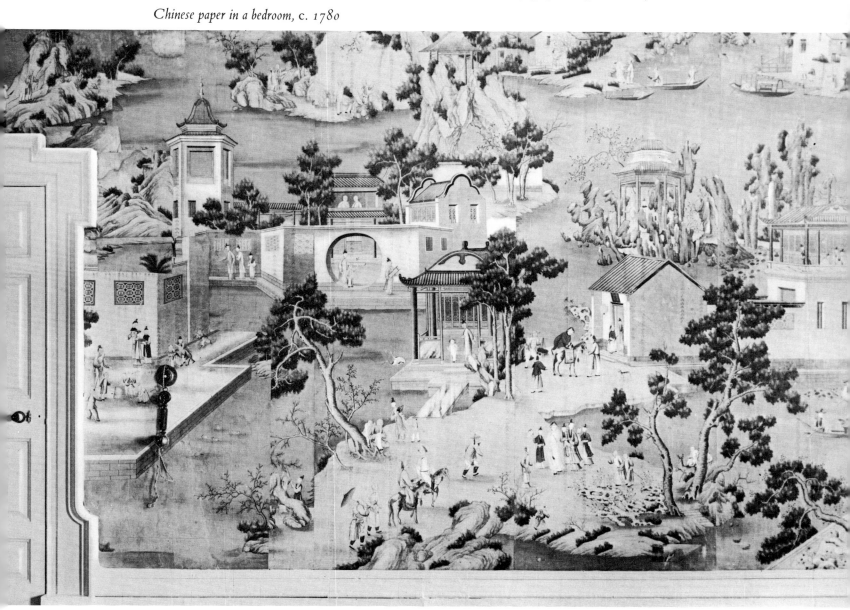

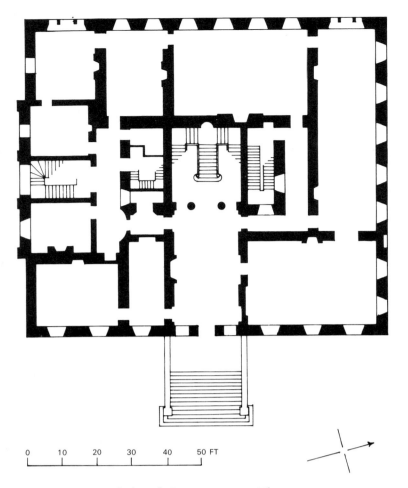

The banner of the Mayo Legion, raised by the French when they landed at Killala, Co. Mayo, in 1798. Hibernia holds the cap of Liberty in her left hand

Ground-plan of Westport House. The main staircase was inserted in the central courtyard in the nineteenth century

The dining-room, designed by James Wyatt in 1781. A bog-oak potato bowl with mid-eighteenth century ring and lid, stands in the centre of the table

building – it is but a poor-house; but it looked like a grand castle in the grey evening. But the Bay – and the Reek which sweeps down to the sea – and a hundred islands in it, were dressed up in gold and purple and crimson, with the whole cloudy west in a flame.'

A plan for enlarging the house was made by Thomas Ivory, the Cork-born architect, in 1773, which is still at Westport, and was reproduced by Dr Mark Girouard in *Country Life,* 29 April, 1965. This shows that Bishop Pococke was indeed right in saying that one of the back wings was not built. The plan was to double the house in size by extending it to the west and create a courtyard in the centre. Although this particular plan was not used, a similar one, presumably also by Ivory, was carried out, and the date 1778 is carved in the pediment on the south front.

A few years later, in 1781, James Wyatt produced designs for the dining-room (as executed) and in 1819 his son Benjamin Dean Wyatt designed a two-tiered library for Westport which was however burnt in 1826. Further alterations were made in 1857 when the windows were reglazed and the main staircase was put in where the courtyard had been.

The only apartment that still has a Richard Castle flavour is the entrance hall, where the ceiling is similar to that in the tapestry room at Russborough. Here the monumental black mantel designed by Castle and described by Pococke has been replaced with one from

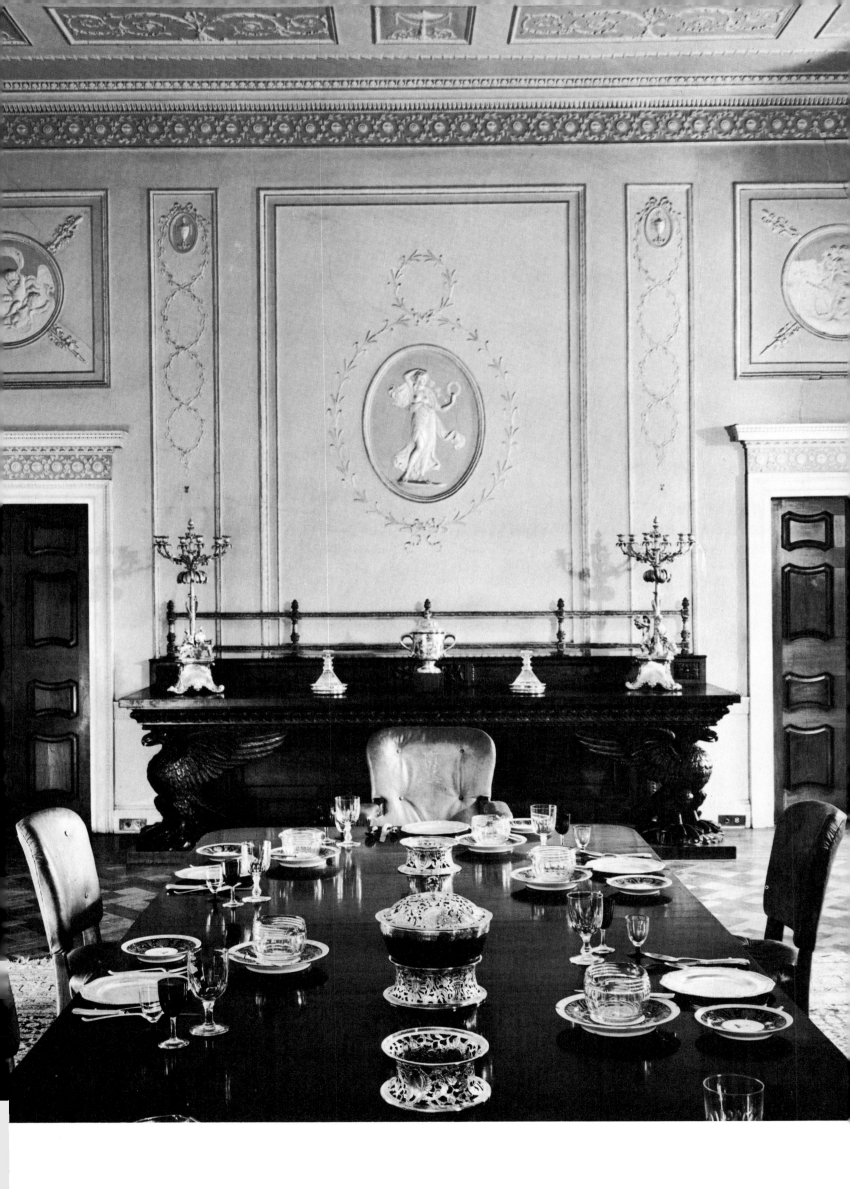

Welbeck Abbey. This mantel (which had incidentally been coated in sand in the 1930s, so oppressive did it seem to the Lord Sligo of the day) is, however, still preserved in the house. The black marble mantels with which Richard Castle liked to embellish his front halls have not been treated kindly by posterity. For example, that at Russborough has had an entire section removed from it, and the one at Leinster House in Dublin is coated in shiny cream paint.

Owing to the crippling rates on the house and land at Westport, Lord Sligo, who had built himself a small house on the property, considered pulling down or selling Westport in 1956 to save the rates. Some years later, following a joint discussion with his son the Earl of Altamont, it was decided to open the house to the public. Although there was no encouragement from the Tourist Board or the national bus company at the start, in ten years Westport has become one of Ireland's major tourist attractions, changing the whole pattern of tourism in the West. Today it attracts 30,000 people a year, a miracle considering the remoteness of the area, and the future of the house would appear to be assured – a considerable achievement.

Westport House contains many items of particular Irish interest as well as some excellent family portraits. There is a Reynolds of the first Earl of Altamont, and a Hudson of Elizabeth Kelly, who married the second Earl. She was the daughter and heiress of Denis Kelly, the Chief Justice of Jamaica, and brought her father's valuable Jamaican estates to the family. There is a Beechey of the second Marquess, the friend of Byron and lover of Greece, who named his fishing lodge in a wild part of Mayo 'Delphi'. He spent four months in a British gaol for bribing English sailors in time of war to bring his ship, loaded with antiquities, to Westport. Replicas of the columns that he brought from the Treasury of Atreus at Mycenae are incorporated in the south front of the house – the originals were found languishing in the basement by the sixth Marquess and presented to the British Museum. The second Marquess was one of the first patrons of James Arthur O'Connor, the Irish landscape painter, and commissioned seventeen views of Westport and the surrounding district that are still in the house. As a record, O'Connor's views of the house and town are valuable portrayals, but his talents found their true expression in the tortured landscapes of the wild and desolate part of Mayo.

The town of Westport is formally laid out with a canal, an octagon, and in the nineteenth century could boast of the best country inn in Ireland. The original village had been clustered about the castle walls, and at the time of Pococke's visit stood in what is now parkland around the house. Westport shares with Newbridge, Co. Dublin, the distinction of being one of the two country houses by Richard Castle to remain in the hands of the family for which it was built.

Westport House : the front hall

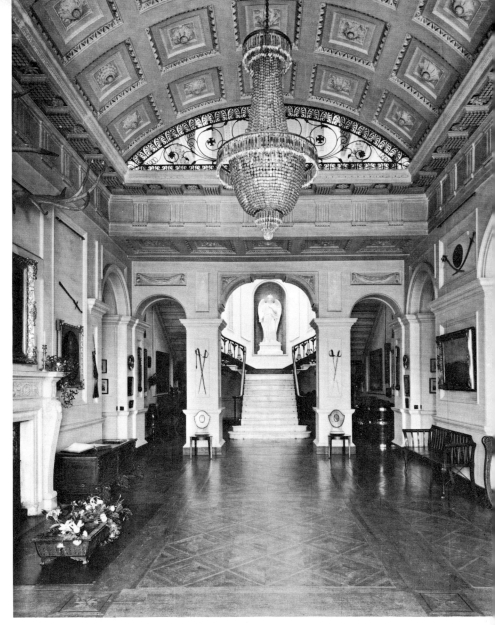

The house seen across the lake created by the second Earl of Altamont

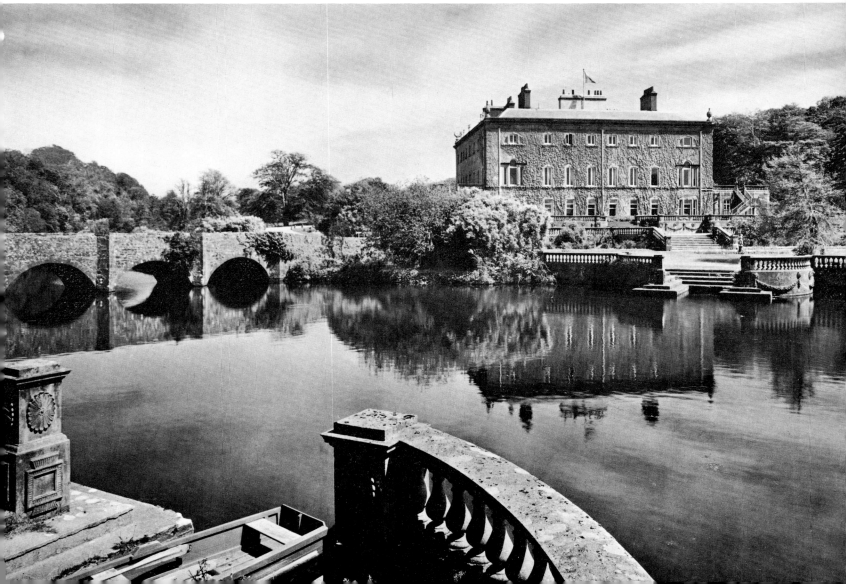

Dunsany Castle:
the front hall

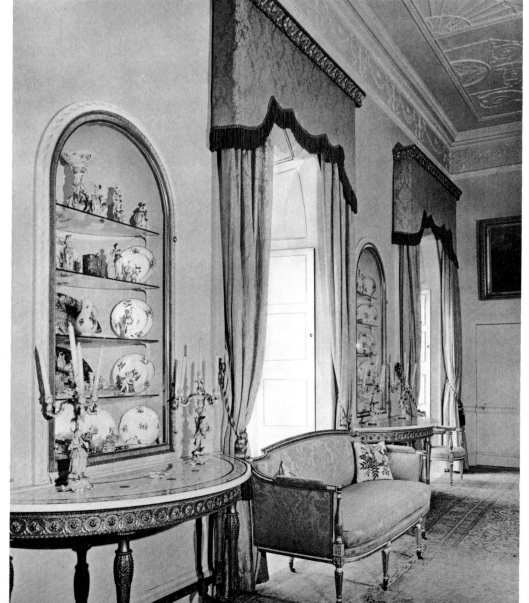

The drawing-room,
with late eighteenth-
century plasterwork
by Michael Stapleton

DUNSANY CASTLE

DUNSANY, COUNTY MEATH

Lord and Lady Dunsany

THERE ARE THREE ENTRANCES to the demesne of Dunsany Castle. One is a Gothic archway that was built as a ruin, the second is a handsome Gothic gateway with mock portcullis, and the third, seldom used, is a neo-Norman archway built of a dark limestone and redolent of strength and antiquity. The extent of the rich green park was, according to legend, decided by contest. Sir Christopher Plunkett, Lord Killeen, gave Dunsany to his younger son and Killeen, barely a mile away, to the elder. The brothers agreed in friendly fashion to draw a boundary between the two properties, and a straight course was marked out from one castle to the other. The dividing line between the estates was to be drawn at the spot where two runners met – Killeen, having the advantage of being on high ground, was distinctly the winner.

Rivalry appears to have deepened between the two brothers, whose families were accustomed to attend devotions in the church at Killeen. Lady Dunsany, having some quarrel with her sister-in-law, is said to have declared that 'she would never set her foot in Killeen Church again, but would build herself another church at Dunsany, similar in every respect *except* that it was to be a foot larger in height, length, and breadth.' Both churches are now in ruins. They are splendid examples of fifteenth-century Gothic, and are now in the care of the Office of Public Works.

Three centuries later a deeper rift came between the two branches of the Plunkett family, when in 1738 Edward, twelfth Lord Dunsany, abandoned the faith of his ancestors and conformed to the Established Church.

The present Lord Dunsany is the owner of the magnificent ruins of Trim Castle, overlooking the River Boyne in County Meath. This was the chief outpost of the Pale; Killeen and Dunsany guarded the approach road from Dublin. The Pale was a ring of castles built by the Anglo-Norman invaders to protect the rich flat lands they had seized to the north and west of Dublin. The expression 'beyond the pale' derives from the attitude of the Normans to the 'wild Irishry' who lived outside the ring.

Dunsany Castle was erected in about 1200 by Hugh de Lacy, whose principal stronghold was at Trim. It was originally held by Geoffrey de Cusack, whose grandfather had come to Ireland with Strongbow. Sir Lucas de Cusack, fourth Lord of Killeen, had an only daughter, Joan, who became the wife of Sir Christopher Plunkett in 1403. Sir Christopher, who was the Deputy Governor of Ireland under Sir Thomas Stanley in 1432, had two sons, the husbands of the jealous sisters-in-law already mentioned. The elder son, John, inherited Killeen and is the ancestor of the Earl of Fingall; the younger, Christopher, was given Dunsany and was created the first Baron Dunsany.

The present Lord Dunsany is the nineteenth to live at Dunsany Castle, and the history of his family is indicative of the violent temper of Ireland over the last five hundred years. The wife of the eighth Lord Dunsany, for example, was murdered in 1609, for which crime a hired servant named Honora Ny Caffry was burned at the stake. She was the victim of a fearful miscarriage of justice, for not long after, a man who was being executed for another crime, confessed to the murder of Lady Dunsany. The ninth Lord Dunsany was imprisoned in Dublin Castle in 1641, where he remained for several years; his only crime, apparently, was being elected from among the Catholic lords as the one to assure the Justices of their attachment and loyalty, and to beg leave for them to be allowed to retain their arms.

In 1653, he was permitted 'at his earnest prayer' to plough his forefathers' fields, as tenant to the State, while awaiting transplantation to Connaught. His wife and children refused to leave until they should be dragged bodily out of Dunsany Castle. This they were, and are said to have perished in the hardships of the journey west. At the time of the Restoration Lord Dunsany regained his property and took his seat in the House of Lords, where he continued to sit until the year 1666. At the Boyne, the tenth Lord Dunsany fought on the side of James II and was outlawed. On his death in 1690 he was succeeded by his brother who was a Jacobite, and also outlawed, but being included in the Treaty of Limerick, his estates were restored. In view of the vicissitudes undergone by the family it is remarkable that they have managed to remain at Dunsany to the present day.

The ground plan of Dunsany shows the extent of the original four-towered Pale castle, clothed now in the additions and alterations of successive generations. The drawing-room and library are the principal reception rooms, and they are reached by the elegant late-eighteenth-century staircase with its delicate Gothic tracery ceiling. The drawing-room has plasterwork of about 1780 by Michael Stapleton and must have been decorated during the lifetime of the thirteenth Baron (1739 – 1821). The windows had delicate Gothic glazing, and on the back of Dunsany where they were not altered they still do. Wood mullions have been inserted in the windows on the front, presumably at the time the nineteenth-century library was made. Of all the rooms the library has the most character; it contains very

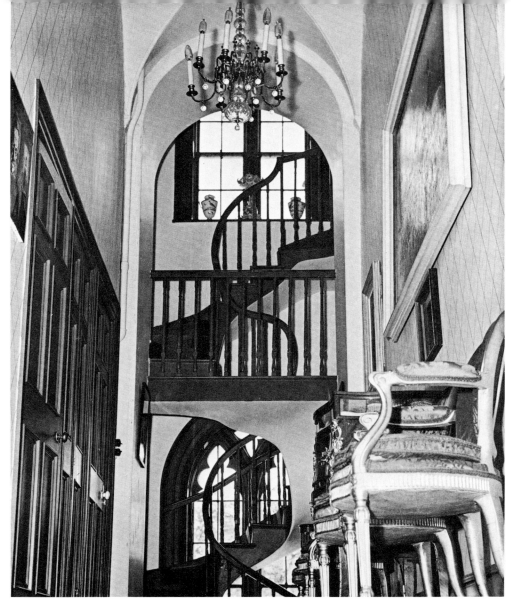

Dunsany Castle : the secondary staircase, dating from the late eighteenth century

The dining-room

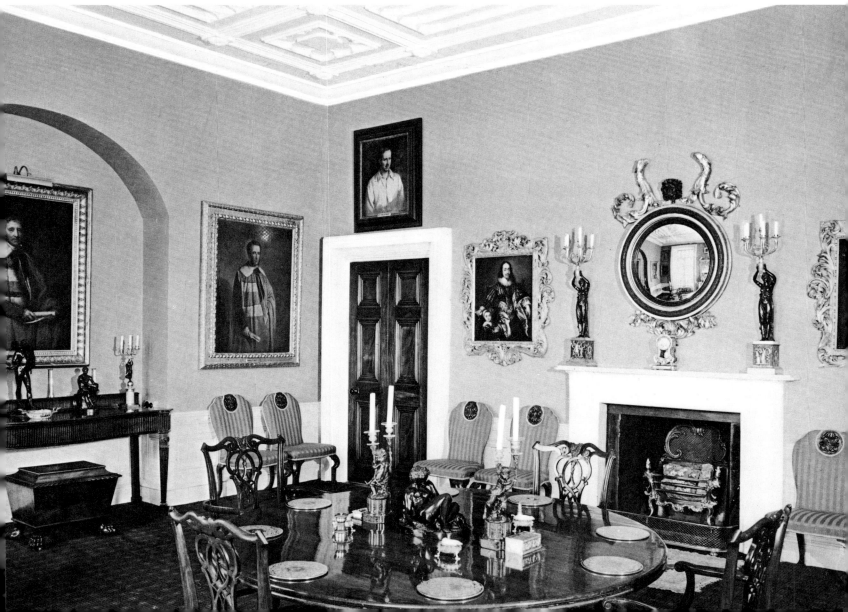

unusual Gothic decoration done in graining. This room and the dining-room on the ground floor have been attributed to James Sheil, who is known to have worked extensively next door at Killeen and may have designed the alterations at Dunsany at the same time. In the last century there was an idea of inviting Sir Giles Gilbert Scott to rebuild Dunsany, but it came to nothing. (*See pp. 281 & 299*)

The mixture of Gothic architecture of the eighteenth, nineteenth, and twentieth centuries makes a happy blend, and in spite of the forbidding exterior, the rooms are light and cheerful. They provide the perfect background for the furniture, pictures and *objets d'art* with which Dunsany is filled. Besides family portraits the pictures include works by Lucas van Leyden, Van Dyck, Morelse, Cuyp, Van der Helst, Wouwerman, Opie, Wilson and Claude Lorraine. There are two early pictures by Jack Yeats, *Bachelors' Walk, A Rose in Memory,* and *The Funeral of Harry Boland.* Among the family relics are the plain gold ring of Patrick Sarsfield, Earl of Lucan, with his arms, crest and initials. There are also, most prized possessions of all, the watch, cross and ring of the Blessed Oliver Plunkett, Catholic Archbishop of Armagh, who was hanged, drawn and quartered in London on 11 July, 1681. The famous Irish martyr was beatified by Pope Benedict XV in 1920, and his cause for canonization has been under close study since 1951.

The late Lord Dunsany was the poet and author whose contribution to the Irish literary revival is well known. Oliver St John Gogarty once dedicated a volume of his poems to his friend Dunsany 'from one who loves the Muses to one the Muses love'. Many of his curiously modelled clay figures are still at Dunsany, and he seems to have collected almost the entire *œuvre* of Syme, a follower of Beardsley; the works hang in the passage leading towards the billiard room.

The fascination in some Irish houses lies in the purity of their architecture, in others, their association with a great family, or in rare cases it might be their contents in particular which attract attention. In the case of Dunsany it is the indefinable atmosphere which is imparted to a place when the same family has lived in it for many hundreds of years, each generation having left its mark in some way, according to the fashion of the day.

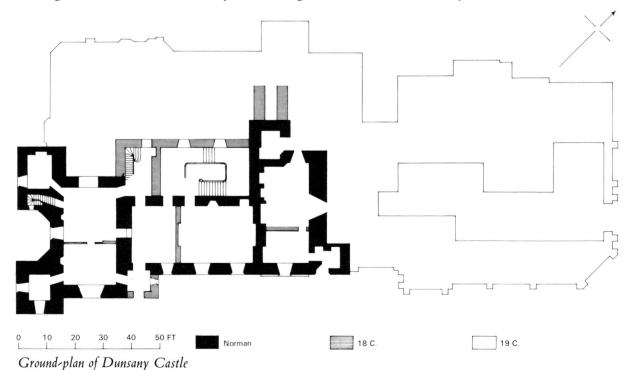

0 10 20 30 40 50 FT ■ Norman ▨ 18 C. □ 19 C.

Ground-plan of Dunsany Castle

SLANE CASTLE

SLANE, COUNTY MEATH

The Earl and Countess of Mount Charles

THE CASTLE OF SLANE stands on an eminence overlooking the River Boyne, in one of the most picturesque natural landscapes in Ireland, that has been embellished by judicious planting. The Gothic revival structure, with its defendant cannon, is eminently suited to the bastion of naked rock it surmounts. By contrast, the neighbouring property, Beauparc, whose trees add so much to the beauty of Slane, is a classical house with curved sweeps and wings, perched on an even more dramatic cliff facing down the Boyne. Sir Richard Colt Hoare, in his *Journal of a Tour in Ireland,* writes of Beauparc: 'all would be perfect, if the architecture of the mansion house accorded with the surrounding scenery of wood, rock, and water; but so unappropriate and discordant a building was never before seen. Here indeed projecting towers, bastions and battlements, would have their due effect.' There is no lack of these at Slane.

J. B. Trotter, whose *Walks through Ireland* was published in 1817, visited Slane when the owner was away from home. His reception by haughty, insolent servants here, 'more difficult of approach than their masters,' probably accounts for his impressions of the place. 'The castle', he writes, 'is of that modern antique so much followed in these days, though not quite appropriate to modern times. Feudal grandeur had a sort of wild magnificence in its abode we can no longer see. The powdered footman ill replaces the armed esquire, or soldier ready for war. The private gentleman, or the noble modestly dressed, and all the modern elegance of his family, are not substitutes for the war-like and haughty baron in armour, and his dames gorgeously apparelled. The ancient picturesque of the inhabitants, and of the interior and environs of the castle, no more exists. A century or two hence some of these buildings may make fine ruins; but at present, however handsome, want much of their proper picturesque.'

The choice of the castle style at Slane was probably inspired as much by its commanding position as by the fact that it is built on the foundation of an early Pale fortress, that of the Norman family of Fleming, Lords of Slane. The Flemings were an ancient Catholic family whose lands were forfeited after the insurrection of 1641.

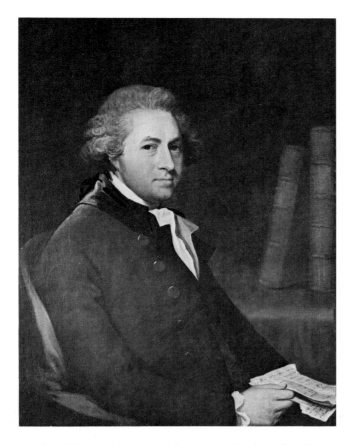

The first Marquess of Conyngham by Gilbert Stuart. (Coll. The Earl of Mount Charles)

The Conynghams, whose intriguing family motto 'Over Fork Over' was granted to them by King Malcolm, first came to Ireland from Scotland in 1611 and settled in County Donegal. Alexander Conyngham of that family was made Dean of Raphoe: one of his sons became Sir Albert Conyngham and fought beside King William at the Boyne. His son, Henry, was the father of the first Baron Conyngham of Mount Charles (cr. 1753), Viscount (cr. 1756) and Earl (cr. 1781) Conyngham, who died a few months after being made an Earl. Mount Charles, incidentally, is the name of a distinguished house of about 1740 in County Donegal which belonged to the family until recently.

Lord Conyngham was succeeded by his nephew in 1781, who rebuilt the castle to the designs of James Wyatt, the work being completed by Francis Johnston. Wyatt had designed a classical hall for the first Lord Conyngham as early as 1775, and various other architects produced designs for Slane at this time, including Capability Brown who designed and built the Gothic stables. A ground plan of Slane, now in the National Library, Dublin, that must date from about this period bears the comment 'a specimen of Capability Brown's skill in Architecture', probably in Wyatt's writing. Brown's proposed elevation for Slane, also in the National Library, was exhibited in the Irish Architectural Drawings Exhibition in 1965, and is illustrated in the catalogue of that exhibition, as are two free-hand drawings by Gandon for a proposed Gothic elevation, and an elaborate series of grottos and statues, with curving staircases, forming a theatrical descent to the river. Other architects consulted were

Westport House (1731), Co. Mayo, with Clew Bay in the distance (see p. 249)

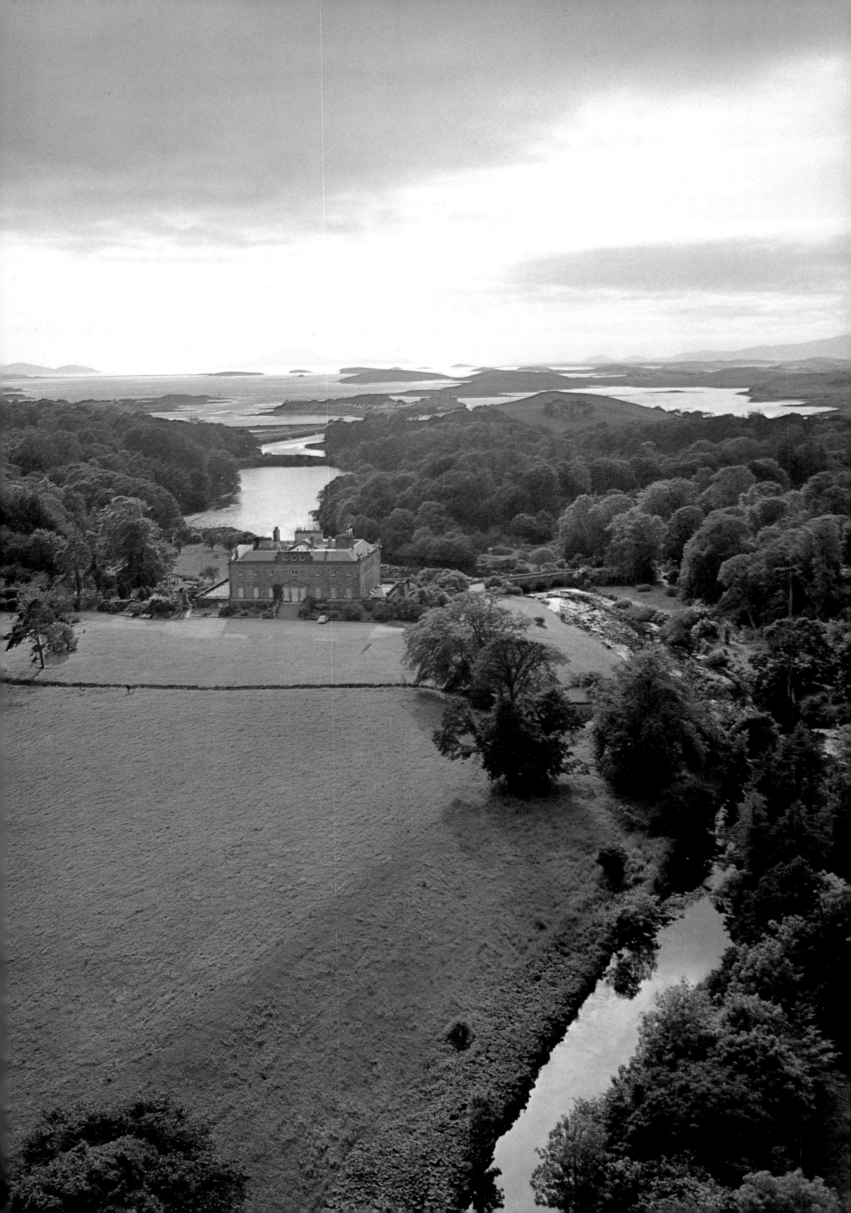

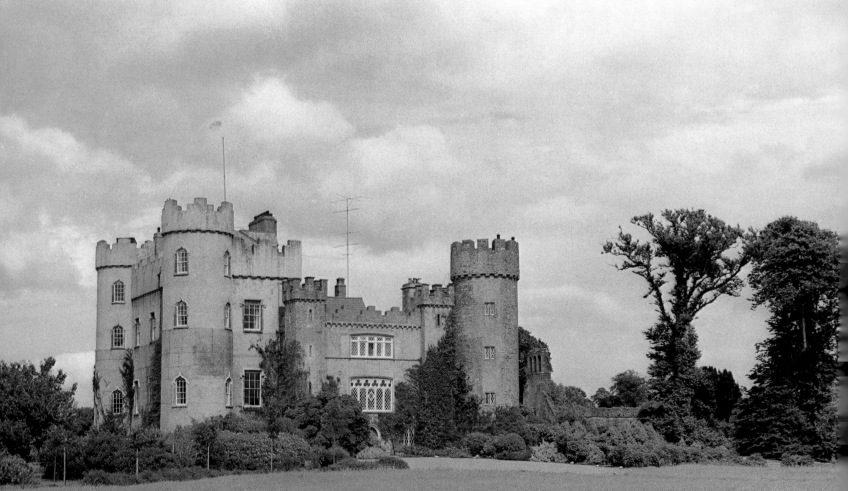

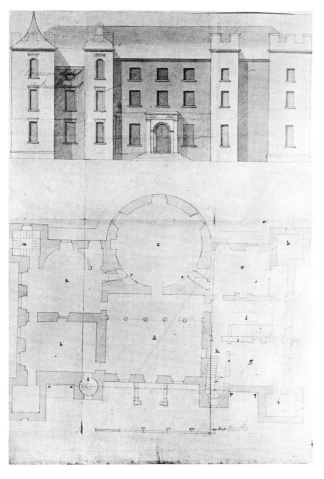

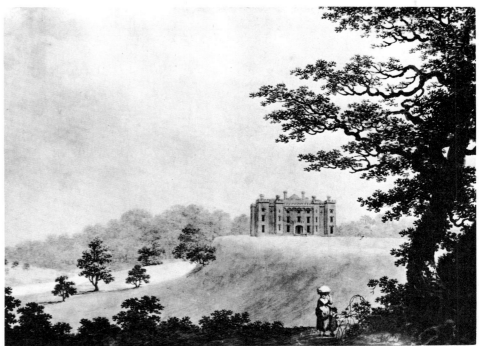

Slane Castle, Co. Meath; a water-colour by James Malton. (Coll. The Hon. Desmond Guinness)

Architectural drawing of Slane Castle, showing the transition from house to castle

Luttrellstown Castle, the garden front (see p. 139)

Malahide Castle, Co. Dublin: the entrance front (see p. 145)

Thomas Penrose and a Mr Robinson. One of the drawings at Slane shows a symmetrical building with two curious cupolas on the left and, on the right, battlements – the cupolas have battlements drawn in on them with dotted lines, and underneath there is the inscription 'Comme il est actuellement', suggesting that a Frenchman might have been consulted. Some of the building accounts of this old house at Slane have somehow found their way to Castletown, Co. Kildare, presumably through old Mrs Conolly who was a Conyngham. It was taken down by Wyatt at the time of his rebuilding.

In an important letter to Brewer written in 1820, Francis Johnston states that James Wyatt had been at Slane in 1785 to rebuild it, and that he (Johnston) had finished the hall, staircase, and entrance to the castle, as well as the steeple of the church and the Gothic gate opposite the mill. If he were not so specific it might have seemed more likely that Johnston, not Wyatt, had designed the great round Gothic library at Slane. Of course it is possible that the pundits (Craig, Glin, McParland, Rowan) are wrong and that Johnston was responsible for the

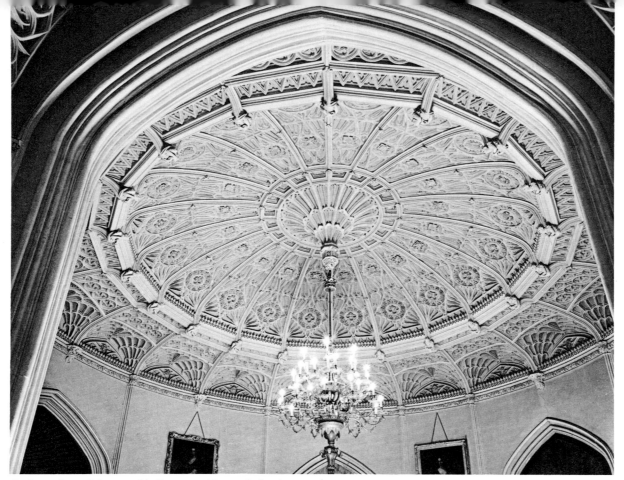

Gothic ceiling of the round ballroom or library (1821)

Gothic library or ballroom, and that it was put in for George IV's visit in August 1821; after all, Johnston's letter to Brewer is dated February 1820, and there is a tradition that a ballroom was added at that time. If so it would not have been the only Gothic interior in County Meath expressly designed to impress the King. Anne's Brook, a few miles away, a small classical house with a Palladian portico, has a large Gothic dining-room that was added to one side of the house to hold a royal banquet. When the day came for the Conyng-hams to take the King over there, however, the sun shone so bright that he expressed the wish to eat *al fresco*.

Mr McParland has shown the importance of the library at Slane as the first Gothic interior in a neo-Gothic house or castle in Ireland. If he was not responsible for its design, Johnston was certainly inspired by it, and plaster heads similar to those at Slane found their way into his work at the Chapel Royal and Killeen Castle.

A. J. Rowan writes of Slane: 'The house is a building of exceptional quality, and a particularly fine example of what might be called the "Classical" type of castle. It is classical in the disposition of its rooms, the symmetry of its plan, and even the decoration of most of the interior. Only the Gothic library and a small arcade in the drawing-room attempted to bring a medieval character within the house. Even these were applied in an essentially classical idiom, for the arcade forms part of a semi-circular alcove, and the beautiful tracery of the library ceiling spreads itself, not to support a vault, but only to pattern the surface of a dome.' *The drawing-room*

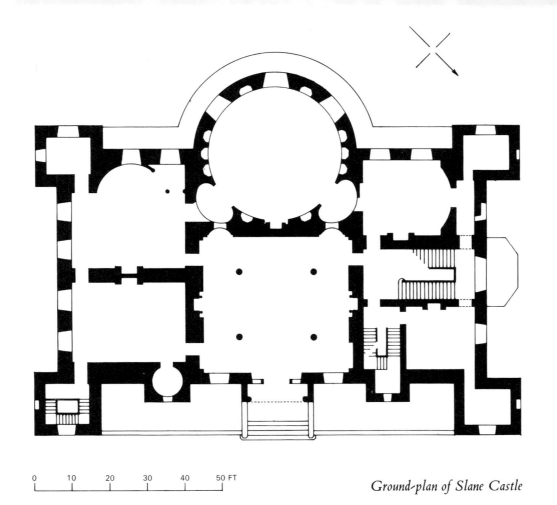

<p style="text-align: right;">*Ground-plan of Slane Castle*</p>

Two gifts from George IV: (left) one of the plaques in the front hall, depicting incidents in the life of Louis XIV; and (right) a christening mug

The six bronze plaques that are set into the walls of the hall have an interesting story linked, like so many other things at Slane, with George IV whose admiration for Lady Conyngham is well known. The plaques were part of a memorial to Louis XIV that stood in the Place des Victoires in Paris, and was destroyed at the Revolution. Apparently they decorated standards which stood around the central memorial. There were originally twelve plaques, depicting events in the life of the French King, and the entire series was somehow procured for George IV by M. Bendis, his chef. Six of them were given to Lady Conyngham, and the others remained at Windsor until the reign of Edward VII who returned them to the French Government; they are now in the Louvre.

George IV stayed twice at Slane, once before he was king, and again in August 1821, a year after he had been crowned. The road from Dublin to Slane, one of the few straight roads in Ireland, is said to have been made for his convenience. The King enjoyed his stay at Slane,

and one evening was in such good spirits that he asked at the dinner table why he could not stay where he was and send Lord Talbot as Lord Lieutenant to England (the second Earl Talbot, of the English branch of that family, was Viceroy in Ireland at this time). Among the many relics of his visit are the three gilt bronze statues in the dining-room, of Frederick, Duke of York, in the uniform of Commander-in-Chief, of George himself standing in a toga, and also of George on a prancing horse. Lord Conyngham was made a Marquess in 1816 and (thanks to his wife's influence, no doubt) was appointed Constable of Windsor Castle, and from 1821 to 1830 Steward of the Household.

The village of Slane is laid out formally; four matching Georgian houses face each other diagonally across the central crossroads. The idea may very well have been Johnston's, although he makes no mention of it in his letter to Brewer. The architectural history of Slane is somewhat confusing; although the Conynghams consulted so many different architects, the castle and village form a memorial to the excellence of their taste.

Slane Castle : the dining-room

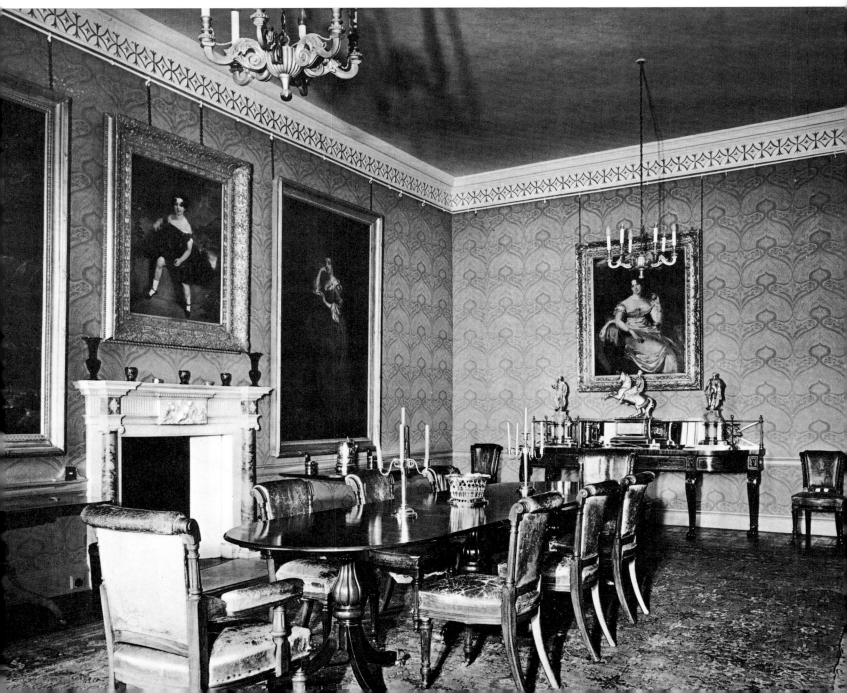

*Birr Castle :
the entrance front*

*Looking across the formal
garden towards the town of
Birr*

BIRR CASTLE

BIRR, COUNTY OFFALY

The Earl and Countess of Rosse

BIRR, OR PARSONSTOWN, clustered beneath the walls of its castle, grew in the eighteenth and early nineteenth century by the addition of two elegant malls and a main square, to be one of the best laid out towns in Ireland. The Parsons family have lived here since 1620, when Sir Laurence Parsons was confirmed in the possession of 'The Castle, Fort and land of Birr' in letters patent issued by Adam Loftus, the Lord Chancellor. Sir Laurence at once set about enlarging the old 'Black Castle' of the O'Carrolls, whose family or clan had reigned over this territory for several hundred years.

The early history was turbulent enough. Birr Castle was attacked three times by the Confederate (Catholic) forces before it was finally captured by General Preston, commanding the confederate army of Leinster, in 1643. Birr remained in their hands until it was retaken by Cromwell's General Ireton in 1650. The castle was besieged twice in the Jacobite wars, first by one Colonel Oxburgh (who had previously been the Parsons' agent) and secondly by Sarsfield. The marks of cannonading can be seen to this day on the east tower.

The central element in the façade of the castle today, which incorporates the Gothic front door and nineteenth-century arrow slits, is the upper part of a gatehouse built between 1620 and 1627 by Sir Laurence Parsons to provide a defensible access from the town to the old Black Castle. This gatehouse has absorbed the flanking towers and been enlarged from time to time, until it has now taken the place of the original castle, which had stood a few yards to the north-west, and was swept away in 1778.

The castle was given its present aspect by another Sir Laurence Parsons, who is remembered as the friend of Wolfe Tone and one of the most vociferous opponents of the Act of Union in 1801. As early as 1782, when only twenty-four, Laurence Parsons presided at a convention of the volunteers at Birr, when the following resolution was passed: 'That we have reason to expect that the liberal spirit of Parliament towards the Roman Catholics of this Kingdom, by emancipating them from the restraints, which we are happy to think are no longer necessary, will be attended by the most beneficial consequences to this country, as nothing can

contribute so much to increase the prosperity and secure the independence of this Kingdom as a cordial union amongst its inhabitants of every religious denomination.' Wolfe Tone, who was eventually to give his life in the cause of Irish independence, described him as 'one of the very *very few* honest men in the Irish House of Commons.' Parsons was the first to draw his attention to the question of Irish independence though Tone admitted, 'I very soon ran far ahead of my master.'

After the Act of Union was passed, Sir Laurence turned his back on the world and devoted his time to improving Birr – no doubt up to this he had spent much of the year at his town house on St Stephen's Green, Dublin. His architect for remodelling Birr was John Johnston, who does not appear to have been related to the more famous Francis. Francis Johnston was the most considerable architect of his day, and his masterpiece in the Gothic style is Charleville Forest, which may have inspired the rebuilding, as it is only a few miles away. Francis Johnston, in the course of a letter to J. N. Brewer (remembered for his *Beauties of Ireland*) dated 1820, writes: 'The alterations and additions made at Lord Rosse's Castle, at Parsonstown or Birr, were done by a Mr John Johnston, who died about five years ago.'

Dr Girouard (*Country Life,* 4 March, 1965) is of the opinion that he did little more than make working drawings based on the ideas of his employer; he has found a note-book at Birr full of sketches for the new work there – for castellating the entrance front, for the main gates, and so on. John Johnston also designed the Protestant church at Birr, built at the end of a mall leading from the castle gates, as well as the Catholic church.

In 1832 there was a fire in the roof of the castle, and the opportunity was taken to raise the central block and battlements one storey. By now Sir Laurence Parsons, fifth Baronet, had become the second Earl of Rosse, on the death of his uncle in County Longford without male heir, due to a special remainder. He died in 1841 aged 83.

His son, Lord Oxmantown, succeeded as the third Earl in 1841. He is remembered for the telescope he constructed (1842 – 5) in the park at Birr, which was to remain the largest in the world for seventy years. The feat is the more remarkable in that it was built on the spot with local labour under the Earl's supervision. Lord Rosse was not a professional scientist; after studying at Trinity College, Dublin, he graduated in mathematics with first class honours at Oxford. He sat as M.P. for King's County, as Offaly was known, from 1823 to 1834 when he resigned his seat in order to give more time to his scientific interests. His first telescope could boast a reflector measuring thirty-six inches. In 1841, the year his father died, he decided to embark on an even more ambitious project. A reflecting telescope collects its light by means of a mirror – the larger the mirror, the greater the amount of light that can be collected for analysis. The mirror in the Birr telescope was of metal cast in a forge specially designed for the purpose in the moat beneath the castle walls. It was almost six inches thick,

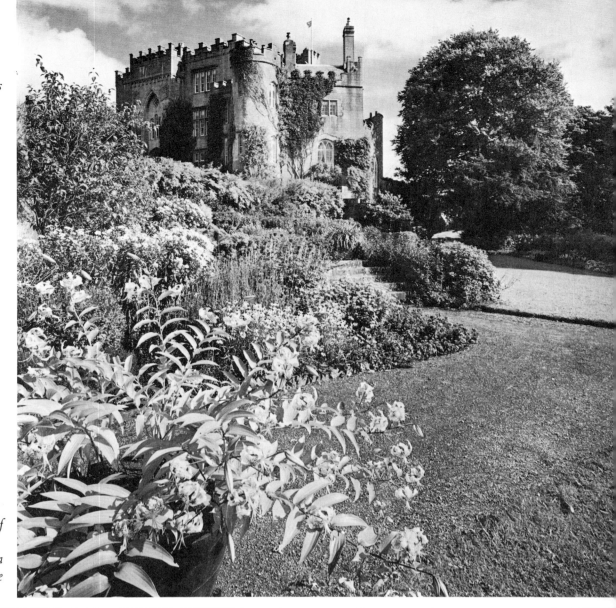

Birr Castle in its garden setting

The stone frame of the great telescope which stands like a Gothic folly in the park

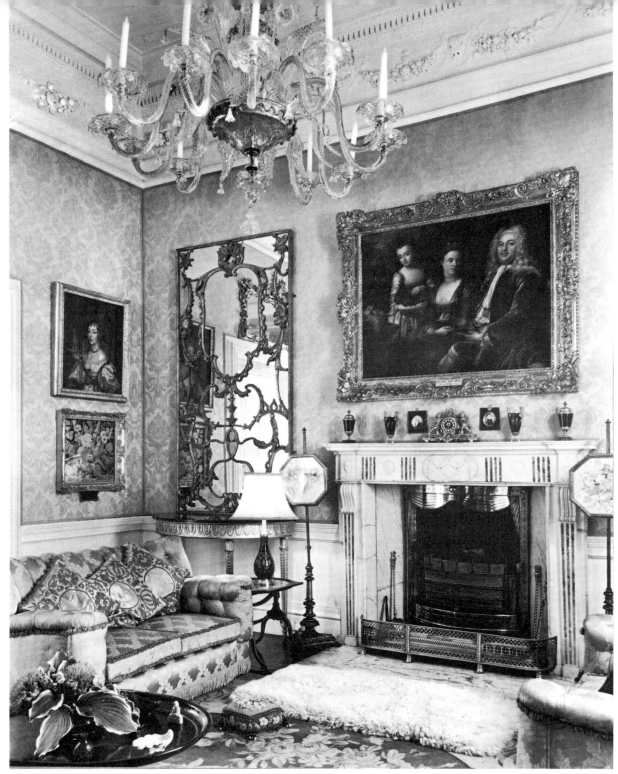

The yellow drawing-room, with its curious Dublin brass grate, signed 'TS & K Clarke Astn Quay'

had a diameter of 72 inches and weighed four tons – it took four months to cool down. Lord Rosse had trained his estate workers in fundamental optics, and between them they succeeded in grinding it to the correct shape, accurate to a 10,000th of an inch. It was inserted in a tube fifty-four feet long, which could be moved backwards and forwards between the massive battlemented stone walls by means of an ingenious mechanism. The casing of the tube is now being repaired and, it is hoped, the reflector, which had gone to the Science Museum in London, may one day be allowed to return to Birr.

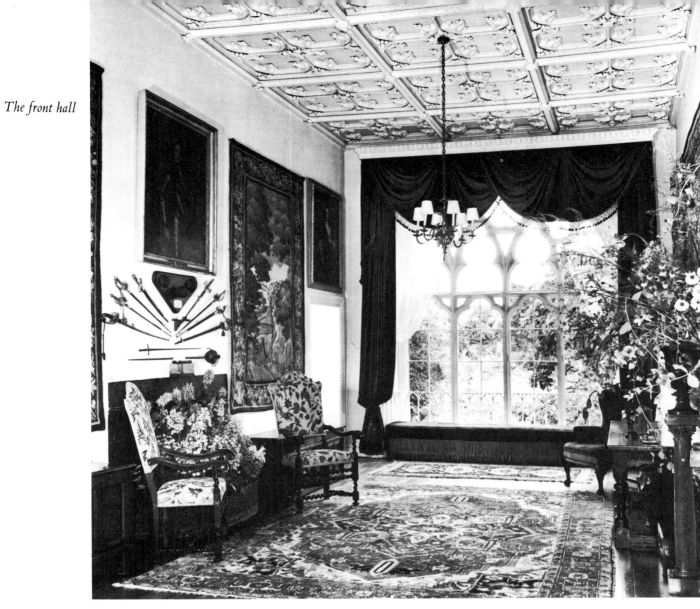

The front hall

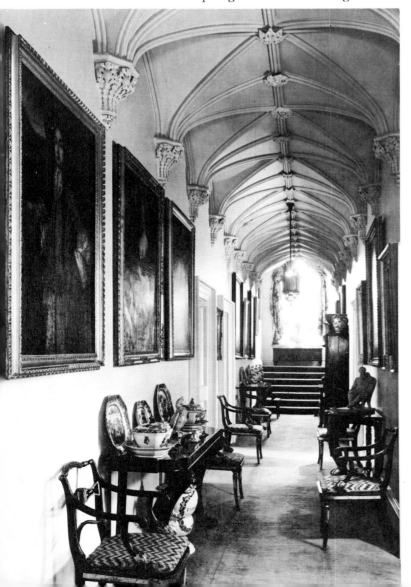

Bedroom passage with Gothic vaulting

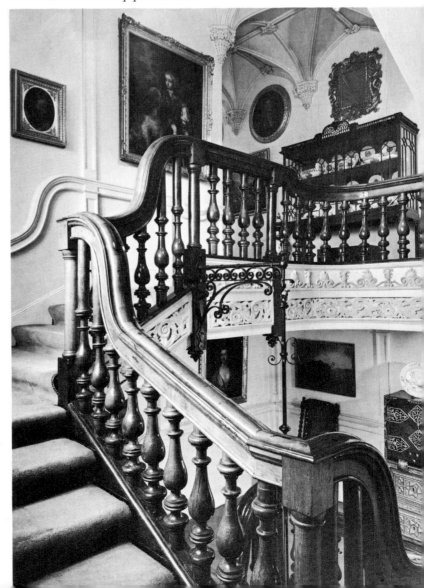

The seventeenth-century yew staircase

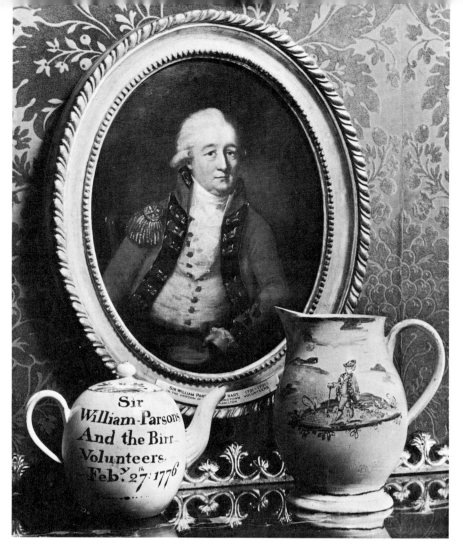

*Sir William Parsons
in the uniform of the
Parsonstown (Birr)
Volunteers*

Lord Rosse's achievement in building the telescope was crowned by the discovery of the nature of the dim, misty patches in the night sky known as nebulae. His drawings of nebulae were published in learned journals thoughout the world, and as a result many astronomers came to Birr in order to make use of the observatory.

The fourth Earl, who succeeded in 1867, followed in his father's footsteps. He improved the mechanical installation, and made a study of the heat radiation from the moon. His younger brother Charles is remembered for having invented the steam turbine engine. He found it hard, however, to convince others of its efficacy at sea. Accordingly he smuggled the experimental *Turbinia* down to Cowes during the Diamond Jubilee Naval Review of 1897, and she suddenly dashed out among the assembled ships at what was then the astounding speed of $34\frac{1}{2}$ knots. The point was made, and the Admiralty promptly built two turbine-engined destroyers.

Birr contains a fascinating collection of pictures and furniture (*see p. 317*), as well as family portraits. The gardens and park, which are open to the public, began to take on their present shape in the mid-eighteenth century when the view from the castle to the lake was enhanced by judicious planting. The lake and the demesne wall were both enlarged at the time of the Famine, and it was then, too, that the Vaubanesque star-shaped ramparts that separate the castle from its park in mock-military style were dug. These were designed by

Colonel Richard Wharton Myddleton, the uncle of the Countess of Rosse of the day. The Countess herself is credited with the design of the cast-iron gates in front of the castle door and in the gate tower in the grounds through which the castle is approached; they were cast in the estate forge under her supervision.

Beside the river Camcor there once stood a monastery dedicated to St Brendan of Birr in the year 550 A D, of which the only trace today is St Brendan's Well. St Brendan of Birr, who should not be confused with St Brendan the Navigator, is also the patron saint of both the churches in Birr. A magnificent illuminated manuscript produced in the monastery and now at the Bodleian Library, Oxford, is known as the Gospels of Mac Riagail. The river flows along the water garden of breathtaking beauty, planted with magnolia and many rare trees introduced to Ireland from western China by the fifth Earl early in this century.

The present owner and his wife have done much to embellish the gardens at Birr. They created a formal parterre to commemorate their marriage in 1935, based on a seventeenth-century Bavarian design. The avenue of box hedges, said to be the tallest in the world, is at least 200 years old. Italy, Portugal, Poland, Tibet, Burma, Tasmania and Chile are some of the countries that are represented here in the shape of plants or trees, many of which have been raised and established from seed. Birr has always been an oasis of civilization and beauty, reflecting the varied tastes of a remarkable series of owners.

The river walk

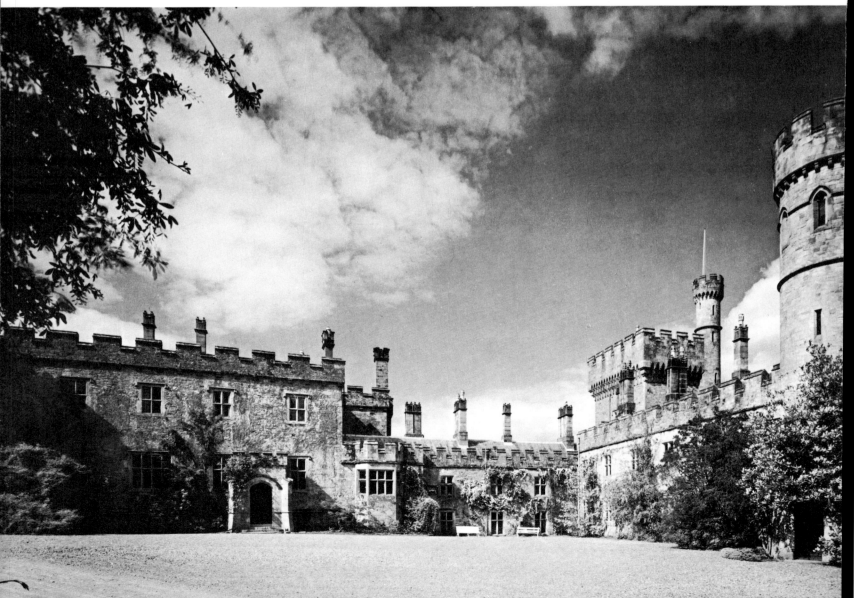

Lismore Castle: the gatehouse and (below) the courtyard

LISMORE CASTLE

LISMORE, COUNTY WATERFORD

The Duke and Duchess of Devonshire

LISMORE WAS AN IMPORTANT SEAT of learning between the seventh and the ninth centuries. St Carthage founded a double monastery here, and the population must have been many times what it is today, as it is on record that there were no fewer than twenty churches as well as a university. In spite of being sacked more than once by the Vikings, the monastery managed to retain its influence in Munster up to the coming of the Normans.

In 1171, Henry II landed at Waterford and made his historic journey to Cashel, to claim his sovereignty at the Acropolis of Ireland. He spent two days at Lismore with the Bishop, and was quick to observe the strategic importance of the ford over the river. In 1185, his son, Prince John, Earl of Morton, during his eight month stay in Ireland, erected the first castle at Lismore on the site of the episcopal palace. This stronghold was sacked, however, by the native Irish only four years later. They took it by surprise, slew the Governor, Sir Robert de Barry, and put the garrison to the sword. When he became king, John paid little heed to this remote corner of his dominions and permitted Lismore to become an episcopal residence once again, with the stipulation that no native cleric should occupy the see. With one exception this was faithfully adhered to, and even after the Church relinquished the property it is remarkable that no native Irish family ever made it their residence.

In 1589 the bishop's palace was presented to Sir Walter Raleigh for a rent of £12 a year by the apostate Bishop of Lismore, Myler McGrath. He had been consecrated Bishop of Down and Connor by the Pope in 1567, become a Protestant in 1569, was made Bishop of his native Clogher in 1570, and a year later Archbishop of Cashel, to which diocese he added Lismore and Waterford. He greedily amassed no fewer than 77 other benefices while the Pope's Archbishop of Cashel was executed by Queen Elizabeth without trial. When Raleigh was in Ireland he resided not at Lismore but at Youghal. His estates in this part of Ireland extended to 42,000 acres; he sold them in 1602 without regret, as they were losing money owing to the ravages of the Elizabethan wars.

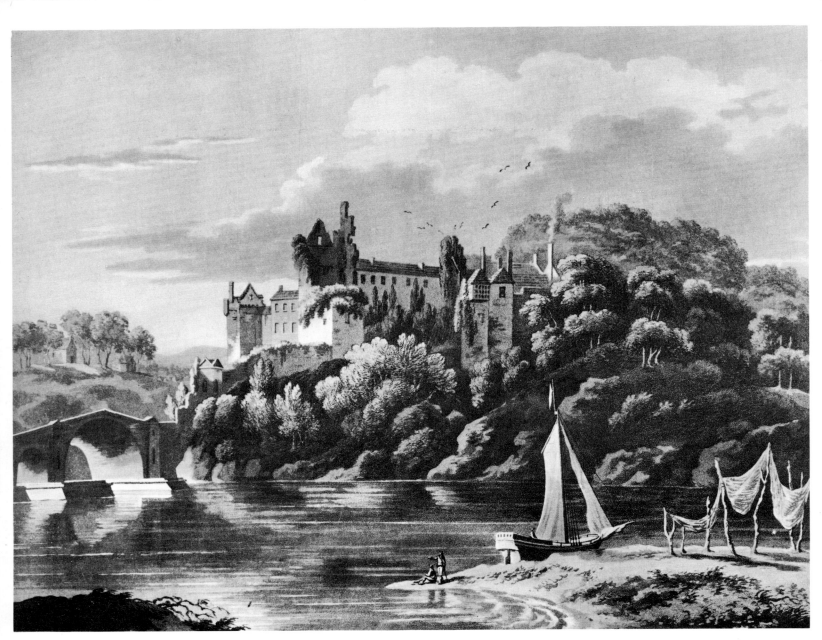

*Lismore Castle at the end of the
eighteenth century, after a painting by
T. S. Roberts*

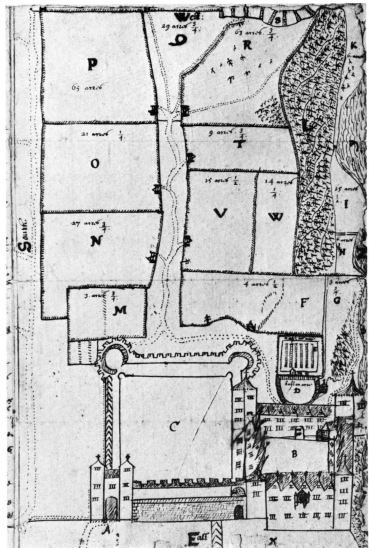

*Plan of Lismore Castle taken from a
survey made c. 1640*

*Lismore Castle, Co.
Waterford, seen from
the bridge across the
Blackwater*

*Dunsany Castle,
Co. Meath: the
entrance front
(see p. 257)*

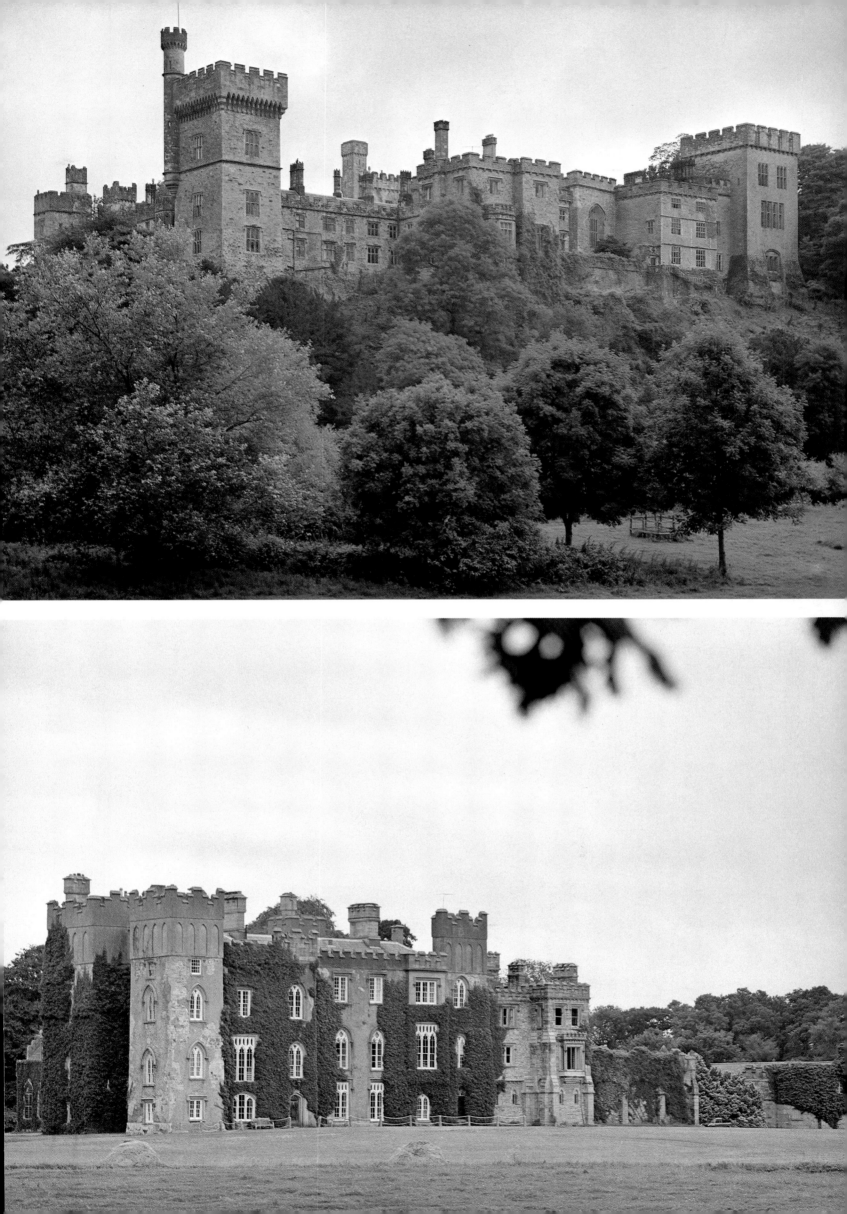

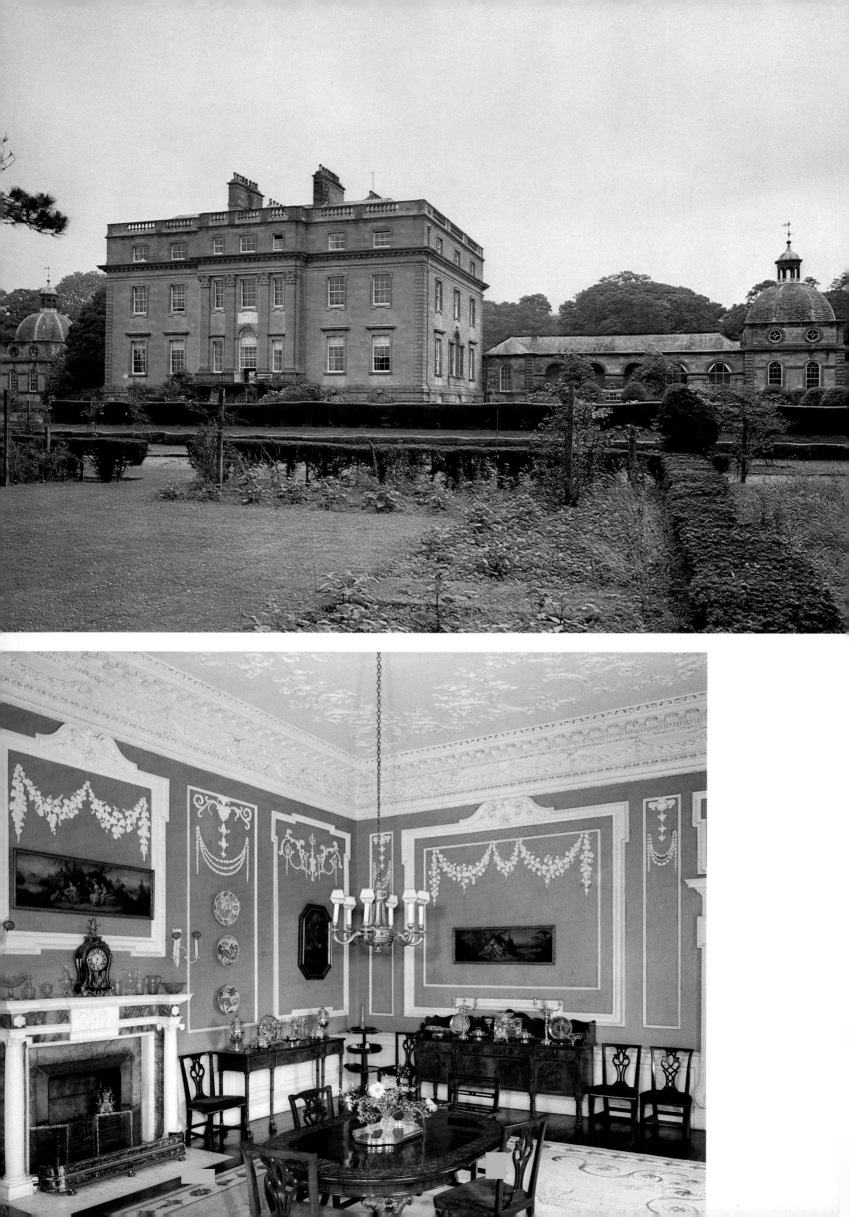

Richard Boyle, the Great Earl of Cork, purchased Sir Walter Raleigh's estates for £1,500. They consisted in the main of three towns, Youghal, Cappoquin, and Lismore, linked by the navigable River Blackwater. Boyle, who received his earldom in 1620, had a sensational career. He arrived in Ireland in 1588 aged 22, with £27 in his pocket, a diamond ring, a bracelet, and the clothes he stood up in but, by the time of his death in 1644, he had amassed enormous wealth. His second wife was Katherine, only daughter of Sir Geoffrey Fenton, principal Secretary of State and Privy Councillor of Ireland. Of their seven daughters and seven sons the most famous was Robert Boyle, the philosopher and father of modern chemistry, who was born at Lismore in 1626. Four of the sons became peers, and Lord and Lady Cork had no difficulty in marrying their daughters into the nobility, on account of their wealth and influence.

The first Earl's rise to fame and fortune was the result of his success in colonizing his great estates with hard-working Protestants, and in the establishment of schools, roads and bridges to facilitate the proper development of industry and agriculture. He enlarged and embellished Lismore Castle, his principal residence, from 1610 onwards, but owing to rebellion, fire, neglect and subsequent alteration little remains at Lismore of the seventeenth century other than the walls, which have been considerably added to since. He entertained lavishly, and no doubt spared no expense in embellishing the interior. In 1614 'two glasurs' were paid for putting the staircase and schoolhouse 'into colours', and a plasterer was engaged 'to ceil with fretwork my study, my bed chamber, and the nursery and to wash them with Spanish white'. His account books are among the Lismore manuscripts in the National Library, Dublin, and his diaries are at Chatsworth. Together they give as full an account as will be found of any building of this date in Ireland. In 1617 he had an elaborate tomb made, with effigies of himself, his wife, and children, which may be seen in the church at Youghal – he was not to need it for another thirty years.

The garden walls at Lismore, which means in Irish 'great fort', date from 1626, and are just as the Great Earl left them, wide enough to walk along. They were not merely built for ornament; they played an important part in the siege of 1642. This siege, by a Catholic Confederate force, was repulsed by Lord Broghill, the Earl's third son. While surrounded by 5,000 Irish 'Rebells' under the command of Sir Richard Beling, Lord Broghill writes to his father, who had removed to Youghal for safety:

I have sent out my Quarter-mailer to know the posture of the enemy; they were as I am informed by those, who were in the action, 5000 strong, and well armed, and that they intend to take Lismore; when I have received certain intelligence, If I am a third part of their number, I will meet them tomorrow morning, and give them one blow before they

The second Earl of Burlington by Van Dyck in the dining-room at Lismore Castle

besiege us: if their numbers be such, that it will be more folly than valour, I will make good this place which I am in.

I tried one of the Ordonances made at the forge, and it held with 2 pound charge; so that I will plant it upon the Terras over the river. My Lord, fear nothing for Lismore; for if it be lost, it shall be with the life of him, that begs your Lordship's blessing, and stiles himself your Lordship's most humble, most obliged, and most dutiful son and servant.

Broghill withstood the siege, but the castle was assaulted again in 1645 and taken by Lord Castlehaven, who rode off to Kilkenny during the siege 'not willing to be present at the destruction of a house where I formerly had received many civilities'.

This time the castle was destroyed, and although it was made habitable by the second Earl, he took less of an interest in his Irish estates. He was created Earl of Burlington, and was the great-grandfather of the architect, the Earl of Burlington and Cork. That he also should have neglected his property in Ireland, except when forced to sell some Irish land to pay for some architectural extravagance, is particularly regrettable. If only he had built in Ireland, which provided a large part of his income! His daughter and heiress, Lady Charlotte Boyle, Baroness Clifford in her own right, brought the major part of the Irish estates of the Boyles to the Cavendish family by her marriage in 1748 to the fourth Duke of Devonshire; the present owner is the eleventh Duke.

The fifth Duke of Devonshire provided Lismore with the elegant bridge, designed by the Cork-born architect Thomas Ivory, which has a single span across the Blackwater of over 100 feet. It cost £9,000 to build in 1775, and is still in use, although narrow by modern standards. Ivory designed the bridge in the park at Carton for the Duke of Leinster, and his best known work is the Blue-Coat School in Dublin. The greater part of the bridge at Lismore, with the exception of the main arch, was destroyed by floods in 1853 and then rebuilt.

In 1811 the sixth Duke of Devonshire, known as the Bachelor Duke, began to restore the castle, described as a 'venerable Ruin' in 1786. His architect was William Atkinson, a pupil of Wyatt, whose designs for Lismore are preserved at Chatsworth. At the time of Atkinson's work of restoration, the workmen found a crosier, now in the National Museum, Dublin, known as the Lismore Crosier. It is inscribed:

> *A prayer for Nial MacAeducain, for whom was made this precious work*
> *A prayer for Nectan who made this precious work.*

MacAeducain, Bishop of Lismore, died in 1113. Also found at the same time was the *Book of McCarthy Reagh,* popularly (but mistakenly) known as the *Book of Lismore,* containing important accounts of the lives of some early Irish saints.

The view down river from the battlements of Lismore Castle, with Thomas Ivory's bridge in the foreground

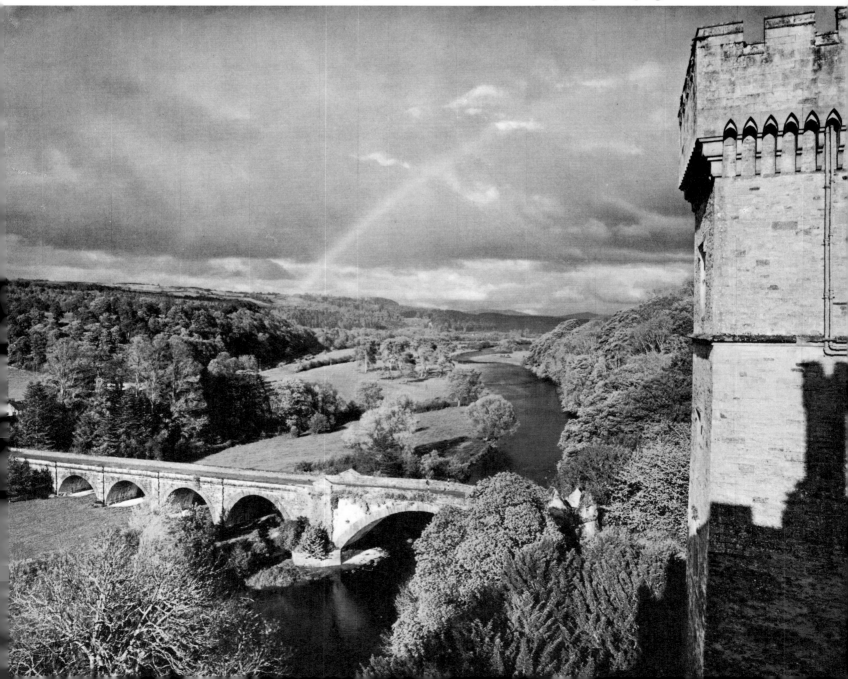

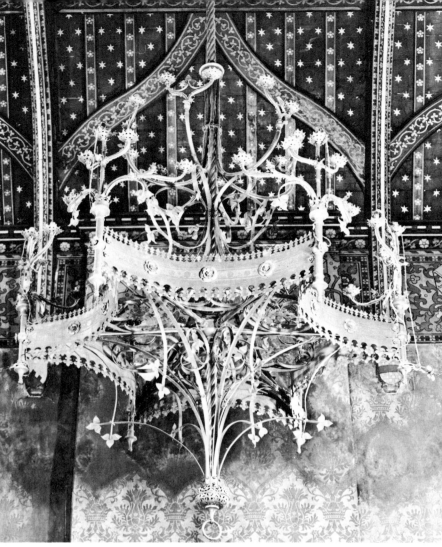

Lismore Castle: chandelier in the banqueting hall

Mantel in the banqueting hall, designed by Pugin, with 'Cead Mille Failte' (a hundred thousand welcomes) in Gothic lettering

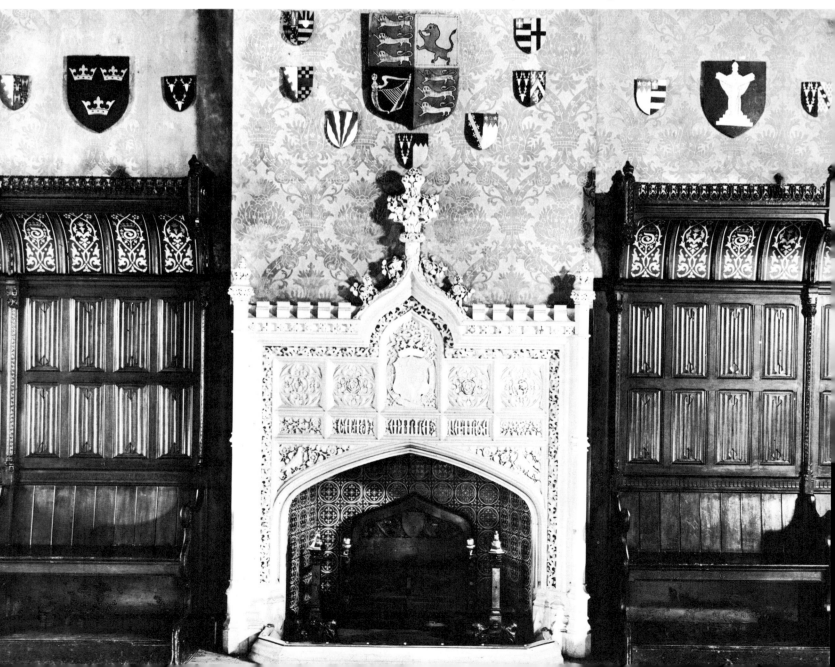

The two main drawing-rooms are essentially as Atkinson left them, but the more interesting Gothic work at Lismore dates from the 1850s and is due to a renewed interest in Ireland on the part of the Bachelor Duke at that time. His architect was Sir Joseph Paxton, who had started life as a gardener at Chatsworth and risen to fame with the Crystal Palace in Hyde Park, built to his designs in 1850. Keeping to the original courtyard plan, he converted Lismore into the ducal pile it is today. The stone he used was quarried in Derbyshire and transported ready-cut to Ireland. It stands in battlemented splendour, looking down across the swift, smooth Blackwater from the edge of its cliff, a totally foreign creation, yet somehow perfectly at home. (*See p. 281*)

The most remarkable decoration at Lismore is in the ballroom or banqueting hall, which replaces the ruined chapel. In fact, with its full complement of Victorian ecclesiastical trappings it looks more like a chapel than a ballroom to this day. Letters to Messrs. Crace and Co., the London firm of decorators, from Pugin, revealing that he was responsible for the design, have been found in the library of the Royal Institute of British Architects by Dr Mark Girouard. He has also noted that the elaborate Gothic mantel came from Pugin's Medieval Court at the Great Exhibition of 1851, and that it was originally made for Francis Barchard of Horsted in Sussex. The crest of the Barchards has been replaced by that of the Devonshires, and the Irish motto of welcome, 'Cead Mile Failte', has been incorporated in the design.

Lismore was the seat of Lord Charles Cavendish, the younger son of the ninth Duke of Devonshire, from 1932 until his death in 1944. His wife, the former Adele Astaire, now Mrs Kingman Douglass, still spends part of the year there with her second husband. The present Duke and Duchess have done much to embellish both the castle and the garden.

The Yew walk

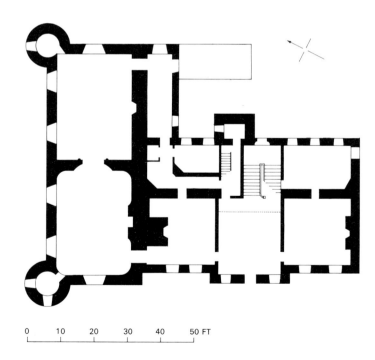

'A View of Ballinlough' by Robert Dickson. (Coll. Dr Drummond)

Ground-plan of Ballinlough Castle

0 10 20 30 40 50 FT

BALLINLOUGH CASTLE

CLONMELLON, COUNTY WESTMEATH

Sir Hugh and Lady Nugent

THE APPROACH TO BALLINLOUGH is heralded by elegant 'grand gates' and undulating parkland. The castle stands above a lake; the Georgian windows, said to be the tallest in Ireland, look out across the water to the woods below. In the 1730s a classical house with narrow early windows and tall pedimented door was built into what was basically a keep or castle. Despite alterations, rooms in the old castle remained habitable. Originally the roof was steeply pitched and the chimneys somewhat askew. At one time the hall was two rooms, the upper connecting with the bedrooms on either side. The present hall, dating from about 1750, is a magnificent apartment, two storeys in height, which takes up practically the whole of the centre of the house; it contains elaborate plaster decoration dating from the same period, with 25 clusters of fruit and flowers, all different, in panels framed with the egg-and-dart motif. When the hall was designed a new staircase, which forms a sort of minstrels' gallery at the far end of the hall, was provided; the original staircase is at the back of the house giving access to the top floor. Despite later additions the seven-bay façade dating from the eighteenth century is still unaltered.

Over the hall door may be seen the O'Reilly coat of arms with its motto *Fortitudine et Prudentia,* the date 1614, and the initials of James O'Reilly, who was responsible for the alterations of that date. The family name would be O'Reilly to this day if it had not been changed in 1812 when Sir Hugh O'Reilly, by Royal Licence, took the name of Nugent in order to inherit a dowry bestowed on his wife by her uncle, Governor Nugent of Tortola. The story that when requested to do so he declared 'I'd sooner be an Old Reilly than a New Gent' is no doubt apocryphal.

The lineal ancestor of the O'Reillys of Ballinlough was Fedlim, or Phelim, 'presumptive heir to the lordship of Breffni, who was sufficiently entitled thereto from his noble and generous principles'. Phelim went to meet Lord Turneval, Lord Lieutenant of Ireland, at Trim, in the year 1447, and was treacherously arrested and detained prisoner there. He died of the plague during his imprisonment, 'after making his peace with God and receiving the rites

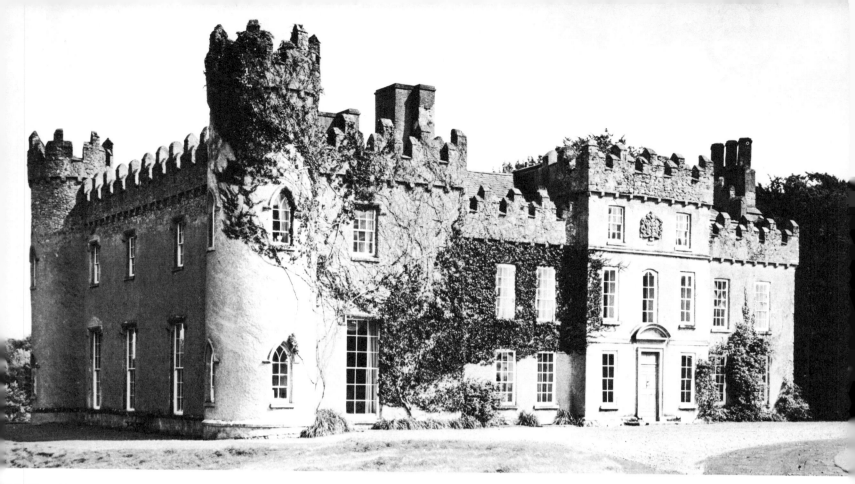

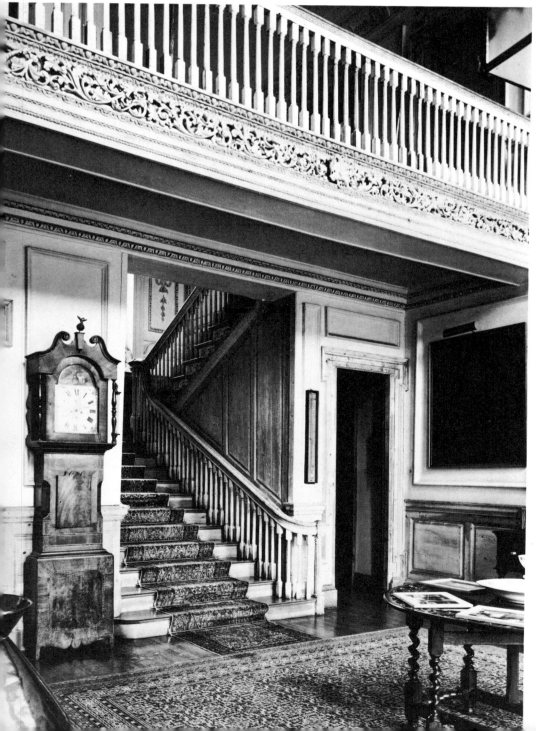

Ballinlough Castle. The early
eighteenth-century house may
be seen on the right; it was
castellated at the time the twin
towers and splendid reception
rooms were added about 1780

The front hall

(Facing) The doors of the
dining-room (left) and window
on the staircase (right)

of the Church.' He was buried in the monastery of Trim. Phelim had issue, a son John, who lived at the Castle of Ross on Lough Sheelin, and, being despoiled of his estates by English adventurers, was obliged to fly from the ancient family inheritance, and settled at Kilskeer. John O'Reilly's son, Brian O'Reilly MacShane, married Elizabeth, daughter of William Nugent, of New Haggard, Co. Meath, and he was succeeded by his son, Hugh, who married Elizabeth, daughter of Thomas Plunkett, of Clonabrany near Loughcrew, Co. Meath.

The O'Reillys (now Nugents) of Ballinlough have retained the old faith, and over the years have intermarried with the leading Catholic landed families in Ireland. It is not surprising to find the younger sons, Andrew and James O'Reilly, applying for permission under the Great Seal to enter the Austrian military service. Their elder brother Hugh was created a Baronet of Ireland in 1795, and it was he who changed the name to Nugent in 1812. In the nineteenth century the head of the house was always a count of the Holy Roman Empire as well as an Irish baronet. A younger son, Count Andrew, was Governor-General of Vienna and Chamberlain to the Emperor of Austria.

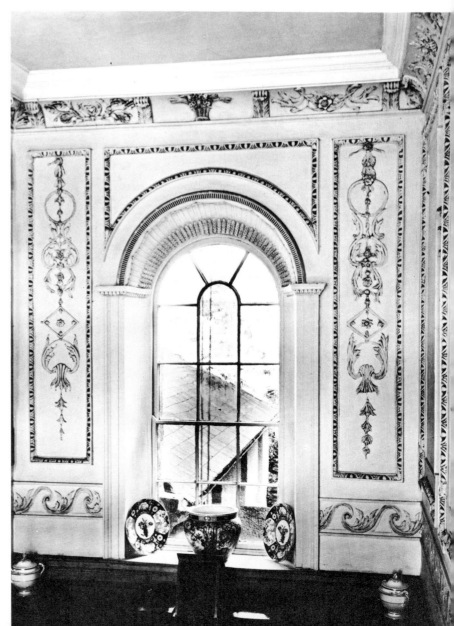

Ballinlough was considerably enlarged in about 1780 by Sir Hugh O'Reilly at about the time of the marriage of Margaret O'Reilly to Richard Talbot of Malahide Castle, which it resembles more than any other castle in Ireland. In each case the extra rooms were added outside the thick walls of the original keep, with, at the corners, twin towers making little turret rooms of great charm and usefulness. Battlements were added to the new addition and carried on as far as possible round the older parts so as to give unity to the whole.

It would be tempting to assume that Margaret O'Reilly wanted to make Malahide remind her of home, but the interiors of the two buildings are rather different. The drawing-rooms at Malahide have somewhat heavy plasterwork suggesting the hand of Robert West and a date about 1755. The drawing-room and dining-room at Ballinlough suggest the hand of James Wyatt and a date about 1780. This is confirmed by the fact that the drawing-room mantel at Ballinlough is a replica of one at Curraghmore which is known to have been remodelled by Wyatt at about the same time. Documentary evidence may yet come to light, since both Malahide and Ballinlough have been well cared for and both remain in the original family.

Dr Alistair Rowan, writing of Ballinlough, Malahide, and Clongowes Wood Castle, Co. Kildare, has pointed out the similarities between all three, the fact that all three families were interrelated, and all Roman Catholic. Wogan Browne, the owner of Clongowes, was an amateur architect. Early in the nineteenth century he drew up plans for Killeen Castle for the Earl of Fingall (also a Catholic) and he would hardly have been called upon to do so unless he had some previous architectural experience. If he did design the additions to Ballinlough, the interior could still be by Wyatt, who would have furnished plans.

The Irish Tourist by Atkinson, 1815, contains the following account of a visit to Ballinlough:

The castle and demesne of Ballinlough, had an appearance of antiquity highly gratifying to my feelings (while the house and demesne of Rosmead seemed distinguished by the beauties of modern improvement). I reined in my horse within a few perches of the grand gate of Ballinlough to take a view of the castle: it stands on a little eminence above a lake which beautifies the demesne; and not only the structure of the castle, but the appearance of the trees, and even the dusky colour of the gate and walls, as you enter, contribute to give the whole scenery an appearance of antiquity, while the prospect is calculated to infuse into the heart of the beholder, a mixed sentiment of veneration and delight.

Having visited the castle of Ballinlough, the interior of which appears a good deal modernized, Sir Hugh had the politeness to shew me two or three of the principal apart-ments; these, together with the gallery in the hall, had as splendid an appearance as any

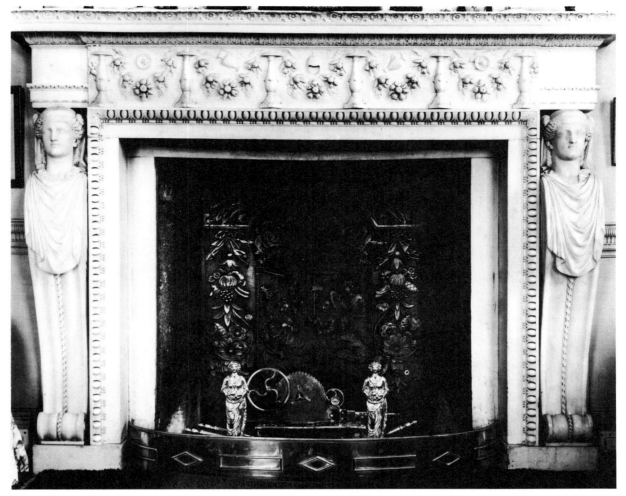

Mantel in the drawing-room, identical to one at Curraghmore, Co. Waterford. James Wyatt, who is known to have been responsible for the decoration at Curraghmore, may perhaps have produced designs for Ballinlough as well

thing which I had, until that time, witnessed in private buildings. The rooms are furnished in a stile – I cannot pretend to estimate the value, either of the furniture or ornamental works, but some idea thereof may be formed from the expence of a fine marble chimney-piece purchased in Italy, and which, if any solid substance can in smoothness and transparency rival such work, it is this. I took the liberty of enquiring what might have been the expence of this article and Sir Hugh informed me only five hundred pounds sterling, a sum that would establish a country tradesman in business! – The collection of paintings which this gentleman shewed me, must have been purchased at an immense expence also – probably at a price that would set up two: what then must be the value of the entire furniture and ornamental works?

The castle was completely restored by Sir Hugh and Lady Nugent in 1939.

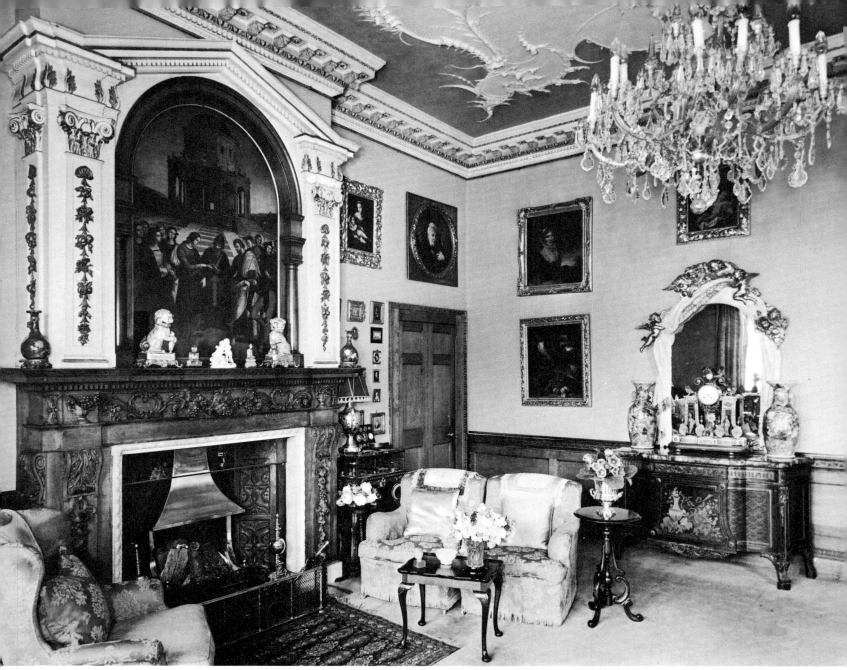

Belvedere : the drawing-room

The front hall

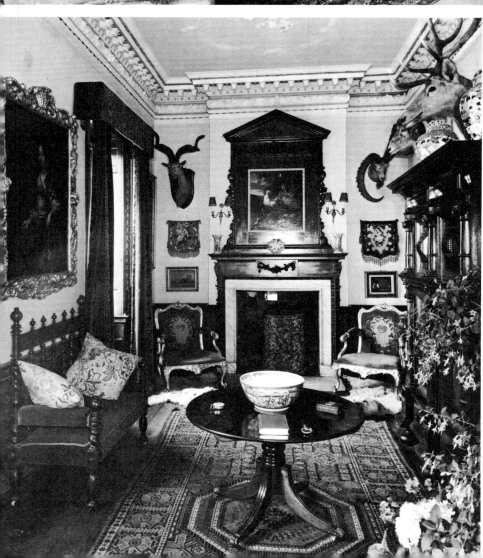

BELVEDERE

MULLINGAR, COUNTY WESTMEATH

Mr Rex Beaumont

STRANGER THAN ANY GHOST STORY, and far more terrible, are the facts that surround the building of Belvedere. In 1736, Robert Rochfort married, as his second wife, Mary Molesworth, the sixteen-year-old daughter of the third Viscount Molesworth. Raised to the peerage as Baron Belfield in 1738, he and his wife lived at Gaulston, Co. Westmeath, the old family house, and soon began to build a villa, which they christened Belvedere, with a lovely view over Lough Ennell, six miles away. Before long, however, the Earl of Egmont was writing in his dairy as follows (2 May, 1743):

> Last post several letters from Ireland gave an account of a most unhappy affair that lately passed in Dublin. Robert Rochfort, Baron Bellfield of that kingdom, who some years ago married a daughter of Richard Viscount Molesworth for love, she being very handsome though no fortune, and used her in the tenderest manner, was privately informed that she cohabitated unlawfully with his younger brother. Upon which he put the question to her, and she with consummate impudence owned the fact, adding that her last child was by him, and that she had no pleasure with any man like that she had with him. My Lord thereupon locked her up . . . and in his rage took a charged pistol with him with intention to find out his brother and shoot him, but that very night he went on board a ship and sailed for England, where he now lies concealed if not fled abroad. My Lord Bellfield then went to Lord Molesworth and telling him his unfortunate case, asked his advice what he should do? My Lord replied he might do what he pleased; that having committed such a crime as incest and confest it, he should have no concern about, and the rather because she was only his bastard by his wife before he married her. My Lord Bellfield resolved to be divorced, is now prosecuting her as an adultress, and we are told that when separated, she will be transported to the West Indies as a vagabond.

In March of the next year Lord Belfield crossed over to London, where Mrs Delany described in a letter to her friend Mrs Dewes meeting him at dinner:

> They say he has come to England in search of *him*, to kill him wherever he meets him; but I hope his resentment will cool, and not provoke him to so desperate an action, and he does not appear to have any such rash design, but is more cheerful and composed than one could

expect him to be; he is very well-bred, and very well in his person and manner; his wife is locked up in one of his houses in Ireland, with a strict guard over her, and they say he is so miserable as to love her even now, she is extremely handsome, and has many personal accomplishments.

> A fairer person lost not heaven;
> she seem'd
> For dignity compos'd and high
> exploit:
> But all was false and hollow.

From 1743 onwards Lord Belfield locked his wife up at Gaulston where she was allowed to see nobody except the servants. If she went into the garden, she would be preceded by a footman, who was forbidden to speak to her, and who rang a bell to keep anyone from coming near. After twelve years of strict confinement she managed to escape and reached her father's house in Dublin, but he refused to admit her and within twenty-four hours she was back in her prison. For the next eighteen years she was locked up, and is said to have walked in the gallery, gazing at the pictures as if conversing with them. In 1774 her husband died, and her son came to release her. She is said to have exclaimed, 'Is the tyrant dead?' Her hair had gone white, she was dressed in the fashions of thirty years before, and she had acquired a wild, scared, unearthly look; the tones of her voice, which hardly exceeded a whisper, were harsh, agitated, and uneven. She had often protested her innocence during her lifetime, and on her deathbed she reasserted it for the last time.

The unfortunate Arthur Rochfort, the younger brother with whom she had been implicated, had managed to escape to Yorkshire but in 1759 he made the mistake of returning to Ireland. Hardly had he landed when he was imprisoned for life, being charged by the unrelenting Lord Belfield, now Earl of Belvedere, with £20,000 damages that were impossible for him to pay. He died in the Marshalsea, the debtor's gaol in Dublin. The Earl of Belvedere never remarried, and found Belvedere large enough for his wants. He entertained there a good deal, however, and when he died his estate was in considerable debt.

It is unusual to find a house of great quality built on so small a scale. The rooms are small but with high ceilings, and the plasterwork, by the same hand as the Mespil House ceilings (*see p. 113*) unequalled in any house in Ireland. There are only four bedrooms in the main block; a small wing was added at the back probably in the late eighteenth century, which does nothing to destroy the symmetry of the façade. The architect is unknown, but is likely to have been Richard Castle, who was at the height of his career in the 1740s. He is known to have favoured the thermal window, as may be seen in his original design for Newbridge, Donabate. Until Victorian times Belvedere had semi-circular thermal windows above the Venetian windows at either end of the façade, like two hooded eyes gazing across the lake.

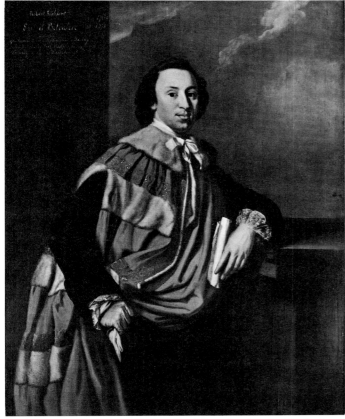

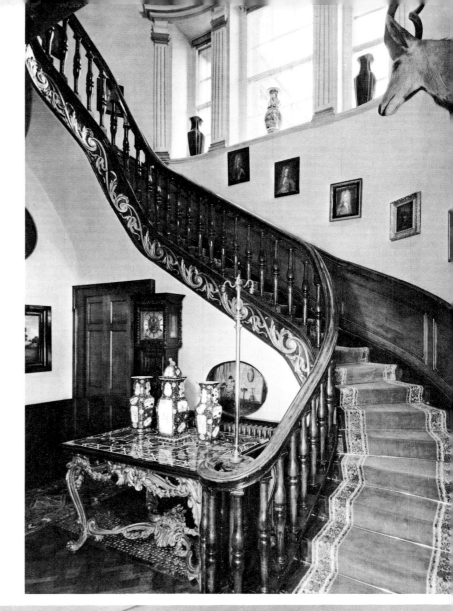

Robert Rochfort, first Earl of Belvedere

The staircase

One of the three bedrooms in the main block

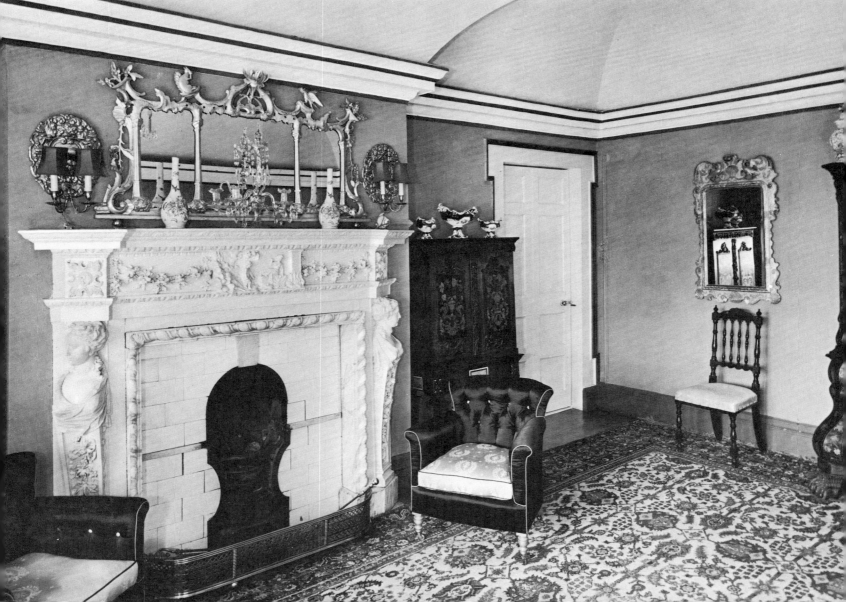

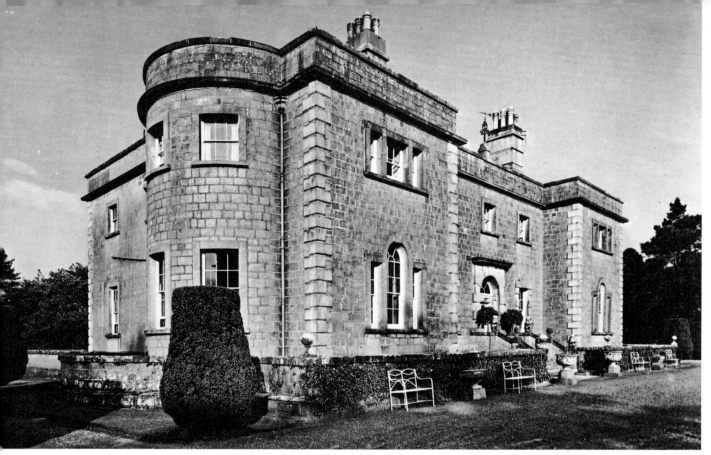

Belvedere : The entrance front

The view from the house is interrupted at one point by a remarkable sham ruin that was built in about 1760 by Lord Belvedere, to blot out the neighbouring house of another brother, George Rochfort, with whom he had also quarrelled. This large mid-eighteenth-century house, originally called Rochfort, and later Tudenham, is now itself a ruin, and the park has been carved up by the Land Commission. It is situated beside the lake about half a mile from Belvedere.

In 1773, Sir James Caldwell wrote to his wife during a stay with the son of George at Rochfort, a religious household: 'We are always at breakfast at eight o'clock, and then read the Psalms and the Bible.' His experience at Belvedere was very different.

The sham ruin

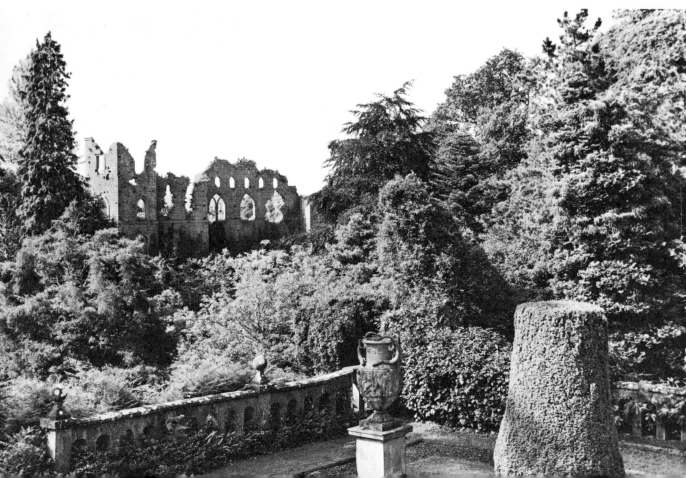

Dunsany Castle, Co. Meath: the library, inspired by that at Strawberry Hill, and (below) the staircase, which dates from the end of the eighteenth century *(see p. 257)*

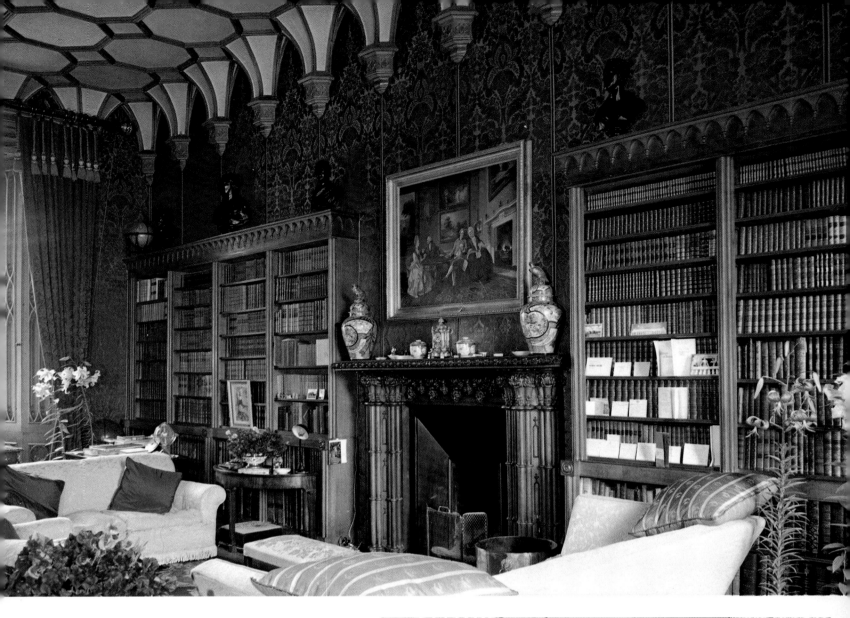

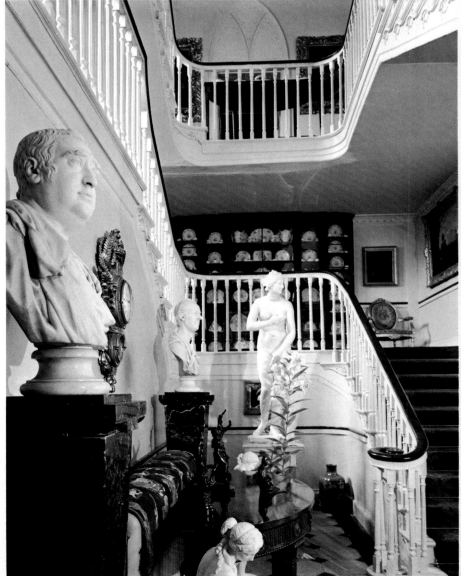

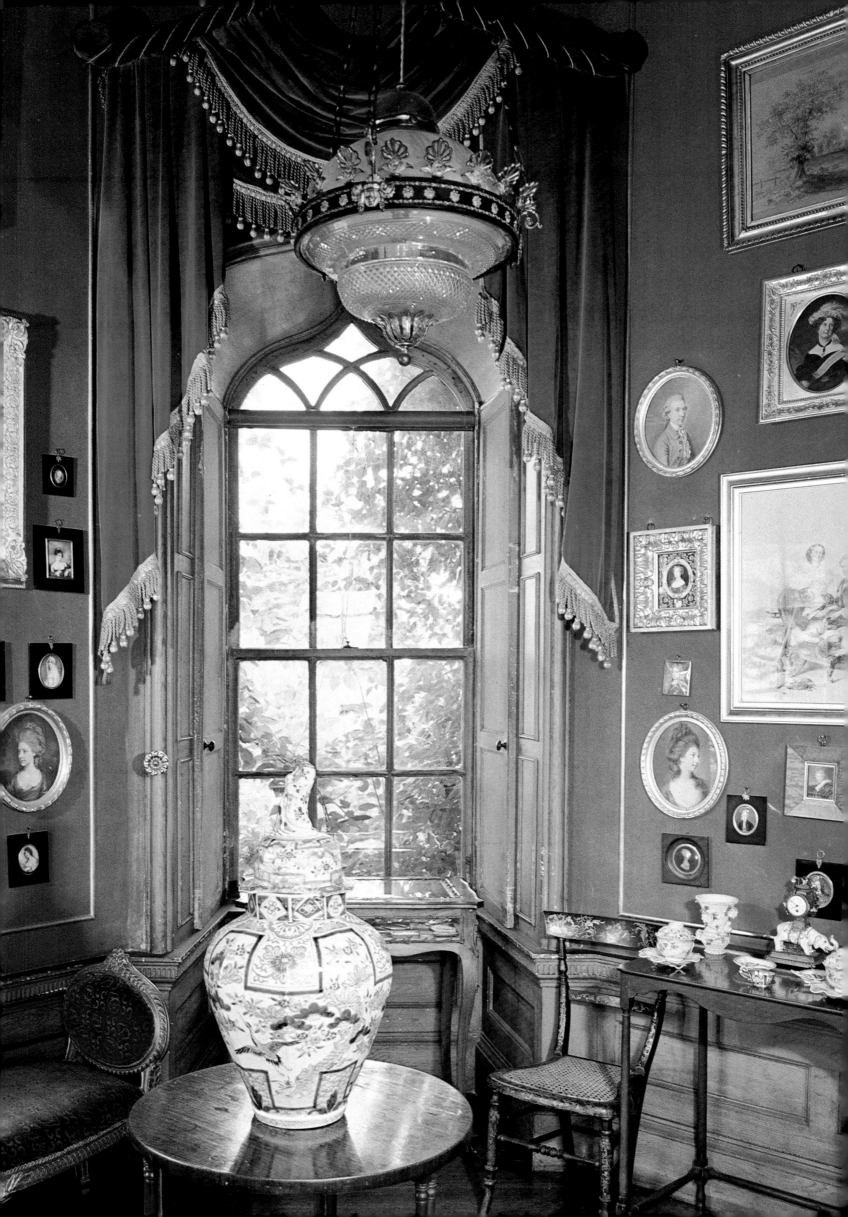

I dined there yesterday, no person but me, Lord Belfield, and Lord Newton, by many degrees the handsomest boy I ever laid my eyes on, much handsomer than his mother. He is quite a show. Only think, for us four, a complete service of plate, covers and all, two soups, two removes, nine and nine, a dessert in the highest taste, all sorts of wine, burgundy and champagne, a load of meat on the side table, four valets-de-chambre in laced clothes, and seven or eight footmen. If the Lord Lieutenant had dined there, there could not have been a more elegant entertainment. He has his hothouses five miles off (at Gaulston) and 18 fires going. There are no such in the kingdom. Three sets of coach-horses in the stables . . . A vast contrast between this house and that. Here all regularity and religion, there all debauchery and dissipation.

When Lord Belvedere died eighteen months later, he left his heir very embarrassed in his circumstances; but, by 1786, the family finances had so far recovered that the second Earl could afford to build what is perhaps the finest late-eighteenth-century town house in Dublin, Belvedere House, Great Denmark Street, facing down North Great George's Street. Michael Stapleton, the foremost exponent of the Adam style in Dublin, was both architect and stuccodore and it provides a complete contrast in style to Belvedere.

Belvedere was left to Lt.-Col. C. K. Howard-Bury by his cousin, Charles Brinsley Marlay, a descendant of the Earl in the female line. On his death the house was bequeathed to Mr Rex Beaumont, the present owner.

Belvedere : the dining-room

Malahide Castle : one of the corner turret rooms (see p. 145)

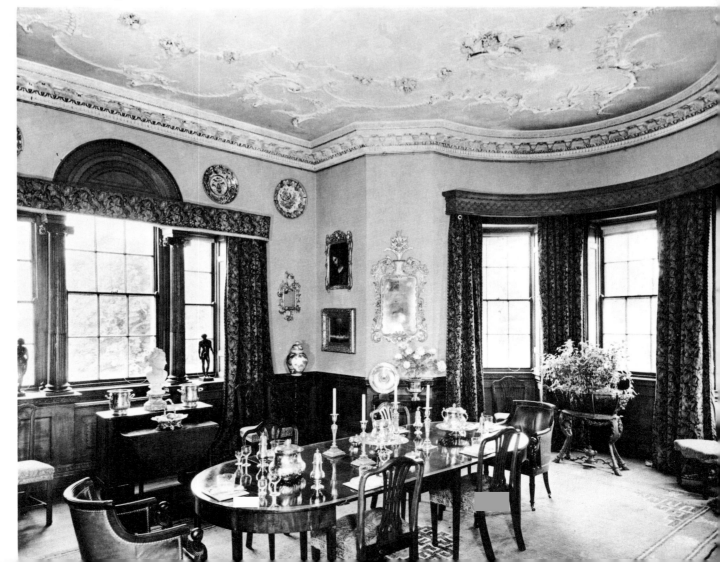

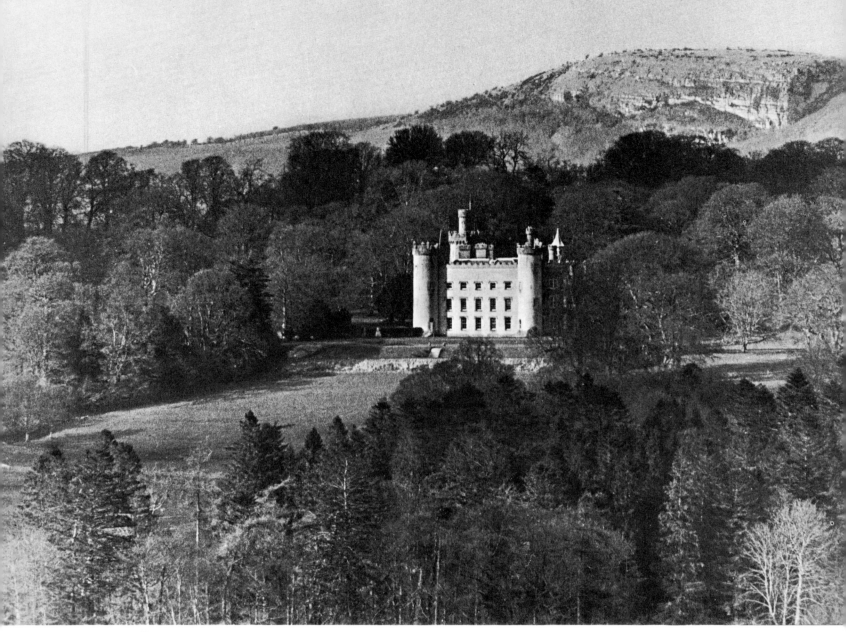

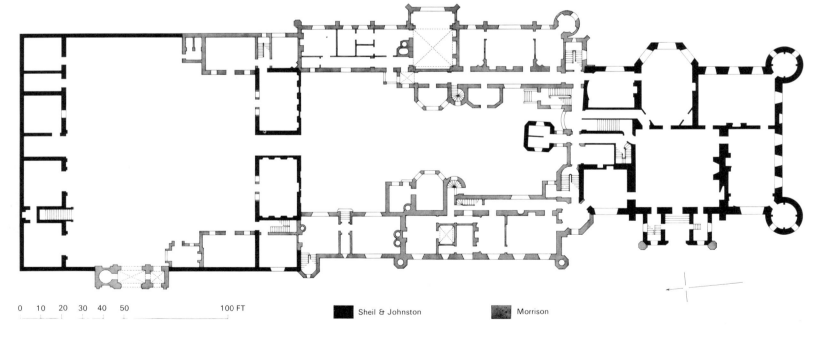

Tullynally Castle, formerly Pakenham Hall *Ground-plan of Tullynally Castle*

0 10 20 30 40 50 100 FT ▉ Sheil & Johnston ▨ Morrison

TULLYNALLY CASTLE

CASTLEPOLLARD, COUNTY WESTMEATH

Mr and Mrs Thomas Pakenham

EDMUND PAKENHAM was the first member of the family, which originated at Pakenham in Suffolk, to set foot in Ireland; he came over as secretary to his first cousin, Sir Henry Sidney, who was Lord Deputy for eleven years during the reign of Queen Elizabeth I. His grandson Henry Pakenham purchased Tullynally in 1655, having been granted some land in County Wexford by Charles II. He must have built the first house on the site where the castle now stands. Henry died in 1691, and his son Thomas Pakenham was knighted two years later. Thomas was created Prime Serjeant in 1695, and sat in the Irish Parliament.

In 1737, a younger son of the family, George Pakenham, writes enviously of Tullynally, then called Pakenham Hall:

> You enter a large pair of gates into a wide avenue of trees, at the end whereof you pass through a stable yard, built regularly, and from thence into a large lawn at the further point of which stands the house, being an old building, 70′× 90′. The gardens are full of fruit trees, etc., and the whole emparked with a stone wall. The household consists of a steward, butler, gardener, and several helpers, and a set of horses etc. besides people employed constantly in the kitchen etc. His estate somewhat better than £2,000 per annum.

He also describes an extensive classical garden layout, giving a good idea of how the house and landscape looked in the early eighteenth century. He speaks of 'a basin of 320 feet wide; from this is a cascade falling into another basin at the head of a canal, 150 foot wide and 1,200 foot long. On each side a large grass walk planted with trees. From this canal there runs in a direct line another near a mile in length, equal in breadth to the first, and terminates in a large basin at the foot of 3 or 4 beautiful hills.' The remains of this layout can still be traced but the surroundings have been deformalized, the water deflected so as to look like a river flowing through the lower end of the park.

The grandson and namesake of Thomas Pakenham married an heiress, Elizabeth Cuffe, in 1740. She was created Countess of Longford in her own right in 1785, by which time she was a widow. Her mother, Lady Alice Cuffe, was the sister and co-heir of Ambrose Aungier,

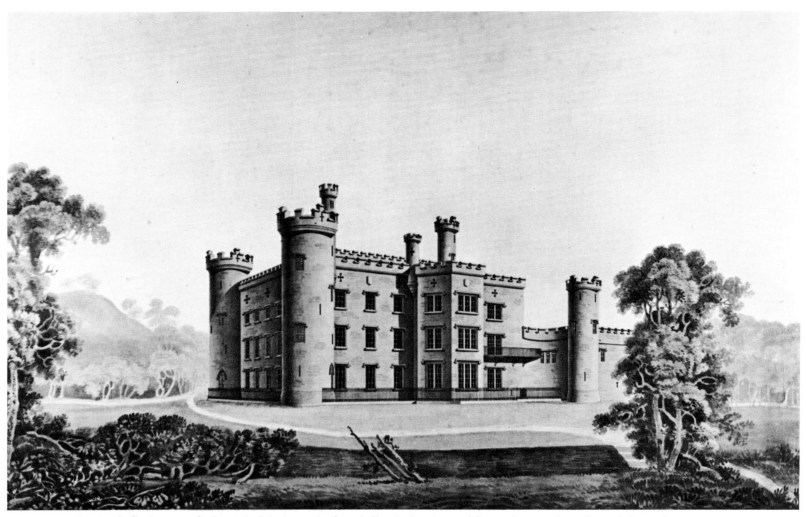

James Sheil's drawing of 1820 which hangs in the front hall. Sheil was one of four architects who gothicized the castle

second and last Earl of Longford of the first creation. She brought the town of Longford to the Pakenhams and a considerable amount of land besides. Thomas Pakenham had been created Baron Longford in 1756. His fourth son married Louisa Staples, the favourite niece of Tom 'Squire' Conolly of Castletown, Co. Kildare, and when their son eventually inherited that property he changed his name from Pakenham to Conolly.

The second Lord Longford was the friend of Richard Lovell Edgeworth, the inventor; the first trial of telegraphic communication was held between Pakenham Hall and Edgeworthstown in August, 1794. Mr Edgeworth also designed a central-heating system for Pakenham which is one of the earliest recorded in the British Isles. The heat came up through grills in the floor of the enormous hall, causing Lord Longford to write to Edgeworth, 'the children play all day in the hall and never cease to thank you'. Maria Edgeworth, his daughter, was a constant visitor – there was twelve miles of bog between Edgeworthstown and 'the seat of hospitality, and the resort of refined society' as she called Pakenham Hall. It was 'a vast Serbonian bog, with a bad road, an awkward ferry, and a country so frightful and so overrun with yellow weeds that it was aptly called by Mrs Greville *the yellow dwarf's country.*'

Maria Edgeworth writes to her father in 1806: 'Lord Longford [the third Baron and second Earl] has finished and furnished his castle, which is now really a mansion fit for a nobleman of his fortune . . . in short he has made such a comfortable nest he must certainly get some bird with pretty plumage and a sweet voice to fill it.' Ten years later he married Lady Georgina Lygon, an English heiress, and took enthusiastically to family life. He wrote to Maria's father in 1817, 'How could I have remained a bachelor so long?'

Although Maria Edgeworth did not take to Georgina, the new mistress at Pakenham Hall, she could not help but admire the gardens she created.

I never saw in England or Ireland such beautiful gardens and shrubbery walks as she has made. In a place where there was formerly only a swamp and an osiery she has made the most beautiful American garden my eyes ever beheld – took advantage of a group of superb old chestnut trees, oak, and ash for a background, trees which had never been noticed in that *terra incognita* before and it is now a fairyland, embowered round with evergreens, and even now when the rhododendron bank was not in flower and all American plants out of bloom it was scarlet – gay with lobelia fulgens and double dahlias of all colours in the green grass, their flower knots looking most beautiful.

Among the interesting accounts preserved at Tullynally there is a bill for dahlias dated 1829. The dahlia was first shown in London in 1828 by Mr Dahl, who had discovered it in Mexico; it was the fashionable flower of the period.

The drawing-room window and attendants

Traces of eighteenth-century panelling, some early fireplaces, and the thickness of the walls are the only remaining evidence of the 'old house, 70′×90′'. It was enlarged in 1780 by Graham Myers, the architect who worked at Trinity College, executing Chambers' designs for the chapel and examination hall. Between 1801 and 1806 Pakenham Hall was gothicized by Francis Johnston for the second Earl (third Baron), who may have been inspired by the castle at Inveraray, Scotland, which he visited in 1793. His comments on the Scottish castle are enlightening. After describing the fine pictures and furniture in the house, he adds that, much as he admires them, if they were in his house in Ireland they would be smashed to bits within a week. Perhaps his remarks need not be taken too seriously; all the same it would be interesting to know if he considered his servants or his friends to be the principal danger.

Francis Johnston's alterations were made only a short time after the 1798 rebellion, in which over 30,000 people lost their lives in the space of five months, six times as many as perished in the American War of Independence in five years. Several 'big houses' were burnt by the rebels, and Protestant landlords were the obvious targets. Lord Longford specifically states that he had security in mind when he added the portcullis entrance porch on to his house. Tullynally, seen from a distance, is very like Inveraray, only the setting is more romantic and its whiteness gives it something of the charm of a castle from a medieval manuscript.

Elaborate stone additions were made for the same Lord Longford in the 1820s by James Sheil, who also added the bow window to the dining-room and redesigned the entrance hall. This great room is typical of the pasteboard Gothic of the period. It resembles an immense stage set; there is a built-in organ, a cast-iron fireplace of the period, and Gothic niches with the arms of Cuffe and Pakenham facing each other across the shafts of sunlight. The reeding that is Sheil's hallmark can be seen around the Gothic doors off the porch, as well as on the ceiling of the dining-room.

In 1842, Sir Richard Morrison added two extensive wings to the north, the family wing, with a self-contained apartment in it, and a billiard room on the ground floor, facing the entrance front. Across the courtyard from it is Morrison's kitchen wing, which provided accommodation for the enormous number of servants that were kept by the third Earl, who was a bachelor. Morrison's additions were beautifully constructed of cut limestone, and every sort of turret, arrow slit, pepper pot, and crenellation has been stuck on, to conjure up visions of the 'true rust of the Barons' wars'. The last addition to the house was the Gothic tower at the north-east corner of the stable yard, designed in 1860 by J. Rawson Carroll, the architect of Classiebawn, Co. Sligo, the Irish seat of Earl Mountbatten.

The present owner inherited Pakenham Hall from his uncle, the late Lord Longford, in 1961 and changed its name to Tullynally Castle. In 1969 it was opened to the public for the

The drawing-room

The front hall

Tullynally Castle: the library

first time. Apart from the intrinsic interest of the building, with its successive layers of Gothic additions, there is a fascinating collection of family memorabilia such as the grant of the Borough of Longford from Charles I to Francis Aungier, and the marriage settlement of Kitty Pakenham and the Duke of Wellington. There are also maps, account books, Victorian photographs of the interior, and pictures of life in the 1930s when Evelyn Waugh and Harold Acton stayed here.

The Pakenhams are a family of writers. A life of President de Valera of which the present Lord Longford is co-author, and Lady Longford's life of the Duke of Wellington have just been published. Mr Thomas Pakenham has published a history of the 1798 rebellion, *The Year of Liberty,* and a sister is embarking on a life of Cromwell. Such literary talent is not often found in one family.

CHARLEVILLE

ENNISKERRY, COUNTY WICKLOW

Mr and Mrs Donald Davies

THE MOST PICTURESQUE view of Charleville is that obtained from the main approach to Powerscourt, the adjoining property. Halfway along this avenue, which runs along a ridge, the house springs into view standing in its exceptionally beautiful natural setting. It is built to a Palladian design extremely common in the dusty, flat Veneto, which seems just as completely at home here among the hills of County Wicklow. A little mountain stream called the Dargle, much loved by eighteenth-century landscape painters, forms a natural boundary between the demesnes of Powerscourt and Charleville.

The estate came into the hands of the Monck family through the marriage of Charles Monck, who was a barrister-at-law, with Agneta Hitchcock in 1705. Thomas, the second son of this marriage, was the father of Charles Stanley Monck, created Baron Monck in 1797 and Viscount Monck in 1801. The latter title came as a reward from the Government for his having voted for the Union, and this advancement must have made for bad blood with his neighbour, Viscount Powerscourt. When the Government emissary called on Lord Powerscourt to offer him an earldom as a similar bribe, his prompt reply was to kick him downstairs.

There is no record of the original house at Charleville which burnt to the ground in 1792. Soon afterwards the present house was built, but for long both the date and architect were unknown. The overall design has much in common with Lucan (q.v.), barely twenty miles away in County Dublin, built in 1775. The Knight of Glin has found a reference to an architect named Whitmore Davis who appears to have designed various country houses, including Charleville, in the 1790s.

The interior detail is early nineteenth-century, and on the side of the house there are wide, Regency windows that come down to the ground. None of the mantels in the house are of eighteenth-century origin, apart from a handsome one recently installed in the front hall. As a result, Charleville does not fit easily into a particular date or category, and it has even been suggested that it might have been built as late as 1830-40. It is unlikely that the Moncks

309

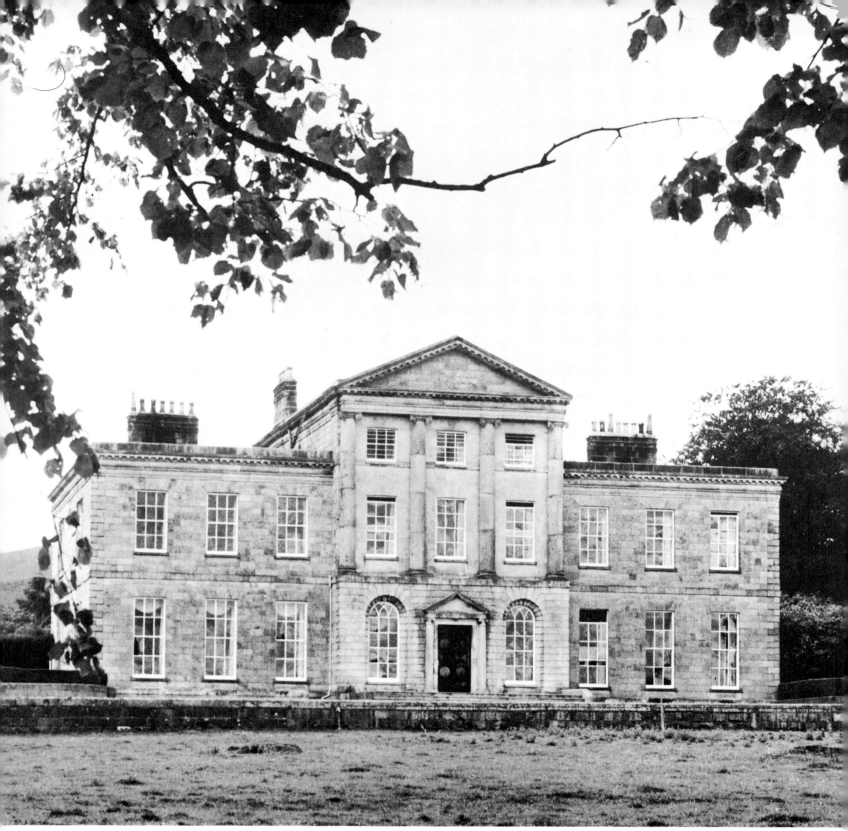

Charleville, designed by Whitmore Davis after the previous house was destroyed by fire in 1792

Ground-plan of Charleville

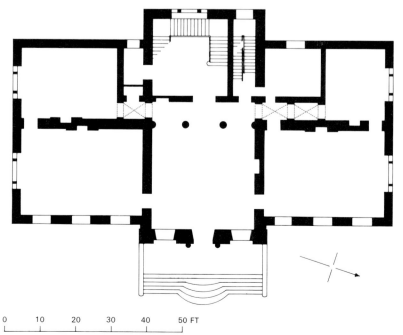

0 10 20 30 40 50 FT

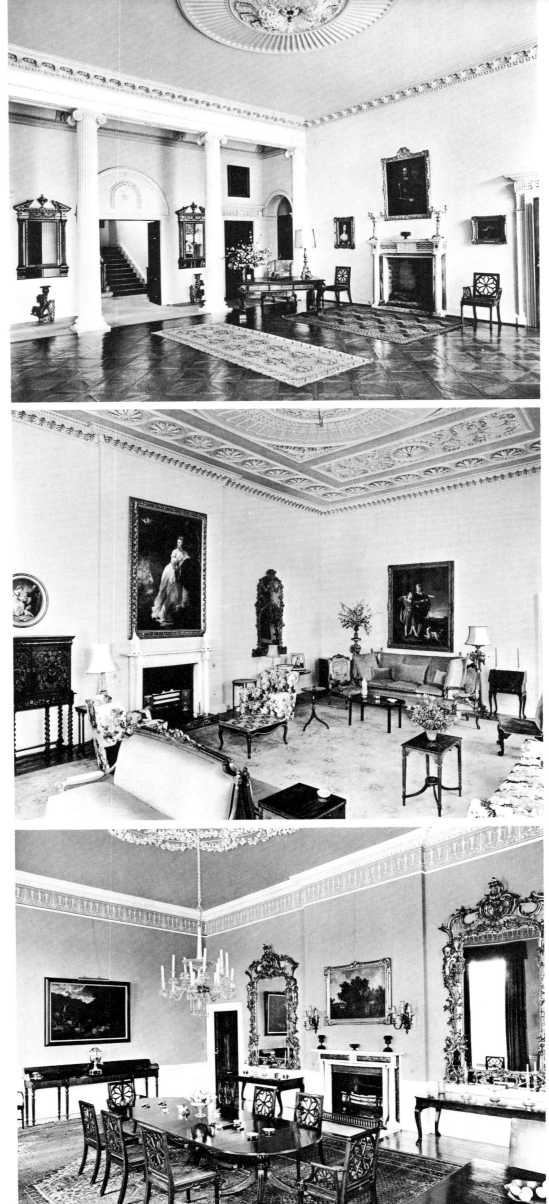

Charleville : the front hall

The drawing-room

The dining-room

The sitting-room

could have waited so long as this to rebuild their house after the fire of 1792, and the most likely solution is that the interior was entirely remodelled in about 1820 by the second Viscount Monck, who was created Earl of Rathdowne in 1822. Perhaps he was hoping for a visit from George IV at the time of the royal visit to Powerscourt in 1821.

The interior as it is today was most likely designed by Sir Richard Morrison, who re-modelled and added to Carton (q.v.) in 1816 and had a large country-house practice at that time. Carton and Charleville both have wide Regency windows that come down to the ground, rooms with barrel-vaulted ceilings, and plasterwork that smacks of the Greek revival. The plasterwork at Charleville is exceedingly fine and as classical houses of the Regency period are uncommon in Ireland, thanks to the Union with England as much as to the taste for Gothic battlements, it is all the more fortunate that it should have survived. There are severely classical laurel wreaths, and as at Carton there are vine leaves and tendrils, keeping safely within the bounds of their heavy compartments. There is not the freedom and gaiety of the 1750s nor the refined delicacy of the 1790s – this is something different again, a return to masculinity in decoration just prior to the Victorian era.

A tunnel of Irish yews forms a ceremonial approach to the walled garden behind the house, dominated by an elegant temple-conservatory which boasts a sturdy portico of mountain granite. The stable courtyard with its cut-stone dressings appears to be earlier than the house, and very likely survives from before the fire of 1792.

The earldom of Rathdowne died with the first Earl whose unfortunate wife produced no fewer than nine daughters but no son; the fourth daughter was to marry her cousin, the fourth Viscount Monck. He had a distinguished career, and was Governor-General of 'British America' at the time the Dominion of Canada was created in 1867. Gladstone came to Charleville in his day, and planted a tree that still grows beside the house.

Edith, Viscountess Monck, the widow of the fifth Viscount, was the last of that family to live at Charleville, which was closed up after she died in 1929. Mr and Mrs Donald Davies purchased the property in 1941 and have restored it to perfection. They run a highly successful clothing industry here which is known the world over, and have been able to succeed in this without having altered the character of any part of the house or outbuildings. In so doing they have saved the house, and are able to maintain it and the garden really well. In return, the house has no doubt helped the industry – it is a magnificent background against which to sell hand-loomed Irish tweeds. The neighbourhood also stands to benefit, for many are employed here; the owners have somehow managed to combine foresight with enterprise, and enterprise with taste.

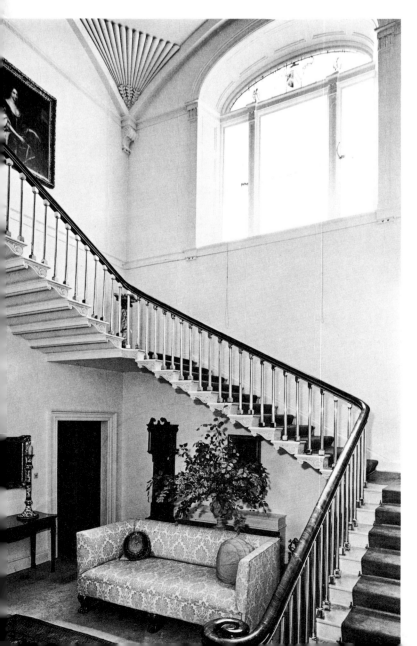

The staircase with its brass balusters

Temple conservatory in the walled garden

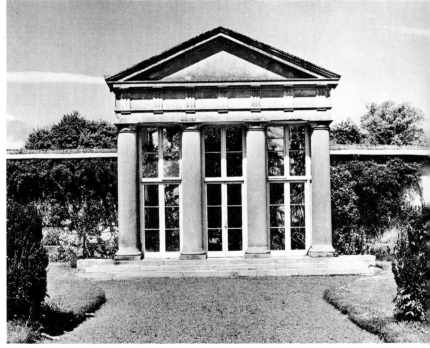

CHARLEVILLE 313

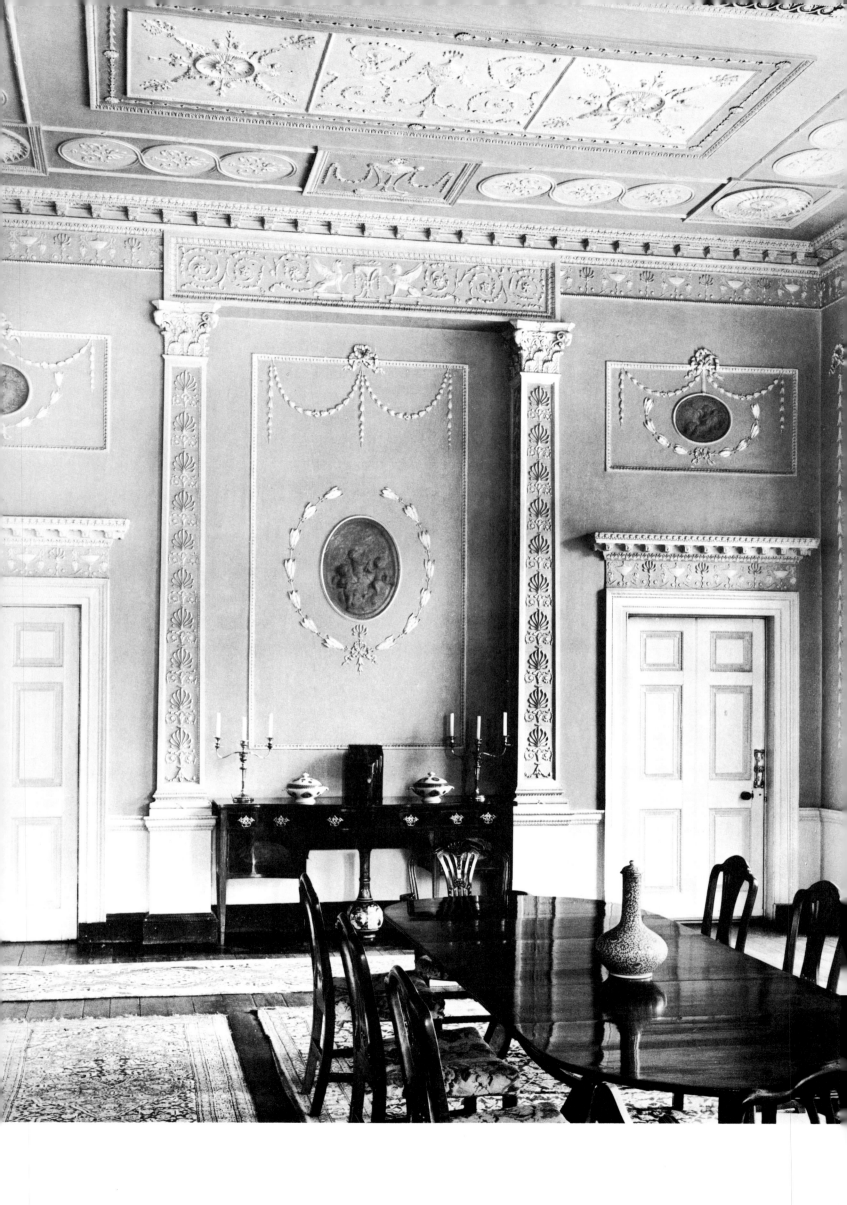

MOUNT KENNEDY

NEWTOWNMOUNTKENNEDY, COUNTY WICKLOW

Mrs Ernest Hull

ONLY 300 ACRES REMAIN today of the estate of 64,000 acres that belonged to General Cunninghame, the builder of Mount Kennedy. He had purchased the original 10,000 acres from Elizabeth Barker, who inherited the property from the last male of the Kennedys, after whom it is named, in 1769. When Arthur Young, the traveller and commentator, visited the demesne in 1776 the house was not yet begun, but he admired the compost, and the park where 'every spot is tossed about in a variety of hill and dale'. The General lost no time in planting and improving his new acquisition, and the trees he put in are now at the height of their beauty. What with the view of the sea on one side, and the wild mountains on the other, the demesne of Mount Kennedy is one of the most picturesque in Ireland.

Cunninghame was the first Irish landlord to commission plans from James Wyatt for his house, as John Cornforth has pointed out in *Country Life,* 28 October, 1965. Wyatt's designs are in the National Library, Dublin. On one of them is written: 'West elevation of a House designed for Major General Cunninghame intended to be built in Ireland – Jas. Wyatt 4 June 1772'. This was barely six months after the opening of the Pantheon in London, the design of which had made Wyatt's reputation overnight. The General waited over ten years, however, before he commenced building, although he lost no time in embellishing the landscape that was to surround his new house.

Thomas Milton, who published in his *Views* an engraving of Mount Kennedy after a painting (recently acquired by Mr Paul Mellon) by William Ashford, states that the building dates from 1784 and was executed by Mr Cooley from a design of Mr Wyatt's. That was the year of Cooley's death, and the building must have been begun a few years before. Cooley came to Dublin from London in 1769 on winning the competition for the Royal Exchange, now the City Hall, and settled in Ireland where he developed a considerable practice. Francis Johnston was apprenticed to him, and took over from him when he died, which may be the reason that in the National Library there is a drawing in the hand of Richard Johnston, elder brother of the more famous Francis, of the elevation of Mount Kennedy. Perhaps when Cooley died, Richard Johnston was commissioned to supervise the completion of the house.

Mount Kennedy: the dining-room with grisaille roundels by de Gree set into Michael Stapleton's plaster decoration

315

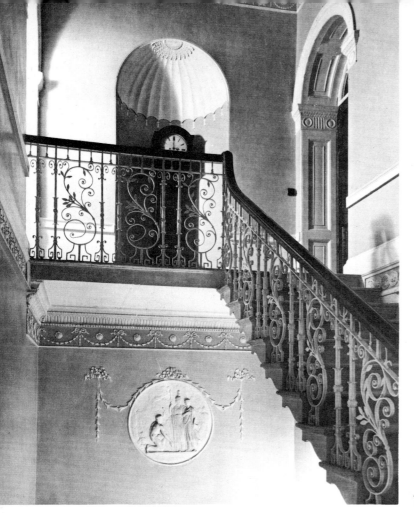

The staircase

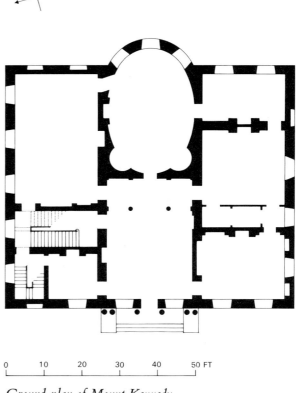

Ground-plan of Mount Kennedy

He was already thirty years old in 1784, whereas Francis would have been a mere 24 at the time of Cooley's death.

The plan is very similar to that of Lucan House (q.v.) even as to the disposition of the rooms. The large drawing-room at Lucan was originally the dining-room, and occupies the same position as the dining-room at Mount Kennedy. The two blind windows at Lucan have now been opened out, but at Mount Kennedy, although they are shown blocked on the Wyatt plan, they have always been open.

The house rises sheer out of the parkland in true Irish fashion, and is pebble dashed. The basement is constructed as a fort. An elaborate series of tunnels and storerooms, one of them an armoury, reaches out from the area, either designed as a means of escape or for surprising an attacker from behind. In the 1798 rebellion General Cunninghame, who had by now been created Lord Rossmore, and Lord Kingsborough, at the head of their troops, managed to beat off a body of insurgents from Mount Kennedy. If captured by the rebels it would have given them a commanding position over the road to Wexford which runs between the mountains and the sea.

The chief beauty of Mount Kennedy is the elaborate plasterwork, by Michael Stapleton, which ornaments all the principal rooms on the ground floor. As at Lucan, *grisaille* roundels by de Gree have been incorporated in the decor. Atkinson, in *The Irish Tourist,* described

Birr Castle, Co. Offaly : the dining-room and (below) the Gothic saloon. The gilt furniture by Thomas Chippendale was originally in Lord Zetland's London house (see p. 271)

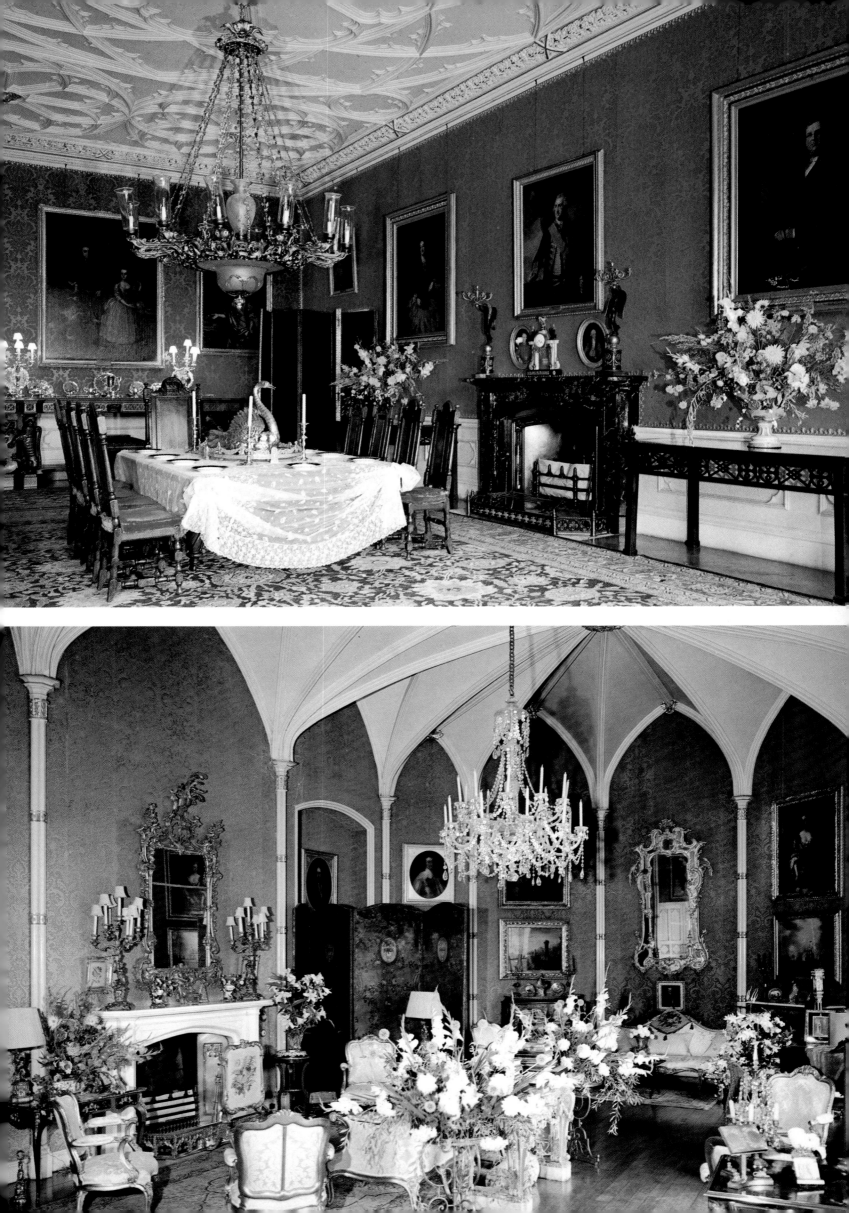

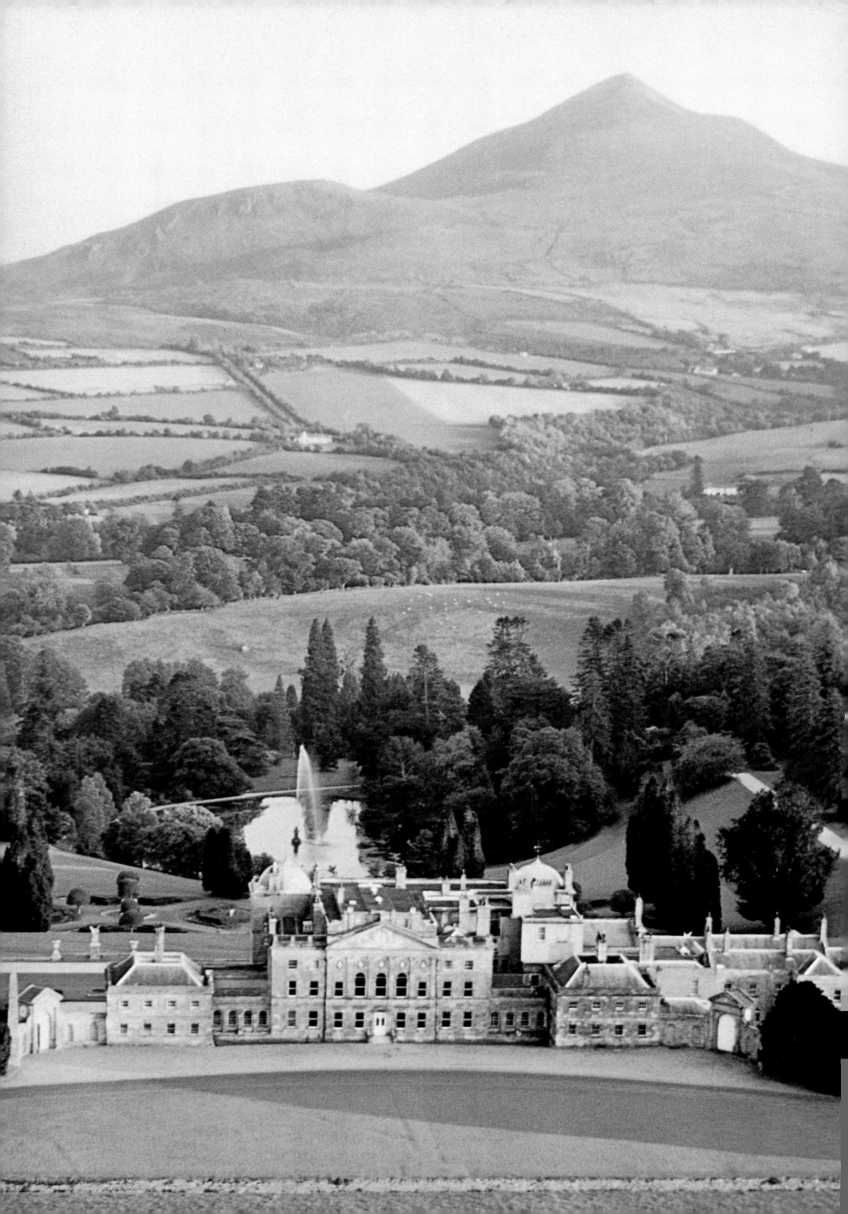

them rather naively as 'Italian devices so exquisitely painted, as to render the sight dependent on the feeling for the discovery of their real character, for they swell upon the eye like groups of the finest figures done in basso relievo, and until touched or accurately inspected, this error is scarcely discovered.' Peter de Gree came to Ireland with an introduction to the Viceroy from Sir Joshua Reynolds in 1785 and died in poverty in 1789. His work is often attributed to Angelica Kauffmann, who did spend a few months in Ireland in 1771, but whose name, like that of Adam and Grinling Gibbons, has been so widely used that it has come to refer to a certain style. De Gree was born in Antwerp, where he studied under M. J. Geeraerts. His *grisailles* for the dining-room at Mount Kennedy have been supplemented there by others imported from a house nearby called Woodstock, which were originally painted for No. 52 St Stephen's Green, the La Touche town house. Other *grisailles* by him, at Luttrellstown Castle and Lucan House, are illustrated here.

At one end of the dining-room there is a rectangular recess flanked by lofty Corinthian pilasters. Two houses in County Limerick, Shannongrove and Carnelly, have a similar feature and it has been suggested that these were used to accommodate a tabernacle for religious services of a private or family nature. It is more probable that they in fact contained a sideboard rather than an altar.

Mount Kennedy was designed by James Wyatt in 1772, but building did not commence until after 1780

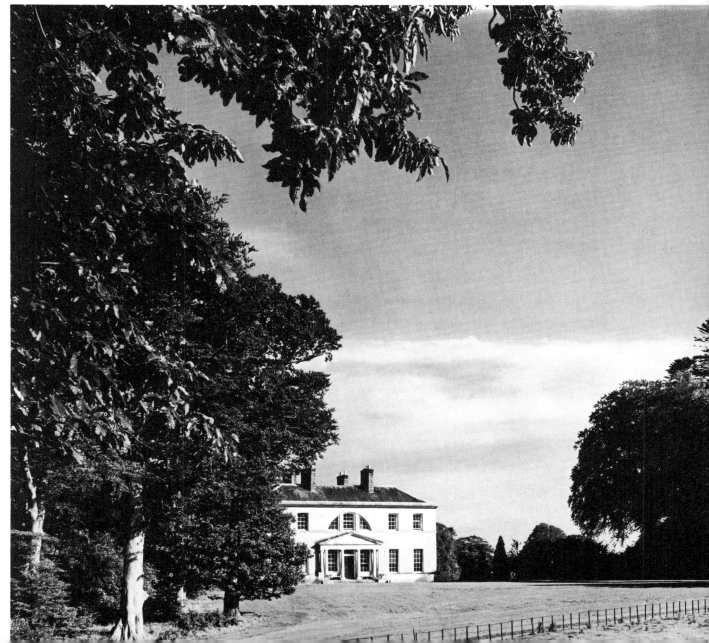

Powerscourt (1731), Co. Wicklow, with the Sugarloaf Mountain behind *(see p. 323)*

The decoration in the hall incorporates General Cunninghames's arms and those of his wife, who was a Murray, above the pillars facing the main door. He died without issue in 1801 and the property was inherited by Jean Gordon, the daughter of one of his sisters. She married George Gun of Kilmorn, Co. Kerry, and their son added the name of Cunninghame to his own.

Mount Kennedy remained in the possession of the Gun-Cunninghames until 1930, and in 1938 it was acquired by Mr Ernest Hull, whose widow lives there today. Many of the delicate ceilings have recently been repainted with the greatest possible care and sensitivity.

Mount Kennedy : the oval drawing-room. (Right) The front hall

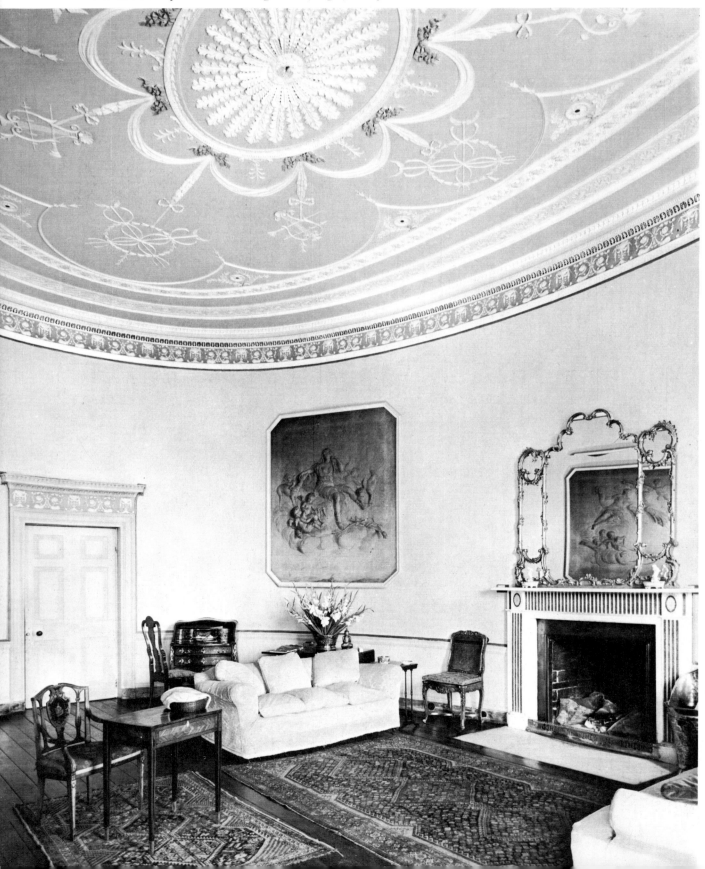

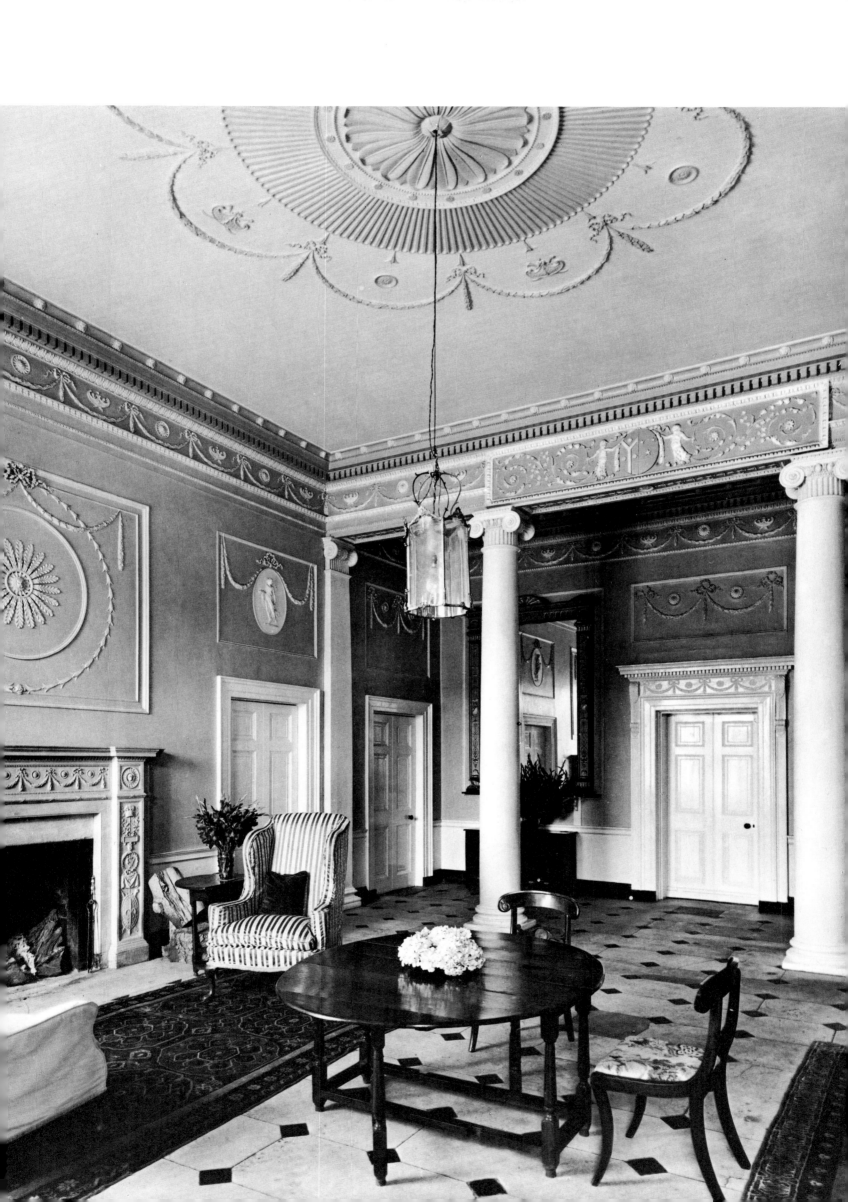

POWERSCOURT

ENNISKERRY, COUNTY WICKLOW

Mr and Mrs Ralph Slazenger

THE NATURAL BEAUTY of the park at Powerscourt has been used to brilliant effect to enhance the drama of the approach to the house. The entrance to the demesne is formed by a Palladian arch which, like so many of the classical adornments here, is one of the Victorian improvements of the seventh Viscount Powerscourt. The drive runs along a ridge between the silver trunks of enormous beech trees, here forming a wood, and there thinning out to reveal breathtaking glimpses on either side. The Sugarloaf Mountain, like some great brooding Vesuvius, dominates the skyline to the south, and below it, nestling in its park, is Charleville. Suddenly the front of the house comes into view. It is Castle's most successful façade. The wings are small and low to allow the central block to make its full impact, yet in spite of the boldness and grandeur of the conception, a degree of intimacy is conveyed by the curved curtain walls, terminating in obelisks carrying the Wingfield eagle. (*See p. 318*)

The name Powerscourt derives from the family of De La Poer, who came into possession of this mountainous territory by marriage with the daughter of Milo de Cogan, a follower of Strongbow. De Cogan erected the original castle here to protect his estates from the powerful septs of the O'Tooles and the O'Byrnes. In the centuries that followed it was twice taken by the O'Tooles, as well as passing through the hands of Talbots and Fitz-Geralds.

In 1608 Sir Richard Wingfield successfully crushed a rebellion in Londonderry and, as a reward, the lands and property of Fercullen, measuring five miles by four, were granted to him by James I in the following year. In 1649 the castle was destroyed on the instructions of the Duke of Ormonde, to prevent it falling into the hands of the Parliamentarians. Tradition has it that when the house was built, the Wingfields were loathe to allow the old castle to be razed, and that they forced the architect to incorporate it in the new house against his will. If this legend is to be believed, presumably the castle must have been made habitable again in about 1700.

Powerscourt: the entrance front

The house is built of a pale Wicklow granite from the quarries at Glencree. The central block is surmounted by a pediment where the family arms of Richard Wingfield and his

Powerscourt by George Barret (1760). (Coll. Paul Mellon)

second wife, Dorothy Rowley, are displayed, carved in a whitish stone. These were evidently in position before 1743, when Wingfield was made Viscount Powerscourt in the third and present creation, as there is no coronet. Beneath the pediment, five circular niches contain white marble busts, four of them Roman emperors and the fifth an unknown lady christened 'Empress Julia' by the seventh Viscount after his wife. Doric arches pierce the curtain walls at either side; they originally gave on to the stable and kitchen courts. When the stable wing to the east was turned into bachelor's quarters in the last century the yard was done away with, so that the arch now leads straight into the garden.

The south front of the house faces across a wide valley towards the wild landscape of Wicklow and the majestic Sugarloaf Mountain, the view spectacularly framed by the elaborate Victorian terraced garden that is known the world over. This front is flanked by towers surmounted by ogee copper domes, and the whole is faced in ashlar granite from top

to bottom. This appears to have been added later, as the elegant carved stone window frames, instead of standing out from the surface of the wall, are now submerged by the stone blocking. Quite possibly this may have been done after the Famine, when there was considerable unemployment among the Glencree quarrymen, at the same time as the terraces were embellished. The central axis of this front is three bays to the west of that on the entrance front, so that it can never have been as perfectly symmetrical as shown in a painting of the 1760s that has been attributed to Barret. The windows on the garden front are themselves thrown out of line on account of the eight-foot thick walls of the old castle which was incorporated into the building. The garden front would be greatly improved if it had glazing bars in the windows, which at present have the lifeless stare of Victorian plate glass.

Mr Christopher Hussey (*Country Life,* 6 Dec., 1946) believes that this front was put on later, and has noted that some of the plasterwork on this side of the house appears later in date than in the saloon. He specifically cites the woodwork in the round, domed room in the east tower on the *piano nobile* as being '1835 Georgian'. In fact, if examined closely, this panelling, together with the inlaid floor and the geometrical ceiling, appears to date from 1740 or before. At some subsequent date, however, probably in the 1840s, strips of darker wood in a bolection mould have been applied to the panelling, entirely changing its character, and the Greek Revival mantel must have been put in at this time.

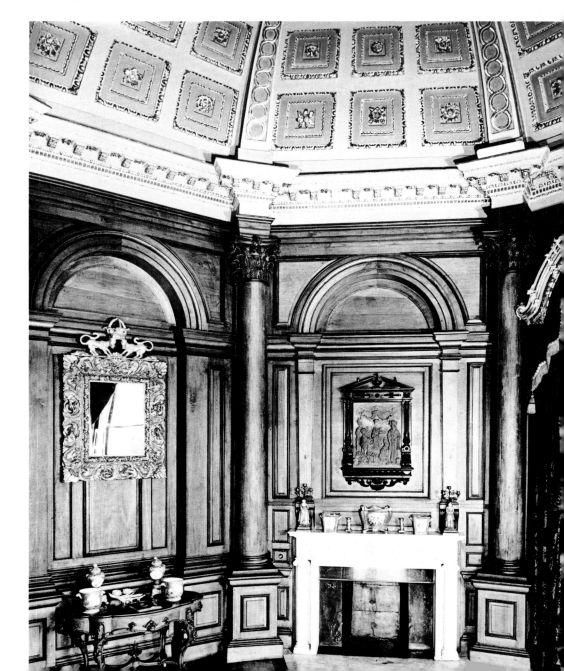

The octagonal room in one of the round towers on the garden front

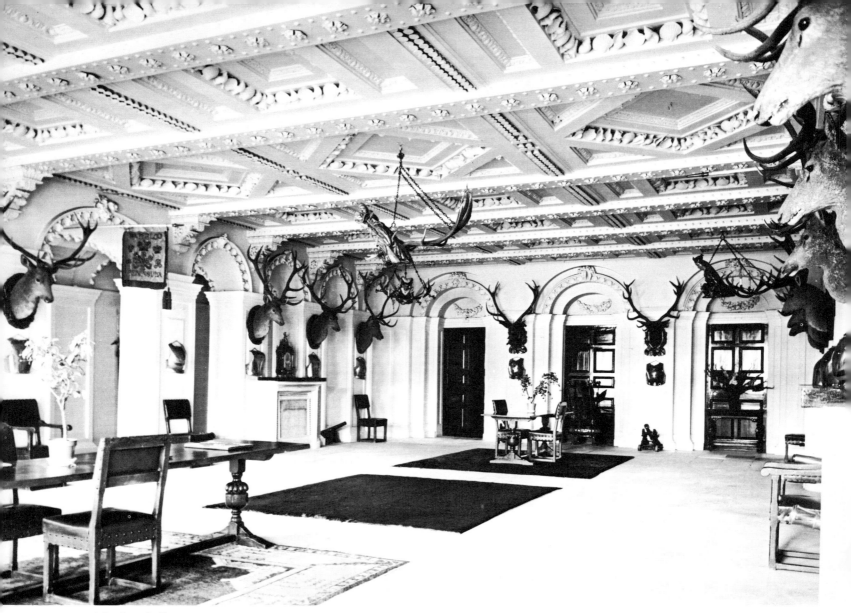

The front hall

Unlike most country houses, the principal reception rooms are upstairs and the secondary ones on the ground floor, an arrangement which left little space for bedrooms. These were provided in the former stable wing to the east, and in wings that were added later to the west. Another very unusual feature is the long low entrance hall; most Irish houses of this period were equipped with front halls that impressed with their height but that at Powerscourt impresses with its length. The effect is by no means heavy or oppressive because the room is flanked by arcades, and also it is painted stark white. The decoration consists of white shells done in plasterwork, and niches adorned with shells, giving it the appearance of a grotto in a Continental palace.

The reason for its long, low shape becomes apparent when the visitor ascends the staircase leading to the great saloon, which is possibly the grandest room in any Irish house. It takes up the whole height of Powerscourt to the roof, measuring sixty feet long, forty feet wide and forty high. It is an adaptation of Palladio's version of Vitruvius' description of 'an Egyptian Hall', on which Lord Burlington modelled the Assembly Room at York which was begun

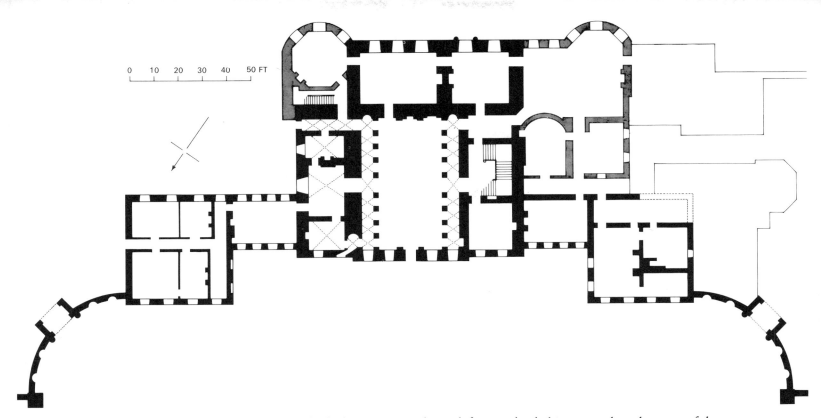

Ground-plan of Powerscourt. The flanking towers on the south front are hatched in grey to show the extent of the medieval castle which was incorporated into the central block

in 1730, a year before Powerscourt. The ceiling is compartmented and very rich in white and gold, its design more or less reflected in the superb parquet floor, a notable feature of Richard Castle's houses. The massive gilt chandeliers were brought here from a palace in Bologna about a hundred years ago, and the chimney piece was inserted at the same time; it was supplied by Pegrazzi of Verona, based on the design of one in the Doge's palace in Venice. Leading off this great apartment are a series of drawing-rooms facing south across the terraces, with unusual plaster ceilings that do not fit easily into any particular date or style, but which are evidently of the same family as the staircase ceiling. These ceilings may have been designed by Sir Richard Morrison, and completed in time for the visit of George IV in 1821. The ceilings at Charleville (q.v.), the next door property, appear to be of the same date and by the same hand. (*See p. 335*)

It is impossible to imagine what the house looked like at the death of its builder in 1757. Most of the interior has been remodelled since, and even the Victorian alterations were done in such good taste that an accurate analysis becomes difficult. In the absence of documentary evidence regarding the alterations (the eighteenth-century building accounts are preserved in the National Library) it becomes the most puzzling of all Irish houses. Originally it had nothing but reception rooms, and seems to have been built for amusement and entertainment in summer, like the great villas of Palladio, rather than for country life. There does not appear to have been a means of heating the front hall or the great saloon above. Perhaps it was never finished, and what are taken for alterations are in fact a belated completion of the interior. This would explain the insertion of marble mantels brought here from houses in Dublin.

The owners of Powerscourt have always been great collectors, and in their additions and improvements they have shown respect for the classical style in which the house is built. Two rooms were put together to form the dining-room on the ground floor, which has an 'Adam' ceiling of 1880 and a monumental sixteenth-century mantel of the kind found in the villas of Palladio near Venice. Most of the mantels in the other rooms were put in later than the house.

The terraces at the back of the house were laid out from 1842 under the direction of Daniel Robertson, and are said to have been inspired by those at the Villa Butera in Sicily. It was not the fashion for the garden to surround the house in the eighteenth century; flowers, vegetables and fruit-trees were enclosed in a walled garden somewhere out of sight. The old walled garden at Powerscourt still exists, but it was eclipsed in the 1840s by Mr Robertson's elaborate series of terraces, centred on the round pond framed by twin pegasi (winged horses are the supporters of the Wingfield arms). The double staircase which forms the centre of the design was executed in 1870 by F. C. Penrose, architect to the dean and chapter of St Paul's. The chief ornament here is the fountain of Aeolus flanked by generous cobbled ramps with Italianate patterns in white on black. The pair of bronze figures of Aeolus are seventeenth-century Italian sculptures, which had found their way from the Duke of Litta's palace in Milan to the Palais Royal, Paris; when it was burnt in 1871 by the commune, they were sold to Lord Powerscourt by Prince Jérome Napoléon who told the new owner: 'Au Palais Royal les Eoles jettaient du gaz par les bouches et de l'eau entre leur jambes; c'était original et joli, un peu baroque.'

It is not generally known that these terraces, as well as the round pond, were conceived by Richard Castle at the time the house was built, and that the bones of this exceptional layout are in fact eighteenth-century. Of course there would have been no Victorian statuary, no urns, no fancy ironwork, no gravel, only the clear-cut lines of the terraces, green shadows falling across them, like the ghost of some great classical garden. The circular pond, directly on axis to the back of the house (as shown in Rocque's map of County Dublin, 1760) was actually deformalized at that time by the insertion in it of an asymmetrical island planted with conifers. Castle provided a similar layout at the back of Russborough (q.v.) in 1745, only there the terraces go up the hill so that the water is out of sight; the theory is that the money had run out before the steps, statues and urns could be provided. By this date, however, the Italian garden had gone out of vogue, and Castle in fact intended the Russborough terraces to be unadorned, grazed by sheep and cattle as they are to this day.

Dr Pococke mentions the Powerscourt terraces in his Irish tour of 1752 – he did not altogether approve of the layout: 'a large house and great improvements, but the slopes are rather too steep and unnatural'. Practically every 'tour' has a reference to Powerscourt which

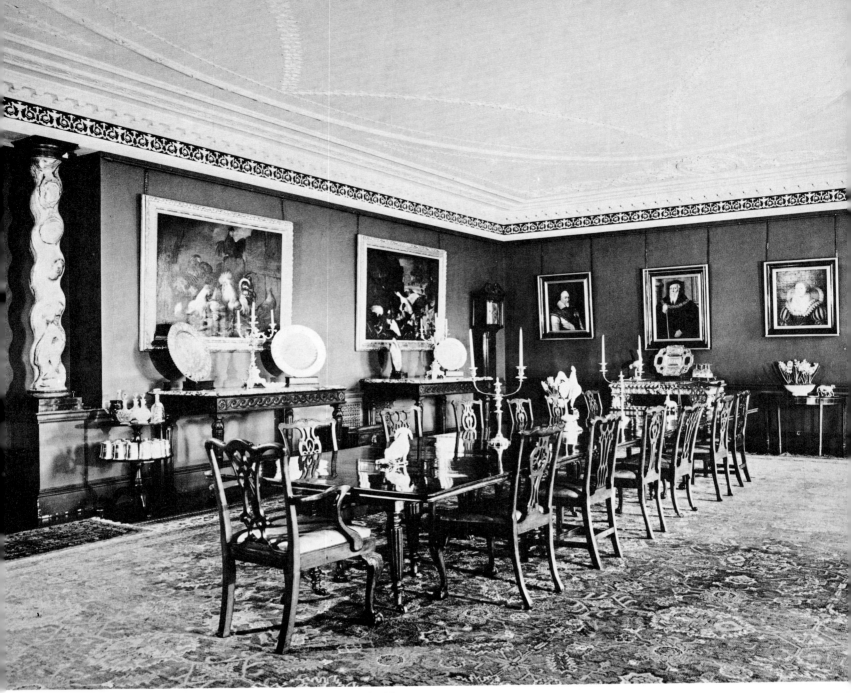

The dining-room with its 'Adam' ceiling of 1880

Layout of the house and garden in 1760 (Rocque's map of County Dublin)

Mantel in the dining-room which was probably installed in 1880. It is of a kind found in the north of Italy

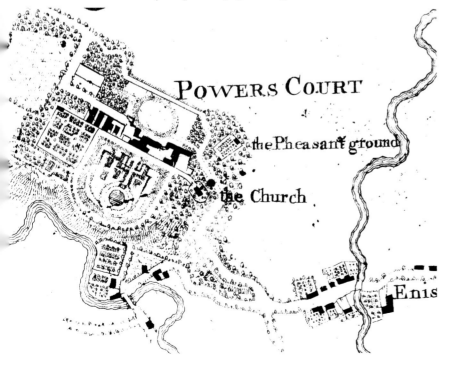

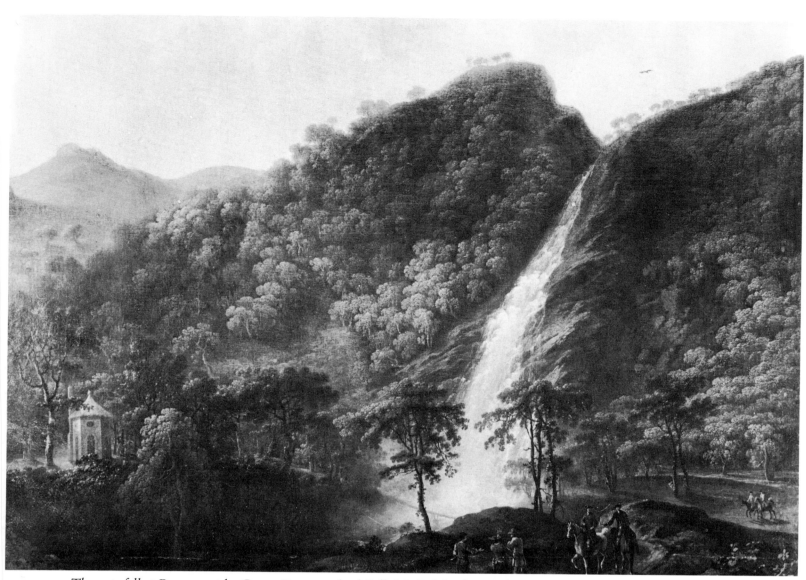

The waterfall at Powerscourt by George Barret, 1762. (Coll. Mr Ralph Slazenger)

has been a mecca for tourists and visitors of all kinds ever since the eighteenth century. Pococke also mentions the famous waterfall, painted by scores of topographical artists, and the subject of numerous engravings, poems, and eulogies of every kind. Fortunately for George IV when he attended a banquet at Powerscourt, on his visit to Ireland, he did not go to see the waterfall. A special bridge had been put up for the royal party to obtain the best possible view of the falls, and a sluice gate had been devised to ensure a good spectacle. When this was opened, the bridge was swept clean away by the torrent.

It was indeed fortunate that when Powerscourt became the property of the present owner in 1961, he was able to purchase the contents at the same time. Furnishing a house of this size and importance would be difficult enough today, financial considerations aside. It is a matter of the greatest satisfaction that Powerscourt should still contain the things that have always belonged there, and that the gardens and estate are still maintained to perfection.

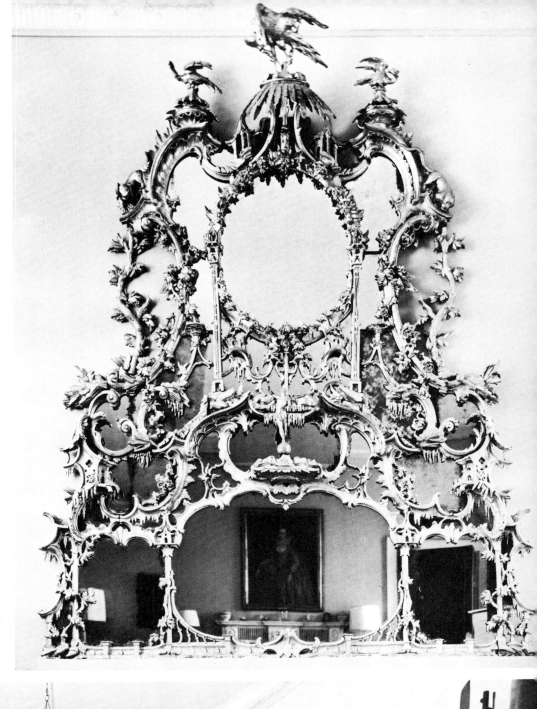

Mirror attributed to Thomas Johnson, formerly at Tyrone House, Dublin

The armoury

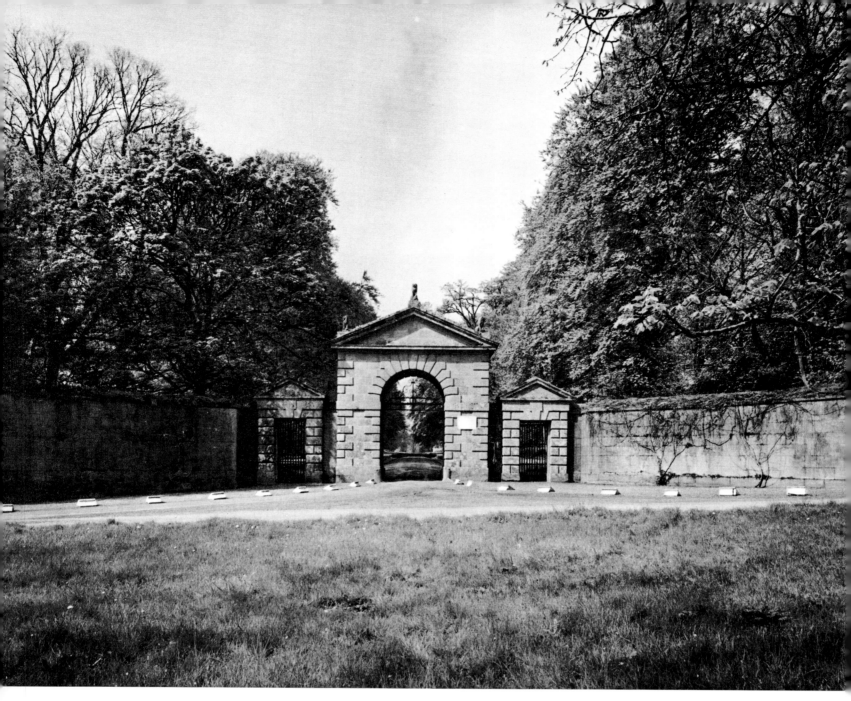

Russborough : the entrance archway. (Below) The main front as seen from the lake

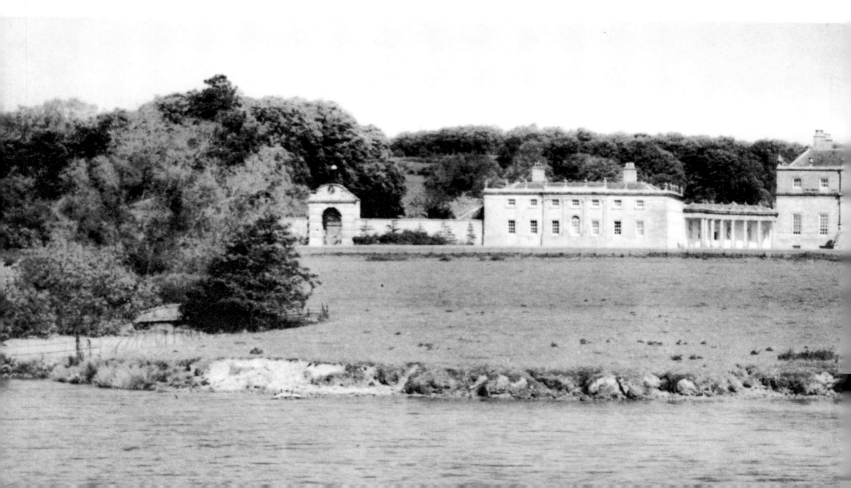

RUSSBOROUGH

BLESSINGTON, COUNTY WICKLOW

Sir Alfred and Lady Beit

A TRIUMPHAL ARCH heralds the approach to Russborough, built, like the house itself, of silver grey granite from the Golden Hill quarry close by; the stone glitters in the sunlight and never seems to darken in rainy weather, as does the limestone used in so many Irish houses. There is no front lodge – the driveway, straight and formal, leads past the walled garden on the left, and on the right a large round building once used for the exercise of horses in wet weather. The avenue is flanked by enormous beeches, and a raised embankment on either side adds to the formality of the approach. All of a sudden, one end of the 700-foot façade comes into view; it is an impressive sight, the most perfect example in Ireland of the Palladian style, and a house that has been maintained in a fitting manner to the present day.

'About two miles from Ballymore-Eustace we came to a beautiful situation, where we found a noble mansion forming into perfection, the seat of Joseph Leeson, Esq. If we may judge of the picture by the outlines, we shall, when finished, see a compleat beauty. Artificers from most parts of Europe are employed in this great new work.' This description of 1748, and Pococke's of 1752 describing Russborough as a 'newly-built house', are only worth quoting to demonstrate the dearth of contemporary references to the house.

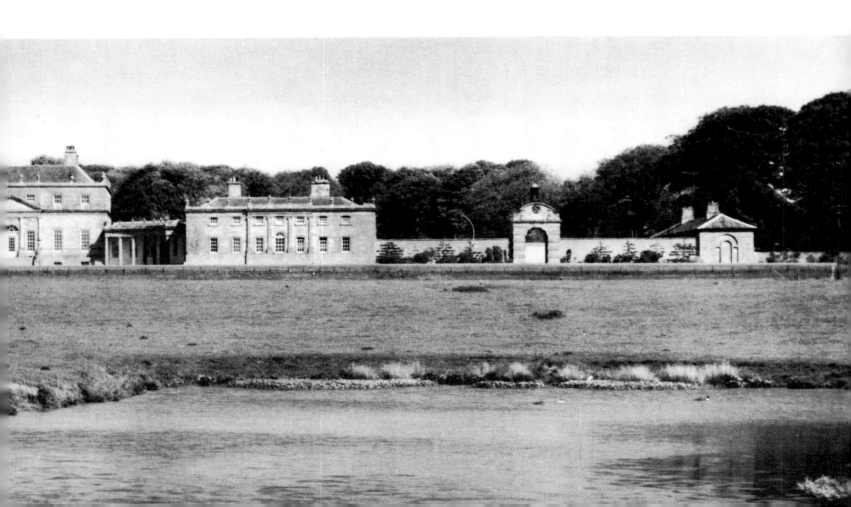

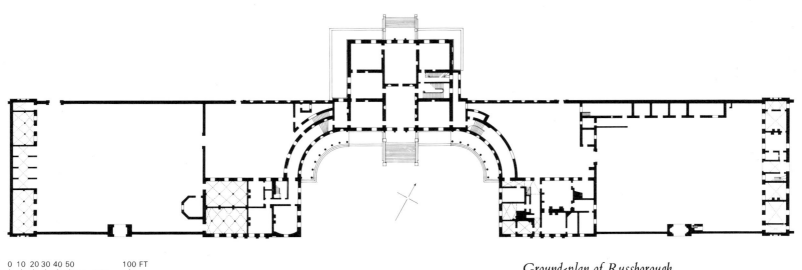

Ground-plan of Russborough

Lady Kildare writes on 9 May, 1759: 'I told you I was to see Russborough. The house is really fine, and the furniture magnificent; but a frightful place. Mr Leeson carried us to see a very fine water fall near it.' This was undoubtedly the Poulaphouca Falls, which have now been engulfed by an electric power dam with the unerring eye for beauty displayed by the Electricity Board (The Salmon Leap, Leixlip; Lower Fitzwilliam St, Dublin; Tarbert Island, Co. Kerry). In this case, however, the dam has immeasurably improved the outlook from Russborough by flooding the entire valley in front of the house, rendering the view inviolate at the same time. When Lady Kildare says 'frightful', she means barren, bleak. It was unusual for Leeson to have chosen such a remote spot for building his great house, but he is said to have planted 40,000 trees in the first year that he owned it. These were mainly beeches, which have now reached maturity and the park is the most civilized imaginable today.

Between the house and the reservoir there are some irregularly shaped fish ponds, which have the appearance of being unfinished, strictly speaking being neither formal nor informal. Occasionally a heron will rise in awkward, primeval flight from the willow trees which dip their branches into the waters. Carducci, the Italian poet, would not have approved of finding such 'decadent, foreign' trees in so pure a classical setting.

Behind the house, symmetrical terraces have been carved out of the side of the hill, with formal water at the centre too high to be seen even from the roof of the house. These may be compared to the terraces at the back of Powerscourt, which have since been embellished with Victorian statuary – at Russborough the spadework alone is said to have cost £30,000. It is like the ghost of some vast classical garden, created when it was no longer the fashion to look out at formal flower beds, but at the same time satisfying the taste for the formal and symmetrical.

Russborough was built in 1741 for Joseph Leeson by the architect Richard Castle. On the death of his father, Leeson had come into a large fortune while still only thirty years old.

Powerscourt: the saloon, which still contains the 'throne' used by George IV on his visit in 1821
(see p. 323)

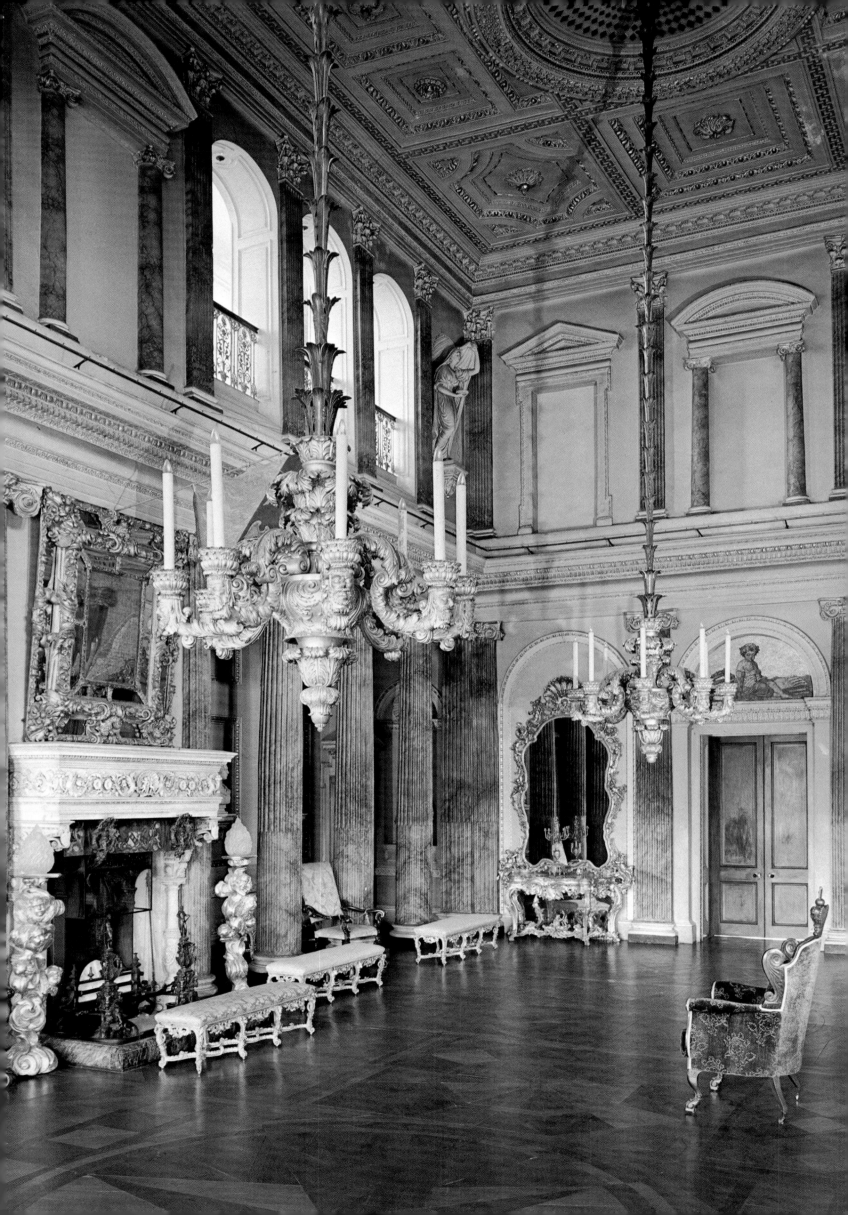

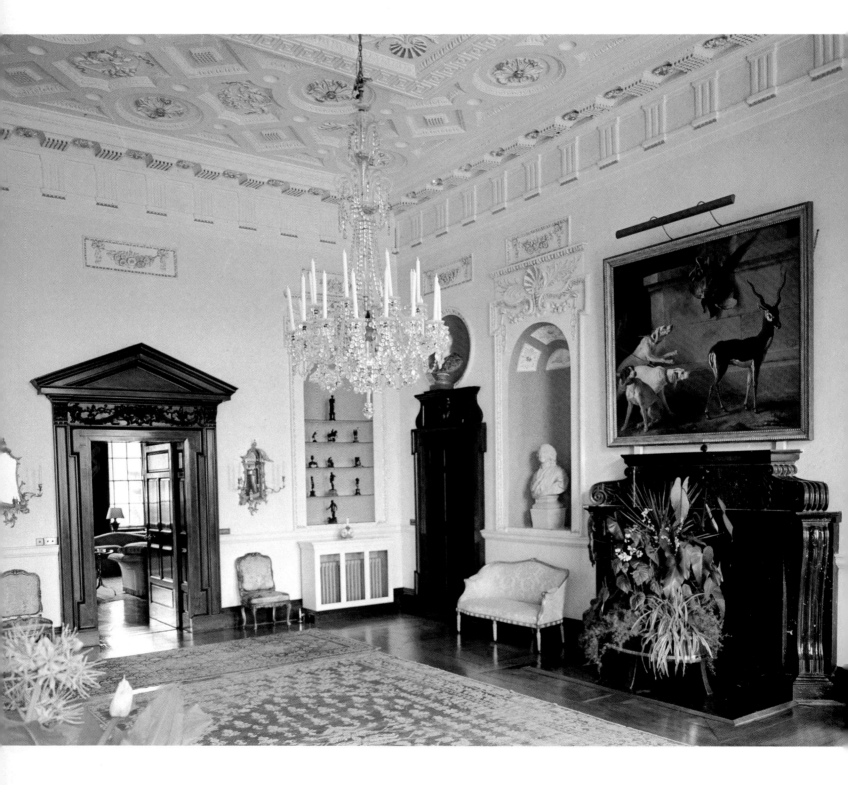

He was M.P. for Rathcormack between 1743 and 1756, when he was raised to the peerage as Baron Russborough; in 1760 he became Viscount Russborough, and three years later he was created Earl of Miltown. He died at his house, No. 17 St Stephen's Green, Dublin, in the year 1783 leaving his third wife to survive him until 1842, when she died aged 100. This Dublin house, designed in 1776 by Michael Stapleton, the Irish Adam, is a complete contrast to Russborough where the only concession to neo-classical taste was the insertion of a Bossi mantel in the boudoir. Otherwise the house remains miraculously unaltered. Every minute and perfect detail has survived: all the original mantels, the inlaid floors, the incredible display of baroque plasterwork, even the door frames. It is fortunate indeed that Russborough and Castlecoole, the two best houses in Ireland of their period, have both escaped alteration or addition in the nineteenth century, although Lord Miltown clearly came to appreciate the Adam style towards the end of his life.

He was a great collector. In 1751 he was in Rome, buying works of art for the house, and together with his son he is included in the celebrated caricature group by Reynolds 'The School of Athens'. This is one of the 59 paintings from Russborough that were bequeathed to the National Gallery of Ireland by the widow of the sixth Earl of Miltown in 1902. She also presented some important statuary and furniture, as well as a rich collection of silver – enough to justify the extension of the Gallery to contain her generous gift.

It is a matter of great satisfaction that Lord Miltown's collection should have remained in Ireland, and also that the vacuum left behind it at Russborough should have been filled with that of the present owner, so admirably suited to the house. Lord Miltown's taste was that

*Russborough
(1741), Co.
Wicklow: the
entrance hall,
dominated by the
Oudry hanging over
the mantel*

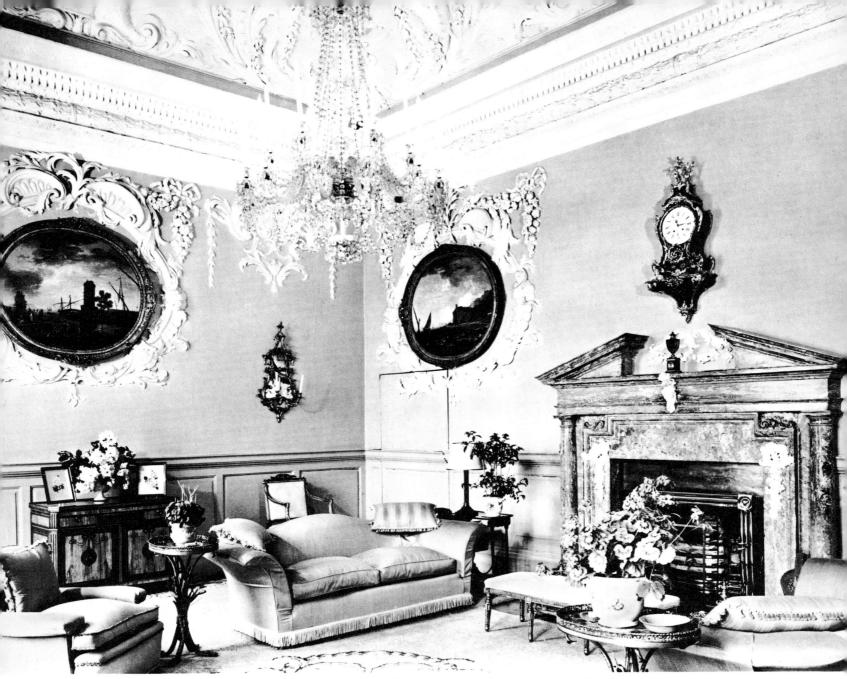

The drawing-room with the set of Vernets recently put back in the elaborate plaster frames made for them

of the typical Grand Tourist of the day. He sat for Pompeo Batoni, and the works of Salvator Rosa, Poussin, Hondecoeter, Vernet, Rosalba Carriera, Luca Giordano, Rubens, Van Dyck, and Barret decorated his walls, besides three groups of caricatures by Reynolds. No fewer than twenty Barrets are listed in Neale's *Views of Gentlemen's Seats,* 1826, eleven of which were in the library, the present dining-room. An important series of oval paintings by Vernet, for which elaborate plaster frames were designed, had been sold out of the house and lost sight of for many years; fortunately the present owner has managed to track them down and put them back where they belong.

Though Russborough was occupied by the rebels during the 1798 rebellion it suffered very little. The rebels refrained from using the large green baize drugget covering the saloon floor to make flags lest, as one of them said, 'their brogues might ruin his lordship's floor'.

The king's troops behaved very differently during their occupation of the house. They not only caused serious damage to works of art but also to the buildings and outbuildings.

When the sixth Earl of Miltown died, Russborough passed to his widow, who died in 1914. The estate eventually devolved on his sister's son, Sir Richard Turton, Bart., who was M.P. for Thirsk in Yorkshire. When he died, in 1929, his widow offered Russborough to the Irish nation, but Mr Cosgrave's government turned down her generous offer and the house was empty until it was bought by Captain Denis Daly, of Dunsandle, Co. Galway, two years later. He and his wife preserved the house through difficult times, and they sold it in 1951 to the present owners.

In 1937, when Sir Alfred Beit was moving into a house in London, he happened on Brian FitzGerald's articles on Russborough which appeared in *Country Life* that year, and decided to have the dining-room chimney-piece at Russborough copied for his library in London. He can scarcely have imagined at the time that Russborough would one day belong to him. It provides the most eloquent setting for the remarkable collection of pictures, furniture, and *objets d'art* put together by his uncle, Mr Alfred Beit, his father, Sir Otto, and himself. It is very much a living collection, and the pictures are constantly being changed from room to room. In accordance with the taste of the 1890s when it was started, the Beit collection was somewhat top-heavy with Dutch masters. The balance has now been redressed; the Soho tapestries, the Oudry, the Puvis de Chavannes and a Sargent are among the works of art that have been brought to Russborough during the last ten years.

In the front hall there is a superb inlaid marble table, signed *D. Petr. Belloni Monache : V :F : Anno Dni. 1750*. The background of the table is black, inlaid with a mixture of ground marble

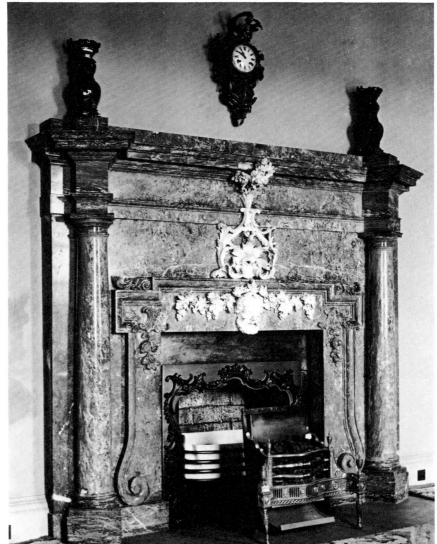

Dining-room mantel

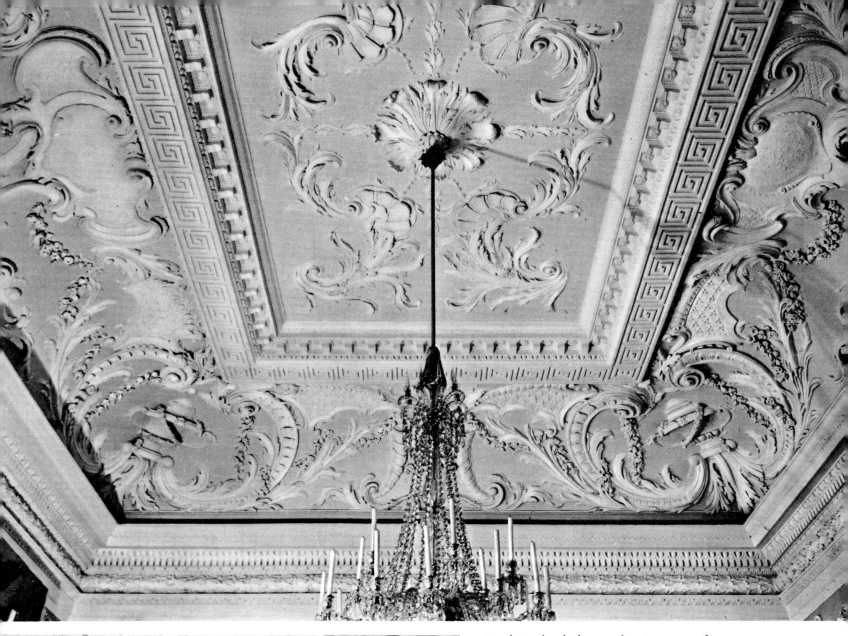

Russborough : the baroque drawing-room ceiling

The boudoir, which contains a mantel made in Dublin by Pietro Bossi

bound with glue; the centre panel contains a fantastic landscape and the remainder of the surface is decorated with rococo scroll-work, animals, butterflies, and the like. It was one of a pair bought by Joseph Leeson in Italy. The front-hall mantel, as is so often found in houses built by Richard Castle, is of black Kilkenny marble and monumental in design. Originally some twenty inches higher, one section has been removed, so oppressive did it seem, but it has been preserved in the house. Three of the niches around the walls, which were designed for classical statuary, now contain bronzes and porcelain, and the other two a pair of Louis XV busts. Above the mantel there is a superb front-hall picture, an Oudry of a stag and hounds straining at their leashes. Facing it are a pair of Magnascos, bought by Sir Alfred before the war, *St Francis preaching to the Birds* and *St Augustine and the Child Christ.* It is unusual to find a wooden hall floor in an Irish country house – the only examples in this volume are Belvedere and Castleward, leaving aside houses where the entrance has been changed. Russborough is a temple to art and beauty designed for refined entertainment. The hall is white picked out in gold; the compartmented ceiling is similar to one in a ground-floor room at Leinster House, Dublin, which Castle was building at the same time, except that at Russborough the flat areas are decorated. Ornate as it is, the hall is the most severe of the seven reception rooms on the ground floor. (*See p. 336*)

The two other rooms on the entrance front, the drawing-room and dining-room, also have monumental marble mantels, unlike the other rooms on the ground floor but similar in feeling to those in the bedrooms. They are probably of Irish manufacture and were very likely made at Mr Colles' marble works in Kilkenny. Similar mantels are to be found in many Irish houses (Rathbeale, Browne's Hill) but nowhere is there the variety and invention found at Russborough.

The dining-room is to the right of the hall, connected with the kitchen wing by a curved service corridor behind the colonnade. The plasterwork is magnificent but less accomplished than that in the saloon, and it is tempting to assume that it is the work of Irish craftsmen; the building accounts have unfortunately not come to light. A series of six paintings by Murillo telling the parable of the Prodigal Son ornament the walls; they were acquired by Mr Alfred Beit from Lord Dudley in 1895. Lord Dudley had purchased five of them at the Salamanca sale in Paris in 1867. The sixth, which had found its way into the Vatican, was acquired by exchanging a Fra Angelico and a Bonifazio. Lord Dudley must be one of the very few to have extracted anything from the Vatican Museum. The dining-room chairs are English, Japanese red-and-gold lacquer in the Queen Anne style, and the carpet is one of several made recently for the house at the Royal Carpet Factory in Madrid.

To the left of the hall is the drawing-room with its magnificent baroque ceiling whose decoration is echoed on the walls where fantastic plaster frames surround the oval paintings

by Vernet recently brought back to the house. Beyond it is the boudoir, panelled in white; a charming, intimate room. Among other pictures it contains a portrait of Lady Beit by Leonore Fini, over the mantel by Pietro Bossi. Bossi's technique, which was similar to that of Belloni whose inlaid table in the hall has been described above, was a closely guarded secret. The story goes that on his death-bed the old man even refused to tell his own son, saying with his last breath, 'There is only one God and one Bossi.' Beyond the boudoir a curved passage leads to the master bedrooms, passing Anne's garden. The passage is hung with tapestries, and paved with black-and-white squares recently laid down – a few of the mauve Victorian tiles have been left in place.

North of the drawing-room is the tapestry room, facing west across the lawns to the back of the house. The 'hidden' door which leads into it actually cuts into the elaborate oval plaster frame of one of the Vernets in the drawing-room which at this point has been made of carved wood, painted to resemble plaster. The tapestry room ceiling is barrel-vaulted, coffered, and richly decorated. No two ceilings at Russborough are alike, yet within the framework of the period and given the fantastic opulence of the plaster decoration it somehow remains a cohesive whole. A unifying factor is the high mahogany dado which goes round most of the rooms on the ground floor, providing a steady bass accompaniment to the plaster flourishes above. In this room and in the three rooms facing north over the terraces the mantels are of a more conventional design, of superb craftsmanship; they were quite possibly imported from England. The room takes its name from the two Soho tapestries of Moghul subjects by Vanderbank, which were formerly at Melville House, Scotland.

Above the mantel hangs the earliest known Velazquez, *The Servant Girl*. Another version of this painting, without the background figures of our Lord with the two disciples at

Curved passage behind the west colonnade

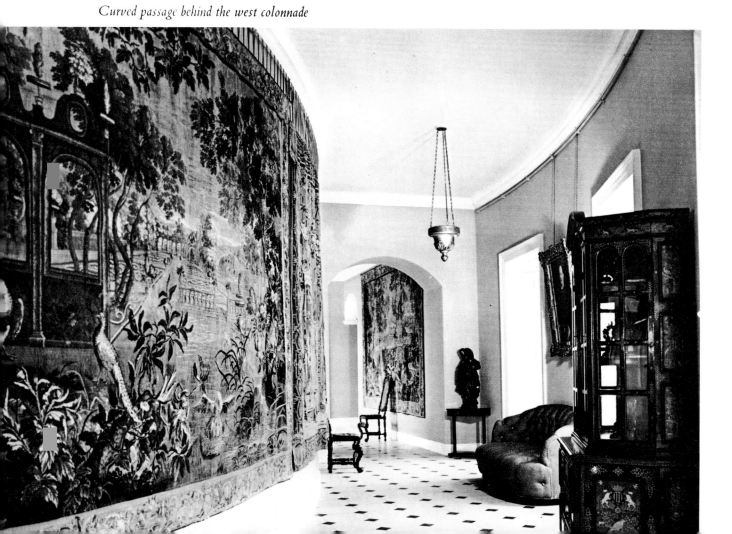

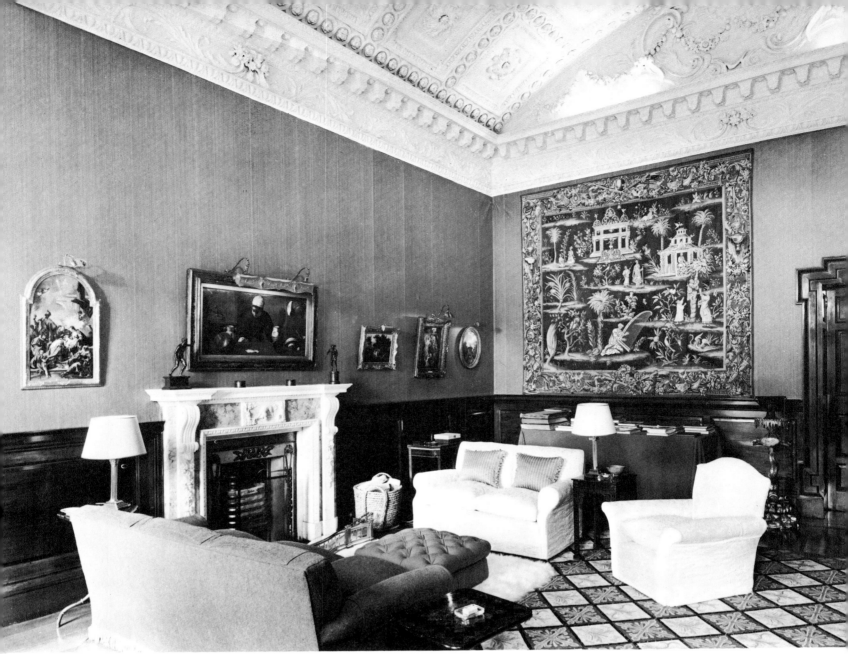

The tapestry room with the early Velazquez over the mantel

Emmaus (painted out in the Russborough version during the nineteenth century but now visible) is in the Chicago Art Institute. Among other pictures in this room there is a painting by Hubert Robert of a cottage built for Catherine the Great as part of her Chinese village at Tsarko-Selo.

The ceiling of the music room is in the form of a coffered dome, which makes a curious echo on passing through the centre of the room. The pure white mantel with its exquisite central panel representing Leda and the Swan was probably imported from England, although the Dublin Society did encourage such work in Ireland and offered premiums for the most successful carved plaques. Between the windows hangs Gainsborough's *Cottage Girl with Dog and a Pitcher,* painted in 1785, which became well-known through the engraving of it. Over the pianos there is a splendid Raeburn, *Sir John Clerk of Penicuik and his wife,* which recently travelled to Moscow for the English Portraits exhibition. There are also five Guardis,

one of which is a view of the Piazza San Marco, the old campanile slightly taller and more ethereal than it seems today, and two Bellottos of the Arno in Florence.

The principal apartment at Russborough is the saloon, which takes up the three central bays of the north front. It is a dark room, the walls being covered in dark red, cut velvet dating from 1870, with curtains to match. The yellow and white mantel stands out against the dark walls. Its relief of Androcles and the Lion is flanked by caryatids, old men with faces superbly carved, the work of Thomas Carter the younger, of London. The Louis XVI furniture in Beauvais tapestry is signed by the hand of P. Pluvinet; the Japanese lacquer cabinets between the windows come from Harewood House. Framed against the central window is a curious round table on three curved legs, surmounted by a palm tree which bears another smaller table. It is possibly English Regency, and it certainly would not be out of place in the Brighton Pavilion: it derives from the French idea of a *table à bouillote*. The ceiling, the best in the house,

Russborough : the saloon. Here the plasterwork is definitely by the Francini brothers

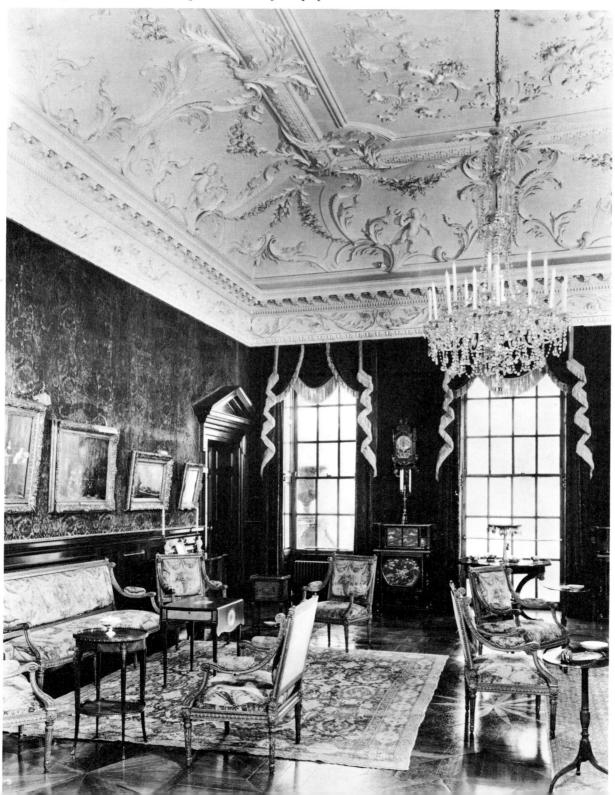

is the work of the Francini brothers. It must be said that their authorship has sometimes been called in question on account of the insubordinate role played by the putti in the decoration, where they carry emblems of the Four Seasons and the Four Elements. It is certainly a great deal lighter than the Carton ceiling which only antedates it by about five years. Perhaps only one brother worked at Russborough, not the one that specialized in figure work. This is pure conjecture, as there is no evidence as to how the work was apportioned between them, and it is more likely that at Russborough the figures were forced into the background so as to avoid any imbalance with the plasterwork in the adjacent rooms. A comparison of the frieze in the saloon or principal room in three of Richard Castle's houses built within the space of five years (Carton, Tyrone House, Dublin, and Russborough) proves beyond reasonable doubt that the Francini worked at all three. Mr John Cornforth (*Country Life,* 19 December, 1963) believes that they decorated the rooms on the north front, the music room, saloon, and library, and he is probably right.

The saloon contains the principal Dutch and Flemish pictures in the Beit collection, the star of which is Vermeer's *Lady Writing a Letter with her Maid,* one of the only three Vermeers to remain in private ownership. Second only in rank to the Vermeer are a pair of Dutch interiors from the Hope collection at Deepdene, *The Letter Writer* and *The Letter Reader,* signed by Metsu, and considered by Mr Francis Watson to be his masterpieces (*The Connoisseur,* 1960, vol. 145, pp. 156–163, 216–224). Irish houses are generally superior in their architecture to their contents; Russborough is the happy exception to this rule.

The library, with Goya's portrait of Doña Antonia Zarate over the mantel

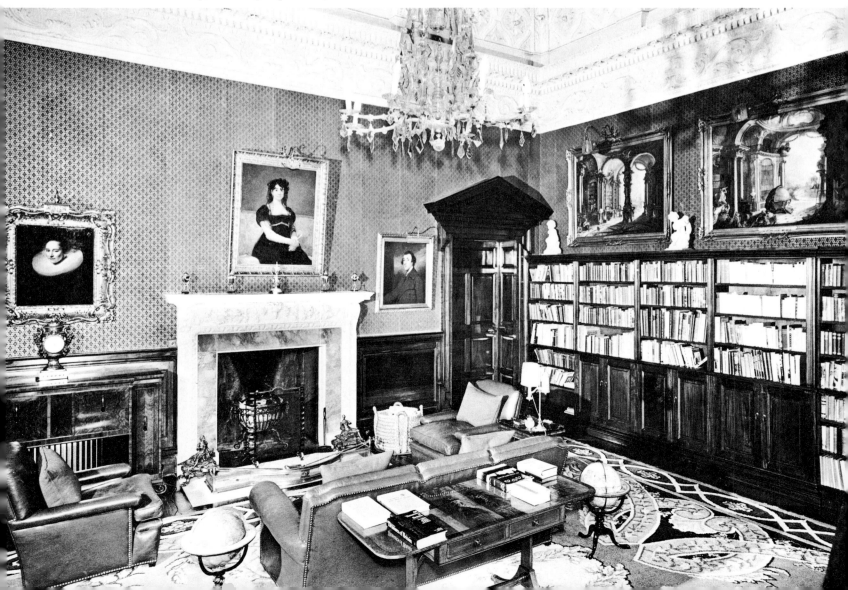

The present library, fitted up with bookshelves by the present owners, who have also made use of extra mahogany overdoors found in the house, was originally the dining-room. The design of the ceiling is most imaginative and unusual, and the Spanish carpet was evidently inspired by it. Over the mantel of yellow and white marble hangs Goya's portrait of Doña Antonia Zarate. To the right is a Reynolds of Tom 'Squire' Conolly of Castletown, and to the left stands a gilt microscope made by Angelo Gozzi in 1772; its kingwood fitted case bears the arms of the last Duke of Parma.

Over the bookshelves may be seen two of the set of four paintings designed originally as overdoors by Jacques Lajoue, representing the interior of one of the most famous scientific collections in Paris, *le Cabinet Physique de M. Bonnier de la Mosson,* signed and dated 1734.

The bedroom floor is approached by a heavy mahogany staircase similar to one designed by Castle for Tyrone House in Dublin. The mahogany has not been spared, and in spite of the exquisite carving and superb finish, the effect is somewhat ponderous. It is here that the plasterwork breaks all bounds of rationality. 'It is the ravings of a maniac, and I am sure the madman was Irish', was the much-quoted comment of Mr Sibthorpe. When Miss Nancy Mitford described Irish plasterwork as 'looking like the stuff you put on your leg when you break it', she may have had the Russborough staircase in mind. In spite of the stairwell being only twelve feet in width, the plaster decoration is more heavy and crowded than can be imagined. It is not without humour – swags of flowers are held up in the mouths of lugubrious hounds with long ears, the Man in the Moon laughing at their discomfort. A music book, surrounded by musical instruments, is open at the page of 'The Early Horn'.

The rococo plasterwork on the staircase; (right) detail

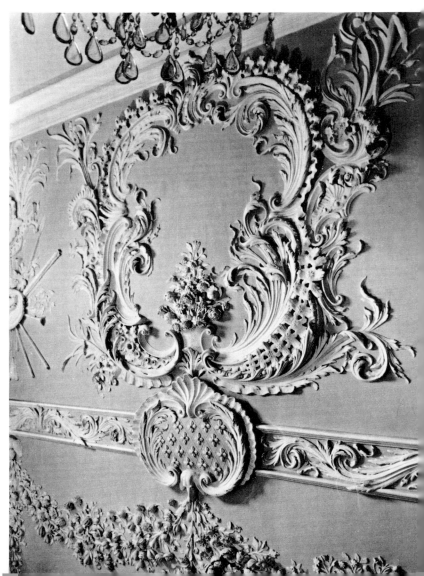

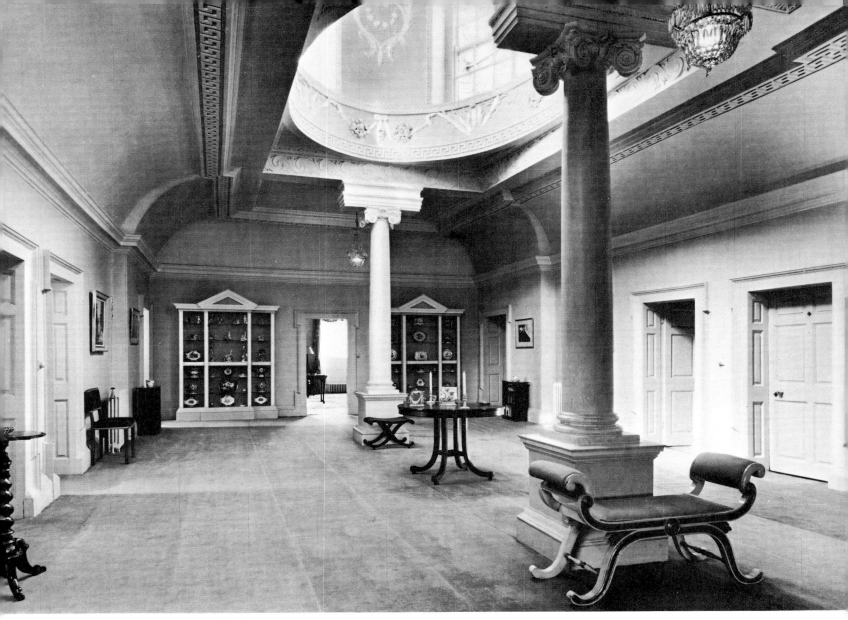

The bedroom landing

The layout of the bedrooms at Russborough is similar to that at Bellamont Forest (q.v.) only on a larger scale. The landing off which the bedrooms open is lit by a beautiful oval lantern decorated with rococo ornament. The two pillars are recent insertions – the lead roofing here was proving too heavy for the old timbers to support. All the bedrooms have contemporary panelling and the fascinating variety of mantels already referred to. The layout is ingenious, and nearly every one has a panelled closet or dressing-room off it which has now been converted into a bathroom. Although of modest size, the bedrooms are in perfect taste and harmonize with the rest of the house; they enjoy superlative views of the surrounding countryside.

Richard Castle died in 1751 and it is assumed that the completion of house and out-offices was put in the hands of Francis Bindon, who is traditionally supposed to have collaborated with Castle on the building of Russborough. What matter if there is so little information on the house or its building – as Castle's best preserved house, it can speak for itself.

The house is only open by special arrangement to cultural societies.

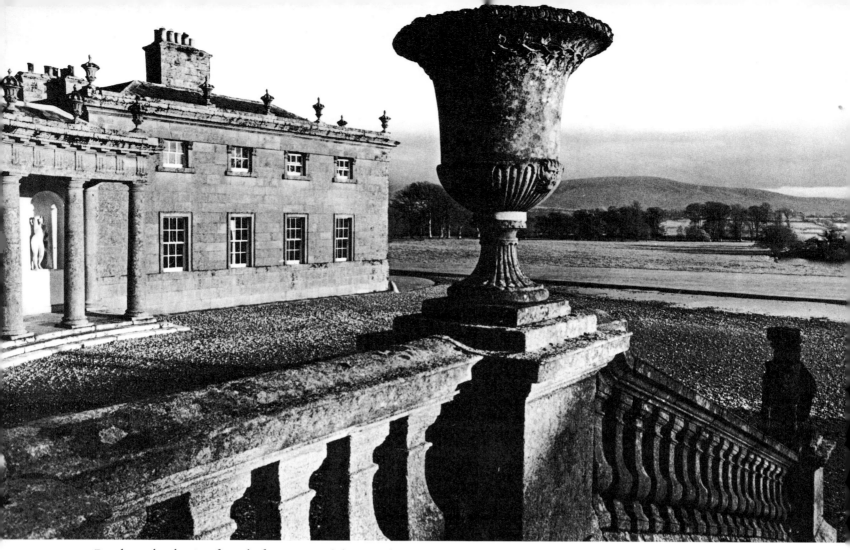

Russborough: the view from the front steps and the east colonnade

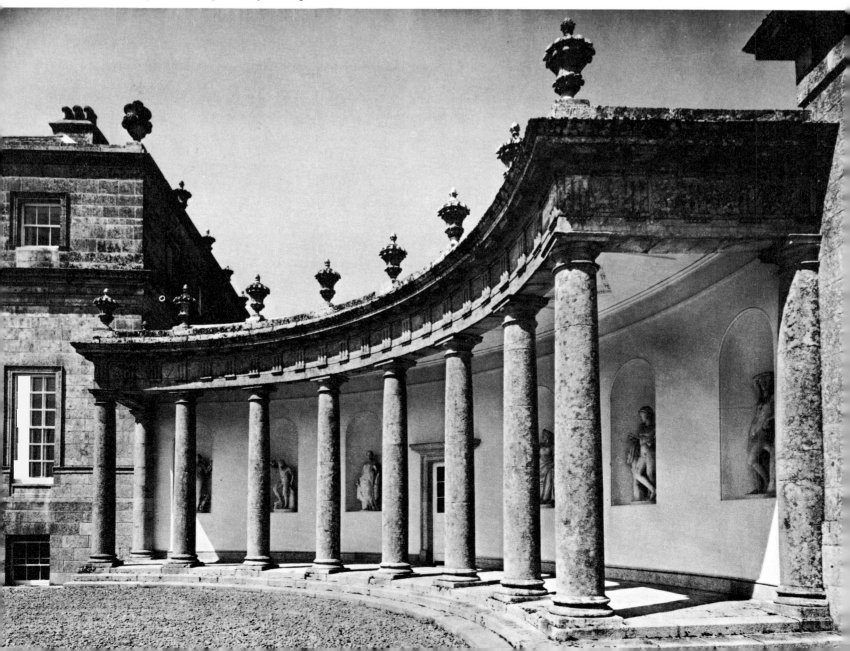

BIBLIOGRAPHY

Atkinson, A. *Ireland in the Nineteenth Century*. London, 1833.
The Irish Tourist. Dublin, 1815.

Bagshawe, W. H. Greaves. *The Bagshawes of Ford*. Pub. privately, 1886.

Ball, Dr Francis Elrington. *A History of the County of Dublin*. 4 vols. Dublin, 1902–6.

Barrington, Jonah. *Personal Sketches of his own times*. London, 1827–32.

Boylan, Lena. *The Early History of Castletown*. Dublin, 1967.

Brewer, James Norris. *The Beauties of Ireland*. 2 vols. London, 1825.

Bulfin, William. *Rambles in Eirinn*. Dublin, 1907.

Burke, John. *A Genealogical and Heraldic History of the Commoners of Great Britain and Ireland*. 4 vols. London, 1833–8.

Burke, Sir John Bernard. *Burke's Genealogical and Heraldic History of the Peerage*. Various editions.
Vicissitudes of Families. London, 1859–63.
A Visitation of the Seats and Arms of Noblemen and Gentlemen of Great Britain and Ireland. 2 vols. London, 1852. Second Series 2 vols. London, 1854.

Campbell, Colen. *Vitruvius Britannicus*. 3 vols. London, 1717–25.

Carte, Thomas. *An History of the life of James, Duke of Ormonde*. 3 vols. London, 1735–6.

Chambers, Sir William. *A Treatise on Civil Architecture*. London, 1759.

Clark, Mrs Godfrey. *Gleanings from an Old Portfolio*. 3 vols. Edinburgh, 1895–8.

Cobbe, Frances Power. *Life of Frances Power Cobbe. By Herself*. 2 vols, London, 1894.

Colvin, Howard and Craig, Maurice. (editors). *Architectural drawings in the library of Elton Hall by Sir John Vanbrugh and Sir Edward Lovett Pearce*. Oxford, 1964.

Craig, Maurice and Knight of Glin. *Ireland Observed*. Cork, 1970.

Crookshank, Anne and Knight of Glin. *Irish Portraits 1660–1860*. Exhibition Catalogue, London, 1969.

Curran, C. P. *Dublin Decorative Plasterwork of the Seventeenth and Eighteenth Centuries*. London, 1967.

D'Alton, John. *The History of the County of Dublin*. Dublin, 1838.
The History of Drogheda with its environs. 2 vols. Dublin, 1844.

Delany, see Granville, Mrs Mary.

FitzGerald, Brian (editor). *Correspondence of Emily, Duchess of Leinster*. Irish Mss. Comm., Dublin, 1949.
Emily, Duchess of Leinster. London, 1949.
Lady Louisa Conolly. London, 1950.

Fraser, James. *A Handbook for travellers in Ireland*. Dublin, 1844.

Frost, James. *The History and Topography of the County of Clare from the earliest times to the beginning of the eighteenth Century*. Dublin, 1893.

The Georgian Society. *The Georgian Society Records of Eighteenth-Century Domestic Architecture and Decoration in Dublin*. 5 vols. Dublin, 1909–1913.

Gibbs, James. *A Book of Architecture*. London, 1728.

Granville, Mrs Mary. *The Autobiography and Correspondence of Mary Granville, Mrs Delany*. ed. Lady Llanover. 3 vols. London, 1861.

Guinness, Desmond. *Portrait of Dublin*. London and New York, 1967.

Hare, Augustus John Cuthbert. *Life and Letters of Maria Edgeworth*. London, 1894.

Harris, Walter and Smith, Charles. *The Antient and Present State of the County of Down*. Dublin, 1744.

Historical Manuscripts Commission. *Manuscripts of the Earl of Egmont*. Diary of Viscount Percival afterwards first Earl of Egmont, 1730–1747. 3 vols. London, 1920, 1923.

Holmes, George. *Sketches of some of the southern counties of Ireland collected during a tour in the autumn, 1797. In a series of Letters*. London, 1801.

Ide, John J. *Some Examples of Irish Country Houses of the Georgian Period*. New York, 1959.

Irwin, George O'Malley. *The Illustrated Hand-book to the County of Wicklow*. London, 1844.

Killanin, Lord and Duignan, Michael V. *The Shell Guide to Ireland*. 2nd edn. London, 1967.

Leask, Harold G. *Dublin Castle, A Short Descriptive and Historical Guide*. Dublin, [1944].

Lecky, William Hartpole. *A History of Ireland in the Eighteenth Century*. 5 vols. London, 1892-6.

Loveday, John. *Diary of a Tour in 1732*. Edinburgh, 1890.

Luckombe, Philip. *A Tour through Ireland*. Dublin, 1780.

Milton, Thomas. *A Collection of select views From the different seats of the nobility and gentry in ... Ireland*. London, 1783-93.

Moore, Thomas. *Life and Death of Lord Edward Fitz-Gerald*. London, 1831.

Morris, Francis Orpen. *A Series of picturesque views of seats of the Noblemen and Gentlemen of Great Britain and Ireland*. 6 vols. London, 1866-80.

Newenham, Robert O'Callaghan. *Picturesque views of the Antiquities of Ireland*. 2 vols. London, 1830.

O'Donovan, John (editor and translator). *Annals of Rioghacta Eirann. Annals of the Kingdom of Ireland, by the Four Masters*. 7 vols. Dublin, 1851.

Pilkington, John Carteret. *Life of John Carteret Pilkington*. London, 1761.

Pococke, Richard. *Pococke's Tour in Ireland in 1752*. ed. George T. Stokes. Dublin and London, 1891.

Prendergast, John Patrick. *The Cromwellian Settlement of Ireland*. Third ed. Dublin, 1922.

Pückler-Muskau, Hermann L. F., Fürst von. *Tour in England, Ireland and France in ... 1828 & 1829*. Trans. Sarah Austin. 2 vols. London (?) 1832.

Rand, Benjamin (ed.). *Berkeley and Percival*. Cambridge, 1914.

Reynolds, James. Andrea Palladio. New York, 1948.

Sadleir, T. U. and Dickinson, P. L. *Georgian Mansions in Ireland*. Dublin, 1915.

Strickland, Walter George. *A Dictionary of Irish Artists*. 2 vols. Dublin and London, 1913.

Summerson, John. *Architecture in Britain 1530 to 1830*. London, 1953 and subsequent editions.

Swift, Jonathan. *Dr S----'s real Diary. The Journal*. London, 1715.

Taylor, W. B. S. *History of the University of Dublin*. London, 1845.

Tocnaye, de la. *Rambles through Ireland by a French emigrant*. Cork, 1798.

Toesca, Ilaria. 'Alessandro Galilei in Inghilterra', *English Miscellany* (Rome). No. 3, 1952.

Tollemache, Beatrix. L. C. (editor). *Richard Lovell Edgeworth. A Selection of his Memoirs*. London, 1896.

Trotter, John Bernard. *Walks through Ireland, in ... 1812, 1814, and 1817*. London 1819.

Twiss, Richard. *A Tour in Ireland in 1775*. London, 1776.

Wilde, Sir William. *The Beauties of the Boyne*. Dublin, 1849.

Wilson, William. *The Post-chaise Companion*. 3rd edn. Dublin, 1803.

Wright, G. N. *Ireland Illustrated in a series of views of Cities, Towns, public buildings, etc*. London, 1829.

Young, Arthur. *A Tour in Ireland, with general observations on the present state of that Kingdom*. London, 1780.

Valuable research on Irish houses and castles has been done in recent years by Lena Boylan, John Cornforth, Maurice Craig, Anne Crookshank, C. P. Curran, Brian FitzGerald, Mark Girouard, the Knight of Glin, John Harris, Christopher Hussey, Harold Leask, Edward McParland, Edward Malins, John O'Callaghan, T. G. F. Paterson, and A. J. Rowan much of which has been published in the form of articles in *Country Life, Apollo,* and the *Bulletin of the Irish Georgian Society.* This material has been freely drawn on here, as have articles in newspapers and periodicals by Mark Bence-Jones, Ita Hynes, James Fleming, Desmond Moore, Kay O'Higgins, Terence de Vere White and others.

Few Irish houses have their records and building accounts intact, and county record offices do not exist.

The Records Office in Dublin, overflowing with family papers specially brought in for safe keeping during 'the troubles', was destroyed by fire in 1922. The dearth of factual information on the Irish country house is, in part, compensated by the picture drawn of the Great House in Irish literature. *Castle Rackrent* and *The Absentee* by Maria Edgeworth, *The Great House at Inver* by Somerville and Ross, and the works of Elizabeth Bowen are well-known classics. They give the flavour of country life in Ireland centred on the Big House. In *Bowenscourt* Miss Bowen has written a factual account of her own forebears, and the life they led in County Cork; the book includes a detailed account of the building of the house, and is a magnificent *apologia* for the Anglo-Irish.

THE PHOTOGRAPHS are by the authors with the exception of those on the following pages
A and C Photography, Belfast: back endpaper, 25 bottom, 94, 101, 164 top and centre; Aerofilms Ltd: 18; Belfast Telegraph: 32 right; *Country Life,* London: 27 bottom right, 31 top, 38, 40, 41, 43, 45, 46, 47 left, 57, 59, 78 left, 80 top, 84 top, 92, 95, 96, 97 top, 99, 185 left, 187 right, 197, 198, 199, 203, 205, 208, 218, 220, 221 top right, 222, 223, 232, 236, 237, 238, 239, 247, 248, 252, 253, 255, 270, 273, 274, 275, 277, 278, 280, 284, 285, 286, 287, 294, 297, 298, 301, 314, 316, 319, 320, 321, 332, 343, 344, 346 left, 347, 348 bottom; Courtauld Institute of Art: 13; Hugh Doran: 47 right, 55, 97 bottom, 147, 150, 152 bottom left and right, 153, 162 bottom, 166, 167 right, 168, 171, 172, 251 bottom, 290, 291, 293, 307 top, 326, 329 bottom right, 339, 340, 346 right; David Eccles: 25 top; The Green Studio Ltd Dublin: front endpaper, 9, 15, 17, 28, 70, 104, 110, 111 bottom, 112 top, 114, 116 top, 129 top, 184, 192, 195, 201 bottom, 202, 209, 206, 212, 213 right, 265 right, 302 top, 307 bottom, 311, 312, 313, 318, 329 bottom left, 337, 345 (a helicopter lent by Mr K. G. Besson was used to take the photographs on pp. 192 and 318); *Irish Times*: 259 top; Irish Tourist Board: 26, 113, 115, 207, 251 top, 305, 308; Lucy Lambton: 201 top, 348 top; Thomas McCleary: 23; National Gallery of Ireland: 33 left; National Museum of Ireland: 27 bottom left; Walter Pfeiffer (with the co-operation of Irish Helicopters Ltd): 263; Edwin Smith: 60, 68; Ulster Museum: 10, 18, 20, 24 top, 31 bottom, 175, 187 left, 304, 324, 330.

ACKNOWLEDGMENTS

THE AUTHORS would like to thank all who have been of assistance in the preparation of this volume, in particular the owners of the houses here described, who have been kindness itself. They would also like to thank John Stewart who made the ground plans, and William Garner who did valuable research in the National Library. Among the many who have been particularly helpful and encouraging are the Knight of Glin of the Victoria and Albert Museum, John Lewis-Crosby of the National Trust (Committee for Northern Ireland) and John Cornforth of *Country Life,* and Jeremy Williams. Large sections of the manuscript were corrected by the Knight of Glin, Anne Crookshank, John Cornforth, John O'Callaghan and Edward McParland. Thanks are also due to Josephine Sheehan and Patricia McSweeney for typing the text.

INDEX

Numbers in italics refer to captions

Abbey Leix 225–31
Adair, John 85
Adam, Robert 10, 13, 14, 30
An Taisce 20, 36
Aras an Uachtaráin 108, 109–16

Ballinlough Castle 289–93, *288*
Bantry House 21, 26, 61–9
Barret, George 32, 338, *324, 330*
Barry, David de, family of 71
Beaulieu 241–4, *247*
Belan 22, 24, *13*
Bellamont, Earl of 43, 44
Bellamont Forest 11, 39–47
Belmore, Earl of 163f., *167*
Belvedere 32, 98, 295–301, *294*
Belvedere, Earl of 295–6, 301, *297*
Bindon, Francis 13, 121, 126, 347, *127*
Birr Castle 271–7, 317, *270*
Bossi, Pietro 131, 337, 342, *340*
Boswell, James 146
Bowenscourt 56, *57*
Boyle, Richard (Great Earl of Cork) and family of 71, 283
Boyle, Robert 283
Boyne, Battle of the 7, 8, 12, 193, 258, *247*
Bristol, Earl of 18, 24, 26, *1*
Brown, Capability 94, 186, 262
Browne, John and family of 249, 250, 252–4
Browne-Clayton, General, column of 24
Bunratty Castle 49–53
Burgh, Thomas 11, 198
Burlington, Earl of 40, 120, 284, 326
Burlington House 39, *41*
Butler, Thomas *see* Ormonde, Earl of

Caldwell, Sir James 95, 298f.
Callan, John of 233–4
Carrick-on-Suir Castle 242, *32*
Carton 13, 19, 22, 29, 78, 98, 183–90, 199, 202, 216, 285, 312, 345, *182*
Cashel, Archbishops of 219, 279
Cashel Palace 11
Castlecoole 163–7, 337, *175*
Castle, Richard 11ff., 32, 110, 151, 170, 183f., 185, 199, 249, 250, 252f., 296, 323, 328, 334, 341, 345, 347, *13*
Castletown (Co. Kildare) 8, 10, 24, 26, 36, 37, 78, 193–208, *82*
Castletown (Co. Kilkenny) 11, 77, 78, 219–23, *218, 282*
Castleward 14, 93–100
Chambers, Sir William 9, 81, 132, 205, *1*
Charlemont, Earl of 9, 26, *1*
Charles II 109, 241, 303
Charleville 98, 309–13
Clements, Nathaniel 14, 109–10
Cobbe, Rev. Charles and family of 151–4
Cobbe, Frances Power 153–4
Cole, John and family of 169–75
Conolly, Lady Anne 197–8
Conolly Folly, the 24, 199f., *192*
Conolly, Lady Louisa 78, 132, 186, 202, 204–7
Conolly, 'Speaker' 193–8, 212
Conolly, 'Squire' Tom 81, 186, 204, 206, 213, 304
Conolly, William 197, 200, 202, 212
Conyngham, Alexander and family of 262, 268
Coote, Charles *see* Bellamont, Earl of

Coote, Thomas and family of 42–7
Corbally, Matthew and family of 161
Corry, John and family of 163
Cox, Michael and family of 219–23
Cramillion, Bartholomew 28
Cromwell, Oliver 7, 49, 55, 178, 241, 242, 249
Cunninghame, General and family of 315, 320
Customs House, Dublin 8, 117
Cuvilliés, Jean-François 108, 113

Davis, Whitmore 309, *310*
Delany, Mrs Mary 93, 105f., 109, 170, 200, 202, 295
De La Poer, family of 323
Derry, Bishop of *see* Bristol, Earl of
Desmond, Earls of 49, 234–5, 236
Devonsher, Abraham and family of 77, *82*
Devonshire, Dukes of 284–5, *287*
Dromana Gate 21, *22*
Dublin Castle 11, 103–8
Ducart, Davis 14, 77, 131, 169, 219, 220f., *76*
Dunsany Castle 256, 257–60, *280, 298*
Dunsany, Lord 211

Edgeworth, Maria 7, 304
Edgeworth, Richard Lovell 304
Elizabeth I 117, 122, 125, 172, 236, 279, 303, *32*
Enniskillen, Earl of *see* Cole, John

Famine, the Potato 17, 85, 153, 180, 325
Faulkner, George 14, 43, 44
Ferneley, John 72, 73, 126, *127*
Fisher, Jonathan 32, *212*
FitzGerald, Lord Edward 186, *187*
Fitz-Gerald, John Bateman 237–8, *237*
Fitz-Gerald, John Fraunceis 238–9
FitzGerald, Thomas ('Silken') 103, 131, 211
Flemings, family of 261
Florence Court 169–75
Fota Island 71–6, *82*
Four Courts, Dublin 8, 117
Francini, Paul and Philip 28, 29, 77f., 81, 114, 131, 159, 184, 202, 204, 344, 345, *203*

Gainsborough, Thomas 72, 122, 343
Gaisford, Julian Charles and family of 126, 128–9
Galilei, Alessandro 10, 11, 131, 194f.
Gandon, James 8, 262, *9*
George IV 268, 330
Glenveagh Castle 85–91
Glin Castle 233–9, *244*
Glin, Knight of 14, 126, 220, 233–4, 309
Gorges, Lt.-Gen. Richard and family of 159
Gort, Viscount 52, 180
Goya, Francisco José de 346, *345*
Gree, Peter de 32, 133, 142, 316, 317, *314*
Guinness, Richard and family of 216

Hamilton, Hugh 33, 148, *187*
Headfort 14, *10, 24, 30*
Healy, Robert 33, 148, *206*
Howth Castle 125–9

Ingoldsby, Maj.-Gen. Richard 183
Irish Georgian Society 24, 34, 36, 57, 114, 193, 208, 216
Ivers, Henry and family of 55
Ivory, Thomas 8, 186, 252, 285, *285*

James II 145, 148, 183, 249, 258
John (King) 103, 145, 216, 279
Johnston, Francis 106, 110, 113, 262, 265f., 272, 306, 315f., *14*
Johnston, Richard 164, 315f., *165*
Jullian, Philippe 88

Kildare, nineteenth Earl of 183, 185
Kildare, twentieth Earl of *see* Duke of Leinster
Kilkenny Castle 35
Kilshannig 77–82, 222, 282, *84*

Landseer, Sir Edwin 91, *90*
Leeson, Joseph and family of 333–9, 341
Leinster, Duke of 19, 44f., 185–90
Lennox, Lady Emily 185, 213
Leixlip Castle 159, 200, 211–16, *217*
Lismore Castle 279–87, *278*
Lough Cutra 177–81
Lovett Pearce, Sir Edward 11, 39, 40, 41, 42, 43, 56, 108, 110, 195f., *108, 197*
Lowry-Corry, Armar *see* Belmore, Earl of
Lucan House 131–6, 316, *120, 121*
Luttrellstown Castle 139–42, *136, 143, 264*
Luttrells, family of 139
Lutyens, Sir Edwin 126, 128, 129, *124*
Lyons, Co. Kildare 18, 19

Malahide Castle 30, 145–9, 183, 292, *227, 264, 301*
Marino Casino 9, 35, 122, *1*
McGrath, Raymond 106, 113, *115*
McIlhenny, Henry 86, 88, 91
Mespil House 108, 115, 296, *113*
Milton, Thomas 32, 110, 132, 315
Monck, Charles and family of 309, 312–13
Morrison, Sir Richard 167, 188, 306, 312, 327, *9*
Mount Charles, Earls of *see* Conyngham, family of
Mount Ievers Court 55–9
Mount Kennedy 315–20, *314*
Mountstewart, the Temple of the Winds *23*
Mussenden Temple 25, *1*
Myers, Graham 9, 306

National Trust of Northern Ireland 34, 100, 163, 167, 169, 170f., *175*
Newbridge 30, 151–8

O'Brien, family of 49
O'Connor, James Arthur 32, 254
O'Conor, Hugh 135
Office of Public Works 35, 52, 257
O'Malley, Grace 125, 249
Ormonde, Earl of 225, 323, *32*
O'Shaughnessy, family of 178
Oudry, J.-B. 341, *336*
Oxmantown, Lord 272

Pacata Hibernica 234, *235*
Pain, James and George Richard 177, *15*

Pakenham, Henry and family of 303–8
Pale, the 211, 257, 261
Palladio, Andrea 39, 120, 193, 326, 327
Parliament House, Dublin 11, 108, 117
Parsons, Sir Laurence and family of 271f.
Phoenix Park 108, *109*
Plunkett, Christopher and family of 257–60
Powerscourt 117, 323–31, *27, 319, 323, 334*
Priestley, Michael *12*
Provost's House, the 117–22
Pugin, Augustus 287, *286*

Raleigh, Sir Walter 279
Ramsay, Allan 68, *167*
Rathbeale Hall 159–61, 341, *157, 158*
Reynolds, Sir Joshua 44, 142, 254, 319, 337, 346, *246*
Riverstown House 28, 77f., *114, 29*
Roberts, T. S. 32, *9, 280, 382*
Rochfort, Robert *see* Belvedere, Earl of
Rocque, J. 18, 128, 161, *129, 329*
Rothery, family of 56, 195f.
Russborough 26, 98, 252, 254, 333–47, *112, 332, 348*
Russell, George 91

Sarsfield, Sir William and family of 132
Sheil, James 260, 306, *304*
Slane Castle 261–9
Sligo, Marquess of 250, 252, 254
Stapleton, Michael 32, 133, 134, 258, 301, 316, 337, *256, 314*
St Patrick's Hall 103, 105, *102, 104*
St Laurence, Sir Armoricus and family of 125–6
Stuart, Athenian *23*
Stuart, Gilbert *23*
Studdert, family of 52
Swift, Dean 16, 126, *127*

Talbot, Richard and family of 145–8
Talbot, Sir William and family of 183
Tone, Wolfe 62, 271
Trench, I. T. 85, *86*
Trinity College 9, 11, 117, 198
Tullynally Castle 22, 303–8, *302*

Van der Hagen, J.-C. 183, *182*
Van Dyck, Anthony 72, 260, 338
Velazquez, Diego 342
Vereker, Col. Charles 179f.
Vermeer, Jan 345
Vernet, studio of 338, 342
Vesey, Agmondisham and family of 132, 134f.
Vierpyl, Simon 198, 204

Walker, Thomas *27*
Ward, Sir Robert and family of 93–100
West, Robert 30, 147, 151, 170
Westport 26, 249–55, *27, 248, 263*
Wheatley, Francis 32, 147, *13*
White, Luke and family of 139–40
Whyte, Sir Nicholas and family of 211f.
William of Orange 8, 42, 178, 179, *247*
Wingfield, Sir Richard and family of 323–34
Wonderful Barn, the 200, *201*
Wyatt, James 163, 164, 226, 252, 262, 265, 292, 315, *172, 224, 252, 293*